SILVER EDITION

Published in the United States of America in February 2008.

Gingko Press, Inc.
5768 Paradise Drive, Suite J
Corte Madera, CA 94925, USA
Phone (415) 924 9615 / Fax (415) 924 9608
email: books@gingkopress.com
www.gingkopress.com

ISBN: 978-1-58423-284-1
LCCN: 2007936279
© 2008 Daniel & Geo Fuchs

Printed in Hong Kong.

TOYGIANTS
DANIEL & GEO FUCHS

SILVER EDITION

GINGKO PRESS

NICE TO MEET YOU

The project TOYGIANTS is the product of several years of collaboration by Daniel & Geo Fuchs and Selim Varol. Daniel & Geo Fuchs have worked together for over 15 years on conceptual artistic projects, the most recent of them being "Conserving", "Famous Eyes" and "STASI – Secret Rooms". Their work is shown in exhibitions and art museums around the world. Selim Varol has collected toys for over 20 years and is the owner of one of Europe's largest collections.

The world of TOYGIANTS is a world full of plastic and vinyl. The figures are true-to-life miniature sculptures, the models for which can be found in the political spectrum, in the film industry and its dream factory, in comic and Manga characters, and in the fantasies of urban, contemporary designers.

– Daniel and Geo, all of the figures you have photographed belong to Selim Varol's collection. How did his collection first come to your attention and, as artists, what aroused your interest in this world of toys?

Geo Fuchs: At the beginning of 2004 we came to Berlin as Artists-in-Residence. One day, as we were wandering around the center of the city, we ventured into a side street and there, in the window of a fashion and design shop, we discovered our first two figures: two robots approximately 20-30 inches (50-80 cm) tall. Prior to that day we hadn't any contact with the toy world, but these two robots appealed to us immediately. We went into the shop and found out that the toys belonged to one of the owners, Selim Varol, and that he had a large collection of them. This excited us due to the fact that for a while now our artistic pursuits have involved working with archives and collections. We made contact with Selim and quickly arranged to meet him. Our first meeting took place in Düsseldorf in one of his company warehouses where a part of his collection was stored. When we first saw these amazing figures we couldn't believe our eyes. Hardly a week passed before we started work on the project.

Selim Varol: We had used the robots to decorate the window of our shop in Berlin. In Germany only a few people were familiar with these figures so they attracted quite a lot of attention. Many people talked to us about them but Daniel and Geo were the first to see more in them....

Selim, what inspired you to become a collector of these figures?

Selim: At first, I just wanted to recapture all of those lost toys from childhood. It started with the robots, and followed with

NICE TO MEET YOU

Das Projekt TOYGIANTS ist Ergebnis der mehrjährigen Zusammenarbeit von Daniel & Geo Fuchs und Selim Varol. Daniel & Geo Fuchs arbeiten seit über 15 Jahren gemeinsam an künstlerisch-konzeptionellen Projekten, so zuletzt „Conserving", „Famous Eyes" und „STASI – Secret Rooms". Ihre Arbeiten werden in internationalen Ausstellungen und auf Kunstmessen gezeigt. Selim Varol sammelt Toys seit über 20 Jahren und besitzt mittlerweile eine der größten Toy-Sammlungen Europas.

Die Welt der TOYGIANTS ist eine Welt voller Plastik und Vinyl. Die Figuren sind detailgetreue Miniatur-Skulpturen, deren Vorbilder der realen Politik, der Traumfabrik der Filmindustrie, dem Character-Design aus Comic und Manga und den Fantasien zeitgenössischer urbaner Designer entstammen.

– Daniel und Geo, alle Figuren, die ihr fotografiert habt, sind Teil der Sammlung von Selim Varol. Wie seid ihr auf die Sammlung gestoßen? Was hat euch als Künstler an dieser Toy-Welt interessiert?

Geo Fuchs: Anfang 2004 sind wir als Artists-in-Residence nach Berlin gekommen. Auf einem Streifzug durch Berlin-Mitte haben wir in einer Seitenstraße im Schaufenster eines Fashion-Design-Stores zum ersten Mal Toy-Figuren bewusst wahrgenommen: zwei Roboter, ungefähr 50-80 cm groß. Davor hatten wir mit der Toy-Welt keine Berührung. Diese beiden Roboter haben uns jedoch sofort angesprochen. Im Laden erfuhren wir, dass die Figuren dem Mitinhaber Selim Varol gehören und dass er eine große Sammlung hat. Da uns in unserer künstlerischen Arbeit Sammlungen und Archive schon seit langem beschäftigen, hat uns das sehr gereizt. Wir haben Kontakt zu Selim aufgenommen und uns bald getroffen – und zwar gleich im Lager eines seiner Firmengebäude in Düsseldorf, in dem sich Teile seiner Sammlung befinden. Wir waren total begeistert von all den Figuren und es hat keine Woche gedauert, bis wir begonnen haben, am Projekt zu arbeiten.

Selim Varol: Mit den Robotern hatten wir in Berlin im Laden das Schaufenster dekoriert. Da die Figuren in Deutschland nur wenige kannten, sind sie ziemlich aufgefallen und viele haben uns darauf angesprochen. Aber Daniel & Geo waren die ersten, die noch mehr darin gesehen haben...

Selim, wie bist du zum Sammler von all diesen Figuren geworden?

Selim: Zunächst wollte ich all das Spielzeug, das in der Kindheit abhanden gekommen war, zurückholen. Mit den Robotern ging es los, es folgten Superhelden, Filmfiguren, natürlich Star Wars.

superheroes, film characters, and of course Star Wars. After that came the phase of completing each series, although in between, there were times when I didn't buy anything. Most recently it's been Designer Vinyl that has given my collection a new kick.

The collection is comprised of approximately 10,000 figures. Given this huge number of toys how did you go about this project?

Daniel Fuchs: The book is actually a very good reflection of the process we underwent. When beginning a new project we always factor a degree for development. The process, from shooting the portraits, staging the scenes, all the way through to Designer Vinyl resulted from getting to know and coming to terms with the collection. At the beginning, our idea was to take portrait shots of these 12-inch-tall figures as if they were real people, and this way transform their plastic heads into something human. When we discovered the political figures in the collection, we introduced the process of staged scenes as a way of dealing with them, and actually started "playing" with them ourselves. Then, Designer Vinyl made its way more and more into the forefront, and became the focus of our work. Designer Vinyl is much more abstract, the forms are reductive and more archaic, facial expressions for example are mostly vague and only dimly recognizable.

Geo: What's generally fascinating about a collection is that each time you visit it you discover something new.

Has the collection undergone change through this project?

Geo: There was a change in the way the toys were handled. As soon as the figures are unpacked their value drops. There are collectors who never open the boxes, never allow them to see the light of day. We, of course, had to unpack the toys, but in doing so we've placed them in a new context and endowed them with a different value.

Selim: Of course, there are a lot of boxes that I still haven't opened, but touch and texture plays a very important role for me. I have to touch the toys, experience them with my senses. This is most evident in the toys I played with as a child. Over time they've been marked with scratches and blemishes, but these are flaws that tell a very personal story. Like the Batman figure featured on the cover of the book, is a good example. The collection has changed in other aspects as well: many of the figures were ordered especially for the project. We

Danach kam die Phase des Vervollständigens von Serien, obwohl es zwischendurch Zeiten gab, in denen ich nichts gekauft habe. In jüngster Zeit hat das Designer Vinyl meiner Sammlung neue Impulse gegeben.

Die Sammlung besteht aus ca. 10.000 Figuren. Wie seid ihr in Anbetracht dieser Fülle von Toys vorgegangen?

Daniel Fuchs: Das Buch spiegelt den Verlauf des Projekts eigentlich gut wider: Wenn wir ein Projekt beginnen, lassen wir immer Entwicklung zu. Der Prozess von den Porträts hin zu den Inszenierungen und dann zum Designer Vinyl hat sich durch die Auseinandersetzung mit der Sammlung ergeben. Am Anfang war unsere Idee, die Köpfe der meist 12-inch großen Figuren wie reale Personen zu porträtieren, die Plastikköpfe menschlich werden zu lassen. Als wir die politischen Figuren in der Sammlung entdeckten, begann der Prozess, sich mit den Figuren über Inszenierungen auseinanderzusetzen – wir begannen selbst mit ihnen zu „spielen". Dann rückte das Designer Vinyl immer stärker in den Fokus unserer Arbeit. Das Designer Vinyl ist viel abstrakter und die Formen sind reduzierter und archaischer, Gesichtszüge sind z. B. meist nur schemenhaft erkennbar oder überzeichnet.

Geo: Das Faszinierende an Sammlungen generell ist, dass man immer wieder, bei jedem Besuch, etwas Neues entdeckt.

Hat sich die Sammlung durch das Projekt verändert?

Geo: Es gab eine Veränderung im Umgang mit den Toys. Sobald man die Figuren auspackt, ist das bereits eine Wertminderung. Es gibt Sammler, bei denen die Kartons nicht ans Tageslicht kommen und niemals eine Packung geöffnet wird. Wir haben die Toys ausgepackt, ihnen aber eine neue Wertigkeit gegeben, indem wir sie in einen anderen Kontext gesetzt haben.

Selim: Natürlich gibt es viele Kartons, die ich noch nicht geöffnet habe, aber für mich spielt die Haptik eine ganz große Rolle. Ich muss die Toys anfassen, muss sie mit den Sinnen wahrnehmen. Vor allem den Figuren, mit denen ich als Kind gespielt habe, sieht man das an. Sie haben im Laufe der Zeit Kratzer oder Macken bekommen und dadurch eine ganz persönliche Geschichte zu erzählen, wie z. B. der Batman, der auf dem Buchcover ist. Die Sammlung hat sich aber auch in anderer Hinsicht verändert: Viele Figuren habe ich extra für das Projekt bestellt. Wir haben uns lange Gedanken gemacht und gezielt überlegt, welche Figuren noch einbezogen werden sollen.

thought long, hard and strategically about which figures we needed to add.

In what way has the newly attracted publicity influenced the collection?

Geo: It became clear at the first exhibition in the Museum Villa Stuck in Munich, and on publication of the book, that a lot of people would become aware of the collection itself and of Selim as a collector. Since then the TOYGIANTS photographs have made their way into international exhibitions and have received a huge response. News of the project, and Selim's collection, quickly spread via the internet forums of toy enthusiasts where Selim has received a lot of positive feedback.

Selim: I didn't actually feel the need to communicate with the public about my collection. The publicity was generated by the project and the exhibitions and taking part in it has been mainly to aid the project's progress. That is the general premise.

Your artistic view of the toys has met with the approval of toy lovers and collectors. How do you explain this?

Daniel: Probably because we have taken a completely different approach than any other publication. Many books on toys look a little like mail-order catalogues. The figures are often photographed in a very technical perspective. But for us it was more important to show their brilliance or charisma. We wanted our pictures to stir the emotions.

Selim: The way the scenes are set, we see that the figures are in action, and are communicating with one other. The whole project is based on a new way of looking at the world of toys, and it is not just for collectors.

Geo: When we work on and develop projects we do a lot of reflecting and observing. We become completely immersed in the new subject matter, involving ourselves with it every day over a period of years and so develop our own, very personal way of looking. That's probably what causes this "otherness".

To what degree have questions relating to the background of the production of the figures played a role in your work?

Daniel: Production background has played a secondary role for

Welchen Einfluss hatte die neu gewonnene Publizität der Sammlung?

Geo: Bereits mit der ersten Ausstellung im Museum Villa Stuck München und dem Buch war klar, dass viele Menschen von der Sammlung an sich und Selim als Sammler erfahren werden. Seitdem sind die TOYGIANTS-Bilder in internationalen Ausstellungen mit großer Resonanz zu sehen. Auch über die Internetforen der Toy-Liebhaber-Szene hat sich das Projekt und Selims Sammlung schnell verbreitet und er hat viel positives Feedback bekommen.

Selim: Das Bedürfnis, einer breiten Masse etwas über meine Sammlung mitzuteilen, hatte ich eigentlich nicht. Die Publizität hat sich durch das Projekt und die Ausstellungen ergeben und ich habe es immer unter der Prämisse getan, die Arbeit voranzubringen.

Wie erklärt ihr euch, dass euer künstlerischer Blick auf die Toys in der Szene der Toy-Liebhaber und -Sammler positiv aufgefallen ist?

Daniel: Wahrscheinlich weil es ein ganz anderer Zugang ist als in anderen Publikationen. Viele Toy-Bücher sehen ein bisschen wie Bestellkataloge aus. Oft werden die Figuren sehr technisch fotografiert. Für uns war aber die Ausstrahlung der Figuren wichtig. Die Bilder sollen emotional berühren.

Selim: Man sieht es den Szenarien an, dass die Figuren mit-einander in Kommunikation treten, in Aktion sind. Das ganze Projekt ist eine neue Sichtweise auf die Welt der Toys – nicht nur für Sammler.

Geo: Wenn wir Projekte machen, reflektieren und beobachten wir viel. Wir lassen uns ganz auf das neue Thema ein, beschäf-tigen uns über Jahre jeden Tag damit und entwickeln so unsere ganz persönliche Sichtweise. Das macht wahrscheinlich den „anderen" Blick aus.

Inwiefern haben Fragen nach den Produktionshintergründen der Figuren bei eurer Arbeit eine Rolle gespielt?

Daniel: Das hat für uns eine zweitrangige Rolle gespielt, weil wir mit den Figuren unsere eigene Welt geschaffen haben. Uns geht es viel mehr um die Emotion und um das, was wir mit den Figuren bewirken.

Sprechen wir noch mehr über die Fotografien, über das

us because we have used the figures to create a world of our own. We're much more concerned with the emotion and the effects we can create with the figures.

Let's talk a little more about the photography, about the artistic project TOYGIANTS. You have photographed the toys from a variety of perspectives: there are portraits, full body shots, multiple figure scenarios and group shots. In the portraits especially, you get unusually close to the figures. This aspect becomes even more evident in exhibitions where your photographs are displayed in very large scale. The faces of these small 12-inch (30 cm) figures are presented in photographs that are 6 feet (1.8 m) high and they can be quite imposing. Each figure's blemishes are clearly visible, some even appear to perspire… How important were these things in triggering the emotional impact and involvement you mentioned before?

Geo: Our first idea was to shoot portraits. This meant using the large format camera to photograph the head of a figure which is barely an inch (few centimeters) in length, just as you would a real person. As a rule, our method of working with large format involves a great deal of consideration, the process is slow and incremental. The images are all painstakingly thought through. Right from the beginning, we planned to exhibit the pictures in large format: larger than life, charming, menacing.

Selim: Right from the beginning I really liked the photos Daniel and Geo have taken of my figures. The focus is completely on the figure, with nothing to detract from it other than a white background. That was exactly the way in which I had always seen them.

Daniel: Initially, most people would be of the opinion that a figure bearing a fixed facial expression must appear the same in every picture. But the emotion expressed can be changed dramatically simply by changing the angle from which you photograph, or by the way you place the figures in the scene. Aside from that, the way we use light is also decisive. Light is what breathes life into a photograph. This is particularly apparent in the Hitler photographs in which the influence of light and positioning and the setting of the scene are clearly visible. When you compare these photographs they all communicate different emotions even though they all feature the same figure.

The fact that a toy figure has been made of a character such as Hitler is quite surprising and shocking, don't you think? Despite our universal acceptance of merchandising and the

künstlerische Projekt TOYGIANTS. Ihr habt die Toys ja aus verschiedenen Perspektiven fotografiert: Es gibt Ganzkörper-Bilder, Porträts, Figuren-Szenarien und Gruppenfotos. Besonders in den Porträts kommt man den Figuren ungewöhnlich nahe. In Ausstellungen, wo ihr Fotografien in großen Formaten zeigt, wird dieser Aspekt noch verstärkt. Die Gesichter von 30 cm kleinen Figuren begegnen einem hier in 1,80 m großen Fotografien und sprechen einen dadurch recht unmittelbar an. So sieht man Blessuren der Figuren, einige scheinen zu schwitzen… Wie wichtig war dieses von euch erwähnte Moment der emotionalen Ansprache und Involvierung?

Geo: Unsere erste Idee waren ja die Porträts. Das heißt den Kopf einer Figur, die ja nur ein paar cm groß ist, mit der Groß-bildkamera wie eine reale Person zu fotografieren. Unsere Arbeitsweise mit Großbild ist in der Regel eine sehr überlegte, langsame Herangehensweise. Die Bilder sind sehr durchdacht. Es war von Anfang an geplant, die Bilder in den Ausstellungen großformatig zu zeigen: überlebensgroß, anmutig, bedrohlich.

Selim: Mir haben die Fotos, die die beiden von meinen Figuren gemacht haben, von Anfang an sehr gut gefallen. Die Bilder waren ganz auf die Figur konzentriert, ganz pur vor weißem Hintergrund. Das war genau so, wie ich sie auch immer gese-hen habe.

Daniel: Viele würden zunächst glauben, dass eine Figur mit einem starren Gesichtsausdruck auf allen Bildern gleich aussehen müsste. Aber alleine der Winkel, aus dem man fotografiert, oder wie man die Figur in Szene setzt, verändert die Emotion unheimlich. Außerdem war sehr entscheidend, wie wir das Licht gesetzt haben, denn mit dem Licht haucht man das Leben ein. Das ist besonders auffällig bei den Hitler-Bildern, bei denen man den Einfluss von Licht und Positionie-rung, von In-Szene-Setzen tatsächlich sehr gut sehen kann. Wenn man sie vergleicht, ähneln sich die Emotionen auf keinem Bild, obwohl es sich ja überall um dieselbe Figur handelt.

Die Tatsache, dass es jemanden wie Hitler als Toy-Figur gibt, ist doch sehr überraschend und erschreckend? Trotz aller Gewöhnung an Merchandising und die kommerzielle Ausnutzung von Popularität drängt sich hier schon die Frage auf, wer hier für wen warum produziert…

Selim: Die Hitler-Figur ist aus einer Serie, die „War Criminals" heißt und von einer chinesischen Firma herausgebracht wurde. In dieser Serie findet man dann unter anderem auch Osama Bin Laden und Saddam Hussein. Die Hitler-Figur hat mich eher

commercial exploitation of everything that becomes popular, in this case one can't avoid the question: who produces it, for whom and why...

Selim: The Hitler figure belongs to a series titled „War Criminals", which is produced by a Chinese company and also includes Osama Bin Laden and Saddam Hussein. The way I came across the Hitler figure was simply by coincidence. I had received another large order from China – approximately 90 percent of toys are made there – and the Hitler figure was included as a freebie.

The portraits of political figures are irritating, partly because the detail is so precise and partly because through the media or its images, the real life models are very familiar to us. In pop cultural and political reality the performances of the protagonists in the media rival the fictitious, be they pop stars or politicians. – In the book you begin with the following image: George W. Bush in a military fighter pilot's uniform. The figure of the saluting president encased in plastic is quite a provocative entry into the toy world, isn't it?

Daniel: The combination of reality and fiction that applies to that particular scene acted out by George Bush we found quite thrilling. The way in which he arrived on that aircraft carrier during the Iraq war could have been a scene from a movie. The fact that this figure actually exists, complete with all of the accessories, is simply mind-boggling.

Selim: As far as I know the White House actually gave approval for the Bush figure in combat uniform to be produced. The company that produced it did so because they knew it would sell well. The effect achieved, when kids play with Bush as military ruler, is nothing short of propaganda.

Your images are very arresting and have an unbelievable degree of immediacy. One notices this in all your projects, in the large size images at exhibitions and while browsing through the books. Can you explain what it is that gives these images such power?

Geo: We always try in our work to create lasting images that will remain with the observer. We are surrounded in our daily lives with a flood of images, so our reaction to visual stimuli has been blunted a little, our capability to remember them diminished. The greatest compliment we had one time came from a woman who had seen one of our photographs at an exhibition many years earlier, and she was able to describe it

zufällig erreicht. Ich bekam mal wieder eine Großbestellung aus China – ungefähr 90 Prozent des Spielzeugs wird ja dort hergestellt – und die Hitler-Figur lag als Geschenk mit dabei.

Irritierend sind die Porträts der politischen Figuren u. a. durch ihre Detailgenauigkeit, zumal die realen Vorbilder insbesondere über die Medien, d. h. durch Bilder bekannt sind. Gerade in der popkulturellen und politischen Wirklichkeit reichen die medialen Inszenierungen der Protagonisten, seien es Popstars, seien es Politiker, mittlerweile ja weit in den Bereich des Fiktiven hinein. – Im Buch beginnt ihr mit einem solchen Bild: George W. Bush in militärischer Kampfjetpiloten-Montur. Die in einer Plastikverpackung salutierende Präsidenten-Figur ist ja ein recht provokativer Einstieg in die Toy-Welt, oder?

Daniel: Die Vermischung von Realität und Fiktion beim Auftritt von George Bush fanden wir ziemlich spannend. Wie er während des Irakkriegs auf dem Flugzeugträger gelandet ist, war ja schon filmreif. Und dass es diese Figur mit all den Accessoires gibt, war einfach umwerfend.

Selim: Bush in Kampfmontur ist meines Wissens nach sogar vom Weißen Haus freigegeben worden und wurde von einer Firma produziert, weil sich so eine Figur gut vermarkten lässt. Der Einfluss, den es hat, wenn die Kids mit Bush als militärischem Herrscher spielen, ist natürlich ganz schön propagandistisch.

Eure Bilder sind sehr einprägsam und haben eine unglaublich präsente Wirkung. Die spürt man in all euren Projekten. Genauso bei den großformatigen Bildern in den Ausstellungen wie auch beim Anschauen der Bücher – wie erklärt ihr euch die Kraft eurer Bilder?

Geo: Wir versuchen in unserer Arbeit immer Bilder zu schaffen, die dem Betrachter im Gedächtnis bleiben. Wir sind alle jeden Tag von solch einer Bilderflut umgeben und können auf visuelle Reize nur noch begrenzt reagieren und Bilder in Erinnerung behalten. Das größte Kompliment, das wir einmal bekommen haben, war von einer Frau, die ein Bild von uns genau beschreiben konnte, das sie vor Jahren auf einer Ausstellung gesehen hatte und sagte, dass sie dieses Bild immer mit sich trägt. Dass unsere Bilder diese Wirkung haben, hat sicherlich etwas mit der sehr reduzierten und konzentrierten Weise zu tun, wie wir sie mit Licht inszenieren. Unsere „Toys" in TOYGIANTS werden fast lebendig und entwickeln ihre eigene Persönlichkeit – der Betrachter fühlt sich direkt von ihnen angesprochen.

to us in precise detail. She said that she carried this mental picture around with her constantly. That our images have this effect has for sure something to do with the highly reductive, concentrated way we set up the lighting. In TOYGIANTS our 'toys' almost come to life, develop their own personalities – and evoke an emotive reaction on the part of the viewer.

Daniel: Our pictures do have perhaps something very present or direct. In the past few years, working on another project, we've concentrated on space and place. In "STASI – Secret Rooms", we sought out former prisons, interrogation rooms, office facilities and bunkers that had been used by the German Democratic Republic's Ministry of Security. Fifteen years after the Berlin wall fell. We actually measured these rooms and located their precise center, and shot them empty, devoid of any human. The feeling of immediacy is clearly evident. The images give the viewer a sense of being in the room, or almost being able to walk into it.

Daniel: Unsere Bilder haben vielleicht immer etwas sehr Präsentes. In den letzten Jahren haben wir uns in einem weiteren Projekt viel mit Raum und Ort beschäftigt. In unserer Serie „STASI – Secret Rooms" haben wir 15 Jahre nach Mauerfall ehemalige Gefängnisse, Vernehmerzimmer, Büros und Bunkerräume aufgesucht die einst vom Ministerium für Staatssicherheit der ehemaligen DDR benutzt wurden. Wir haben diese Räume vermessen, sie ganz zentral erfasst und menschenleer fotografiert. Die Bilder vermitteln dem Betrachter fast das Gefühl selbst in diesem Raum zu stehen oder ihn betreten zu können. Auch hier spürt man wieder diese Unmittelbarkeit.

Interview: Anika Heusermann

Interview: Anika Heusermann

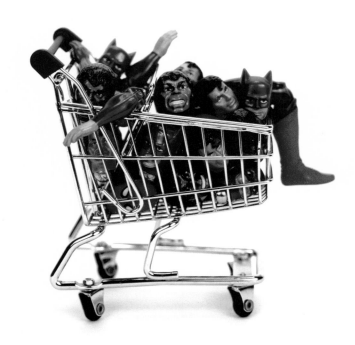

DANIEL & GEO FUCHS IN TOYLAND

The photographic images by artist duo Daniel and Geo Fuchs exert their own special attraction. It's a fascination that is particularly noticeable in the large-format framed color photographs on the walls of the exhibition halls. Even in the artists' self-conceived publications the brilliance of these images is in no way diminished. As objects, these lavish volumes – which were created by the artists themselves – come closest to an embodiment of the artists' intentions, or rather their passion. In the book it is quite evident to the viewer: Daniel and Geo Fuchs use the camera to 'collect'. They do not view these extremely disparate collections in a conventional way, but rather see archiving, or the placing in order of particular things that interest them, as photogenic landscapes. The Fuchs' approach is well-nigh scientific and their technical brilliance and meticulous precision reinforce their innermost intention: to conserve the world in absolute detail. But these photographic images have not simply been created from materials that exist, as was the case with "Conserving", a project featuring photographs of illuminated animal and human specimens in extreme close-up. Instead, these images develop their own special fields of 'collecting' by pursuing a particular theme, such as the orchestrated gaze of famous personalities ("Famous Eyes"), or the documenting of prison cells and examination rooms built by the former East German Ministry of State Security, which have become museum-like relics ("STASI – Secret Rooms").

Under the title, "Conserving", Daniel and Geo Fuchs published a series of close-ups of preserved animals and people. The human specimens featured are not amongst those objects generally considered acceptable for viewing, so these photographs have ventured into territory that is seen as taboo. Not all things are exposed to the curious in our society. Images of dissecting rooms and pathological collections were totally off limits for a very long time, and to a certain extent they still are. The desire to see something that is forbidden, to wrest it out of the gaze of science and publish it as art, to democratize established taboo zones such as death and sexuality – all of these things the artists have taken to a higher level with their photographs of human specimens. This is in no way related to the fleetingness of pornographic images, it is a carefully and precisely planned application of aestheticism. By reinjecting life into preserved human specimens, some of which are hundreds of years old, and attracting attention to the delicate nature of existence without banishing death from consciousness, the artists have created a complex image of the human condition. Horror and the desire for horror have been elevated to the level of photographic art, aesthetically transformed

DANIEL & GEO FUCHS IM TOYLAND

Von den fotografischen Bildern des Künstlerpaars Daniel und Geo Fuchs geht eine besondere Anziehungskraft aus. Diese faszinierende Wirkung haben vor allem die großformatigen, gerahmten Farbfotografien an den Wänden der Ausstellungssäle, und selbst die Bilder in den von den Künstlern initiierten Publikationen verlieren nichts von dieser Ausstrahlung. Die aufwendig produzierten Bände – die eigentlich Künstlerbücher sind – kommen als Objekte der Intention oder besser: der Leidenschaft der Künstler am nächsten, im Buch ist sie für den Betrachter noch deutlicher wahrnehmbar: Daniel und Geo Fuchs sammeln mit der Kamera. Sie betrachten die unterschiedlichsten Sammlungen aber nicht im herkömmlichen Sinne, sondern begreifen die Archivierung, das heißt das Ordnen bestimmter sie interessierender Dinge, als fotogene Landschaften. Ihre geradezu wissenschaftliche Annäherung, die handwerkliche Brillanz und Akribie verstärken das innere Anliegen, die Welt im Detail möglichst vollständig zu konservieren. Diese fotografischen Visionen entstehen aber nicht nur aus vorhandenen Stoffen, wie etwa ihre ausgeleuchteten, aus großer Nähe fotografierten tierischen und menschlichen Präparate in „Conserving", sondern sie entwickeln durch das Verfolgen eines Themas – etwa des inszenierten Blicks berühmter Persönlichkeiten („Famous Eyes") oder die Aufnahmen inzwischen musealisierter Gefängniszellen und Untersuchungsräume der ehemaligen Staatssicherheit der DDR („STASI – Secret Rooms") – eigene Sammlungsgebiete.

Unter dem Titel „Conserving" veröffentlichten Daniel und Geo Fuchs eine Bildfolge von Nahsichten konservierter Tiere und Menschen. Die Fotografien menschlicher Präparate sind von den allgemein dem Gegenstand unterlegten Konventionen in einer der Tabuzonen des Sehens angesiedelt. Nicht alles wird in der Gesellschaft der Neugier, dem Sehenwollen, preisgegeben, die Anatomiesäle und pathologischen Sammlungen waren lange und sind immer noch mit einem begrenzten Bilderverbot belegt. Die Lust, das Verbotene in Augenschein nehmen zu dürfen, es gleichsam der wissenschaftlichen Sicht zu entreißen und im künstlerischen Blick zu veröffentlichen, diese „Demokratisierung" in gesellschaftlich festgelegte Tabuzonen – wie Tod und Sexualität – hinein, wird von den Künstlern am Beispiel der fotografierten menschlichen Präparate auf hohem Niveau gestaltet. Es ist nicht die Flüchtigkeit, etwa pornografischer Bilder, sondern eine Form der Ästhetisierung, die präzise und vorsichtig geplant ist. Das Leben in den mitunter Hunderte Jahre alten menschlichen Präparaten zurückkehren zu lassen, das Auge auf die feingliedrige Existenz zu lenken und gleichzeitig den Tod nicht aus dem Bewusstsein zu verdrängen, führte zu einem komplexen Bild über das menschliche Sein. Das Grauen und die Lust am Grauen sind hier in fotografischen Kunstwerken aufgehoben, ästhetisch gewandelt und in die geheimnisvolle Dimension des Lebens hinein erweitert.

and transposed into a mysterious dimension of life.

Another series of photographs, "STASI – Secret Rooms", is devoted to the secret places where power is exercised, twenty-four hour surveillance and punishment. It was fifteen years after the German Democratic Republic had ceased to exist that Daniel and Geo Fuchs photographed these sparse rooms that had been home to totalitarian violence, these penal institutions for political prisoners of an autocratic regime. The camera peers into rooms that will never be "occupied" again, neither by perpetrators nor victims. Still, the details preserved record the bluntness of thought, the brutal and insensitive order in a frighteningly sterile way. The inhuman "minimalism" of these rooms exudes a great coldness. The photographs record this coldness so successfully that it requires no comment. They are not aesthetic images that even in this bleak environment sense a trace of formal principle, but clear, cold pictures of a world that is dead.

In their notable series of portraits, "Famous Eyes", Daniel and Geo Fuchs used a special Polaroid camera. Initially they photographed only the eyes, the physical characteristic that makes a face distinctive and creates the unique gaze that we bestow on other people. The eyes reach down into the depths of the soul and within them a person's life history can be read. Captured on Polaroid were the uniquely expressive eyes of a series of famous people. Ultimately, the artists together with their subjects, were looking for a way to place the photographs of the eyes within other portraits. By undertaking this unusual collaboration with the subjects, and allowing them to become involved in the creative process, the artists fostered a special psychosocial relationship between their "subjects" and the camera. They used the picture within the picture to tell a story that, on a secondary level, throws light on the nature of the person portrayed. The question they wanted to answer was: Given that these people are constantly being looked at and are used to being seen - so much so that, as artists, they have virtually made being seen a profession - how do they consciously use their eyes?

Meeting collector Selim Varol introduced Daniel and Geo Fuchs to the world of toys. These toys are plastic figures that are largely produced in Asia and mimic contemporary life in modern western culture and all of its current fantasies. The toy has traditionally represented a secondary, artificially constructed world. In German, the term for Toy, "Spielzeug", literally means play stuff. In etymological terms, the German word "Zeug" in-cludes not only the idea of "stuff" or "tool" but also the idea of engendering (from the verb zeugen – to make). The

Eine andere Fotoserie, „STASI - Secret Rooms", widmet sich den geheimen Orten der Machtausübung, der totalen Überwachung und der Strafen. Die kargen Räume überlieferter Orte totalitärer Gewalt, die Bußanstalten für politische Gefangene eines autokratischen Regimes fotografierten Daniel und Geo Fuchs erst 15 Jahre nach dem Ende der DDR. Die Kamera sieht in Räume, die von keinem Personal mehr „bewohnt" werden, weder von den Tätern noch von den Opfern. Dennoch ist in den bewahrten Details das stumpfe Denken, die entsinnlichte und brutalisierte Ordnung auf erschreckende Weise festgehalten. Der unmenschliche „Minimalismus" dieser Räume ist von einer ungeheuren Kälte. Die Fotografien schaffen es, diese Kälte kommentarlos festzuhalten. Sie sind keine ästhetisierten Bilder, die noch in diesen trostlosen Umgebungen formalen Prinzipien nachspüren, sondern klare, fast kalte Abzüge einer toten Welt.

In den „Famous Eyes", in ihrer besonderen Porträtserie, fotografierten Daniel und Geo Fuchs mit einer speziellen Polaroidkamera zunächst nur die Augen, also das, was ein Gesicht in seiner Unverwechselbarkeit wesentlich prägt: der Blick, der dem Gegenüber geschenkt wird. Die Augen reichen in das Innere der Seele, in ihnen ist die Geschichte einer Person ablesbar eingeschrieben. Diese sprechenden Augen berühmter Menschen waren auf den Polaroids festgehalten. Die Künstler haben schließlich gemeinsam mit den Porträtierten nach einer Idee gesucht, wo diese Augenbilder in ihrem Bildnis platziert werden könnten. Durch diese ungewöhnliche Mitgestaltung der Porträtierten an ihrem eigenen fotografischen Abbild, stellten die Künstler eine besondere psychosoziale Beziehung zwischen ihrem „Objekt" und der Kamera her. Sie erzählen durch das Bild im Bild, gleichsam auf einer zweiten Ebene, eine das Wesen der dargestellten Person erhellende Geschichte. Die Frage war, wie gehen Menschen mit ihren Augen um, die es gewohnt sind, dass andere auf ihnen ruhen, dass sie gesehen werden, und die als Künstler das Sehen zu ihrem Beruf erhoben haben.

Durch den Sammler Selim Varol entdeckten Daniel und Geo Fuchs die Welt der Toys, Plastikfiguren, die, zumeist in Asien produziert, das Leben der westlichen Moderne bis hinein in deren Fantasiewelten nachfigurieren. Das Spielzeug, wie es interessanterweise in der deutschen Sprache heißt, war von jeher eine zweite, künstliche Welt. Etymologisch gesehen, verbirgt sich in dem Wort „Zeug" nicht nur der Stoff oder das Gerät, sondern auch das Hervorbringen, das Zeugen von etwas. Das vorangestellte Wort „Spiel", dessen Herkunft unklar bleibt, verkleinert oder verharmlost diesen Vorgang allerdings in das Kindhafte hinein. Gleichwohl bedeutet es eine ernsthafte Vorbereitung: Im Spiel werden die kommenden Regularien des Erwachsenseins eingeübt. Das Spielzeug war, um pädagogisch effizient zu sein, eine naturalistische Nachbildung der wirklichen Welt. Die Pup-

prefix "Spiel" or play, a term with no clear etymological origins, diminishes the latter definition by presupposing something childlike. Nevertheless it means something more serious, the idea of preparedness. In play, we exercise and learn the rules of becoming an adult. To state it succinctly in pedagogic terms, the toy is a naturalistic emulation of the real world. Doll's houses, railways, weapons, cars, etc. were produced in miniature by adults for children with the utopian objective of introducing the child to a model of the adult world as a means of orientation. The model guides us through the formative years, and serves its purpose by facilitating the onset of adulthood. At play we not only simulate our societal hierarchies but also reinforce gender roles. Boys would stereotypically play with toys such as weaponry, model trains and airplanes, or technological items such as erector sets, cars and building blocks. In other words, they would act out the obligatory male professions in the midst of a childish, virtually anarchic fantasy world. Conversely, girls learned their place by playing with doll's houses with miniature living rooms and tiny kitchens. The preoccupation with dolls would set the stage in advance for their future roles as mothers.

By contrast, the toys that we are writing about here, those that Daniel and Geo Fuchs are including in their latest series of photographic collections, should be characterized differently. Plastic toys have been in existence since the invention of plastic. They have replaced other more complex materials, have proved to be more durable. The kind of toys that are illustrated in this book, however, are mainly by-products of the film industry's marketing strategies. Favorite personalities from global blockbusters have been naturalistically simulated in plastic, and re-born as a fetish out of the temporality of disincarnate images.

Superman, who could fly while the film was showing but suddenly disappeared when the lights came on, now stood at home, a "real" figure, tangible and ready for action. Hollywood's superheroes enabled the banal dreams of many millions to be gloriously realized: to just once defy the laws of everyday existence. The plastic figures of the film industry are more than mere toys in the traditional sense. They are creations charged with narrative, and their roles are firmly etched in advance. To take on the role of Superman, Batman or Rambo meant, by no stretch of the imagination, playing the prototypical roles of society. Their masculinity has been hypertrophied, mutated, so to speak, from an extra dimension that transcends everyday affairs. The fantasy of having super powers is a sub-cultural dream of the underclass, the masses who do not participate in the exertion of power. Superman is the hero of the disenfranchised, someone who can restore justice in the face of all evil and when necessary transcend the laws of physics. The ideology of the superhero is that of the lone warrior, not one born out of leftist

penstuben, Eisenbahnen, Kriegsgeräte, Autos etc. wurden von Erwachsenen als Kleinform für Kinder produziert. Das utopische Ziel dieser Produktion war es, sich in einem Modell der Welt auf die Welt einzustellen. Es begleitete die ersten Lebensjahre und sollte mit dem Eintritt in das Erwachsenenalter seinen Dienst geleistet haben. Im Spiel wurden nicht nur die gesellschaftlichen Hierarchien nachgebildet, sondern auch die Geschlechterrollen zugeordnet. Die Jungen wurden vor allem mit Kriegsspielzeug, Eisenbahnen, Flugzeugen, technischen Geräten, wie Kränen und Autos, und mit Bausteinen bedacht. Sie spielten also die erforderlichen männlichen Berufsgruppen in die kindliche, noch völlig anarchische Fantasie hinein. Die Mädchen hingegen waren in der Puppenstube mit ihrem verkleinerten Wohnzimmer und der winzigen Küche zu Hause und hantierten mit Puppen, die schon ihre zukünftige Mutterrolle vorinszenierten.

Die Toys hingegen, über die wir hier schreiben und die Daniel und Geo Fuchs als ihr jüngstes Projekt in die Serien ihrer fotografischen Sammlungen einbeziehen, sind anders zu charakterisieren. Plastikspielzeuge gibt es seit der Erfindung der Kunststoffe. Sie lösten die aufwendiger zu handhabenden Materialien ab und waren zudem haltbarer. Die Art der Toys aber, die in dem Buch abgebildet sind, wurde wesentlich aus den Vermarktungsstrategien der Filmindustrie gespeist. Die Lieblingsfiguren weltweit erfolgreicher Streifen wurden in Plastik naturalistisch nachgestaltet und als Fetisch aus der Temporalität der nicht materialisierten Bilder „geboren". Superman, der fliegen konnte, solange der Film lief, und nachdem das Licht anging, einfach verschwand, stand nun zu Hause als „reale" Figur greifbar, einsatzbereit. Die banalen Träume vieler Millionen Menschen, einmal den Gesetzen des Alltags entrinnen zu können, realisierten sich glanzvoll in den Übermenschen Hollywoods. Die Plastikskulpturen dieser Industrie sind keine Spielzeuge im herkömmlichen Sinne, sie sind durch die Filmerzählung aufgeladene und in ihren Rollen vorgeprägte Gestalten. Superman, Batman oder Rambo nachzuspielen bedeutete keinesfalls die Einübung in gesellschaftlich vorgebildete Rollen. Das Männliche in ihnen ist hypertrophiert, in eine das Alltagsgeschäft übersteigende Sonderrolle sozusagen entartet. Der Traum von der Übermacht ist ein subkultureller Traum der Unterschichten, der an der Macht nicht beteiligten Massen. Superman ist der Held der Entrechteten, der die Ordnung gegen alle bösen Mächte, wenn es sein muss, sogar durch die Überwindung der Naturgesetze wieder herzustellen versteht. Die Ideologie der Superhelden ist die des Einzelkämpfers, nicht die der Gemeinschaften der im Westen gefürchteten linken Klassensolidarität. Er kommt als Erlöser von irgendwoher. Diese Gestalt des teleologisch geprägten Führers zieht sich durch alle gesellschaftlichen Formationen, im Westen wie im Osten. Sie ist die profane Variante der religiösen Superstars wie Jesus

solidarity so feared by the western world. He comes as a savior out of nowhere. This creation of the teleologically induced leader is found in all social systems, both in the West and the East. It is the profane version of religious superstars such as Jesus Christ, Mohammed, Buddha etc, all of whom performed miracles with supernatural powers. The whole arsenal of these larger-than-life figures with all their super powers is masterfully staged by Daniel and Geo Fuchs in large-format portraits of their plastic counterparts. Strange as it may seem, the large format images overcome the limited context of the toys, even though they show the scratches these figures have sustained in everyday use much more clearly than the naked eye can see. The clever use of lighting endows these primitive plastic faces with an eerie sense of reality.

This overarching illusion however, this oscillation of reality and truth, is propogated by the toy industry itself. Alongside Batman and Superman, we also have the good and the evil of history in attendance, such as Che Guevara and Bin Laden. And the evil creatures such as Hitler, Saddam Hussein and other 20th-century cohorts outnumber the good guys. As new initiates in the toy circus, or the illusory world of plastic emulation, these villains must abide by different laws and have to be prepared for anything. As we well know from Tim Burton's films, Batman, is a particular threat, with his exceptional intellect and scientific knowledge, In the cabinet of real-world evil figures, Daniel and Geo Fuchs have put together some absurd groups, impressively invoking the forces of Fantasia. Adolf Hitler is killed by the militant hybrid of a crocodile and a guerrilla fighter. His agony in the jaws of a Godzilla is an apt metaphor for the madness he unleashed on society in his own time. In a world of nightmarish re-enactments of evil, the figure of Hitler is reduced to a helpless shadow that is overcome by the kingdom of nature, as symbolized by Godzilla. In the meticulous replication of this incarnate, evil figure, right down to its clothes and wrinkled brow, the Hitler costume and mask are fetishes of a negative veneration, fetishes that are warded off and flung apart in Toyland. Hitler and his power, subject to the anarchistic laws of play, are destroyed once and for all by a plastic effigy. George W. Bush, together with his crusade to impose democracy on the empires of evil, is reduced to the status of an insignificant doll in an ordered environment of plastic packaging, a full-figure portrait or collector's item that owes its fascination entirely to detail and precision. The double quantity of gloved hands, all featuring the famous raised thumbs as a naive gesture of victory, recalls the aircraft carrier photo-opportunity that so convincingly trivialized political power, reducing it to a sound bite.

These large-format color photographs of this world of play evoke the semblance of a real world and give it meaning.

Christus, Mohammed, Buddha etc., die allesamt durch überirdische Kräfte Wunder vollbrachten. Das Arsenal dieser Überfiguren mit ihren Sonderrechten wird von Daniel und Geo Fuchs eindrucksvoll in großformatigen Porträts der Plastiknachbilder in Szene gesetzt. Das große Format entzieht sie eigenartigerweise dem Spielzeugland, obwohl sie mit allen Blessuren des Gebrauchs schärfer gezeichnet sind, als es das bloße Auge wahrnimmt. Die geschickte Ablichtung der immer noch primitiven Plastikgesichter lässt sie zu realen Bildnissen werden.

Diese Grenzüberschreitung, das Changieren zwischen Realität und Wirklichkeit wird aber auch durch die Toyindustrie selbst provoziert. Neben Bat- und Superman tauchen die Guten und Bösen der geschichtlichen Wirklichkeit auf, etwa Che Guevara oder Bin Laden. Deutlich überwiegen die bösen Gestalten wie Hitler, Saddam Hussein und anderes Personal des 20. Jahrhunderts. Eingereiht in den Toyzirkus, in die unwirkliche Welt der Plastiknachbildungen, gelten aber für diese Bösewichte andere Gesetze, müssen sie mit allem rechnen, auch und besonders mit dem auf Intelligenz und Wissenschaft vertrauenden Batman, wie wir aus den Filmen von Tim Burton wissen. In der Spielabteilung der Bösen unserer wirklichen Welt haben Daniel und Geo Fuchs absurde Gruppen aufgestellt, die auf eindrückliche Weise die Kräfte von Fantasia herbeirufen. Adolf Hitler wird endlich durch militante Mischwesen aus Krokodil und Guerillakämpfer der Garaus gemacht. Sein Schmerzballett im Maul eines Godzillas ist eine gelungene Metapher für den Wahnsinn der in dieser Figur geschichtlich verbürgten Rolle. Sie wird im Reich der nachgestellten Albträume zu einem hilflosen Gespenst, das von dem Bösen, in Godzilla symbolisierten Reich der Natur überwunden wird. Die akribische Nachbildung der Inkarnation des geschichtlich bösen Menschen bis hin zur Kleidung und den Stirnfalten, das Hitlerkostüm und die Maske sind Fetische einer negativen Verehrung, die im Toyland apotropäisch ausgetrieben wird. Hitler, wie alle seine Nachfolger, ist den anarchischen Gesetzen des Spiels unterworfen, seine Macht ist am Plastikbild endgültig zerbrochen. Auch ein westlicher Führer und Politiker wie George Bush, der die Demokratie mit Gewalt in die *Länder des Bösen* tragen will, wird im fotografischen Abbild seines ganzfigurigen Plastikporträts im Ordnungsfeld seines Verpackungsbehältnisses zur bedeutungslosen Puppe, zum Sammelobjekt, dessen Faszination allein in der Detailgenauigkeit liegt. Die dem Spiel geschuldete doppelte Anzahl der behandschuhten Hände – darunter der berühmte erhobene Daumen als simple Siegergeste auf dem Flugzeugträger – banalisiert die politische Macht zum kurzfristigen Zeitstück.

Es sind die großformatigen Farbbilder dieser Spielwelt, die ihr die Bedeutung einer wirklichen Welt zugestehen. Daniel und Geo Fuchs haben die Toys fotografiert, als seien sie auf seltsame Weise in das Toyland geraten, was in gewisser Hin-

Daniel and Geo Fuchs have photographed the toys as if they had somehow arrived in Toyland through a unique portal - which to a certain extent is true. Making the acquaintance of collector Selim Varol and his 10.000 figures unleashed the magical power of a fairy tale utopia. One becomes a member of this Toy nation primarily via the Internet; the predominantly Asian manufacturers make use of this rapid information channel to distribute entire editions to collectors in the shortest possible time. The figures range from the better known Barbie dolls and Star Wars heroes to the new heroes of Japanese Manga, TV series, horror films and more. Anything successful in the real/ unreal dream world of the pop industry is sure to be made into hard and soft plastic. And then there are the figures that do not see the light of day, the purely inventive designer creations that are the children of the imagination. They are as capable of conquering the heart as any replica of real people. But we can speak about toys here only in a qualified sense. Mostly, adults buy up the entire production runs of these figures before a single child can lay his hands on one. For quite some time, catalogs have been circulating, recording the increased values of certain rare figures. Today they've developed into a form of subculture, the names of their creators are well-known and their collectors are in principle barely distinguishable from art collectors. Nevertheless, they constitute a new species, and have nothing to do with lovers of other toy or doll collectibles such as Steiff teddybears, or Käthe-Kruse dolls. Indeed, it's no surprise that these figures appear now and then, arranged like art installations, in the interiors and window displays of designer and fashion shops. They have long become a part of the commercial world of the young, who strangely enough, appear not too dissimilar from their plastic doubles. Their clothes, and indeed their entire outfits mimic their fictitious role models - successful stars from the entertainment industry. The plastic figures vividly recall these roles in three-dimensional miniature, fetishes of a decorative form of self-discovery. Aside from Barbie dolls, the women are militant, highly sexualized fighting machines that emulate the hunky males. The models in the uberdesigned glossy portfolios of the fashion industry are barely distinguishable from the most sophisticated of these toys. They have been living in a Toyland of their own, where the aging process, death and the other imperfections of real life are seemingly overcome. In their pictures, Daniel and Geo Fuchs report from a special dimension of a secondary world, one which has already ingrained itself successfully within the first.

EUGEN BLUME

Eugen Blume is director of the Nationalgalerie in Hamburger Bahnhof – Museum für Gegenwart, Berlin

sicht der Wahrheit entspricht. Die Begegnung mit dem Sammler Selim Varol und seinen ca. 10.000 Figuren hat die magische Macht dieses märchenhaften Utopia vor ihnen ausgebreitet. Mitglied dieses Figurenstaates wird man im Wesentlichen über das Internet; die zumeist asiatischen Produzenten nutzen den schnellen Informationsweg, um die gesamte Auflage möglichst rasch an die Sammler zu bringen. Die Gestalten wachsen über die bekannten Figuren von den zeitlosen Barbiepuppen bis zu den Star-Wars-Helden hinaus in neue Helden, die aus den japanischen Mangas, Fernsehserien, Horrorfilmen oder anderen künstlichen Bildwelten kommen. Alles entsteht in Hart- und Weichplastik, was in der wirklich-unwirklichen Traum-Welt der Popindustrie Erfolg hat. Dazu kommen die Figuren, die noch von niemandem gesehen wurden, reine Designererfindungen, Schöpfungen der Fantasie, die sich ebenso die Herzen erobern, wie die Kopien realer Menschen. Von Spielzeug aber können wir nur noch bedingt sprechen, Erwachsene kaufen die Auflagen, noch bevor ein einziges Kind die Hand an eine der Figuren legen kann. Längst schon kursieren Kataloge, die die Preissteigerungen bestimmter seltener Figuren verzeichnen. Sie sind zu einer subkulturellen Kunstform avanciert, man kennt inzwischen die Namen ihrer Schöpfer, und ihre Sammler unterscheiden sich prinzipiell kaum von den Kunstsammlern. Sie bilden aber gleichwohl eine eigene Spezies und haben nichts zu tun mit den Liebhabern von Steiff-Teddybären oder Käthe-Kruse-Puppen. Nicht von ungefähr tauchen die Figuren in den wie Kunstinstallationen gestalteten Räumen und Auslagen von Design- und Modeläden auf, sie sind längst Teil der wirklichen kommerziellen Welt von jungen Menschen geworden, die ihren Plastikdubletten äußerlich eigenartig nahe kommen. Ihre Kleidung wie ihr gesamtes Outfit ist den fiktiven Rollenbildern erfolgreicher Stars der Unterhaltungsindustrie nachgestaltet. In den Plastikfiguren werden diese Rollen als dreidimensionale Miniaturen, als Fetische einer dekorativen Selbstfindung anschaulich erinnert. Die Frauen sind, abgesehen von den Barbiepuppen, martialische, stark sexualisierte Kampfmaschinen. Sie gleichen ihren männlichen Muskelmännern. Die Models in den überdesignten Glanzportfolios der Modeindustrie sind von den Raffiniertesten unter den Toys kaum noch zu unterscheiden. Längst schon leben sie in einem Toyland, in dem das Altern, der Tod und alle anderen Mängel des wirklichen Lebens überwunden scheinen. Daniel und Geo Fuchs berichten in ihren Bildern aus diesem Sondergebiet einer zweiten Welt, die sich in die erste Welt hinein schon erfolgreich ausgebreitet hat.

EUGEN BLUME

Eugen Blume ist Leiter der Nationalgalerie im Hamburger Bahnhof – Museum für Gegenwart, Berlin

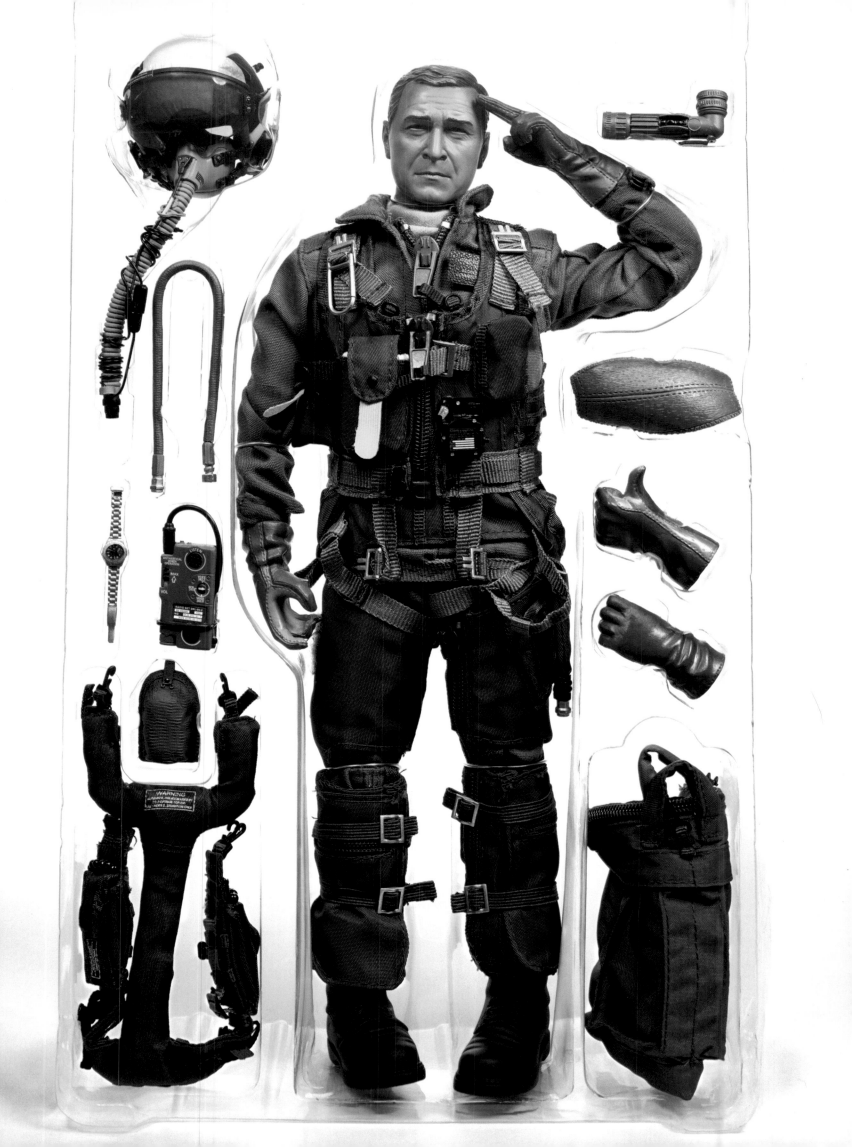

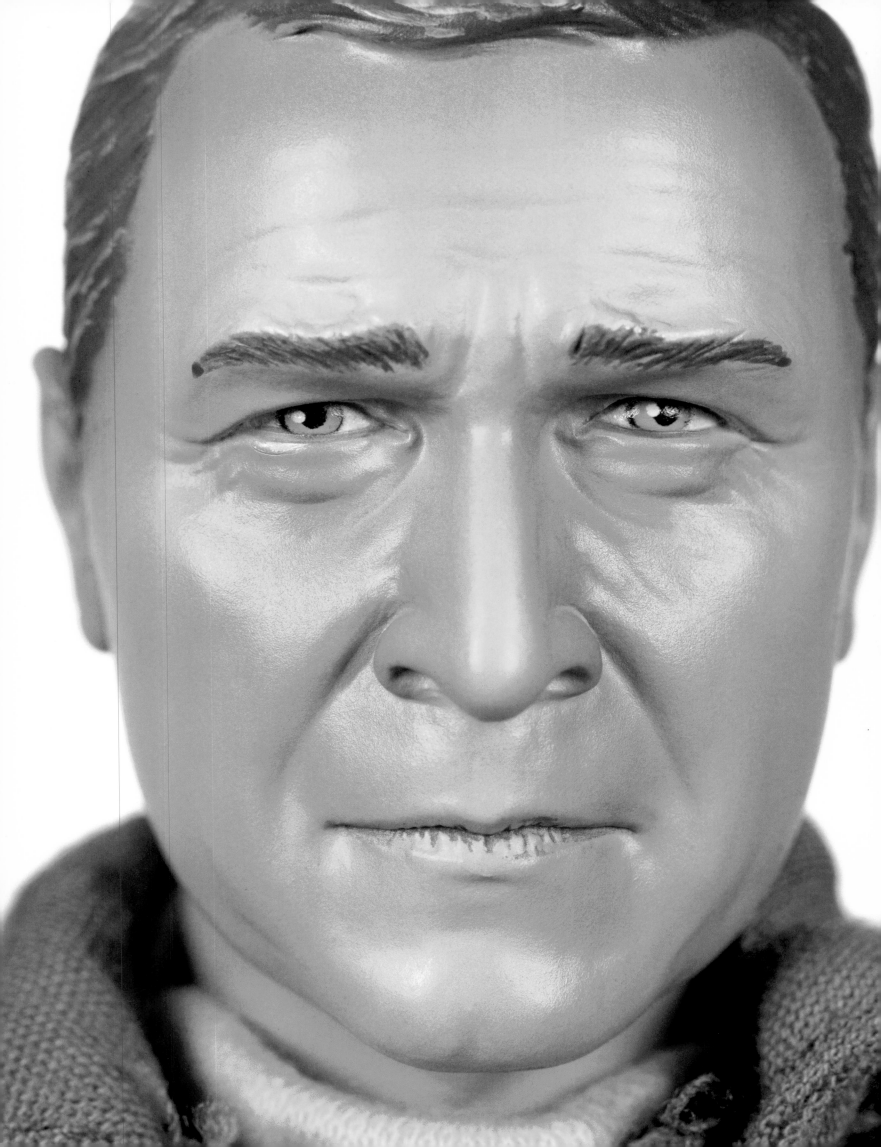

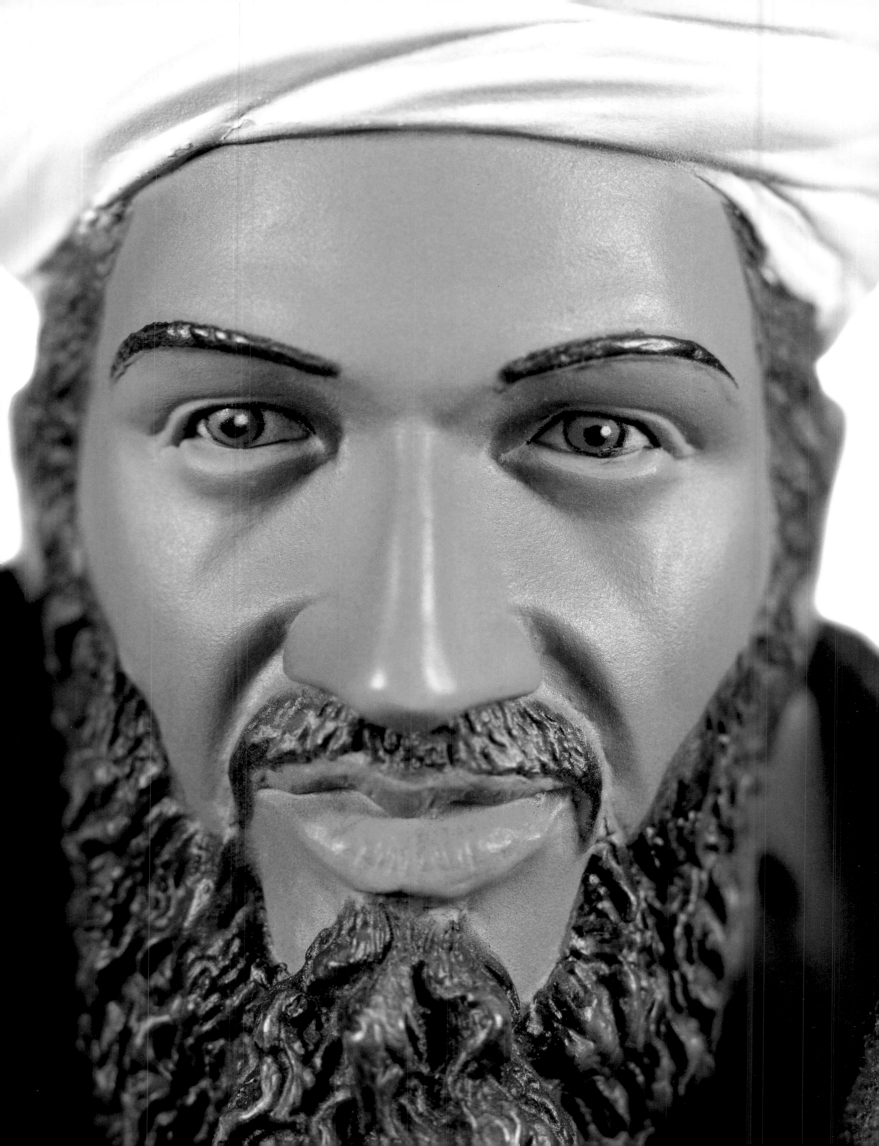

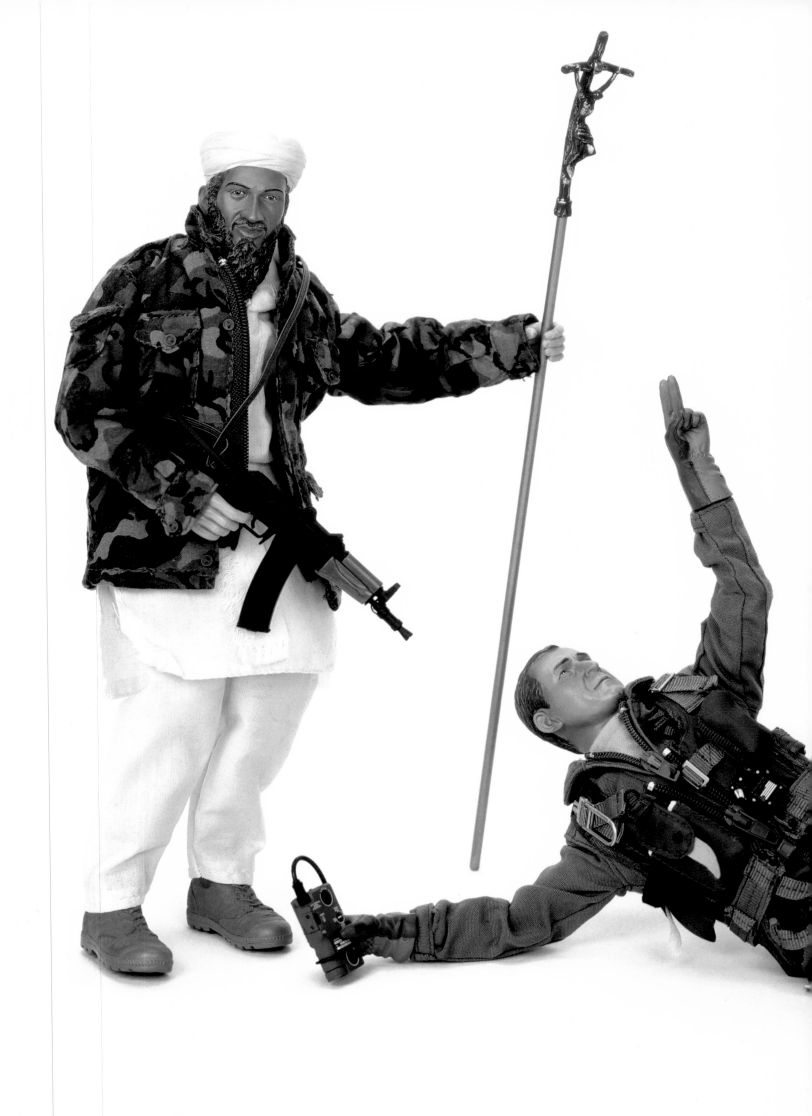

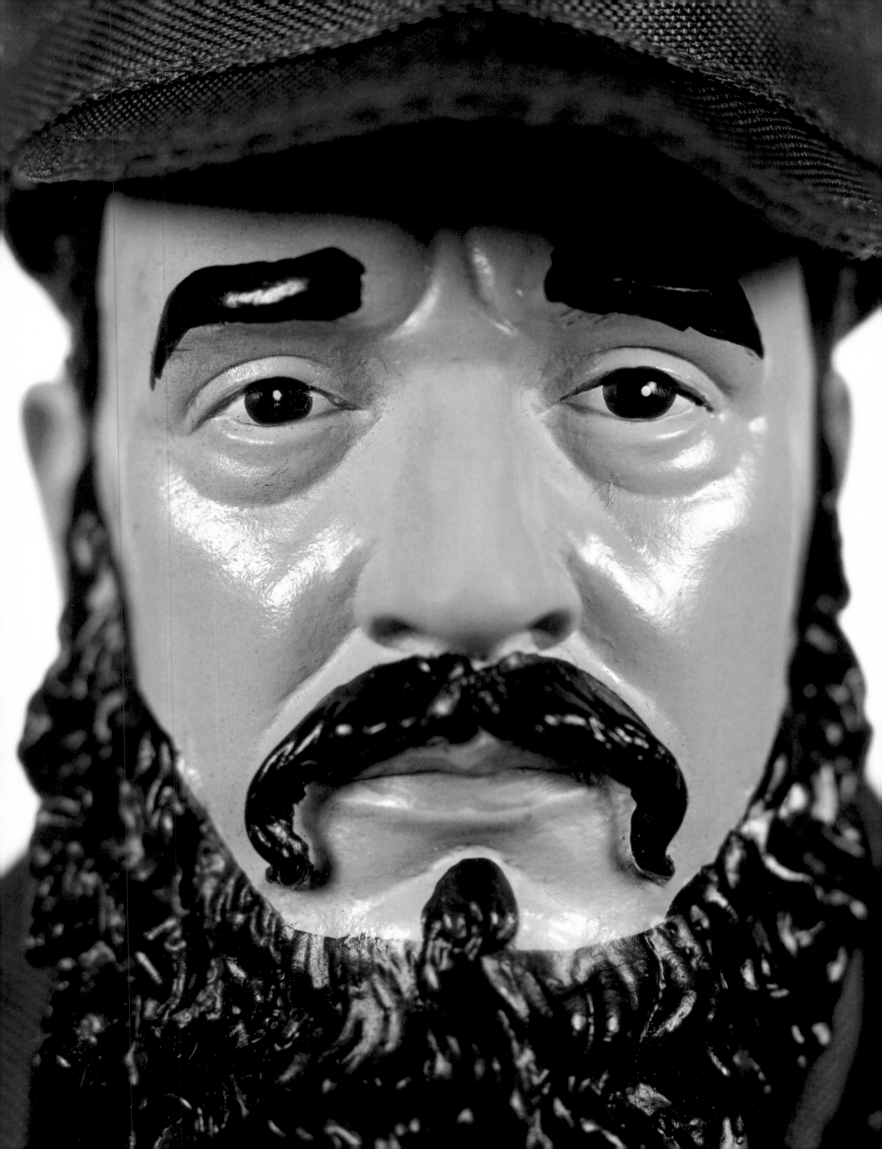

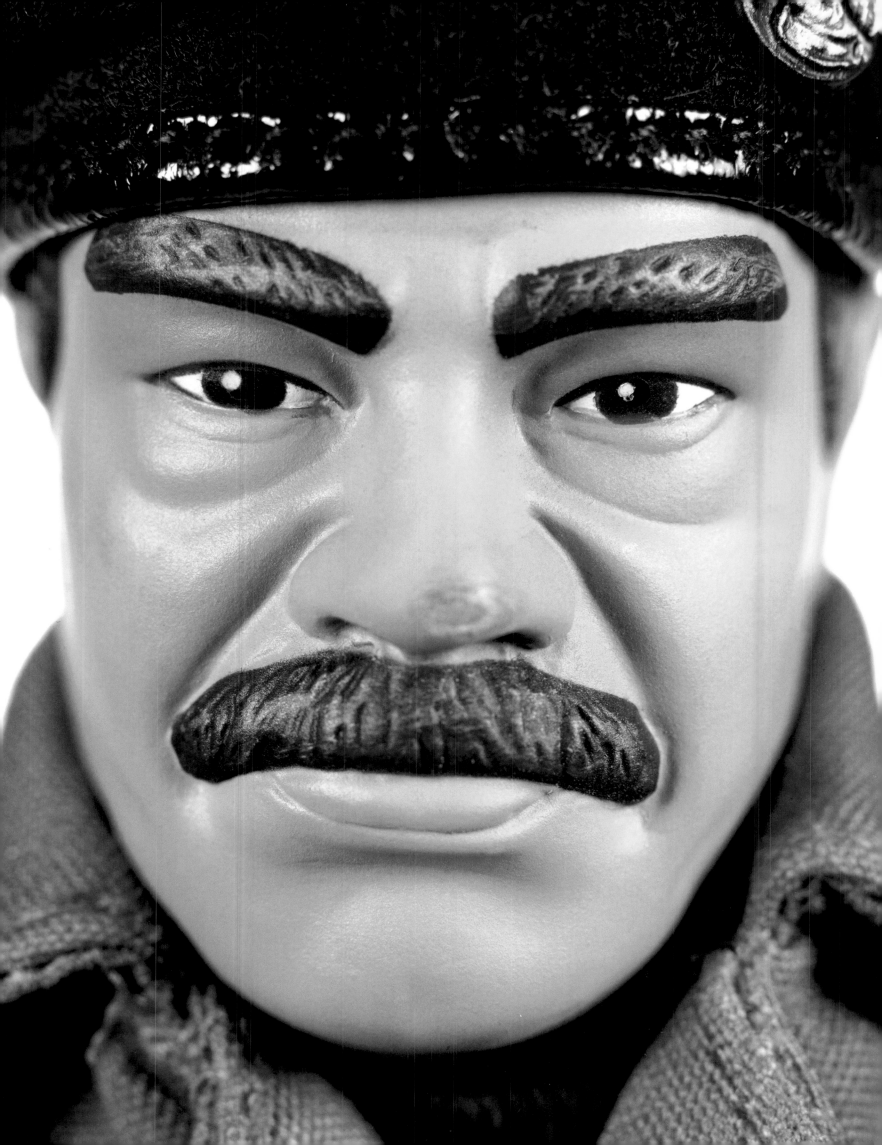

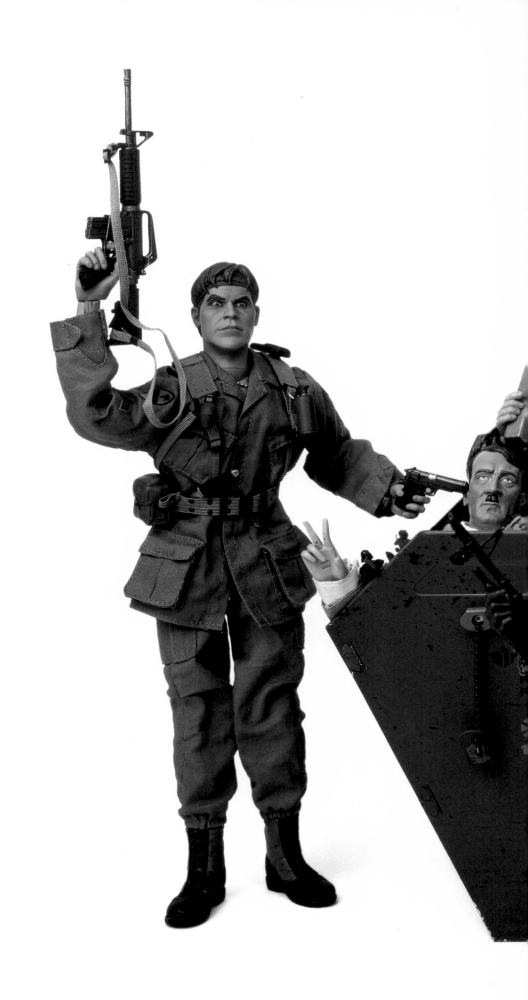

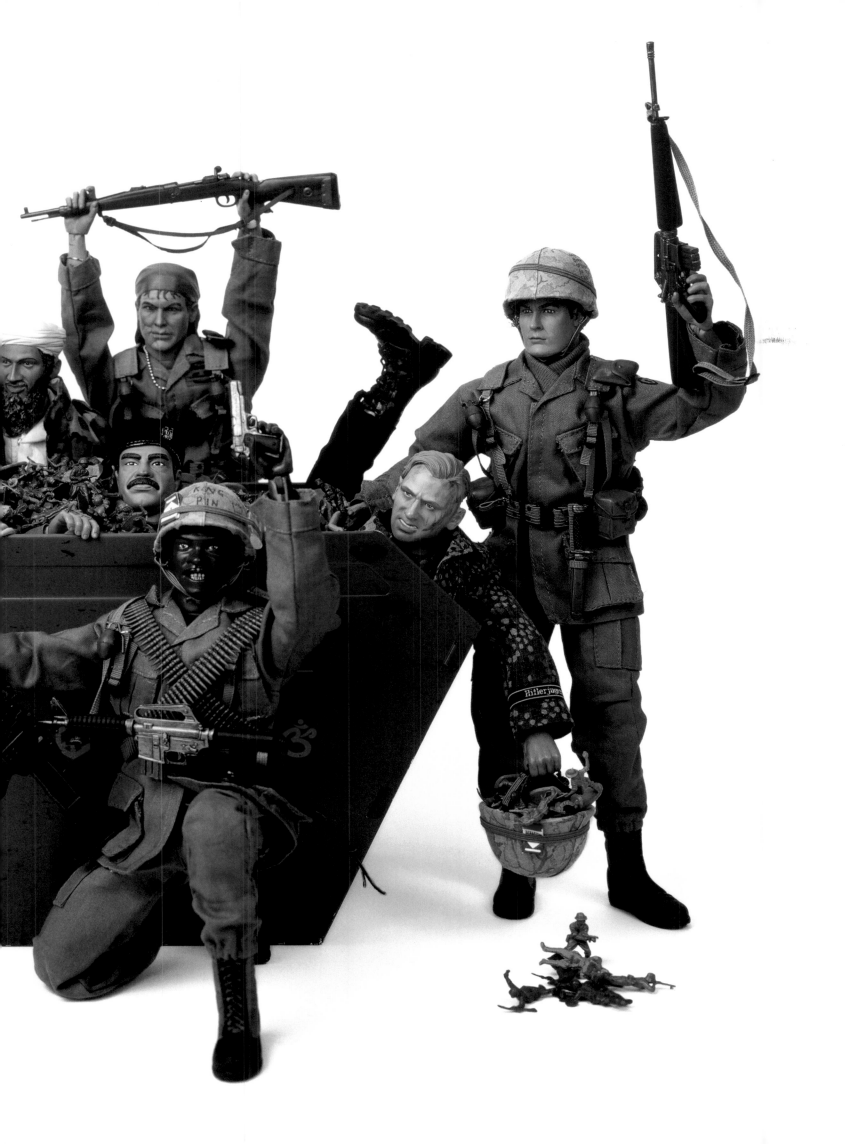

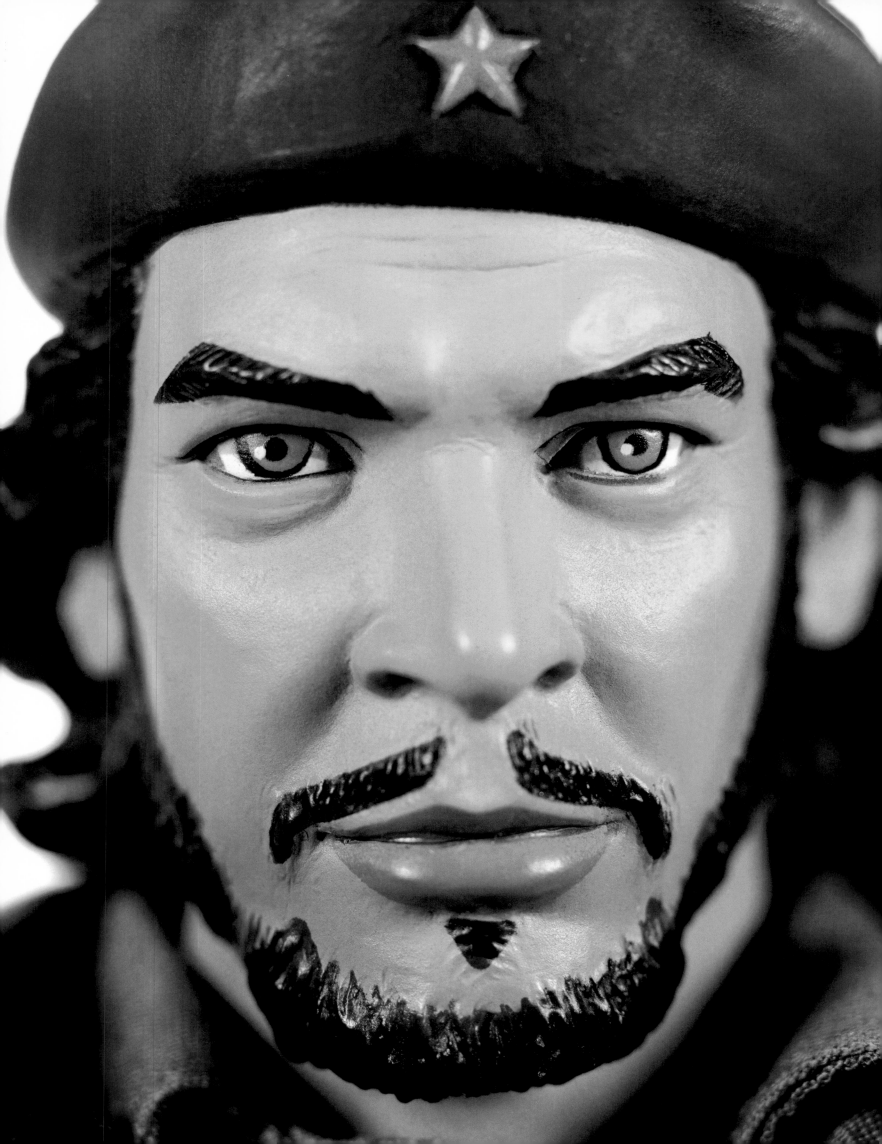

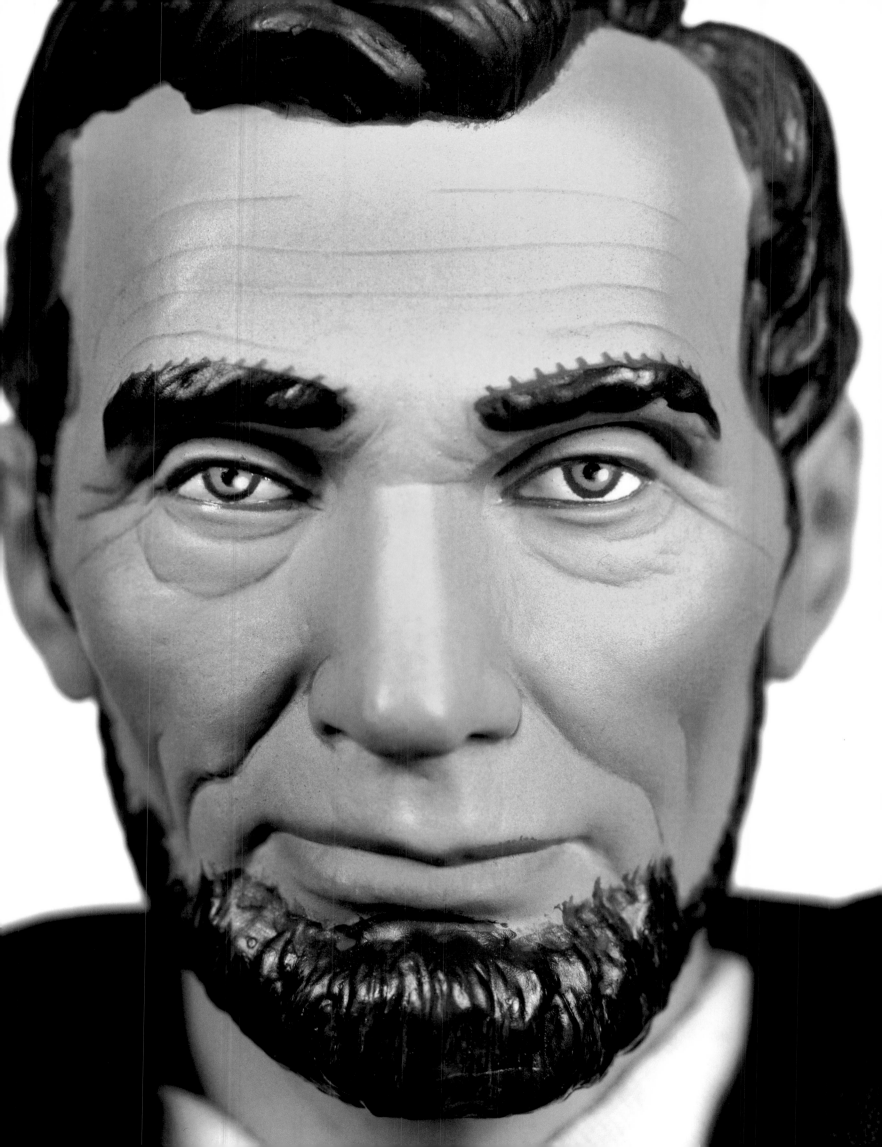

ADOLF HITLER: 35000000 · MAO ZEDONG: 33000000 · JOSEF STALIN: 30000000 · SLOBODAN MILOSEVIC: 230000 · MUSSOLINI: 220000 · THEONESTE BAGOSORA: 1000000 · OLIVER CROMWELL: 600000 · IDI AMIN: 300000 · SADDAM HUSSEIN: 2000000 · POL POT: 1700000 · ATTILA THE HUN: 1000000 · IVAN THE TERRIBLE: 100000 · FRANCOIS DUVALIER: 50000 · OSAMA BIN LADEN: 4000 · MOHAMMED OMAR: 5000 · AUGUSTO PINOCHET: 3200 · SUHARTO: 1000000 · ADOLF HITLER: 35000000 · MAO ZEDONG: 33000000 · JOSEF STALIN: 30000000 · SLOBODAN MILOSEVIC: 230000 · MUSSOLINI: 220000 · THEONESTE BAGOSORA: 1000000 · OLIVER CROMWELL: 600000 · IDI AMIN: 300000 · SADDAM HUSSEIN: 2000000 · POL POT: 1700000 · ATTILA THE HUN: 1000000 · IVAN THE TERRIBLE: 100000 · FRANCOIS DUVALIER: 50000 · OSAMA BIN LADEN: 4000 · MOHAMMED OMAR: 5000 · AUGUSTO PINOCHET: 3200 · SUHARTO: 1000000 · ADOLF HITLER: 35000000 · MAO ZEDONG: 33000000 · JOSEF STALIN: 30000000 · SLOBODAN MILOSEVIC: 230000 · MUSSOLINI: 220000 · THEONESTE BAGOSORA: 1000000 · OLIVER CROMWELL: 600000 · IDI AMIN: 300000 · SADDAM HUSSEIN: 2000000 · POL POT: 1700000 · ATTILA THE HUN: 1000000 · IVAN THE TERRIBLE: 100000 · FRANCOIS DUVALIER: 50000 · OSAMA BIN LADEN: 4000 · MOHAMMED OMAR: 5000 · AUGUSTO PINOCHET: 3200 · SUHARTO: 1000000 · ADOLF HITLER: 35000000 · MAO ZEDONG: 33000000 · JOSEF STALIN: 30000000 · SLOBODAN MILOSEVIC: 230000 · MUSSOLINI: 220000 · THEONESTE BAGOSORA: 1000000 · OLIVER CROMWELL: 600000 · IDI AMIN: 300000 · SADDAM HUSSEIN: 2000000 · POL POT: 1700000 · ATTILA THE HUN: 1000000 · IVAN THE TERRIBLE: 100000 · FRANCOIS DUVALIER: 50000 · OSAMA BIN LADEN: 4000 · MOHAMMED OMAR: 5000 · AUGUSTO PINOCHET: 3200 · SUHARTO: 1000000 · ADOLF HITLER: 35000000 · MAO ZEDONG: 33000000 · JOSEF STALIN: 30000000 · SLOBODAN MILOSEVIC: 230000 · MUSSOLINI: 220000 · THEONESTE BAGOSORA: 1000000 · OLIVER CROMWELL: 600000 · IDI AMIN: 300000 · SADDAM HUSSEIN: 2000000 · POL POT: 1700000 · ATTILA THE HUN: 1000000 · IVAN THE TERRIBLE: 100000 · FRANCOIS DUVALIER: 50000 · OSAMA BIN LADEN: 4000 · MOHAMMED OMAR: 5000 · AUGUSTO PINOCHET: 3200 · SUHARTO: 1000000 · ADOLF HITLER: 35000000 · MAO ZEDONG: 33000000 · JOSEF STALIN: 30000000 · SLOBODAN MILOSEVIC: 230000 · MUSSOLINI: 220000 · THEONESTE BAGOSORA: 1000000 · OLIVER CROMWELL: 600000 · IDI AMIN: 300000 · SADDAM HUSSEIN: 2000000 · POL POT: 1700000 · ATTILA THE HUN: 1000000 · IVAN THE TERRIBLE: 100000 · FRANCOIS DUVALIER: 50000 · OSAMA BIN LADEN: 4000 · MOHAMMED OMAR: 5000 · AUGUSTO PINOCHET: 3200 · SUHARTO: 1000000 · ADOLF HITLER: 35000000 · MAO ZEDONG: 33000000 · JOSEF STALIN: 30000000 · SLOBODAN MILOSEVIC: 230000 · MUSSOLINI: 220000 · THEONESTE BAGOSORA: 1000000 · OLIVER CROMWELL: 600000 · IDI AMIN: 300000 · SADDAM HUSSEIN: 2000000 · POL POT: 1700000 · ATTILA THE HUN: 1000000 · IVAN THE TERRIBLE: 100000 · FRANCOIS DUVALIER: 50000 · OSAMA BIN LADEN: 4000 · MOHAMMED OMAR: 5000 · AUGUSTO PINOCHET: 3200 · SUHARTO: 1000000 · ADOLF HITLER: 35000000 · MAO ZEDONG: 33000000 · JOSEF STALIN: 30000000 · SLOBODAN MILOSEVIC: 230000 · MUSSOLINI: 220000 · THEONESTE BAGOSORA: 1000000 · OLIVER CROMWELL: 600000 · IDI AMIN: 300000 · SADDAM HUSSEIN: 2000000 · POL POT: 1700000 · ATTILA THE HUN: 1000000 · IVAN THE TERRIBLE: 100000 · FRANCOIS DUVALIER: 50000 · OSAMA BIN LADEN: 4000 · MOHAMMED OMAR: 5000 · AUGUSTO PINOCHET: 3200 · SUHARTO: 1000000 · ADOLF HITLER: 35000000 · MAO ZEDONG: 33000000 · JOSEF STALIN: 30000000 · SLOBODAN MILOSEVIC: 230000 · MUSSOLINI: 220000 · THEONESTE BAGOSORA: 1000000 · OLIVER CROMWELL: 600000 · IDI AMIN: 300000 · SADDAM HUSSEIN: 2000000 · POL POT: 1700000 · ATTILA THE HUN: 1000000 · IVAN THE TERRIBLE: 100000 · FRANCOIS DUVALIER: 50000 · OSAMA BIN LADEN: 4000 · MOHAMMED OMAR: 5000 · AUGUSTO PINOCHET: 3200 · SUHARTO: 1000000 · ADOLF HITLER: 35000000 · MAO ZEDONG: 33000000 · JOSEF STALIN: 30000000 · SLOBODAN MILOSEVIC: 230000 · MUSSOLINI: 220000 · THEONESTE BAGOSORA: 1000000 · OLIVER CROMWELL: 600000 · IDI AMIN: 300000 · SADDAM HUSSEIN: 2000000 · POL POT: 1700000 · ATTILA THE HUN: 1000000 · IVAN THE TERRIBLE: 100000 · FRANCOIS DUVALIER: 50000 · OSAMA BIN LADEN: 4000 · MOHAMMED OMAR: 5000 · AUGUSTO PINOCHET: 3200 · SUHARTO: 1000000 · ADOLF HITLER: 35000000 · MAO ZEDONG: 33000000 · JOSEF STALIN: 30000000 · SLOBODAN MILOSEVIC: 230000 · MUSSOLINI: 220000 · THEONESTE BAGOSORA: 1000000 · OLIVER CROMWELL: 600000 · IDI AMIN: 300000 · SADDAM HUSSEIN: 2000000 · POL POT: 1700000 · ATTILA THE HUN: 1000000 · IVAN THE TERRIBLE: 100000 · FRANCOIS DUVALIER: 50000 · OSAMA BIN LADEN: 4000 · MOHAMMED OMAR: 5000 · AUGUSTO PINOCHET: 3200 · SUHARTO: 1000000 · ADOLF HITLER: 35000000 · MAO ZEDONG: 33000000 · JOSEF STALIN: 30000000 · SLOBODAN MILOSEVIC: 230000 · MUSSOLINI: 220000 · THEONESTE BAGOSORA: 1000000 · OLIVER CROMWELL: 600000 · IDI AMIN: 300000 · SADDAM HUSSEIN: 2000000 · POL POT: 1700000 · ATTILA THE HUN: 1000000 · IVAN THE TERRIBLE: 100000 · FRANCOIS DUVALIER: 50000 · OSAMA BIN LADEN: 4000 · MOHAMMED OMAR: 5000 · AUGUSTO PINOCHET: 3200 · SUHARTO: 1000000 · ADOLF HITLER: 35000000 · MAO ZEDONG: 33000000 · JOSEF STALIN: 30000000 · SLOBODAN MILOSEVIC: 230000 · MUSSOLINI: 220000 · THEONESTE BAGOSORA: 1000000 · OLIVER CROMWELL: 600000 · IDI AMIN: 300000 · SADDAM HUSSEIN: 2000000 · POL POT: 1700000 · ATTILA THE HUN: 1000000 · IVAN THE TERRIBLE: 100000 · FRANCOIS DUVALIER: 50000 · OSAMA BIN LADEN: 4000 · MOHAMMED OMAR: 5000 · AUGUSTO PINOCHET: 3200 · SUHARTO: 1000000 · ADOLF HITLER: 35000000 · MAO ZEDONG: 33000000 · JOSEF STALIN: 30000000 · SLOBODAN MILOSEVIC: 230000 · MUSSOLINI: 220000 · THEONESTE BAGOSORA: 1000000 · OLIVER CROMWELL: 600000 · IDI AMIN: 300000 · SADDAM HUSSEIN: 2000000 · POL POT: 1700000 · ATTILA THE HUN: 1000000 · IVAN THE TERRIBLE: 100000 · FRANCOIS DUVALIER: 50000 · OSAMA BIN LADEN: 4000 · MOHAMMED OMAR: 5000 · AUGUSTO PINOCHET: 3200 · SUHARTO: 1000000 · ADOLF HITLER: 35000000 · MAO ZEDONG: 33000000 · JOSEF STALIN: 30000000 · SLOBODAN MILOSEVIC: 230000 · MUSSOLINI: 220000 · THEONESTE BAGOSORA: 1000000 · OLIVER CROMWELL: 600000 · IDI AMIN: 300000 · SADDAM HUSSEIN: 2000000 · POL POT: 1700000 · ATTILA THE HUN: 1000000 · IVAN THE TERRIBLE: 100000 · FRANCOIS DUVALIER: 50000 · OSAMA BIN LADEN: 4000 · MOHAMMED OMAR: 5000 · AUGUSTO PINOCHET: 3200 · SUHARTO: 1000000 · ADOLF HITLER: 35000000 · MAO ZEDONG: 33000000 · JOSEF STALIN: 30000000 · SLOBODAN MILOSEVIC: 230000 · MUSSOLINI: 220000 · THEONESTE BAGOSORA: 1000000 · OLIVER CROMWELL: 600000 · IDI AMIN: 300000 · SADDAM HUSSEIN: 2000000 · POL POT: 1700000 · ATTILA THE HUN: 1000000 · IVAN THE TERRIBLE: 100000 · FRANCOIS DUVALIER: 50000 · OSAMA BIN LADEN: 4000 · MOHAMMED OMAR: 5000 · AUGUSTO PINOCHET: 3200 · SUHARTO: 1000000 · ADOLF HITLER: 35000000 · MAO ZEDONG: 33000000 · JOSEF STALIN: 30000000 · SLOBODAN MILOSEVIC: 230000 · MUSSOLINI: 220000 · THEONESTE BAGOSORA: 1000000 · OLIVER CROMWELL: 600000 · IDI AMIN: 300000 · SADDAM HUSSEIN: 2000000 · POL POT: 1700000 · ATTILA THE HUN: 1000000 · IVAN THE TERRIBLE: 100000 · FRANCOIS DUVALIER: 50000 · OSAMA BIN LADEN: 4000 · MOHAMMED OMAR: 5000 · AUGUSTO PINOCHET: 3200 · SUHARTO: 1000000 · ADOLF HITLER: 35000000 · MAO ZEDONG: 33000000 · JOSEF STALIN: 30000000 · SLOBODAN MILOSEVIC: 230000 · MUSSOLINI: 220000 · THEONESTE BAGOSORA: 1000000 · OLIVER CROMWELL: 600000 · IDI AMIN: 300000 · SADDAM HUSSEIN: 2000000 · POL POT: 1700000 · ATTILA THE HUN: 1000000 · IVAN THE TERRIBLE: 100000 · FRANCOIS DUVALIER: 50000 · OSAMA BIN LADEN: 4000 · MOHAMMED OMAR: 5000 · AUGUSTO PINOCHET: 3200 · SUHARTO: 1000000 · ADOLF HITLER: 35000000 · MAO ZEDONG: 33000000 · JOSEF STALIN: 30000000 · SLOBODAN MILOSEVIC: 230000 · MUSSOLINI: 220000 · THEONESTE BAGOSORA: 1000000 · OLIVER CROMWELL: 600000 · IDI AMIN: 300000 · SADDAM HUSSEIN: 2000000 · POL POT: 1700000 · ATTILA THE HUN: 1000000 · IVAN THE TERRIBLE: 100000 · FRANCOIS DUVALIER: 50000 · OSAMA BIN LADEN: 4000 · MOHAMMED OMAR: 5000 · AUGUSTO PINOCHET: 3200 · SUHARTO: 1000000 · ADOLF HITLER: 35000000 · MAO ZEDONG: 33000000 · JOSEF STALIN: 30000000 · SLOBODAN MILOSEVIC: 230000 · MUSSOLINI: 220000 · THEONESTE BAGOSORA: 1000000 · OLIVER CROMWELL: 600000 · IDI AMIN: 300000 · SADDAM HUSSEIN: 2000000 · POL POT: 1700000 · ATTILA THE HUN: 1000000 · IVAN THE TERRIBLE: 100000 · FRANCOIS DUVALIER: 50000 · OSAMA BIN LADEN: 4000 · MOHAMMED OMAR: 5000 · AUGUSTO PINOCHET: 3200 · SUHARTO: 1000000 · ADOLF HITLER: 35000000 · MAO ZEDONG: 33000000 · JOSEF STALIN: 30000000 · SLOBODAN MILOSEVIC: 230000 · MUSSOLINI: 220000 · THEONESTE BAGOSORA: 1000000 · OLIVER CROMWELL: 600000 · IDI AMIN: 300000 · SADDAM HUSSEIN: 2000000 · POL POT: 1700000 · ATTILA THE HUN: 1000000 · IVAN THE TERRIBLE: 100000 · FRANCOIS DUVALIER: 50000 · OSAMA BIN LADEN: 4000 · MOHAMMED OMAR: 5000 · AUGUSTO PINOCHET: 3200 · SUHARTO: 1000000 · ADOLF HITLER: 35000000 · MAO ZEDONG: 33000000 · JOSEF STALIN: 30000000 · SLOBODAN MILOSEVIC: 230000 · MUSSOLINI: 220000 · THEONESTE BAGOSORA: 1000000 · OLIVER CROMWELL: 600000 · IDI AMIN: 300000 · SADDAM HUSSEIN: 2000000 · POL POT: 1700000 · ATTILA THE HUN: 1000000 · IVAN THE TERRIBLE: 100000 · FRANCOIS DUVALIER: 50000 · OSAMA BIN LADEN: 4000 · MOHAMMED OMAR: 5000 · AUGUSTO PINOCHET: 3200 · SUHARTO: 1000000 · ADOLF HITLER: 35000000 · MAO ZEDONG: 33000000 · JOSEF STALIN: 30000000 · SLOBODAN MILOSEVIC: 230000 · MUSSOLINI: 220000 · THEONESTE BAGOSORA: 1000000 · OLIVER CROMWELL: 600000 · IDI AMIN: 300000 · SADDAM HUSSEIN: 2000000 · POL POT: 1700000 · ATTILA THE HUN: 1000000 · IVAN THE TERRIBLE: 100000 · FRANCOIS DUVALIER: 50000 · OSAMA BIN LADEN: 4000 · MOHAMMED OMAR: 5000 · AUGUSTO PINOCHET: 3200 · SUHARTO: 1000000 · ADOLF HITLER: 35000000 · MAO ZEDONG: 33000000 · JOSEF STALIN: 30000000 · SLOBODAN MILOSEVIC: 230000 · MUSSOLINI: 220000 · THEONESTE BAGOSORA: 1000000 · OLIVER CROMWELL: 600000 · IDI AMIN: 300000 · SADDAM HUSSEIN: 2000000 · POL POT: 1700000 · ATTILA THE HUN: 1000000 · IVAN THE TERRIBLE: 100000 · FRANCOIS DUVALIER: 50000 · OSAMA BIN LADEN: 4000 · MOHAMMED OMAR: 5000 · AUGUSTO PINOCHET: 3200 · SUHARTO: 1000000 · ADOLF HITLER: 35000000 · MAO ZEDONG: 33000000 · JOSEF STALIN: 30000000 · SLOBODAN MILOSEVIC: 230000 · MUSSOLINI: 220000 · THEONESTE BAGOSORA: 1000000 · OLIVER CROMWELL: 600000 · IDI AMIN: 300000 · SADDAM HUSSEIN: 2000000 · POL POT: 1700000 · ATTILA THE HUN: 1000000 · IVAN THE TERRIBLE: 100000 · FRANCOIS DUVALIER: 50000 · OSAMA BIN LADEN: 4000 · MOHAMMED OMAR: 5000 · AUGUSTO PINOCHET: 3200 · SUHARTO: 1000000 · ADOLF HITLER: 35000000 · MAO ZEDONG: 33000000 · JOSEF STALIN: 30000000 · SLOBODAN MILOSEVIC: 230000 · MUSSOLINI: 220000 · THEONESTE BAGOSORA: 1000000 · OLIVER CROMWELL: 600000 · IDI AMIN: 300000 · SADDAM HUSSEIN: 2000000 · POL POT: 1700000 · ATTILA THE HUN: 1000000 · IVAN THE TERRIBLE: 100000 · FRANCOIS DUVALIER: 50000 · OSAMA BIN LADEN: 4000 · MOHAMMED OMAR: 5000 · AUGUSTO PINOCHET: 3200 · SUHARTO: 1000000 · ADOLF HITLER: 35000000 · MAO ZEDONG: 33000000 · JOSEF STALIN: 30000000 · SLOBODAN MILOSEVIC: 230000 · MUSSOLINI: 220000 · THEONESTE BAGOSORA: 1000000 · OLIVER CROMWELL: 600000 · IDI AMIN: 300000 · SADDAM HUSSEIN: 2000000 · POL POT: 1700000 · ATTILA THE HUN: 1000000 · IVAN THE TERRIBLE: 100000 · FRANCOIS DUVALIER: 50000 · OSAMA BIN LADEN: 4000 · MOHAMMED OMAR: 5000 · AUGUSTO PINOCHET: 3200 · SUHARTO: 1000000 · ADOLF HITLER: 35000000 · MAO ZEDONG: 33000000 · JOSEF STALIN: 30000000 · SLOBODAN MILOSEVIC: 230000 · MUSSOLINI: 220000 · THEONESTE BAGOSORA: 1000000 · OLIVER CROMWELL: 600000 · IDI AMIN: 300000 · SADDAM HUSSEIN: 2000000 · POL POT: 1700000 · ATTILA THE HUN: 1000000 · IVAN THE TERRIBLE: 100000 · FRANCOIS DUVALIER: 50000 · OSAMA BIN LADEN: 4000 · MOHAMMED OMAR: 5000 · AUGUSTO PINOCHET: 3200 · SUHARTO: 1000000 · ADOLF HITLER: 35000000 · MAO ZEDONG: 33000000 · JOSEF STALIN: 30000000 · SLOBODAN MILOSEVIC: 230000 · MUSSOLINI: 220000 · THEONESTE BAGOSORA: 1000000 · OLIVER CROMWELL: 600000 · IDI AMIN: 300000 · SADDAM HUSSEIN: 2000000 · POL POT: 1700000 · ATTILA THE HUN: 1000000 · IVAN THE TERRIBLE: 100000 · FRANCOIS DUVALIER: 50000 · OSAMA BIN LADEN: 4000 · MOHAMMED OMAR: 5000 · AUGUSTO PINOCHET: 3200 · SUHARTO: 1000000 · ADOLF HITLER: 35000000 · MAO ZEDONG: 33000000 · JOSEF STALIN: 30000000 · SLOBODAN MILOSEVIC: 230000 · MUSSOLINI: 220000 · THEONESTE BAGOSORA: 1000000 · OLIVER CROMWELL: 600000 · IDI AMIN: 300000 · SADDAM HUSSEIN: 2000000 · POL POT: 1700000 · ATTILA THE HUN: 1000000 · IVAN THE TERRIBLE: 100000 · FRANCOIS DUVALIER: 50000 · OSAMA BIN LADEN: 4000 · MOHAMMED OMAR: 5000 · AUGUSTO PINOCHET: 3200 · SUHARTO: 1000000 · ADOLF HITLER: 35000000 · MAO ZEDONG: 33000000 · JOSEF STALIN: 30000000 · SLOBODAN MILOSEVIC: 230000 · MUSSOLINI: 220000 · THEONESTE BAGOSORA: 1000000 · OLIVER CROMWELL: 600000 · IDI AMIN: 300000 · SADDAM HUSSEIN: 2000000 · POL POT: 1700000 · ATTILA THE HUN: 1000000 · IVAN THE TERRIBLE: 100000 · FRANCOIS DUVALIER: 50000 · OSAMA BIN LADEN: 4000 · MOHAMMED OMAR: 5000 · AUGUSTO PINOCHET: 3200 · SUHARTO: 1000000 · ADOLF HITLER: 35000000 · MAO ZEDONG: 33000000 · JOSEF STALIN: 30000000 · SLOBODAN MILOSEVIC: 230000 · MUSSOLINI: 220000 · THEONESTE BAGOSORA: 1000000 · OLIVER CROMWELL: 600000 · IDI AMIN: 300000 · SADDAM HUSSEIN: 2000000 · POL POT: 1700000

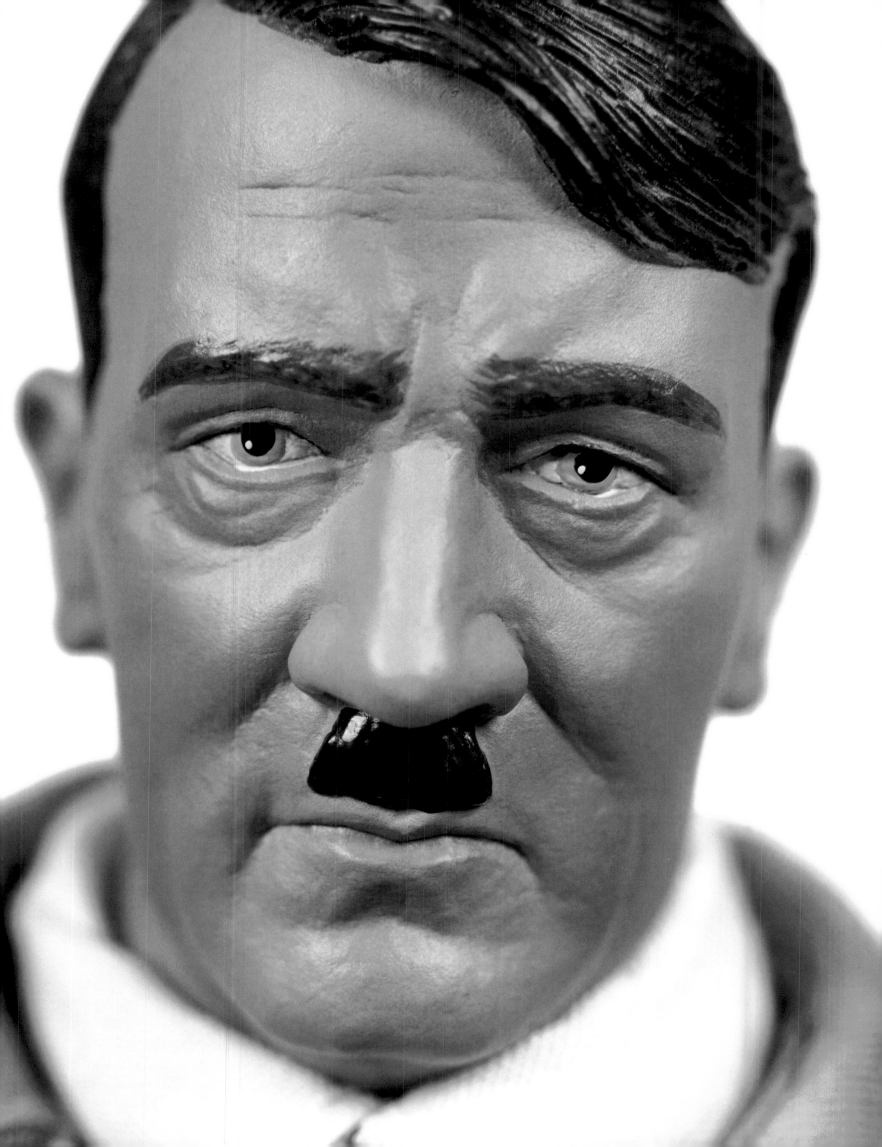

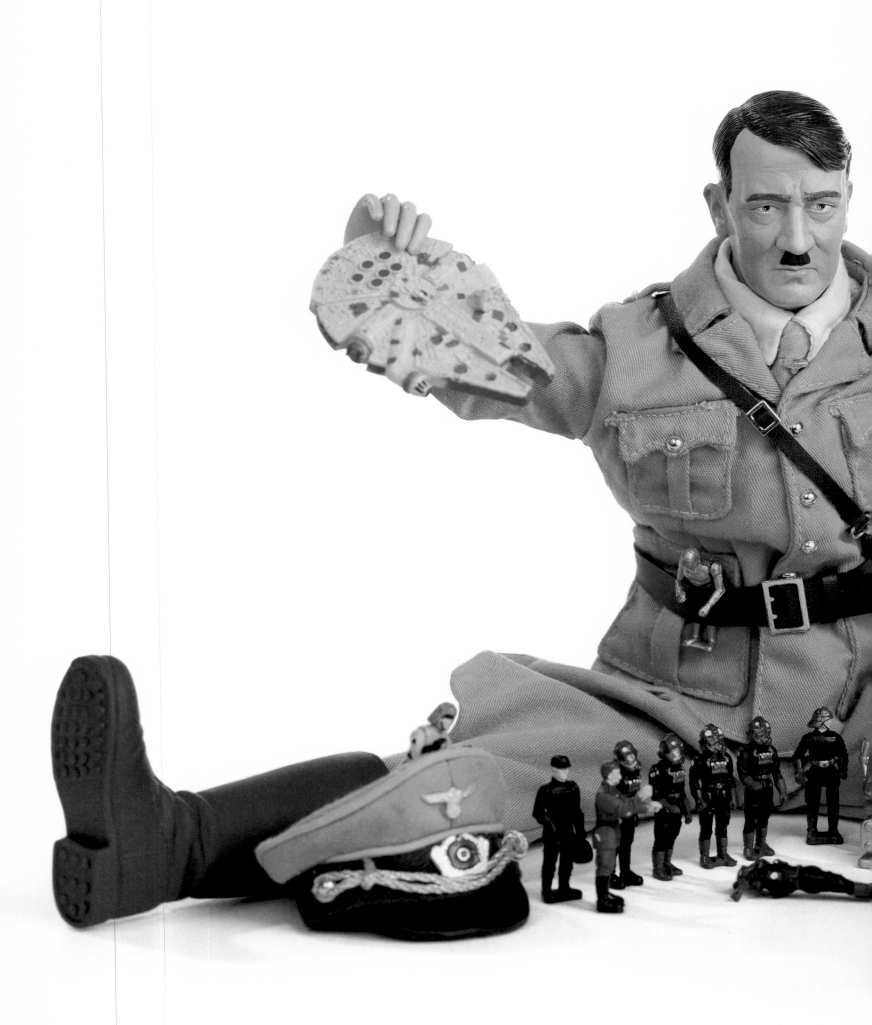

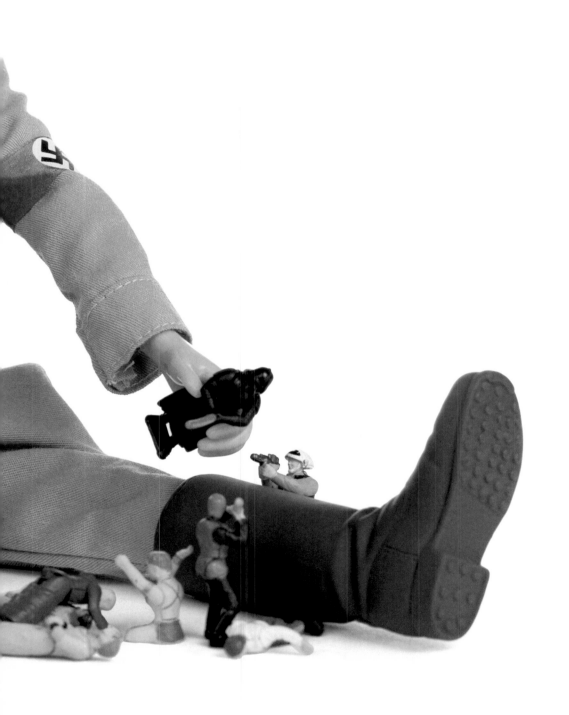

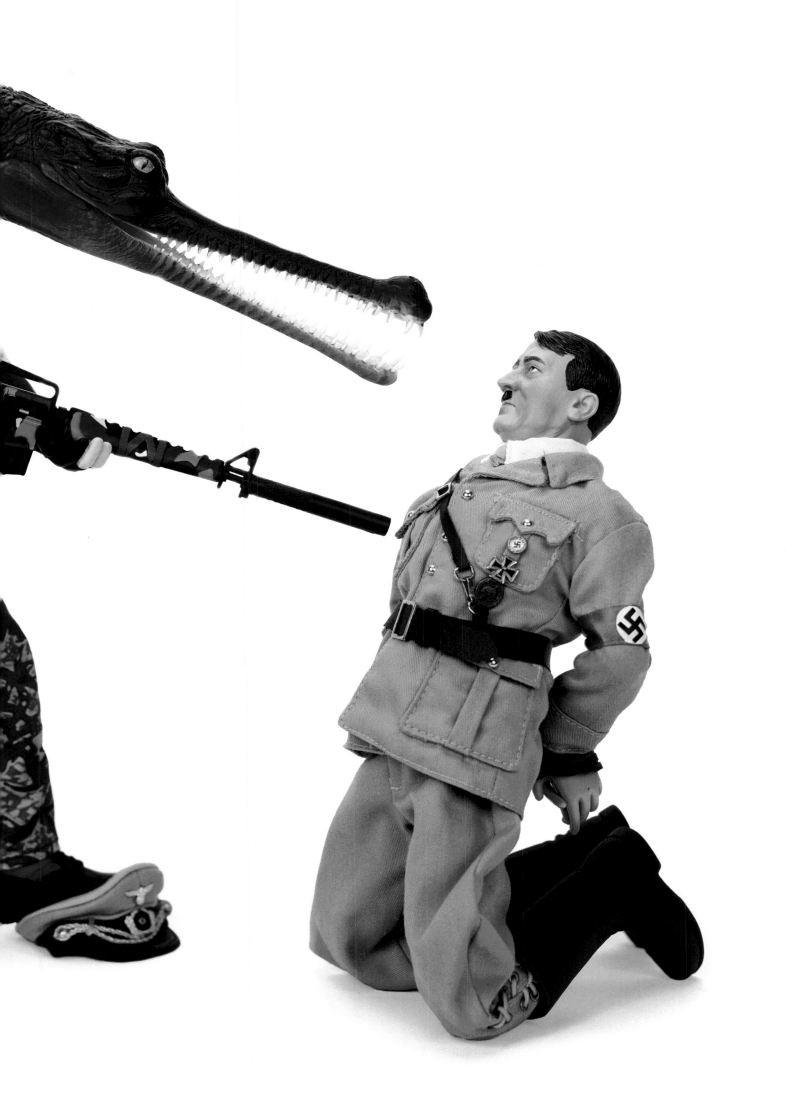

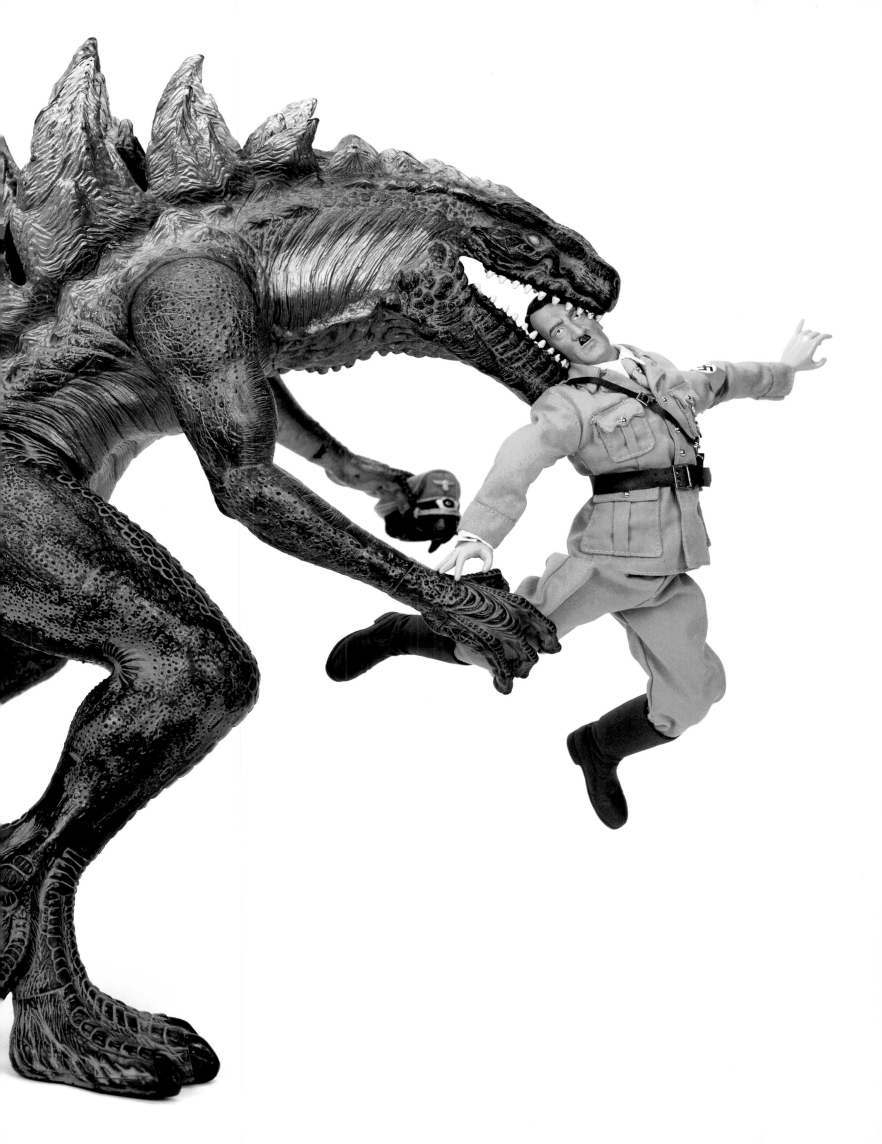

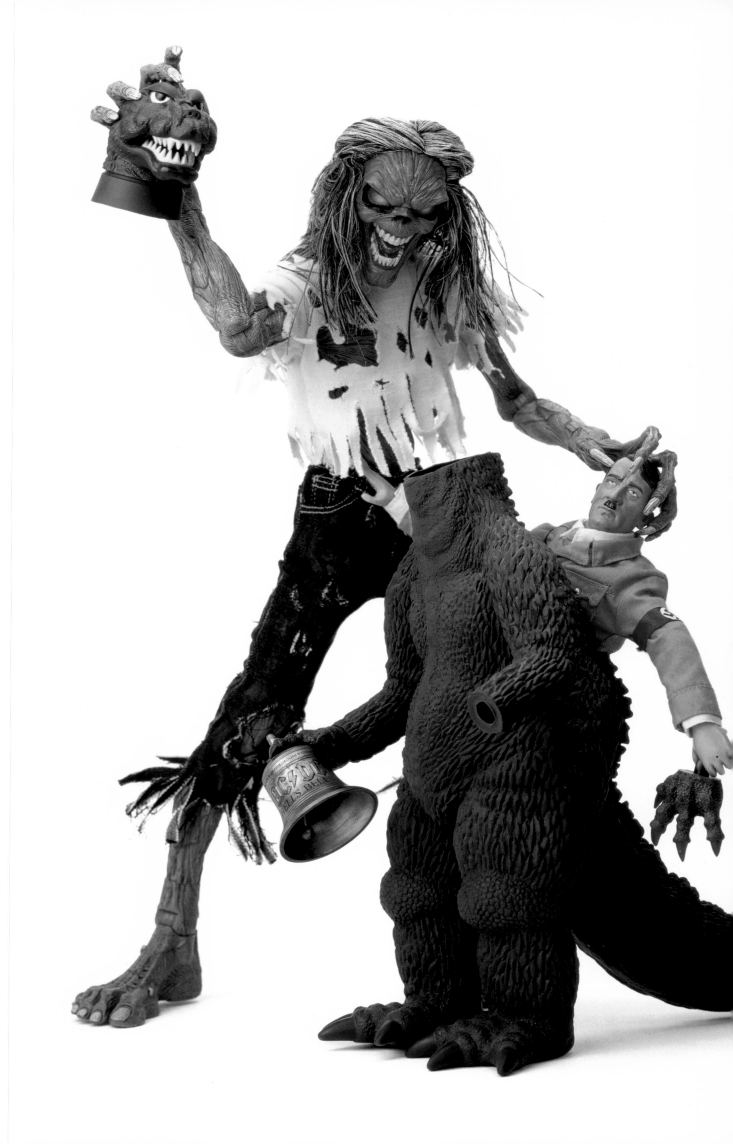

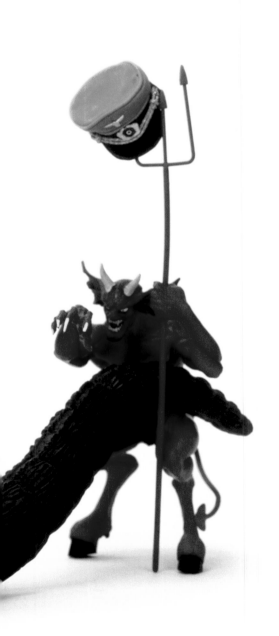

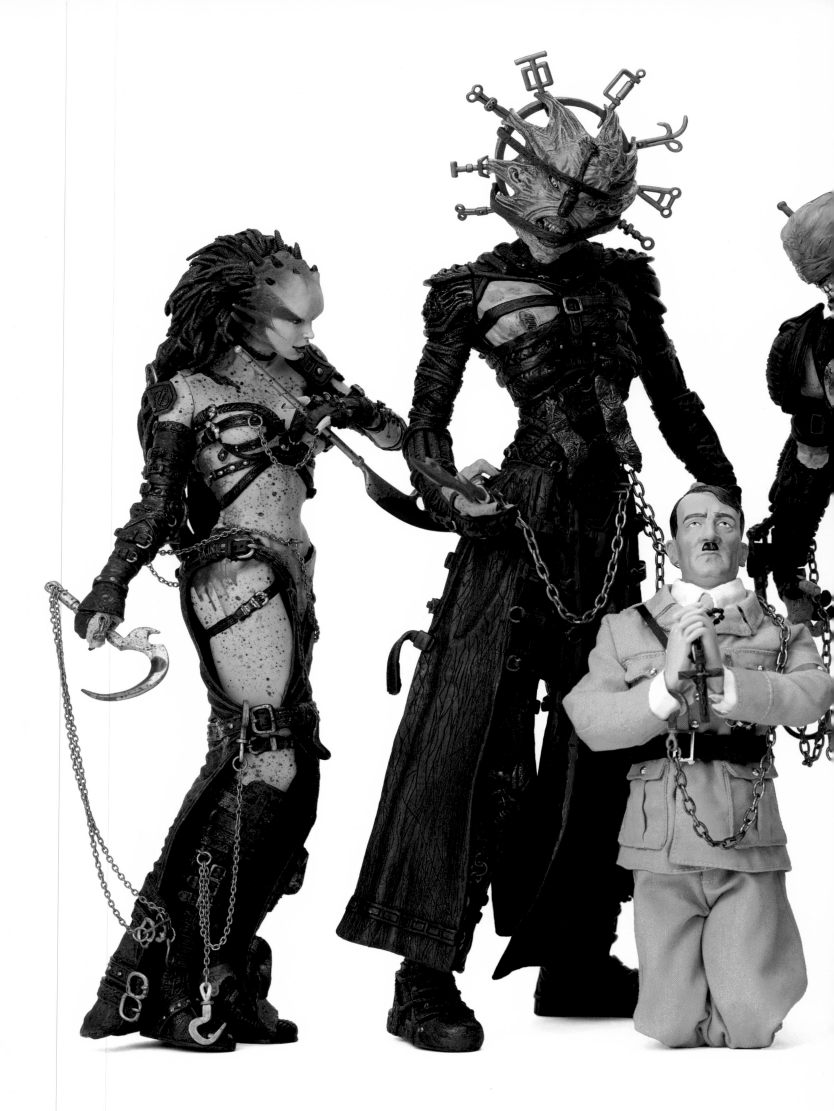

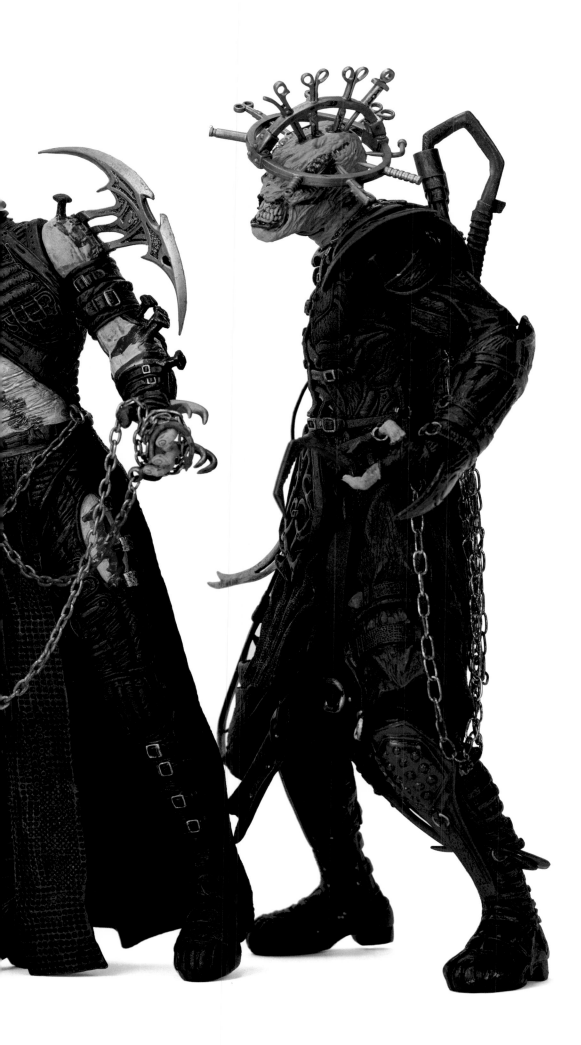

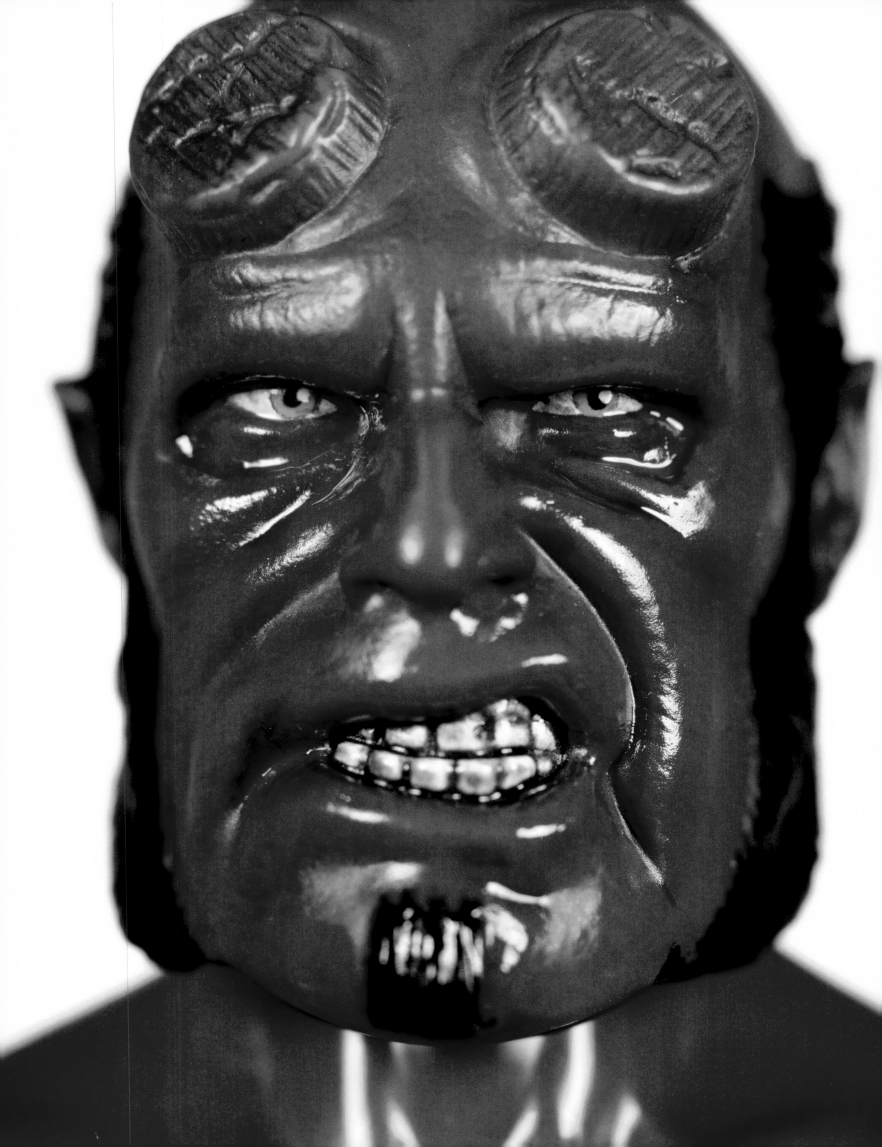

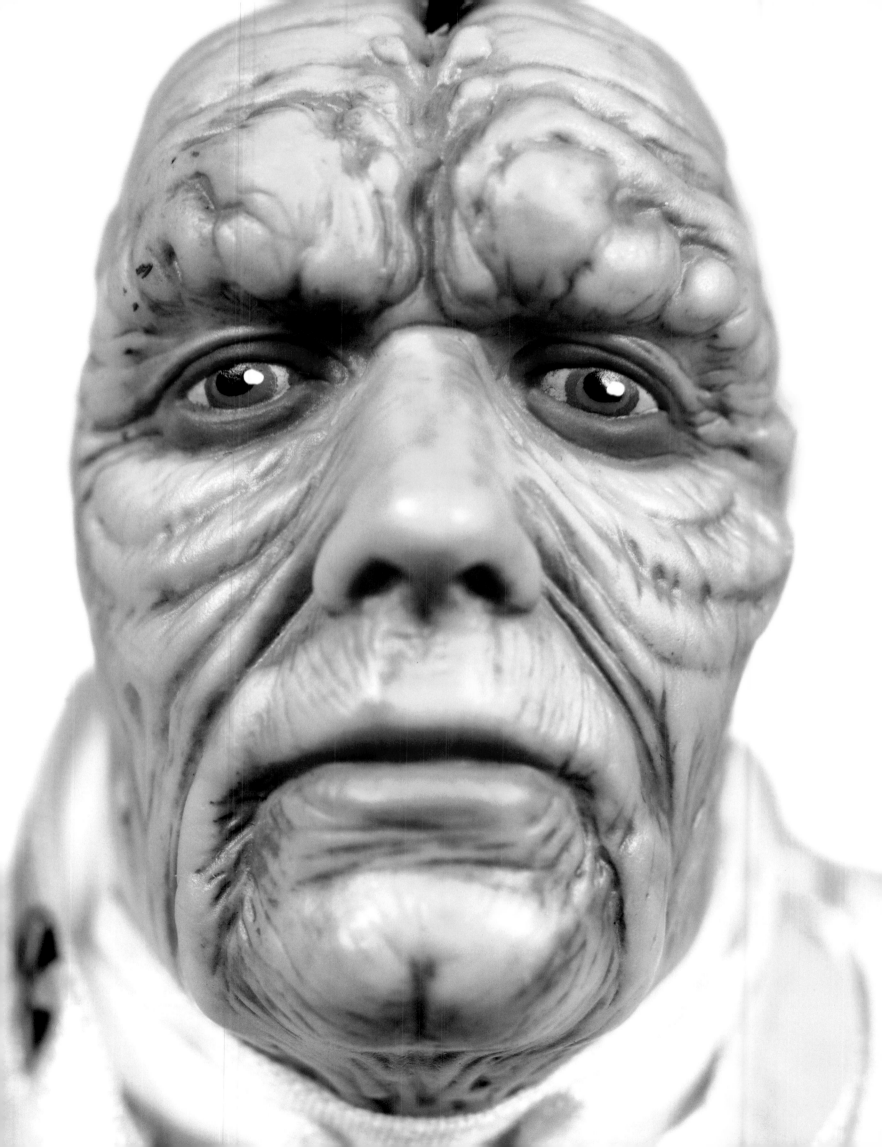

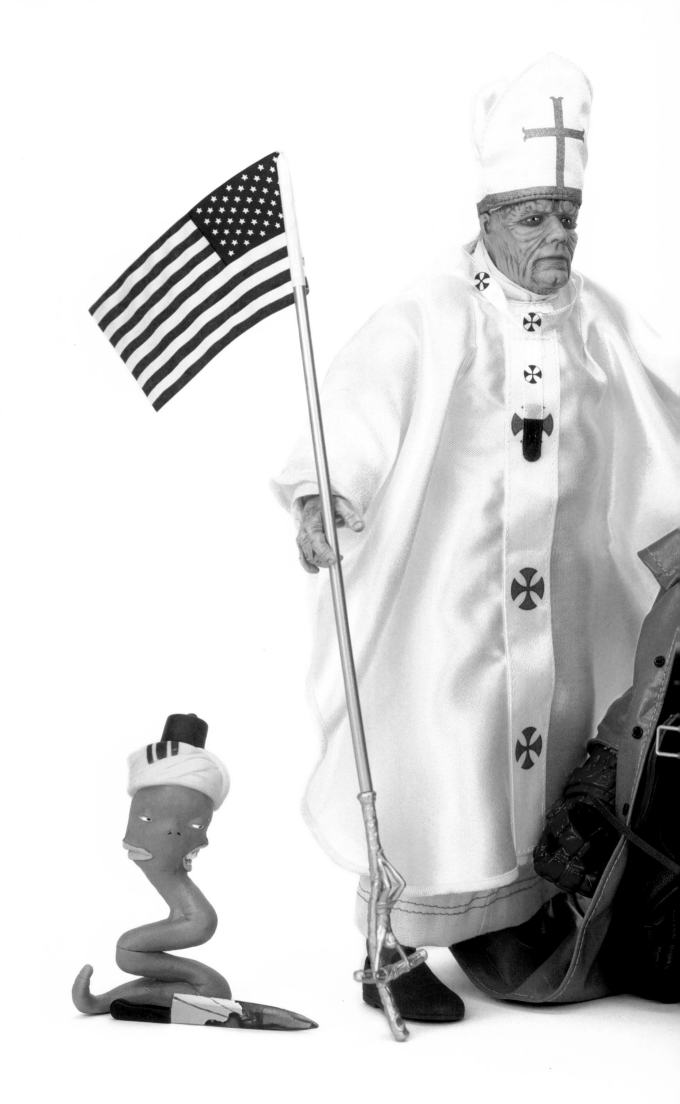

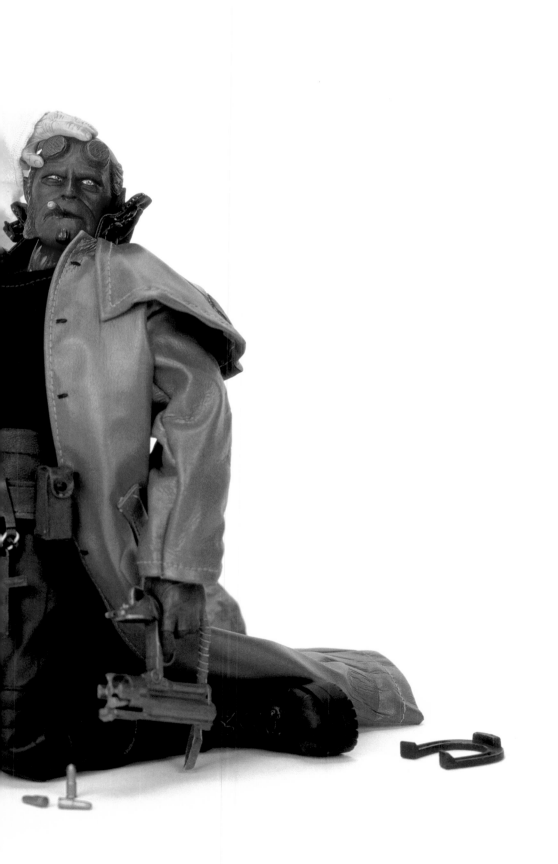

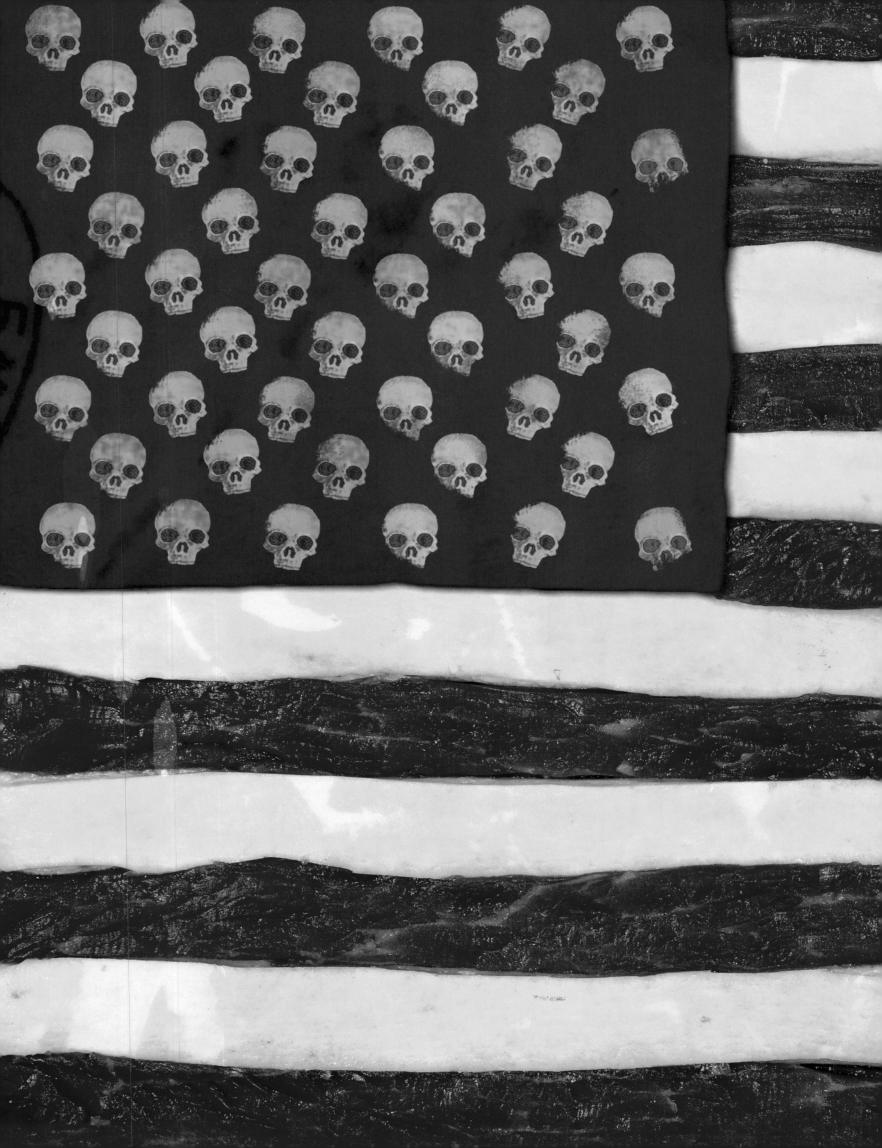

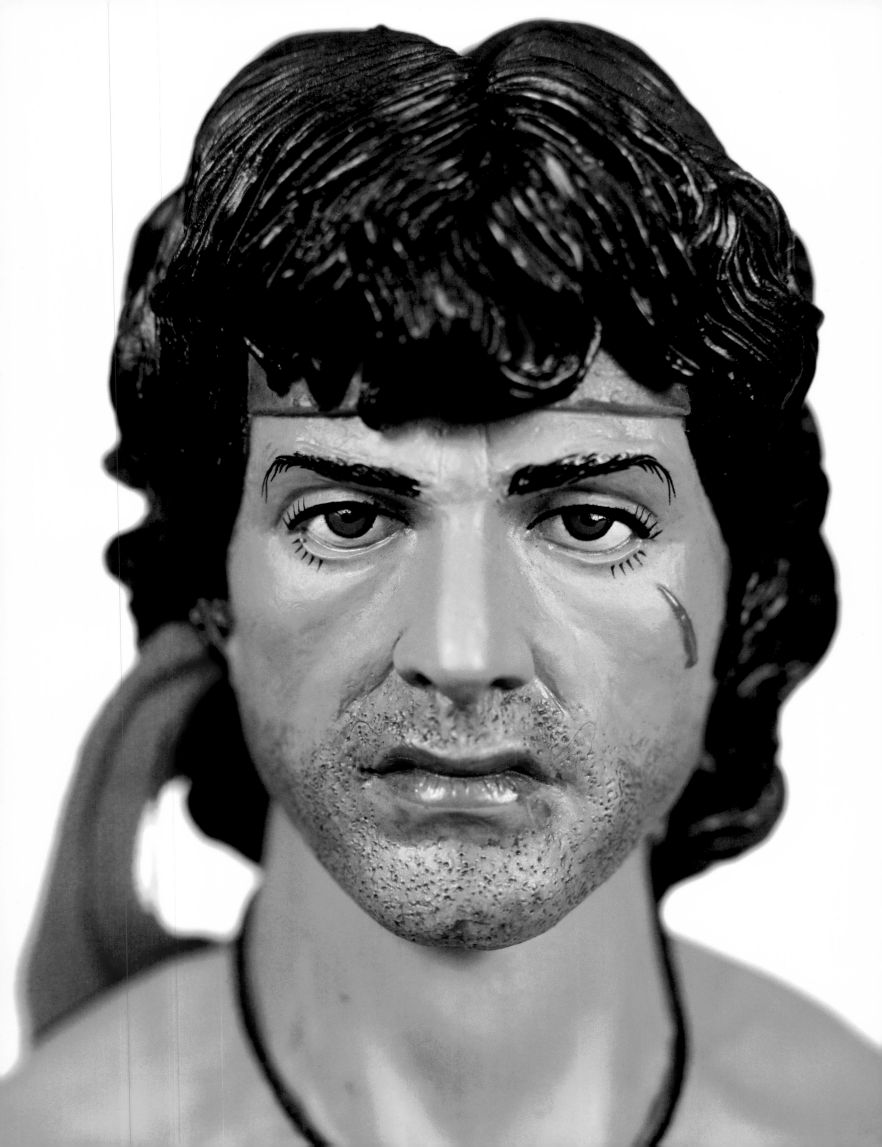

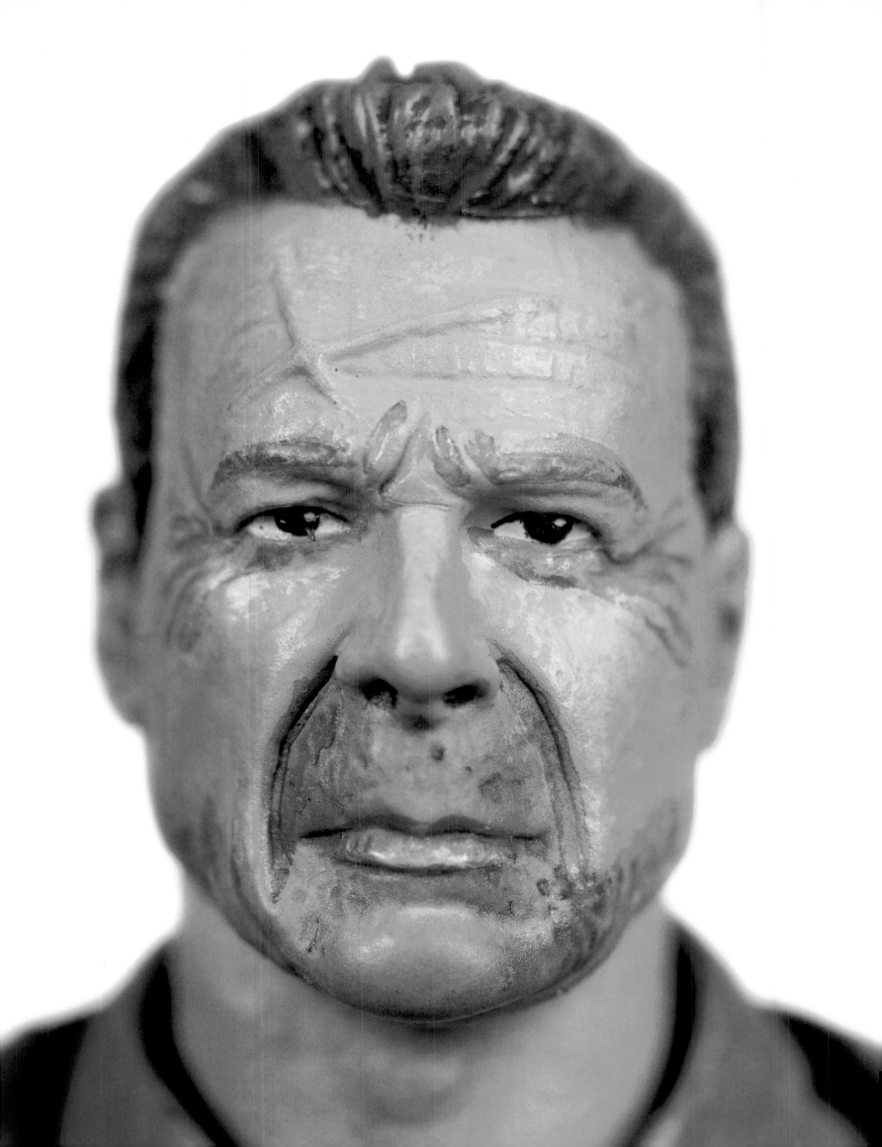

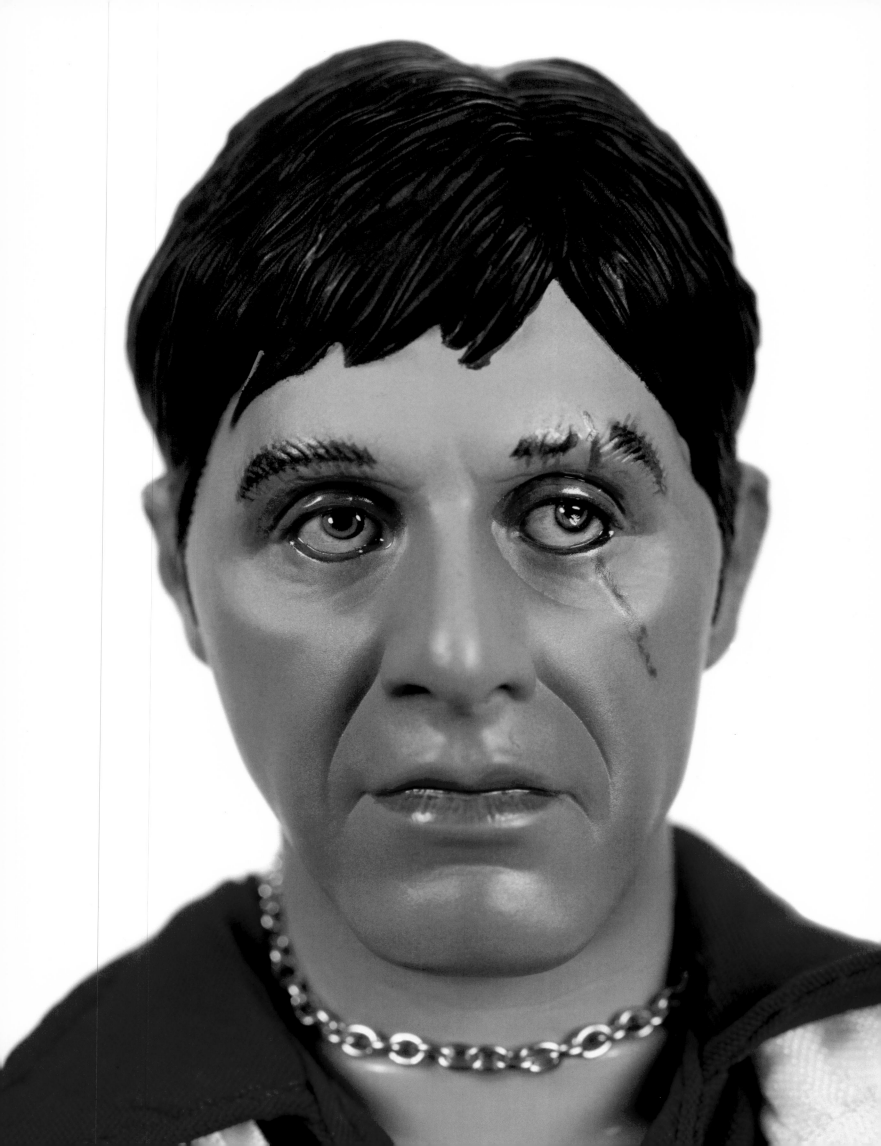

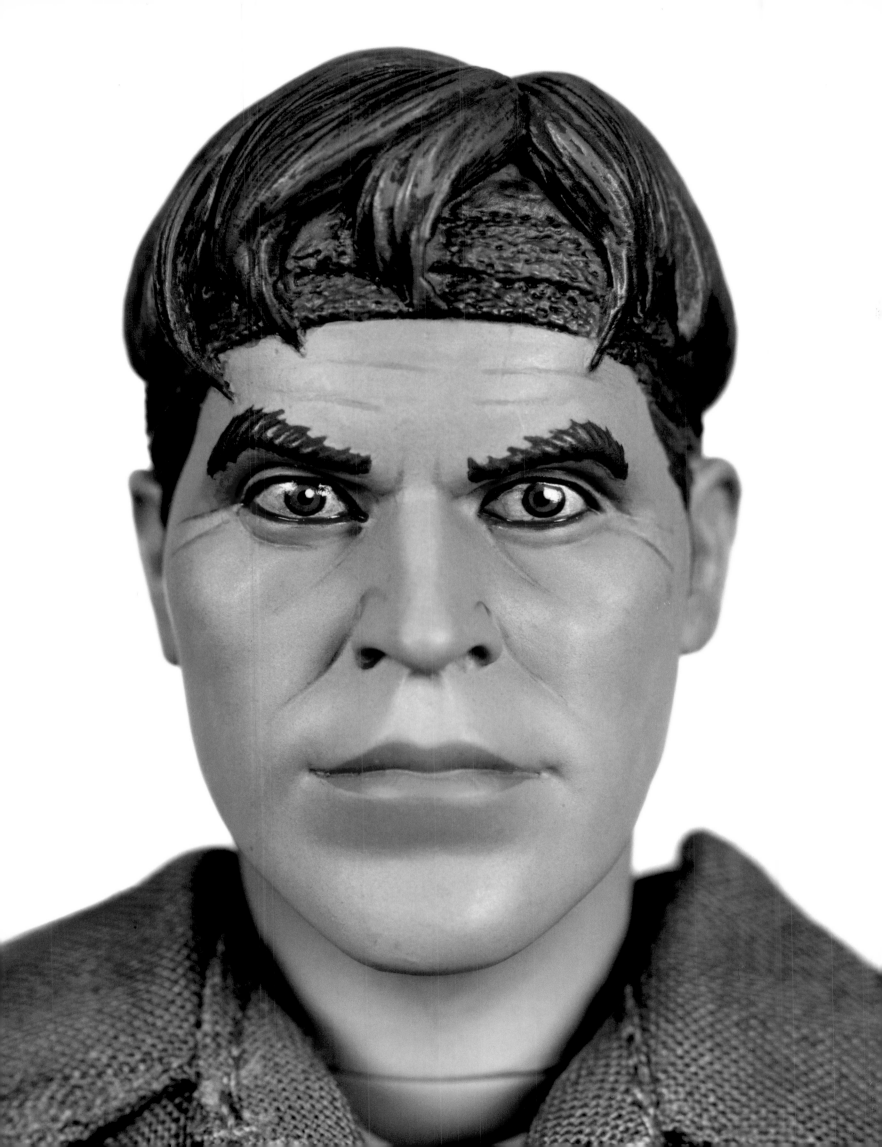

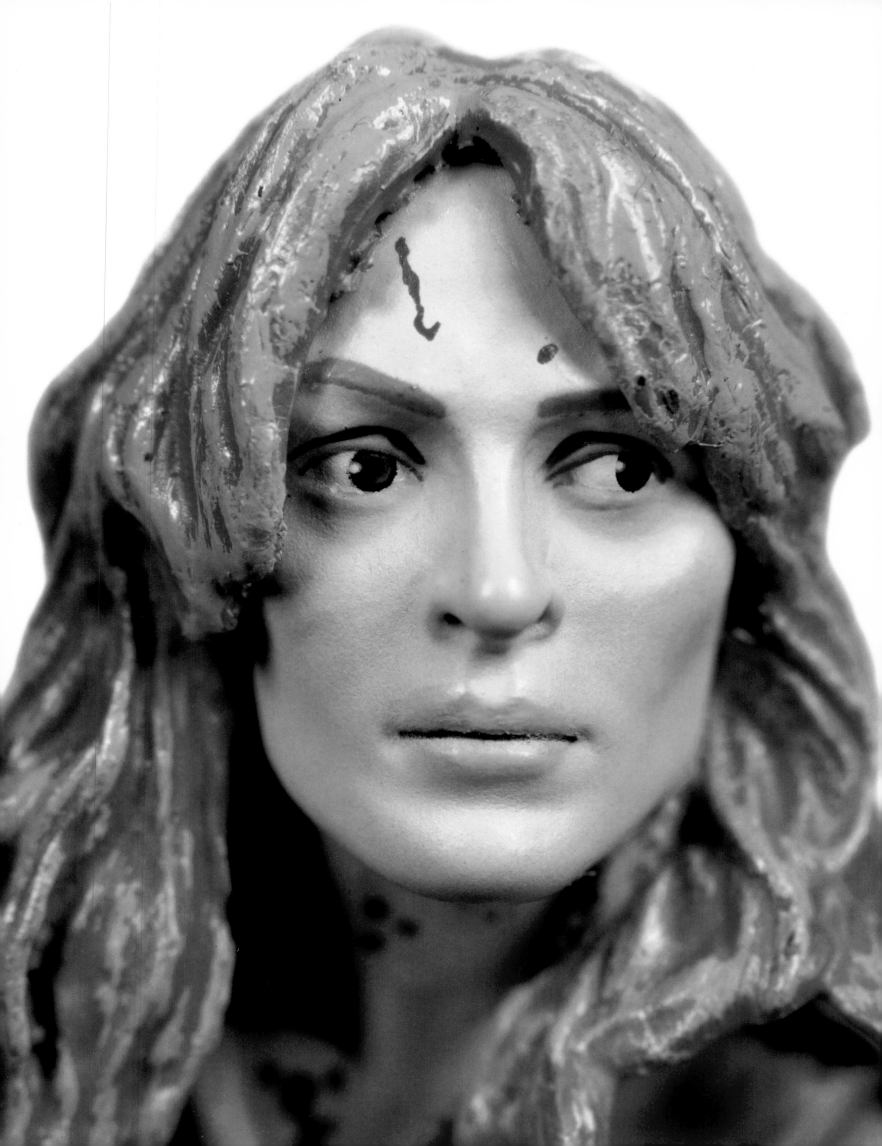

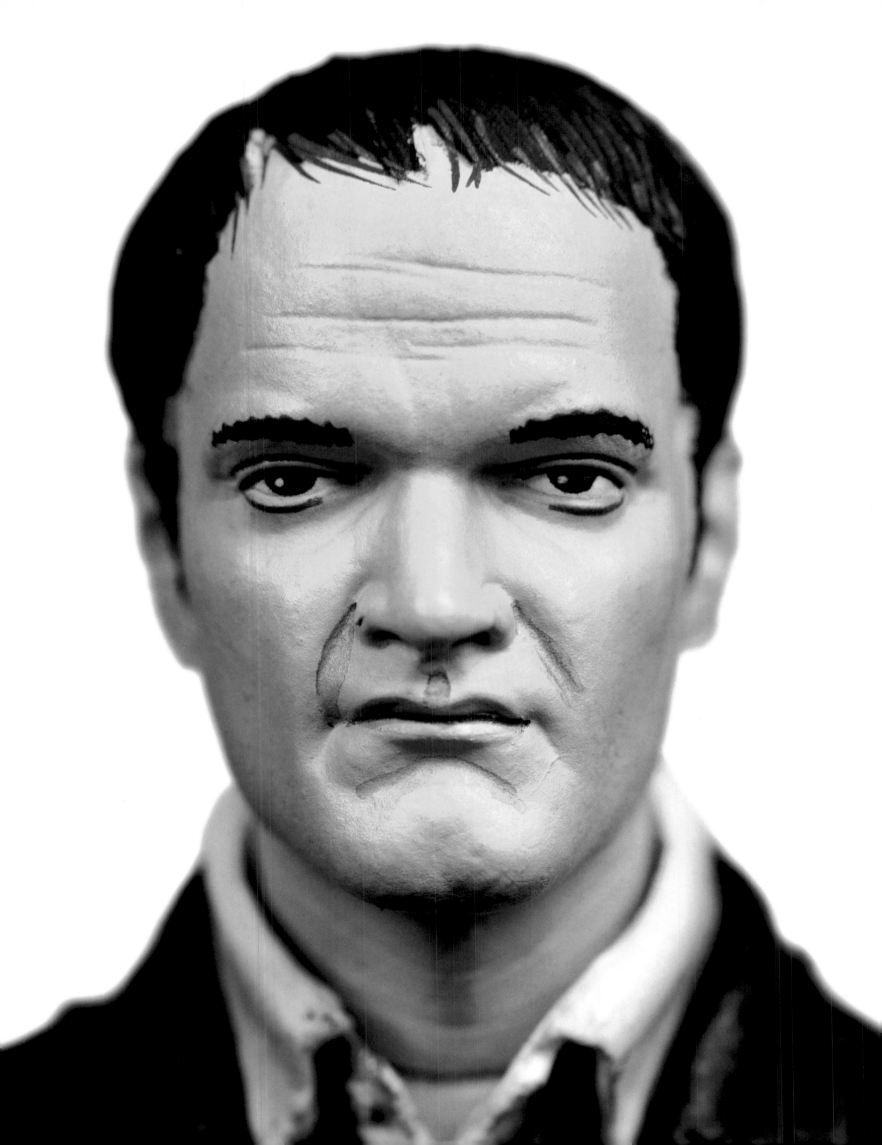

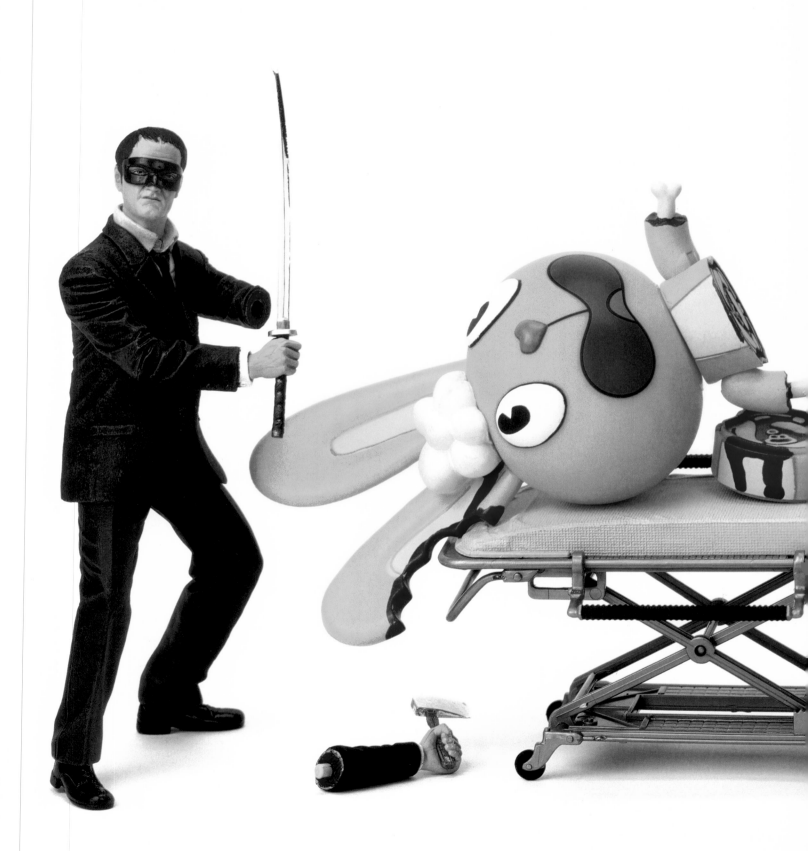

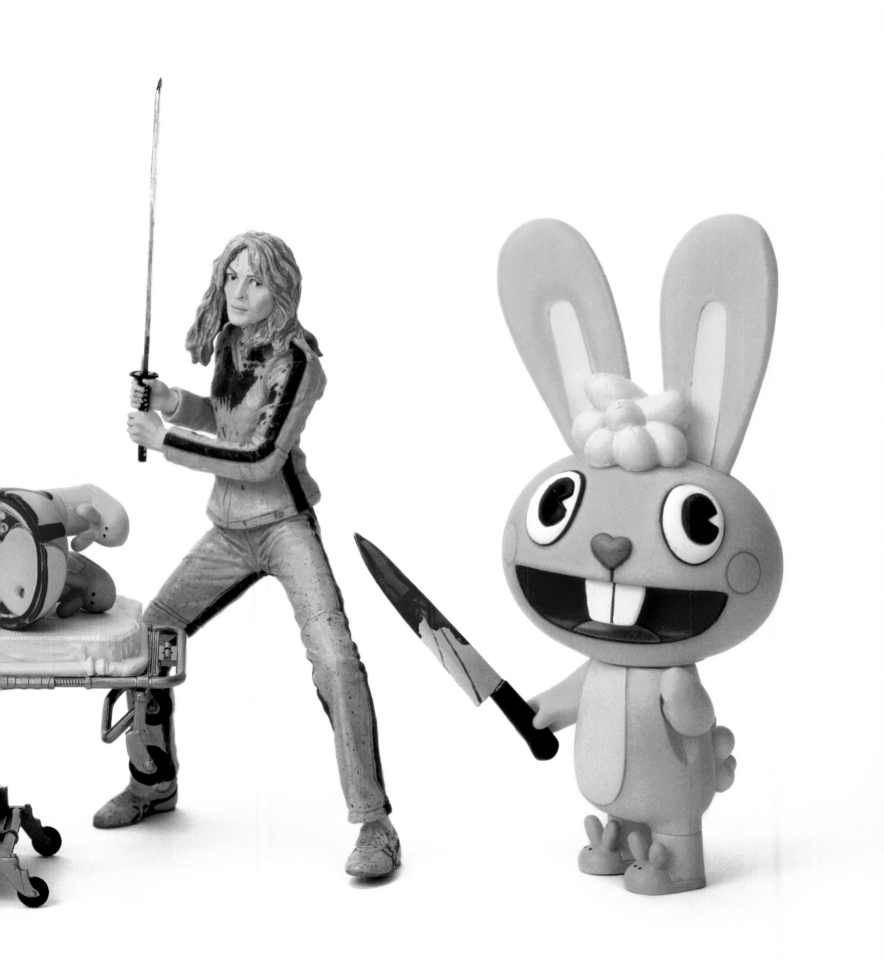

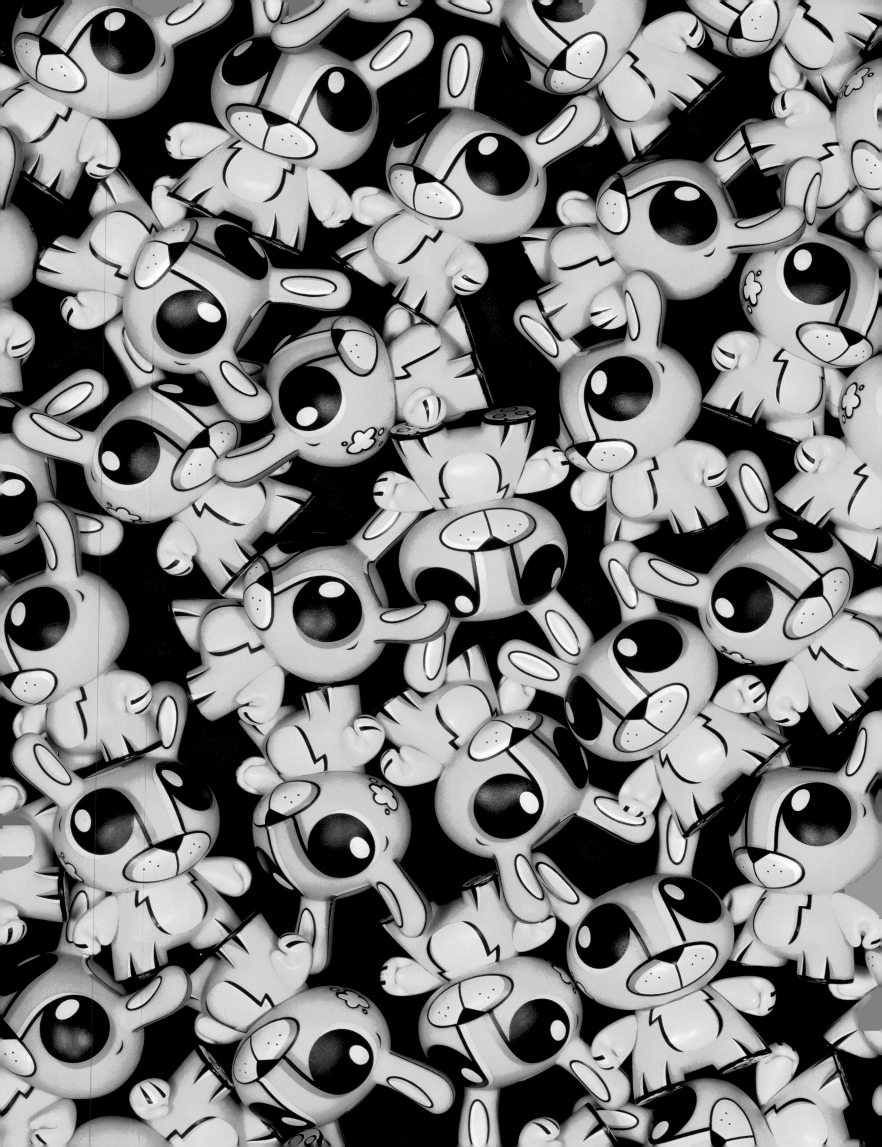

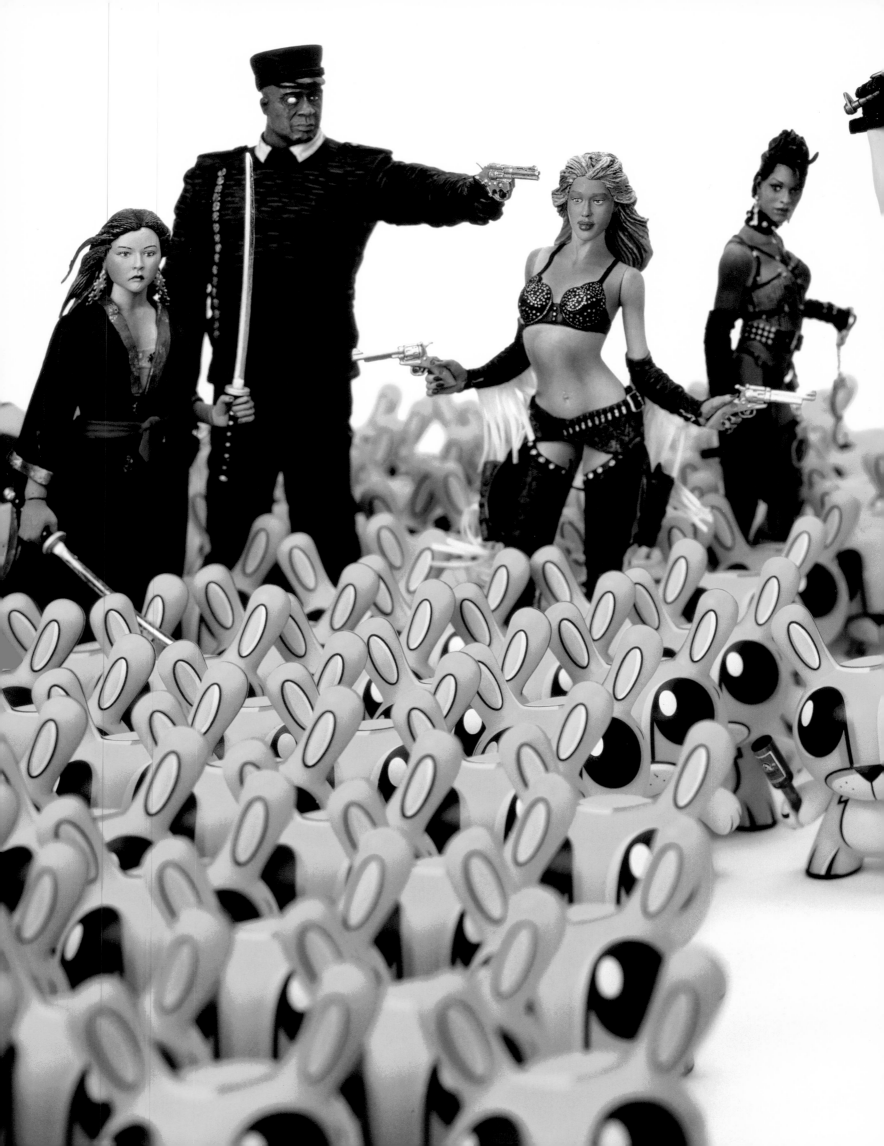

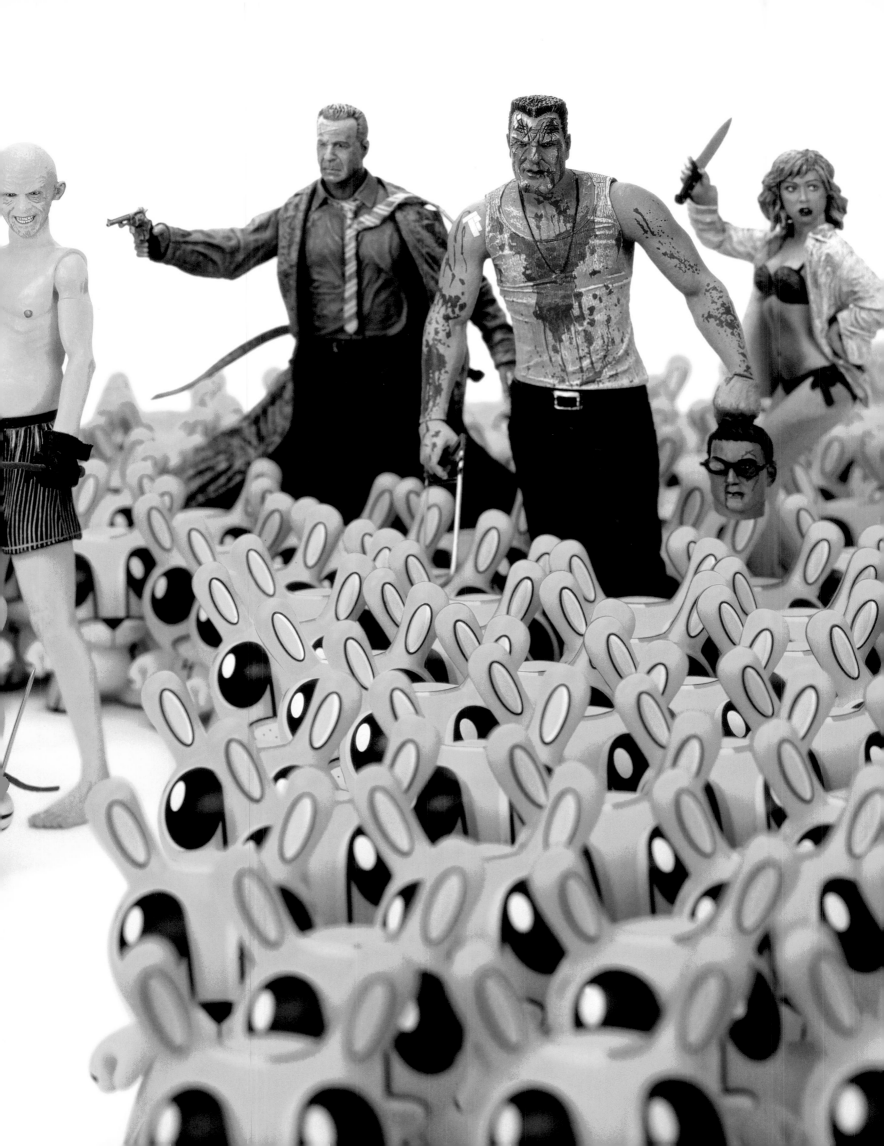

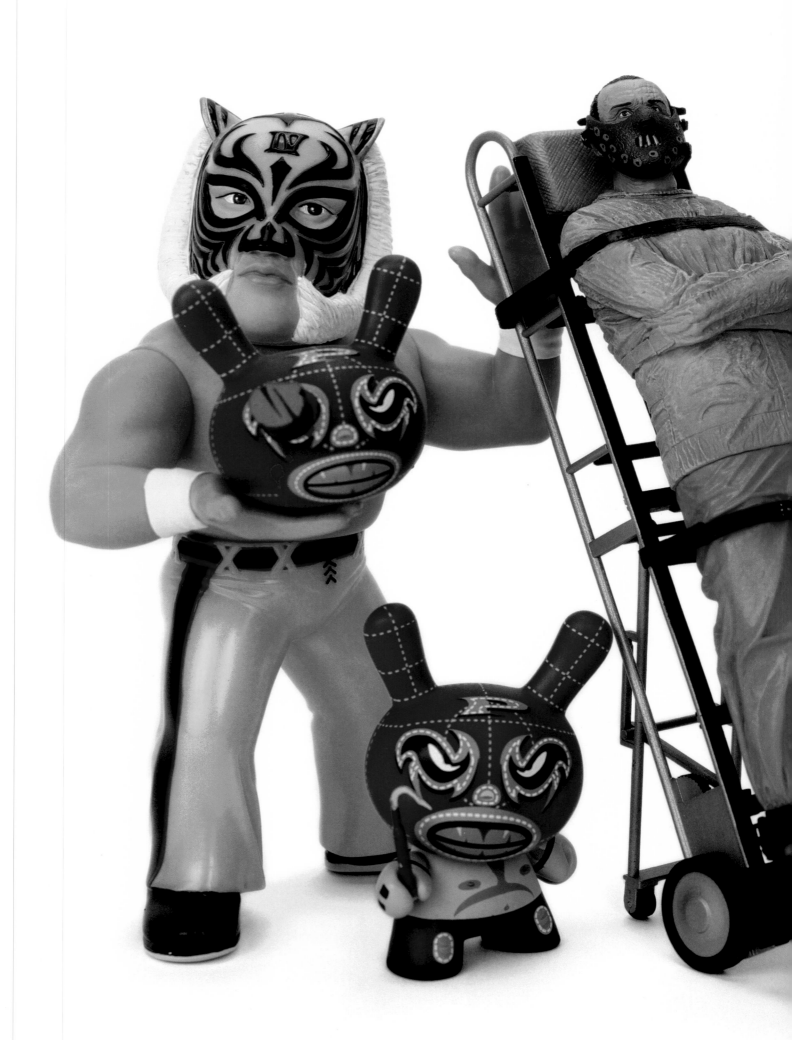

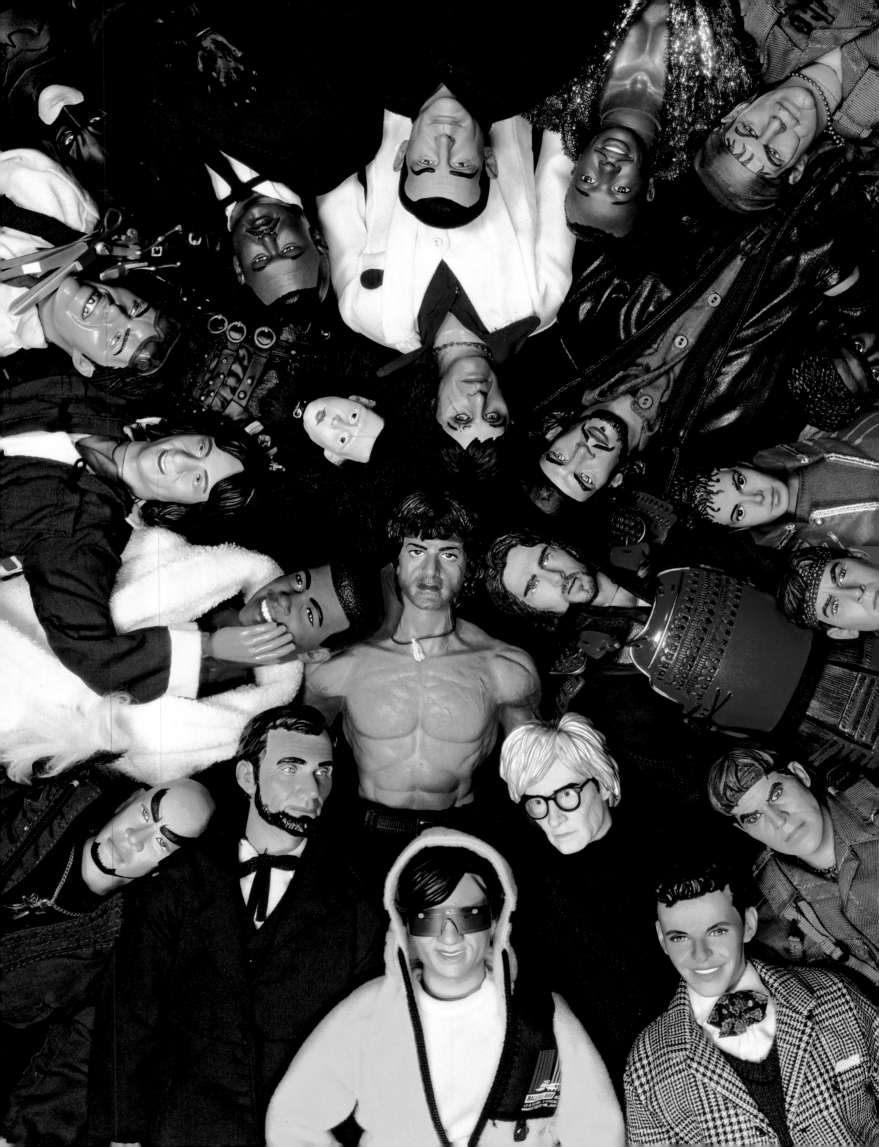

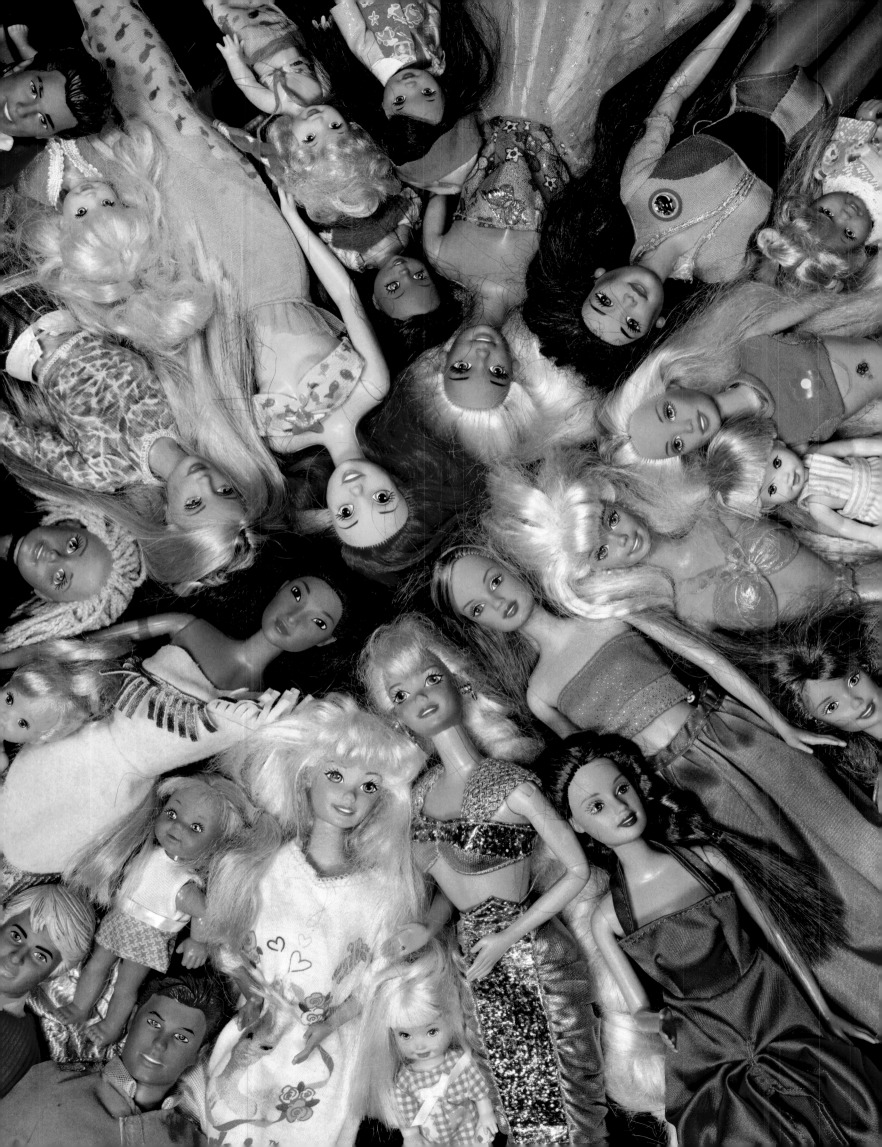

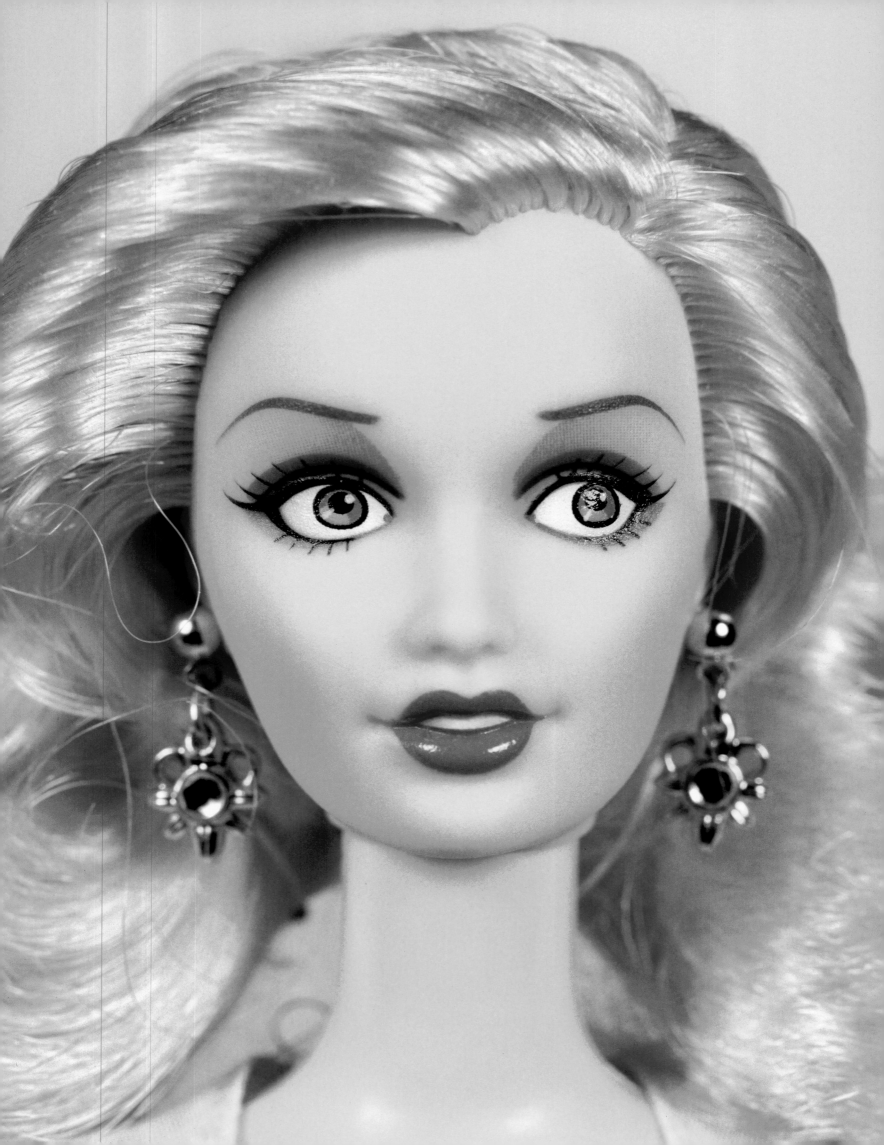

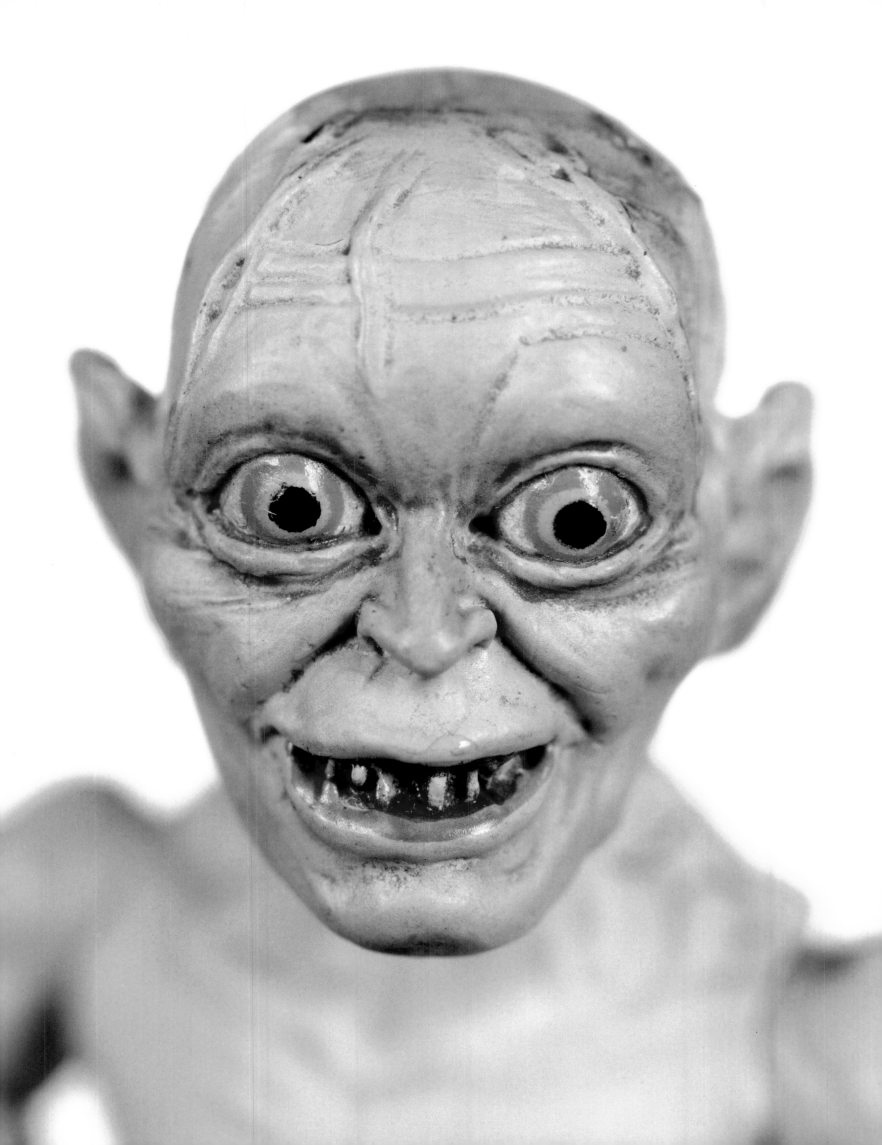

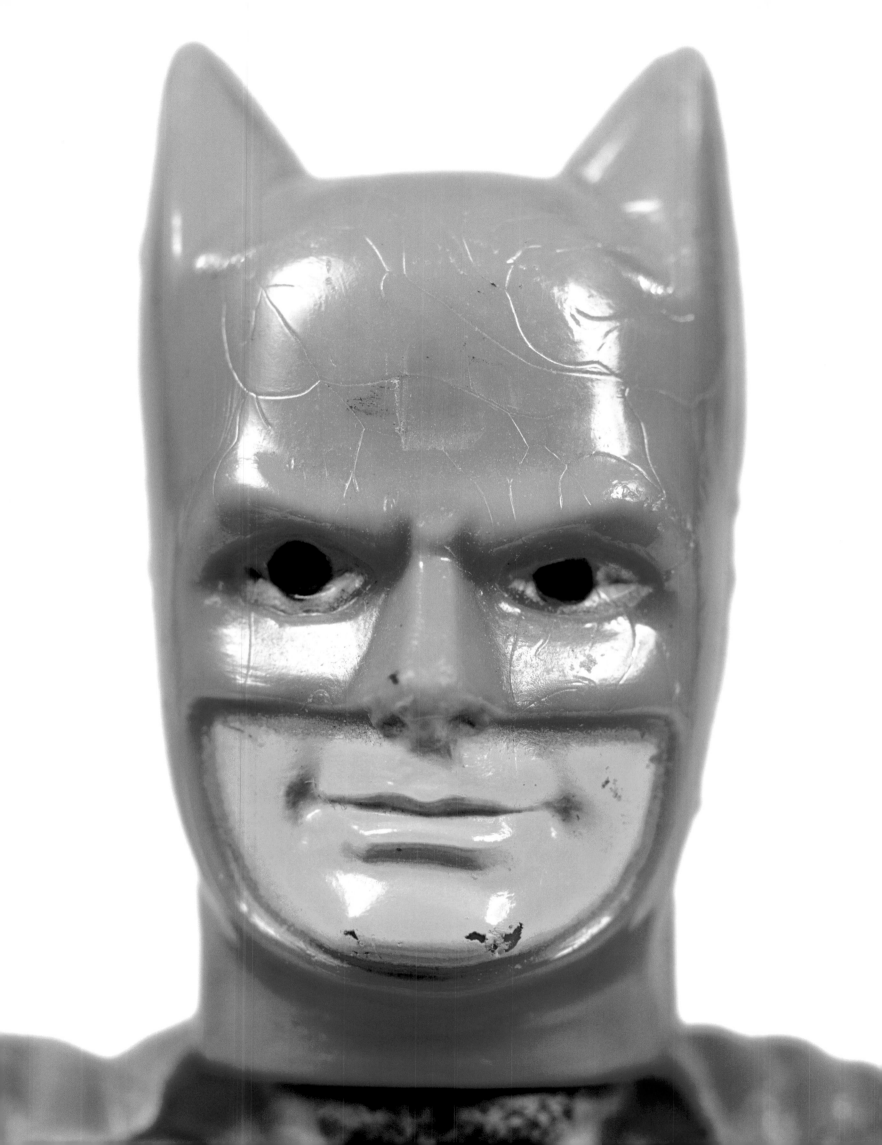

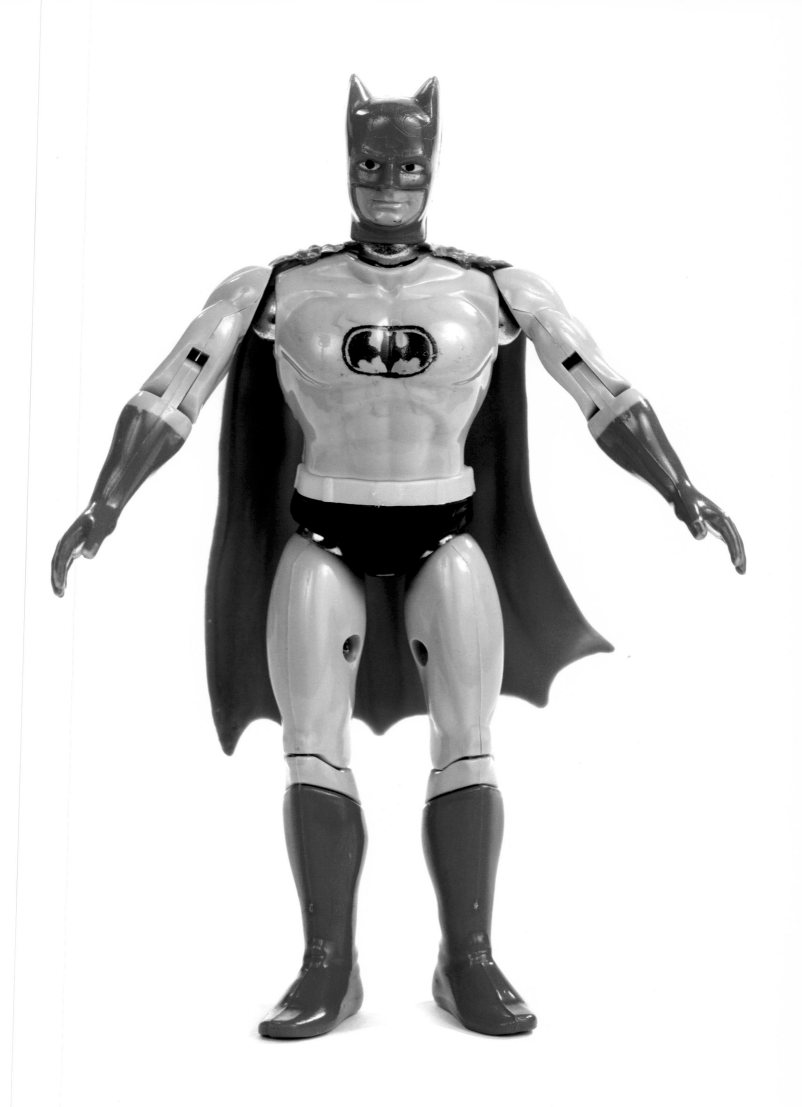

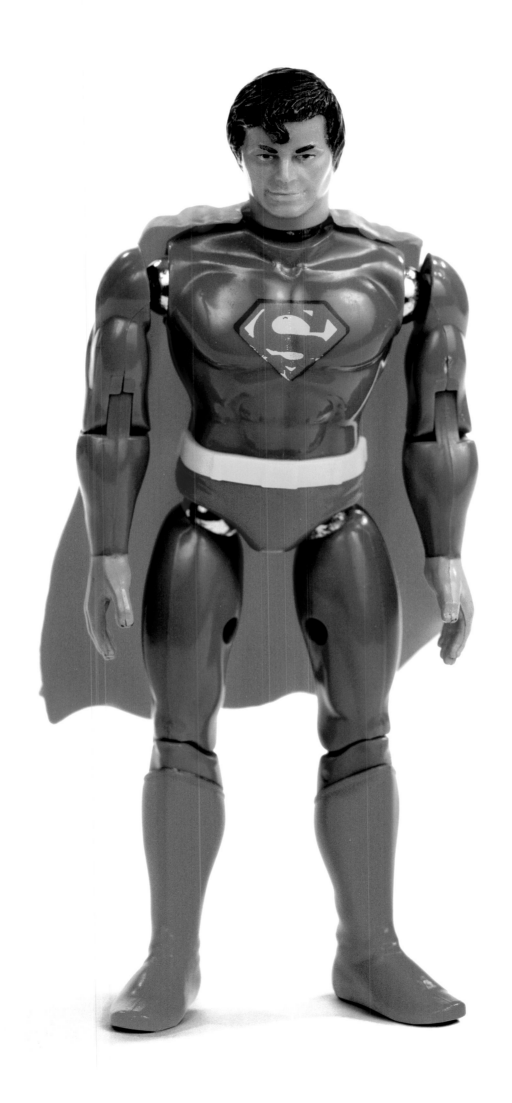

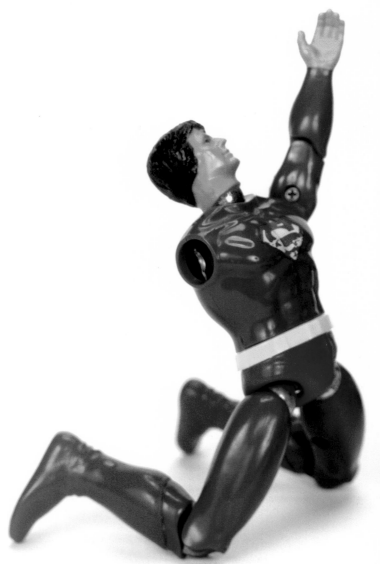

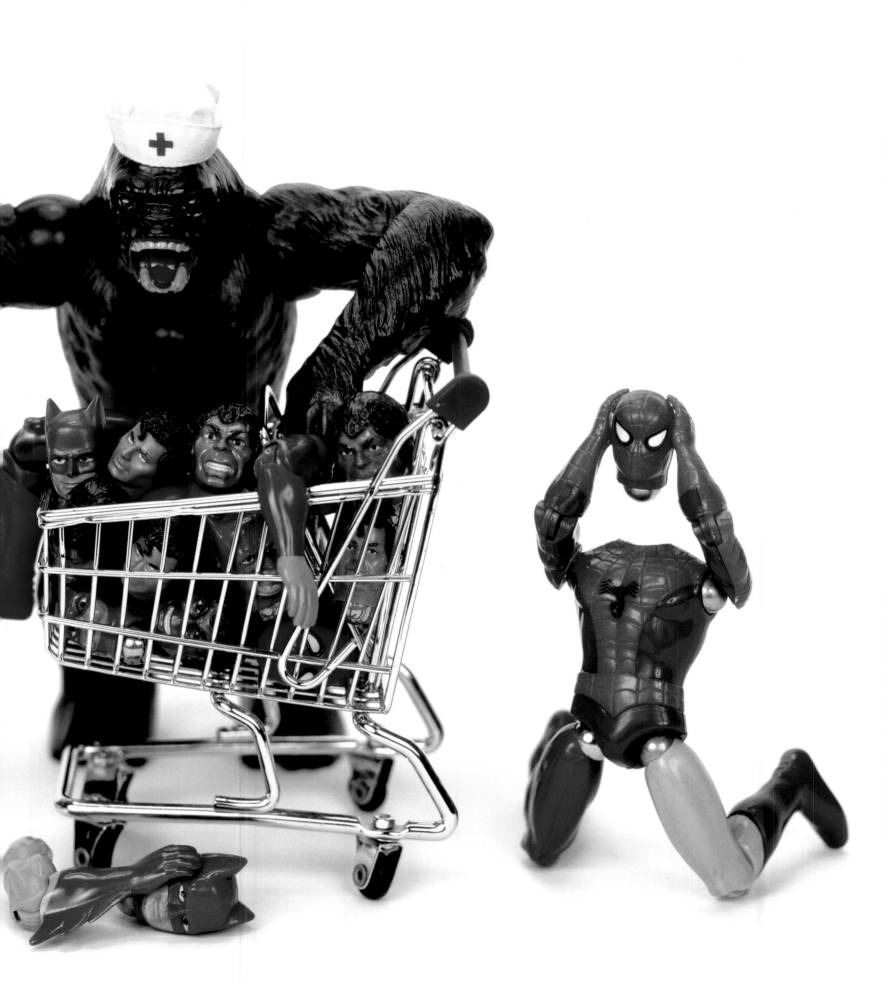

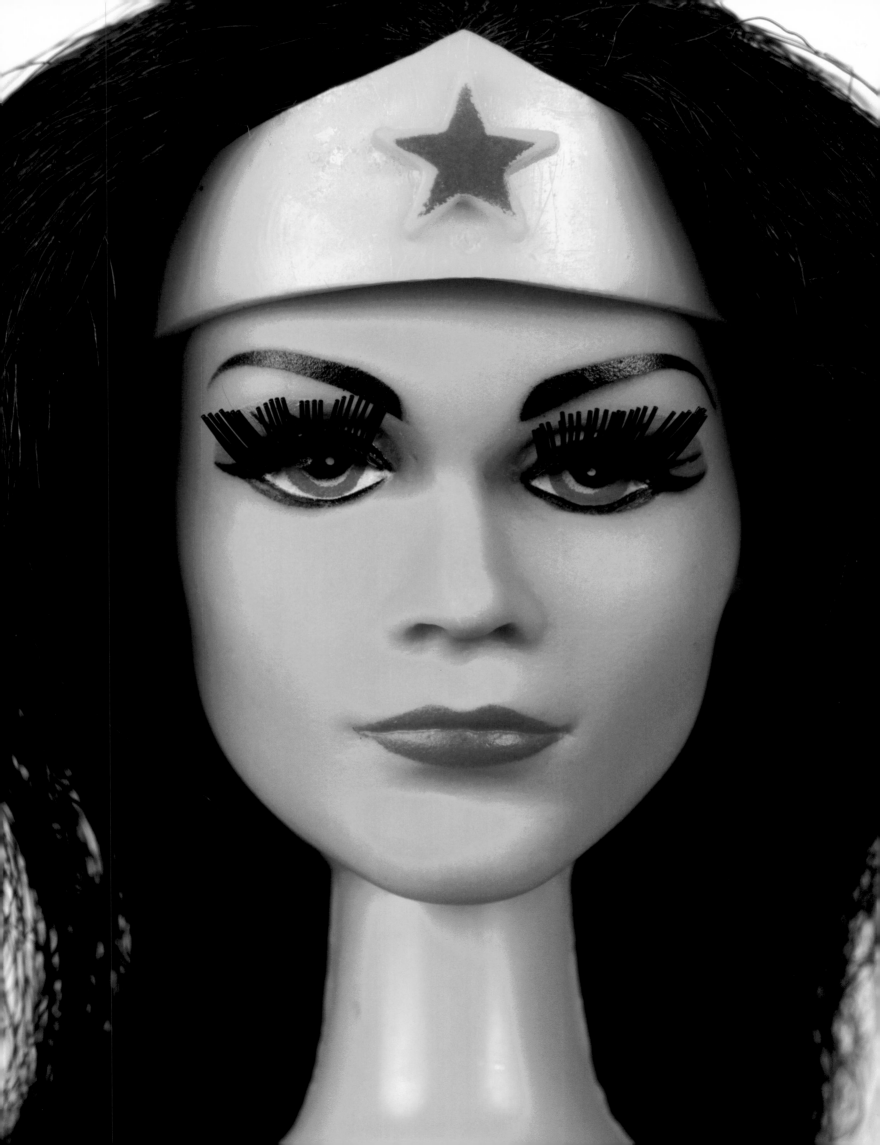

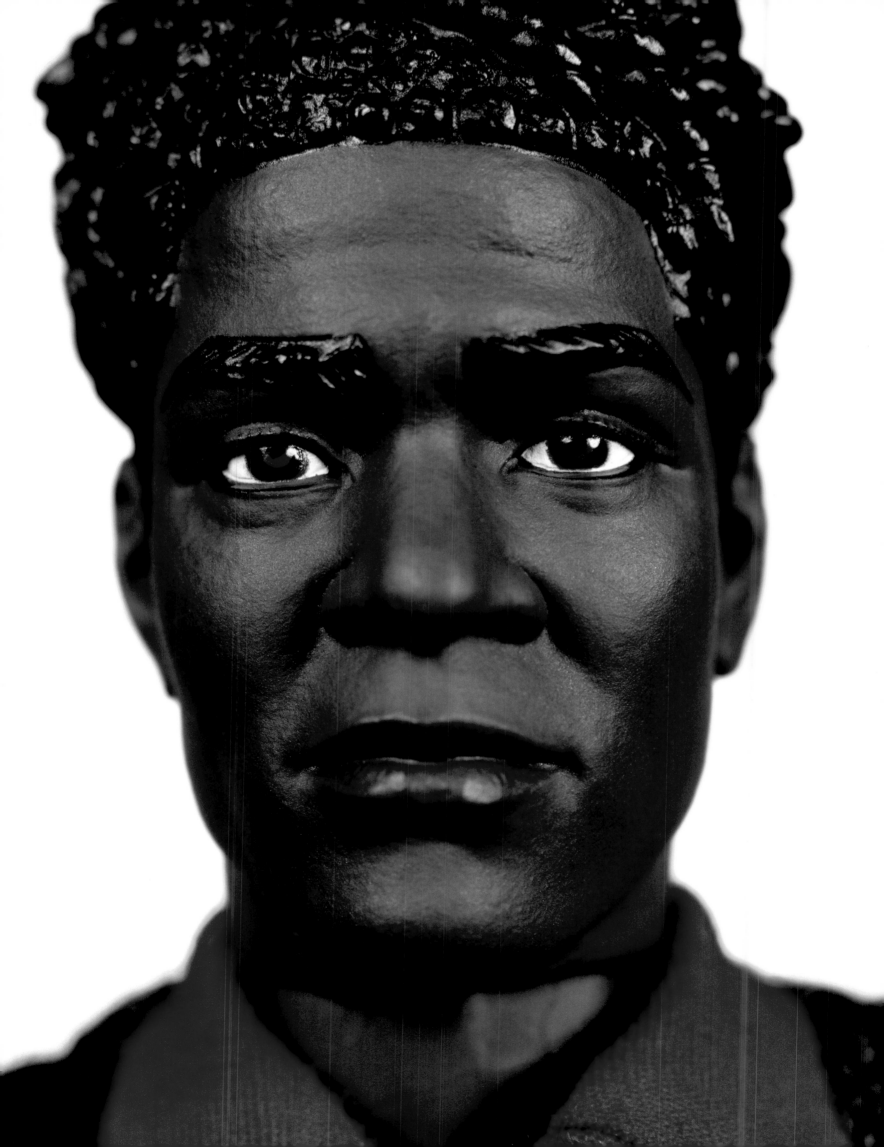

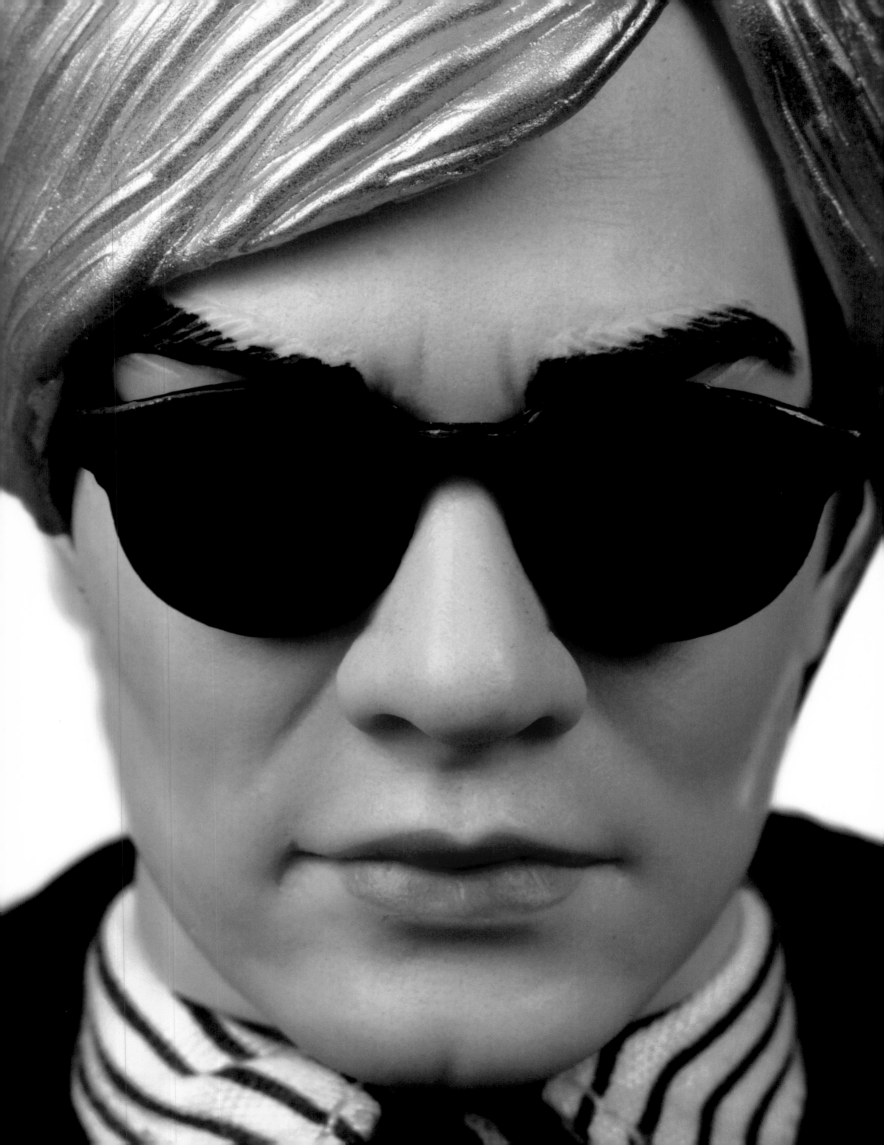

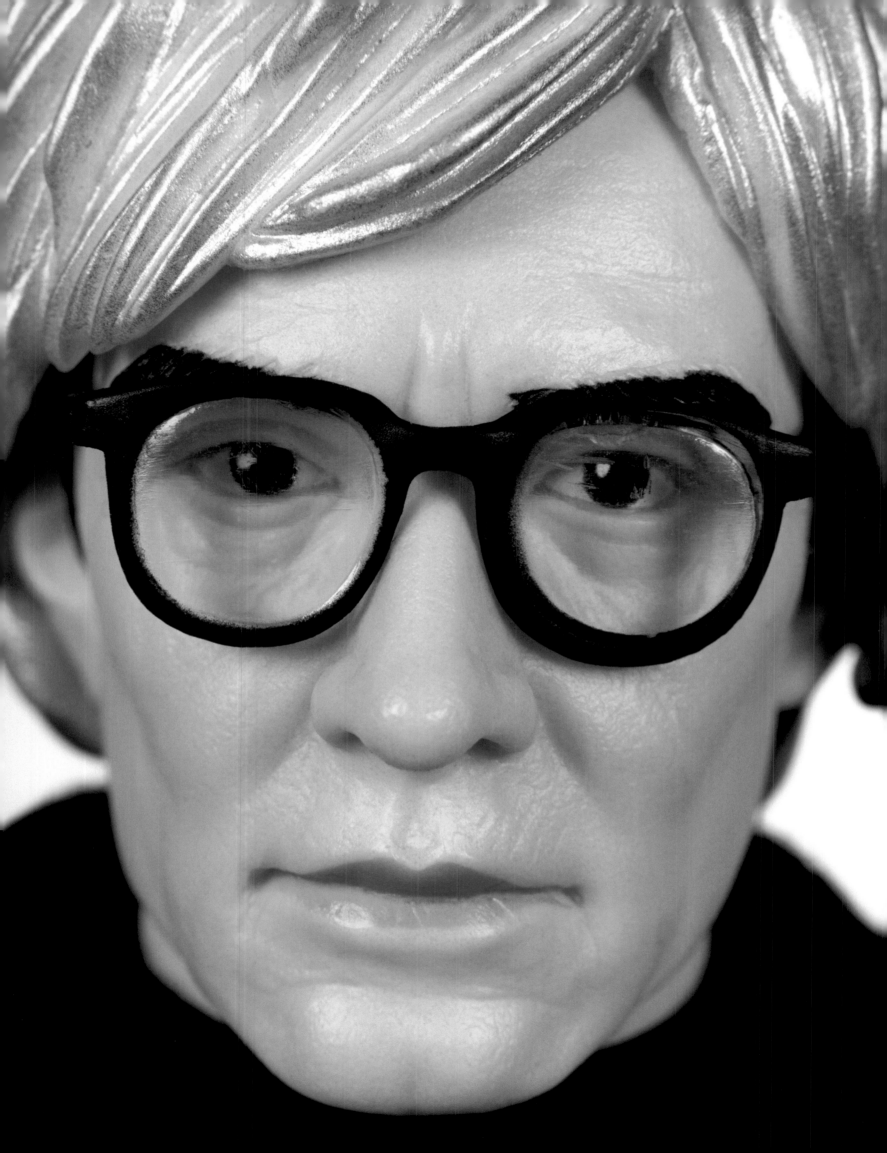

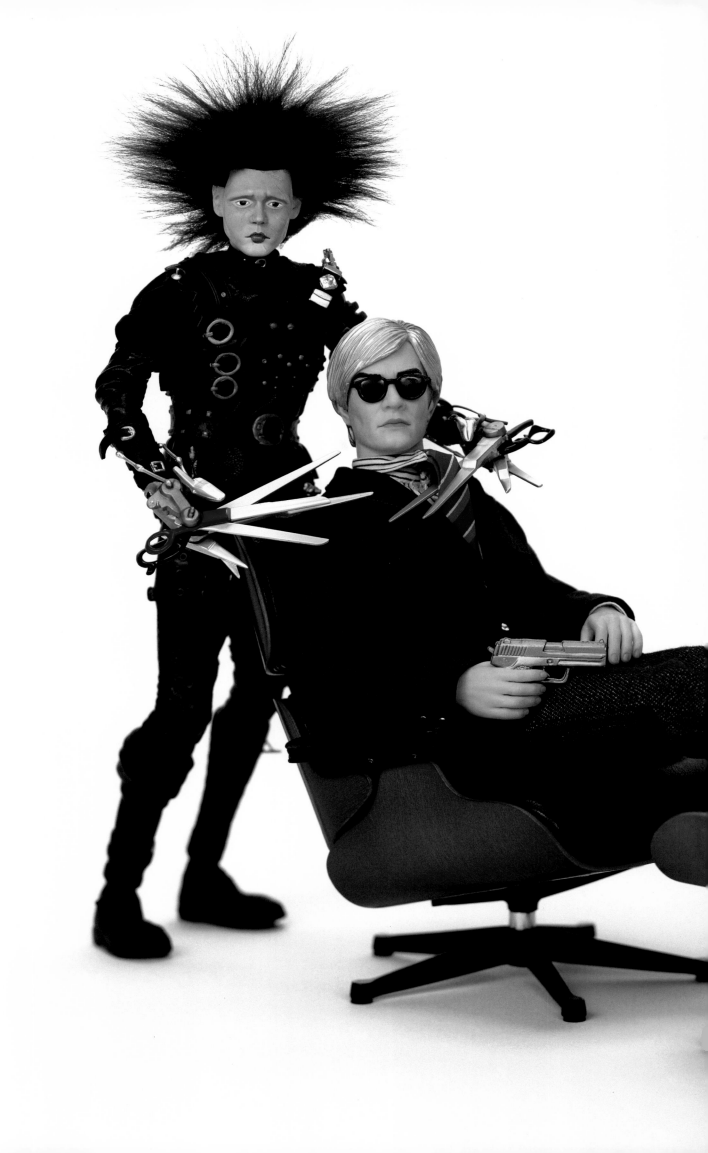

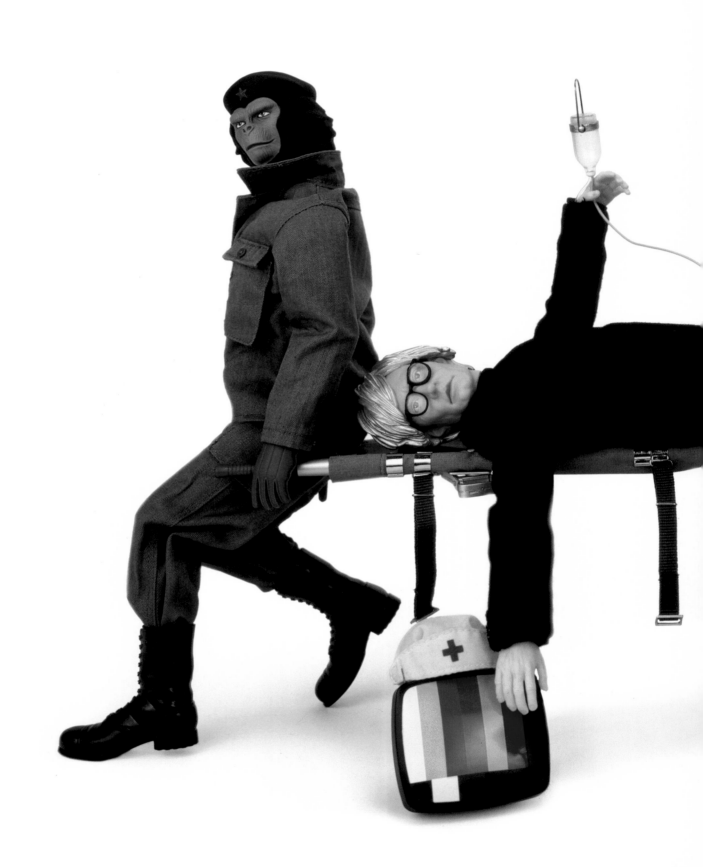

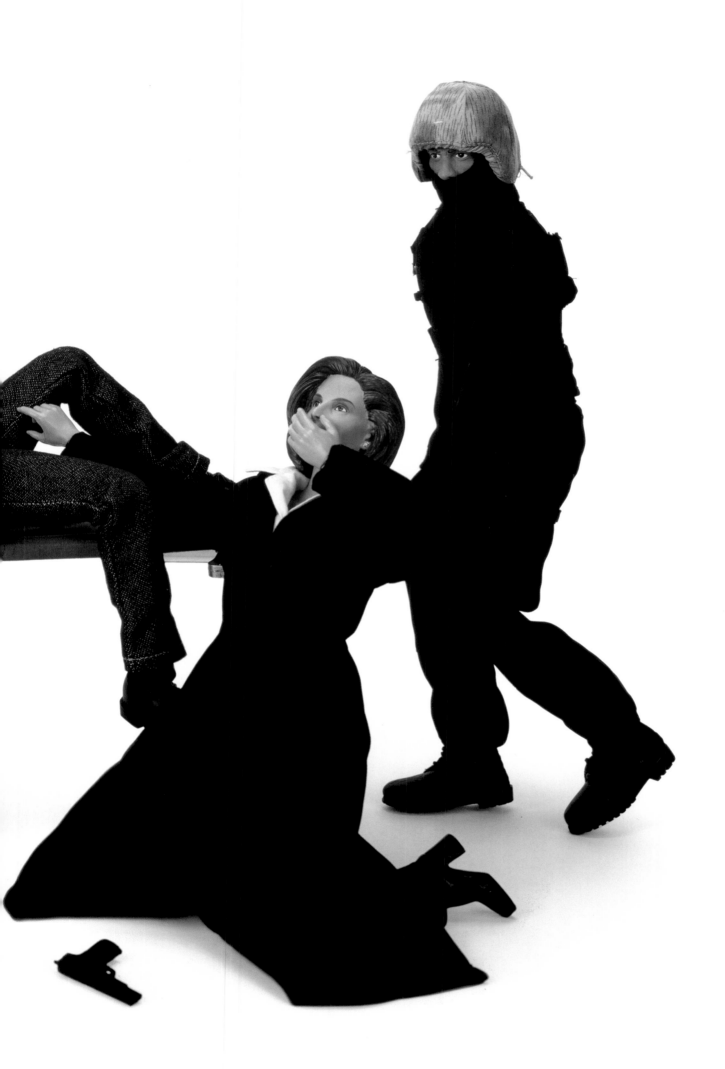

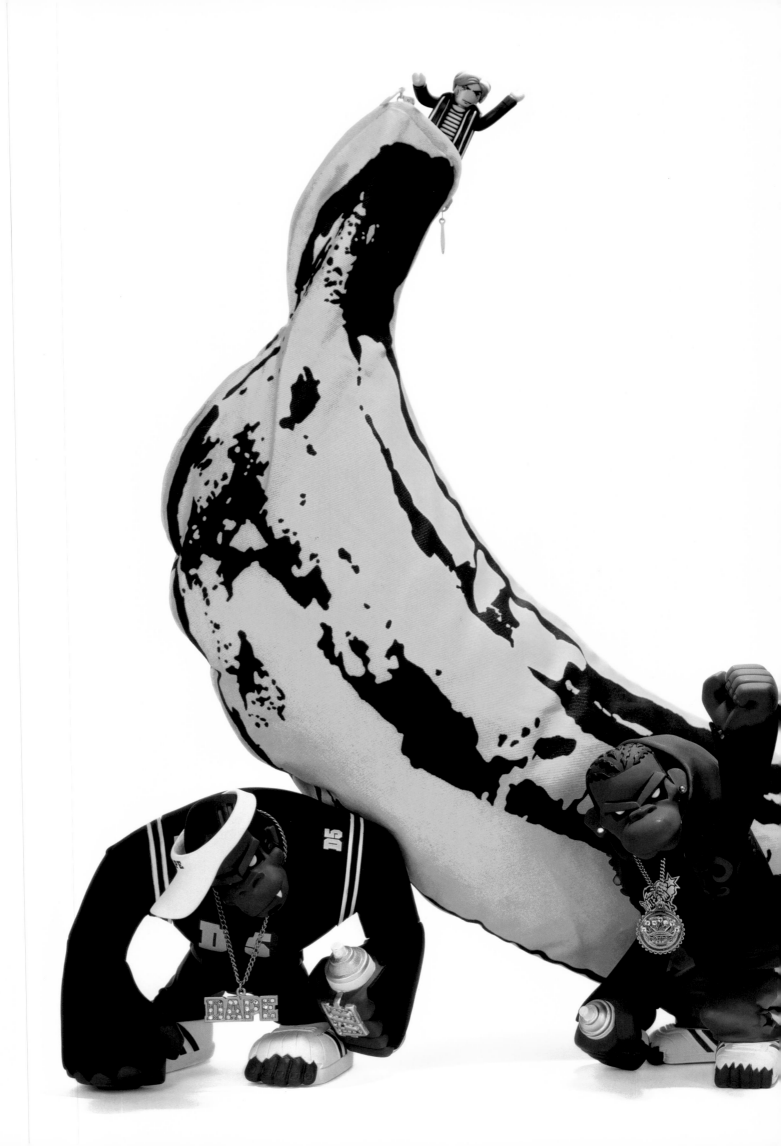

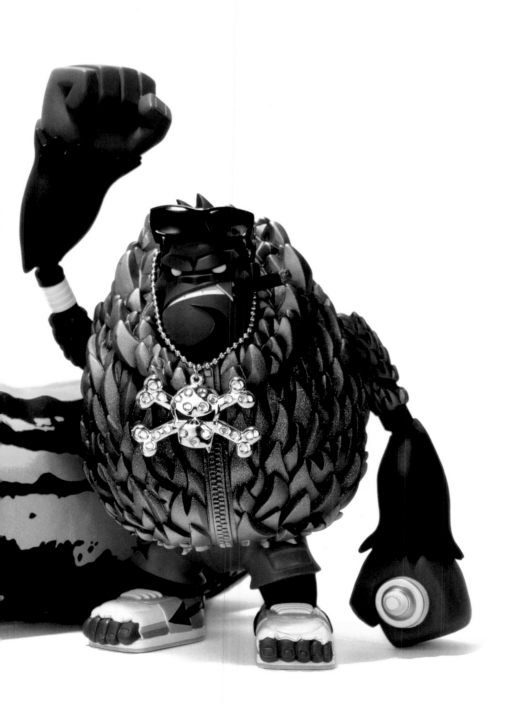

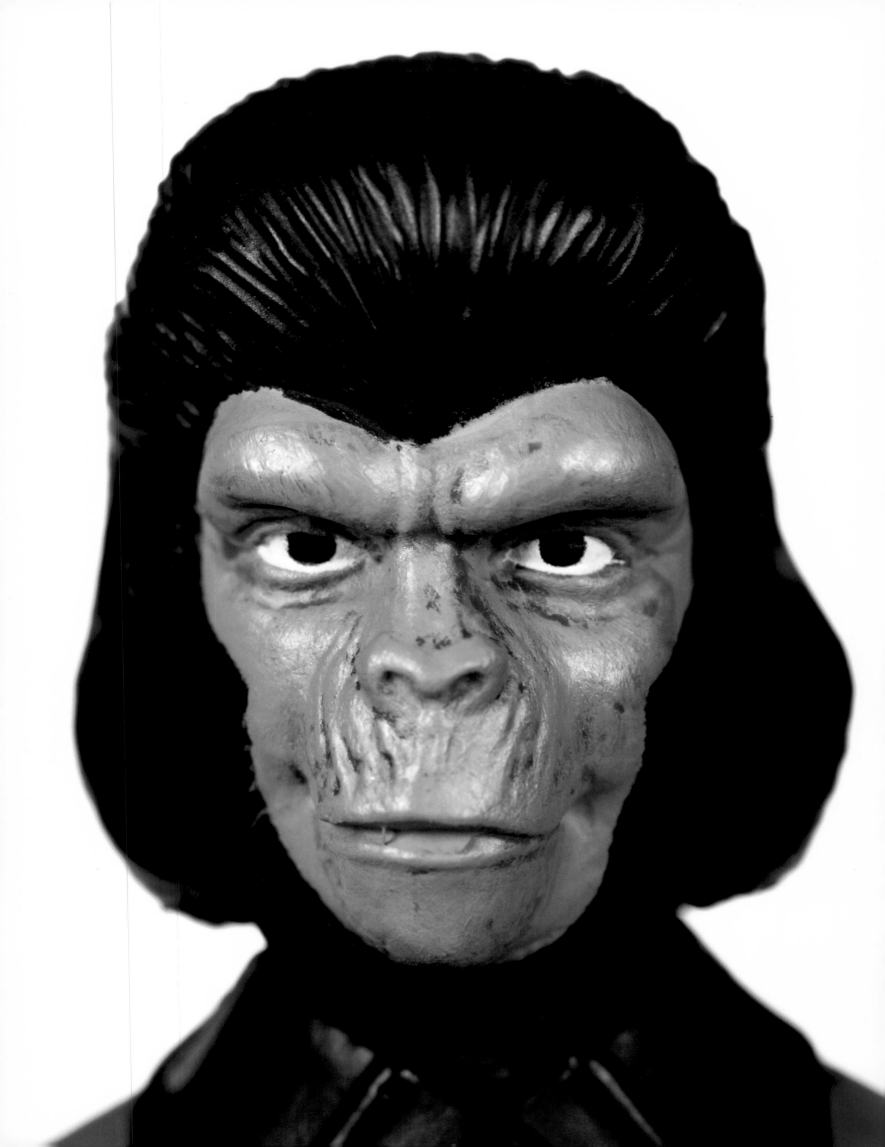

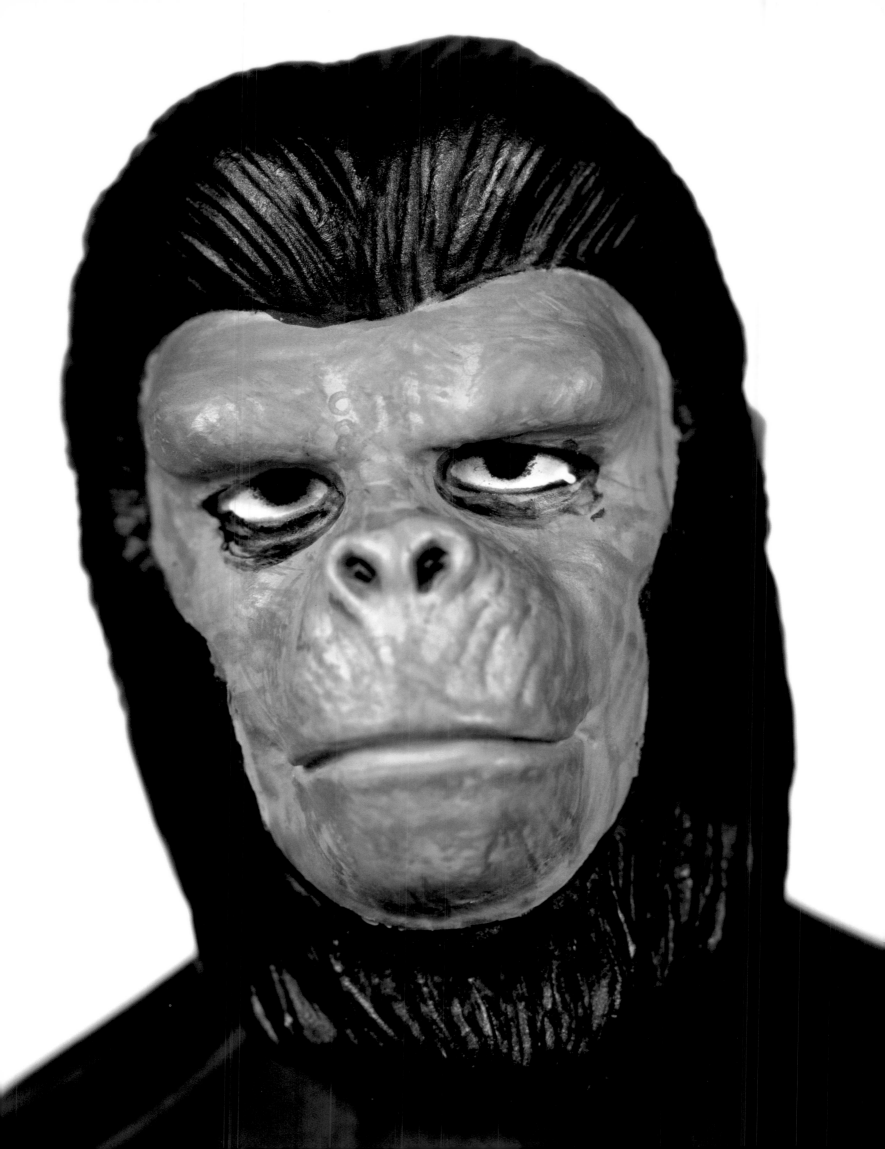

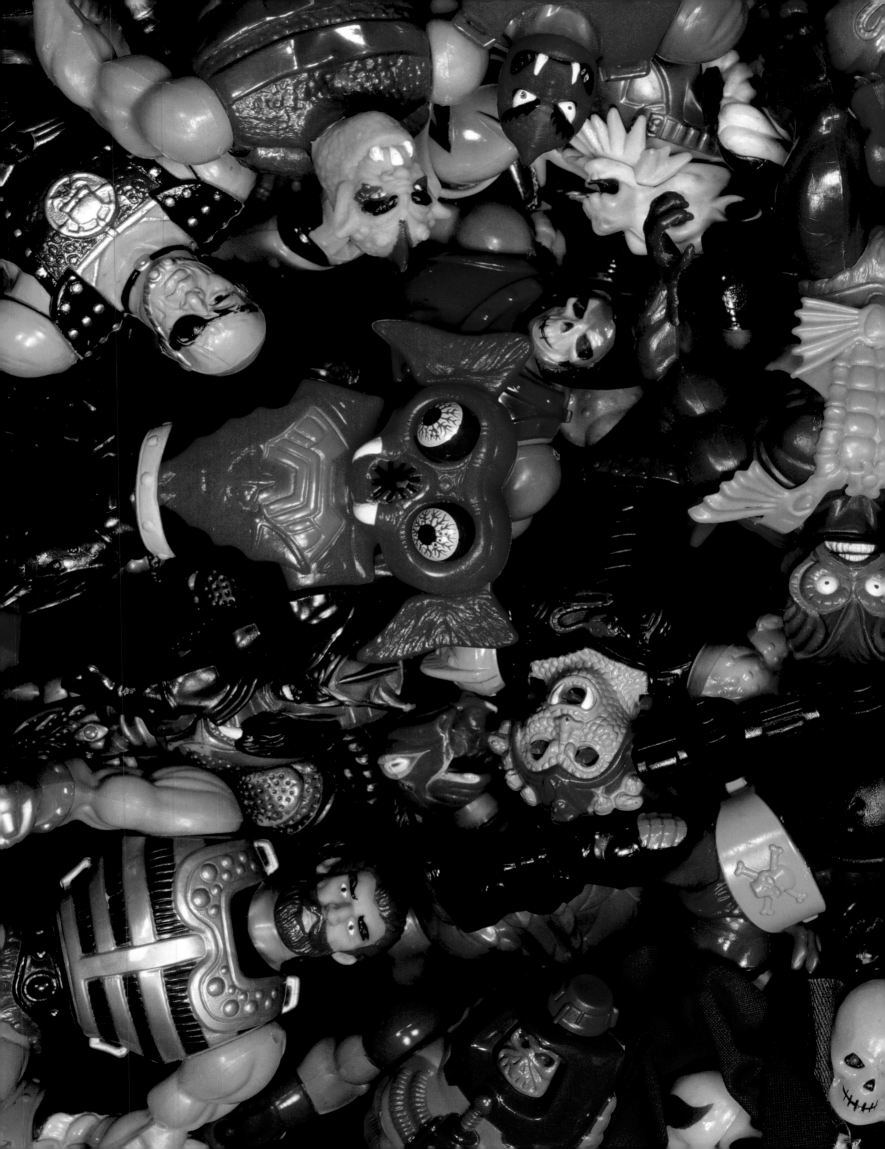

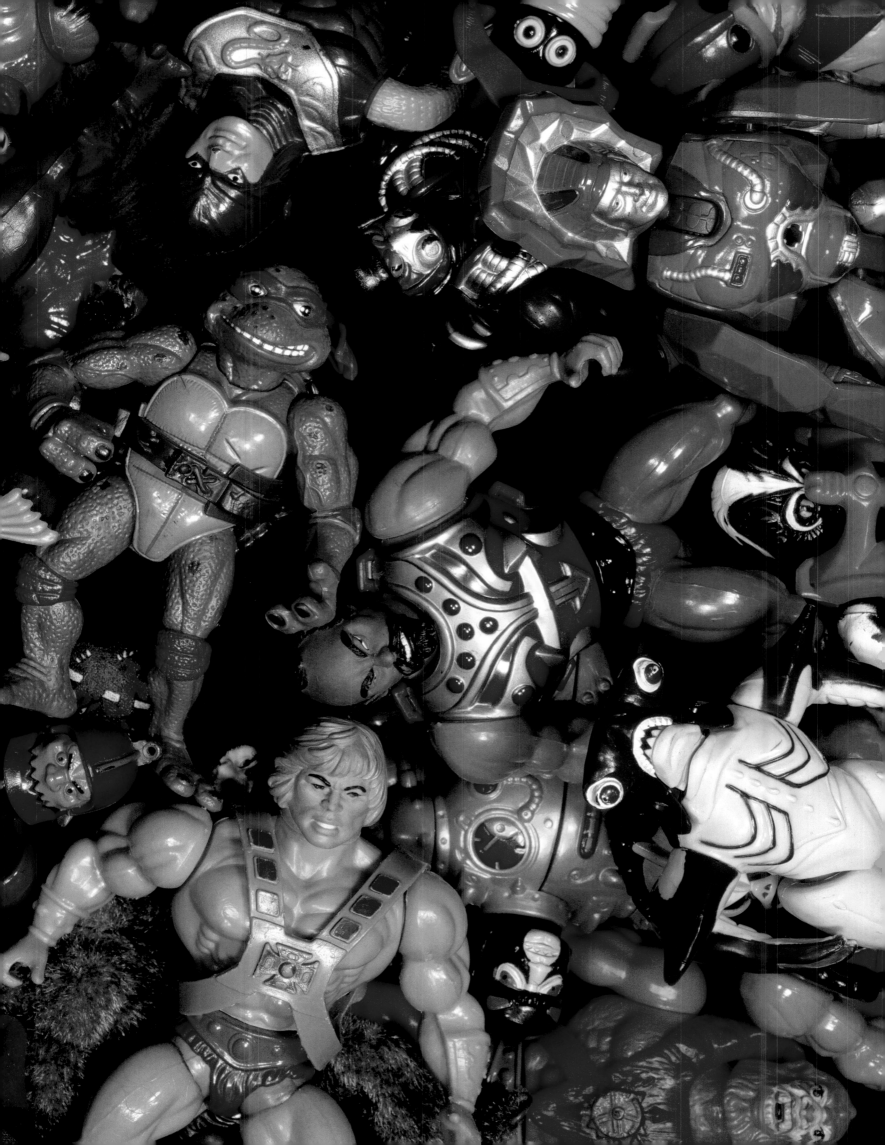

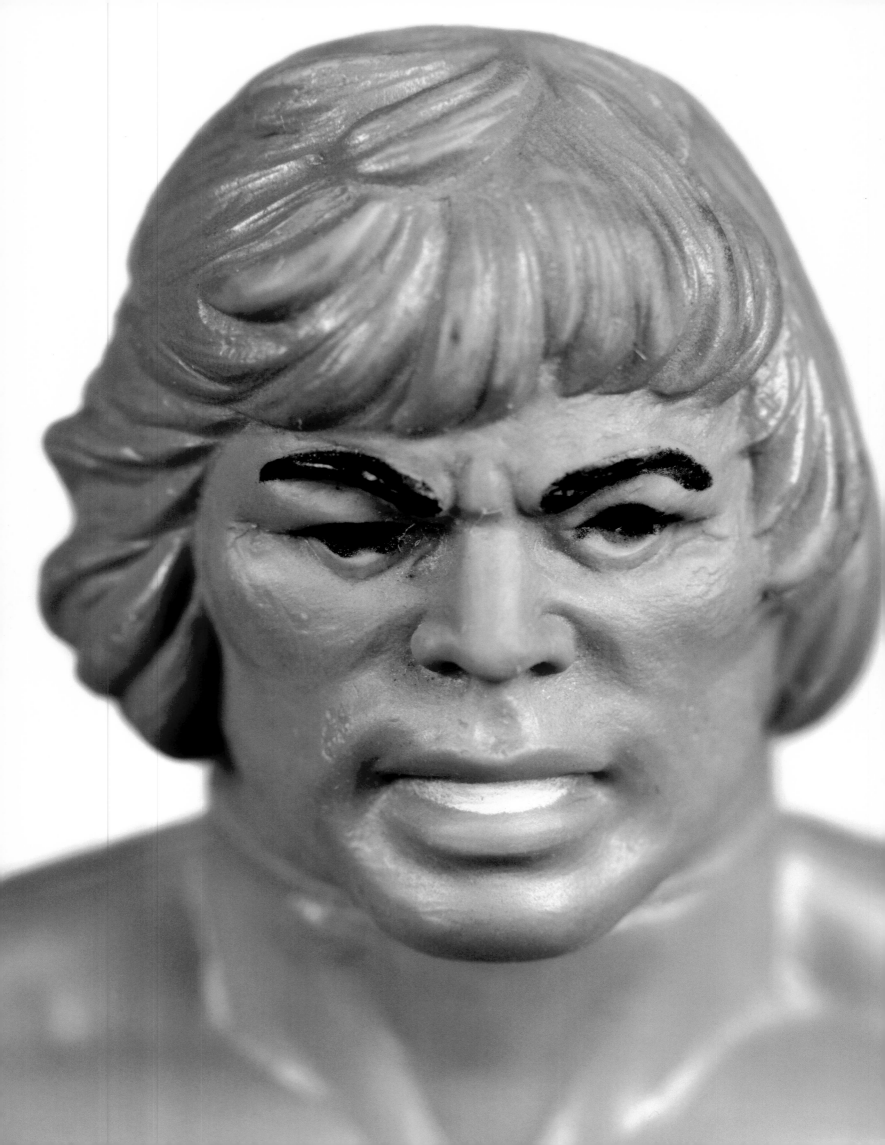

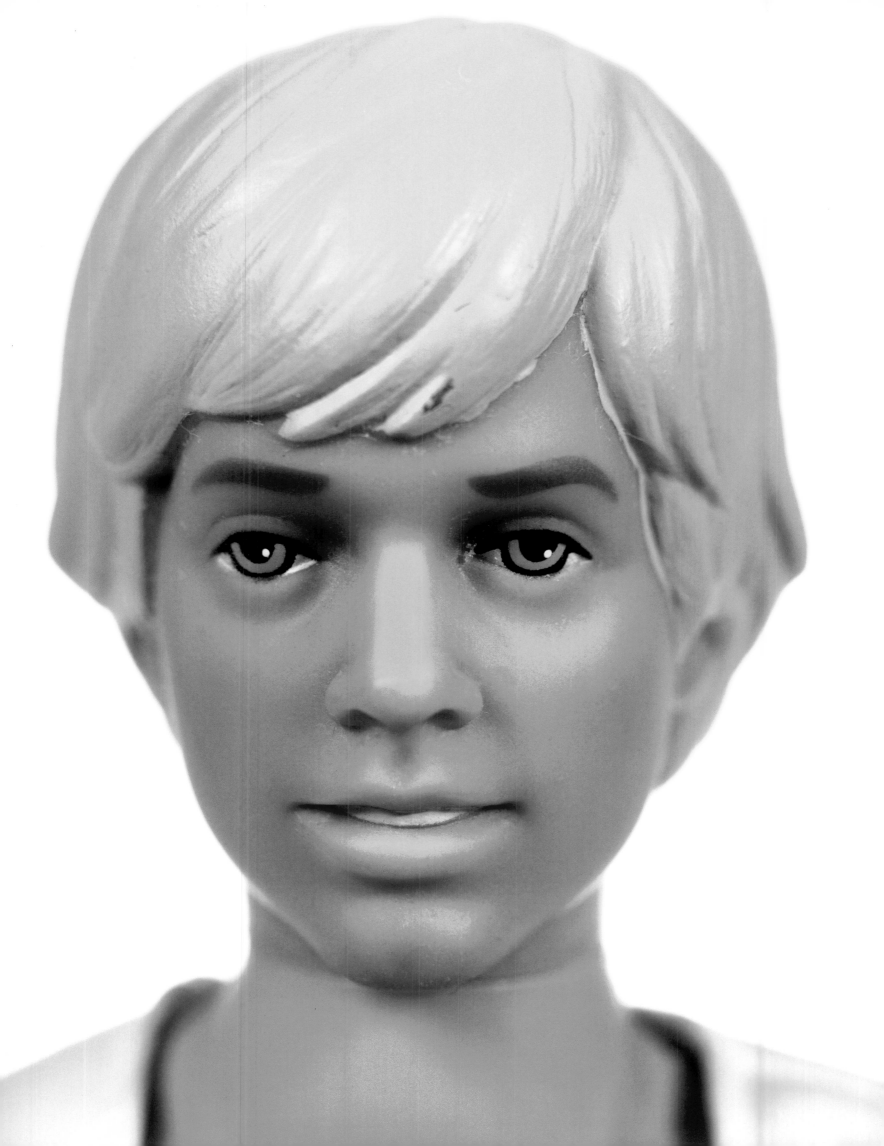

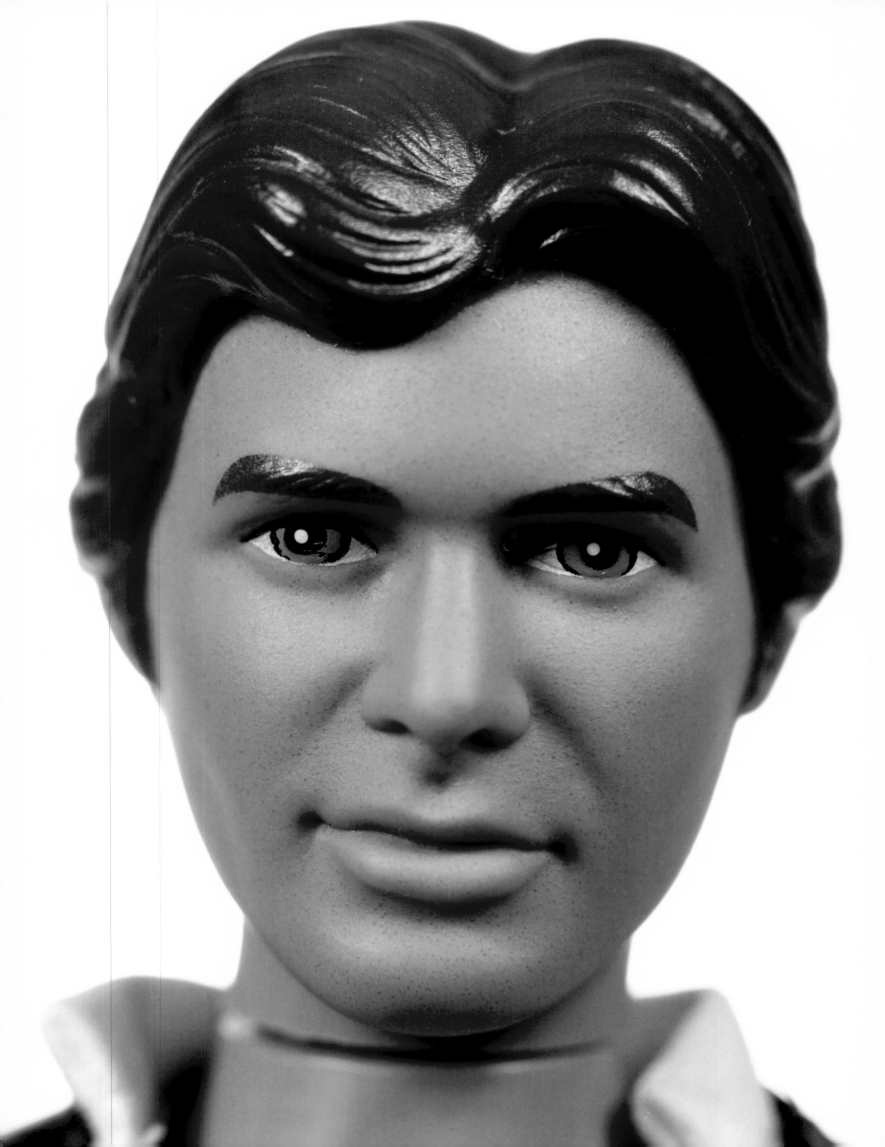

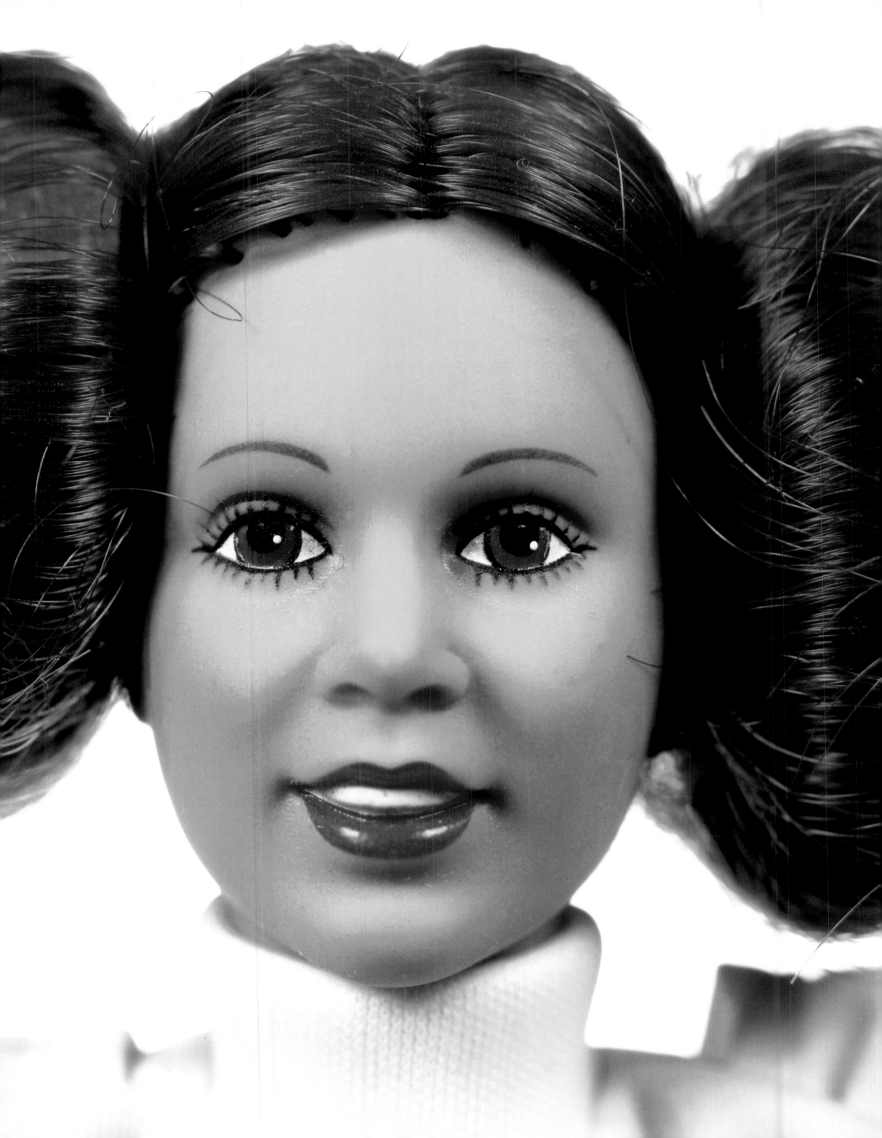

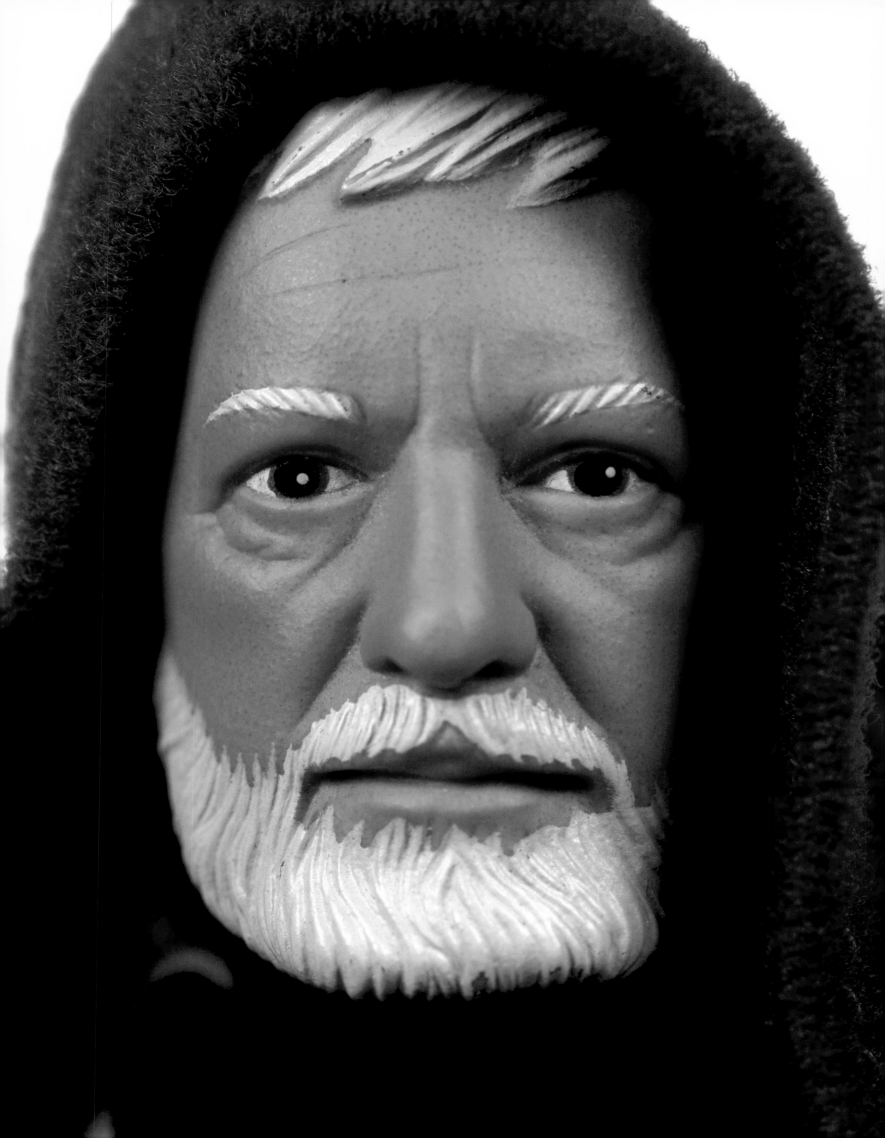

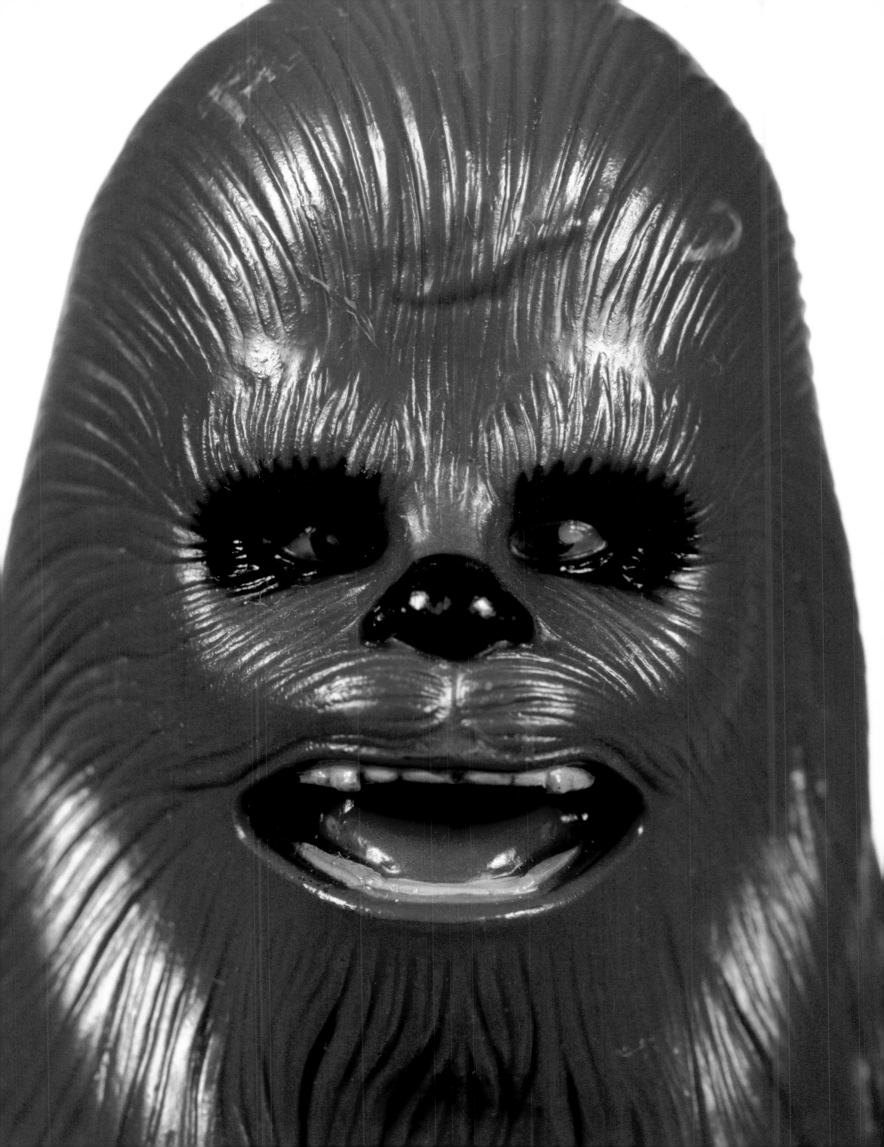

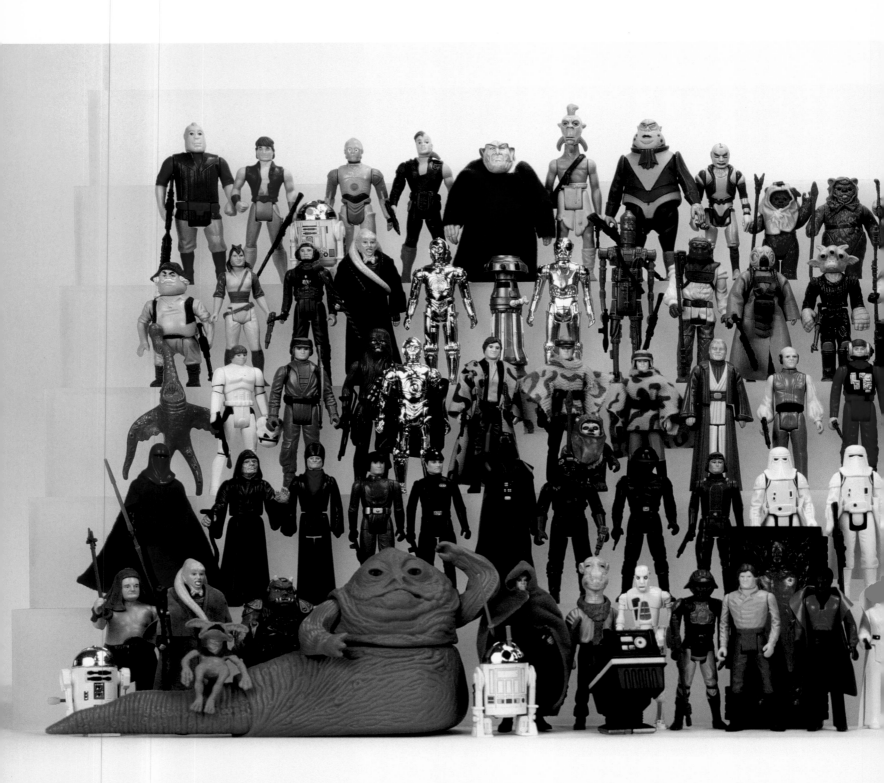

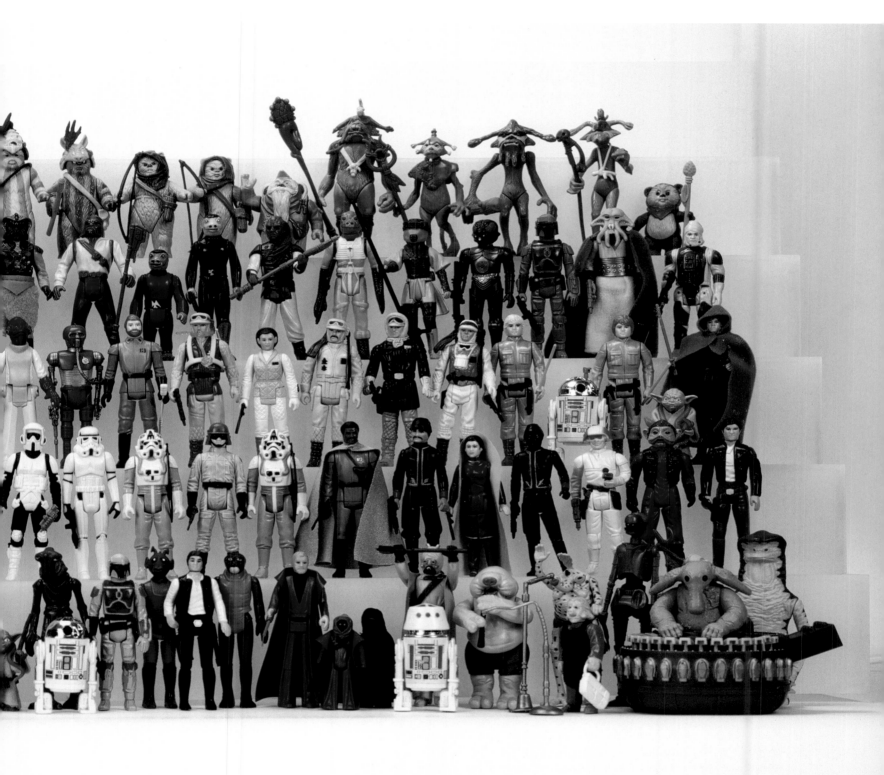

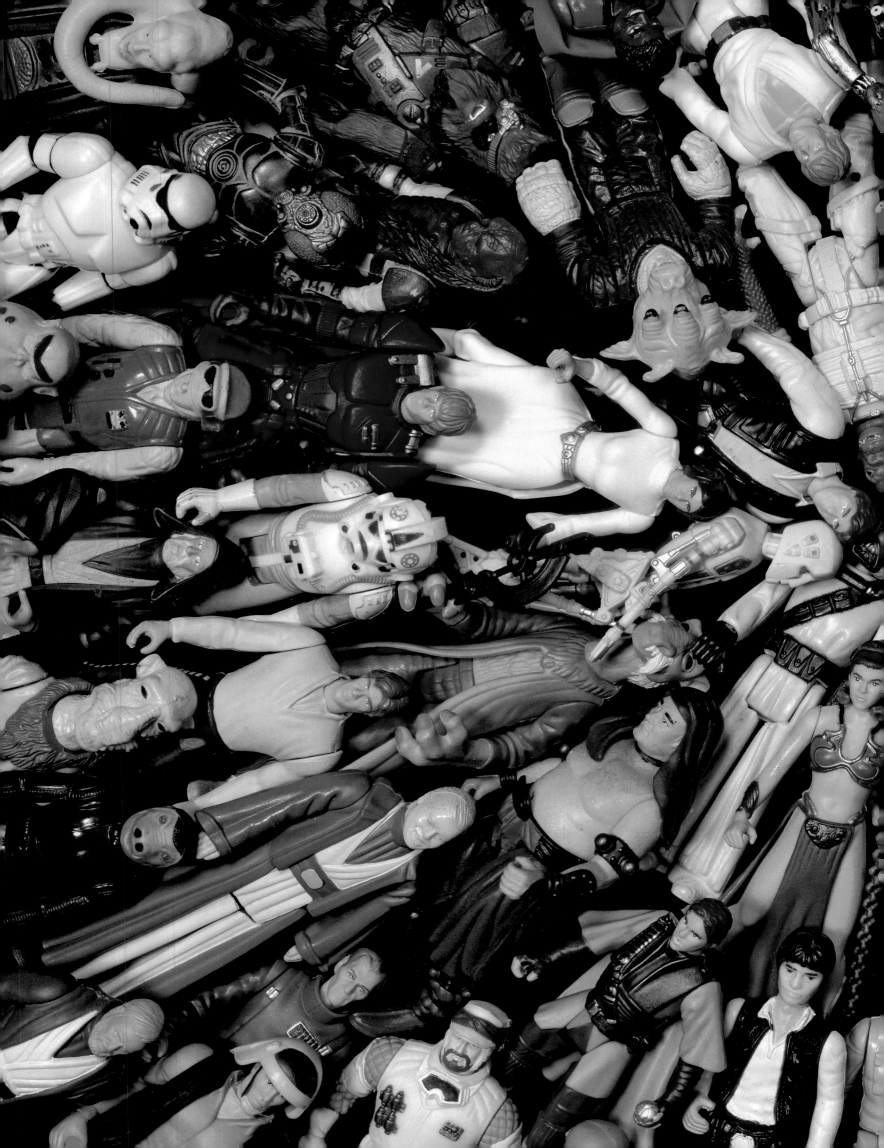

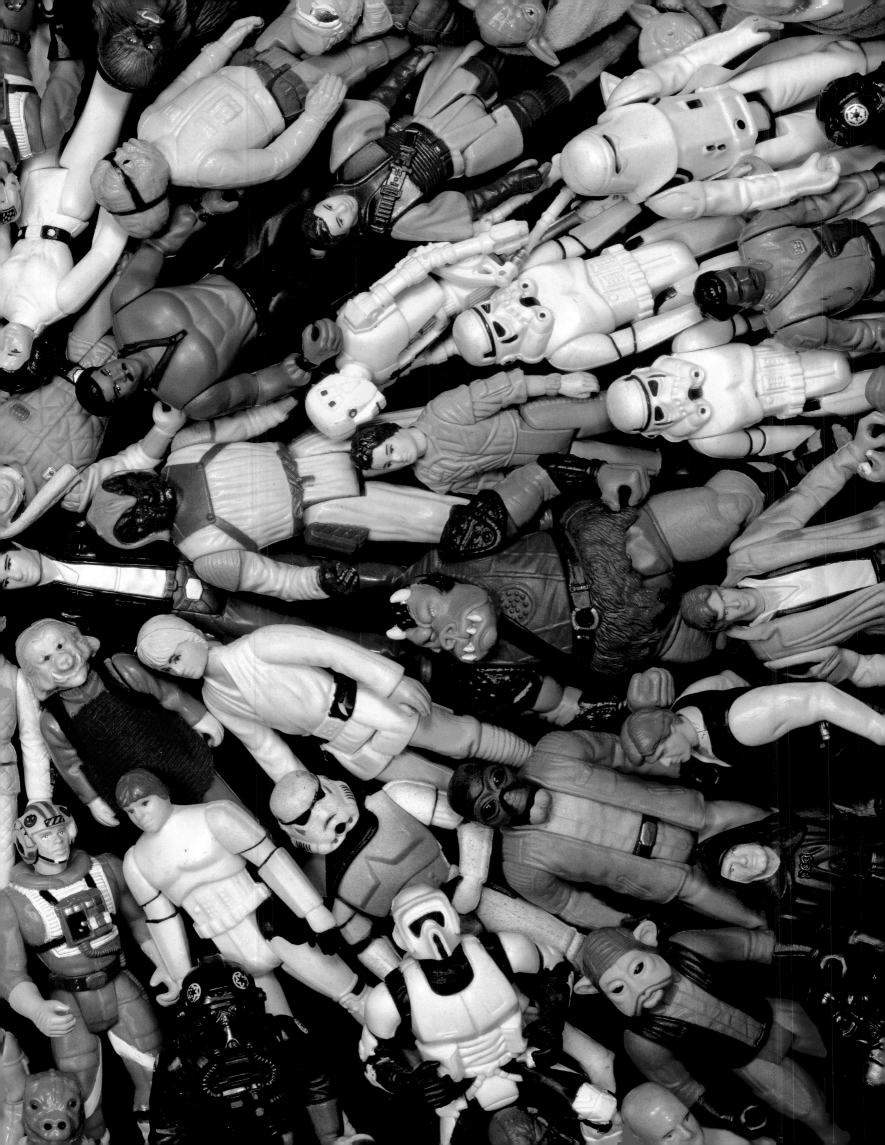

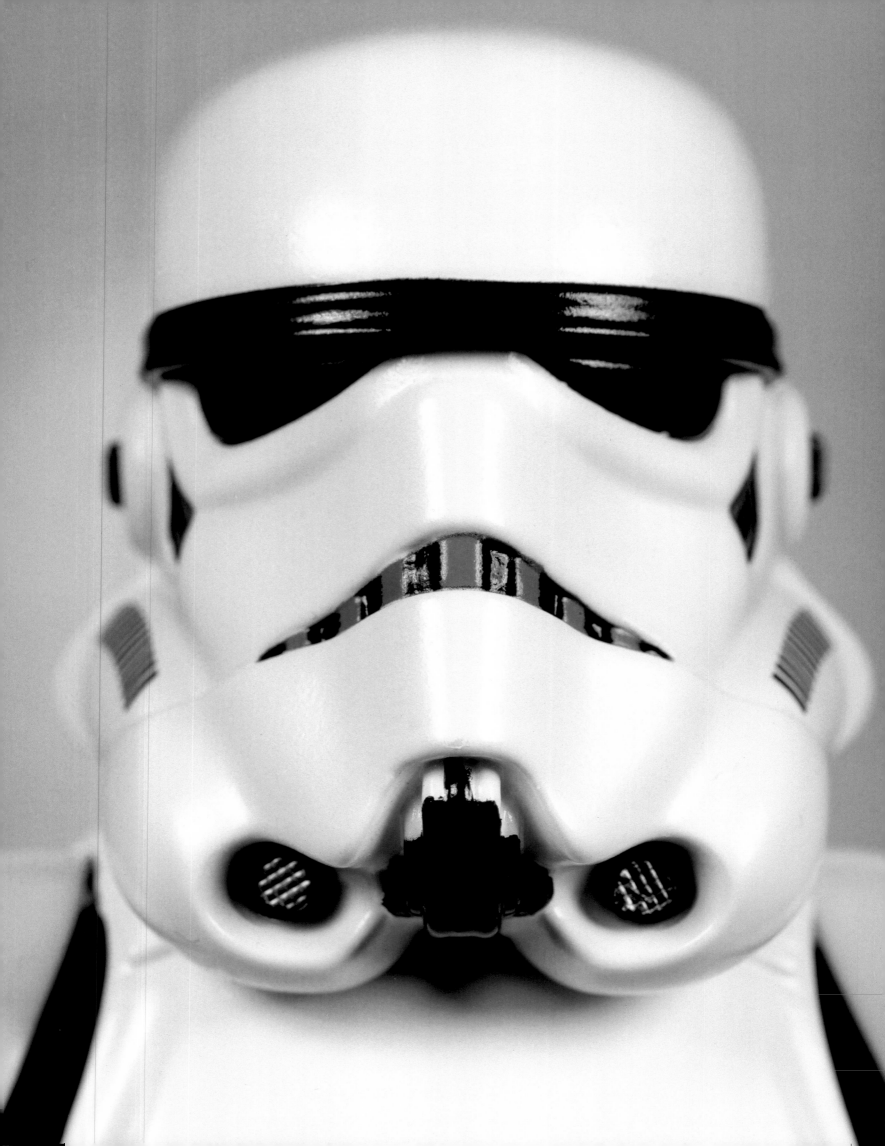

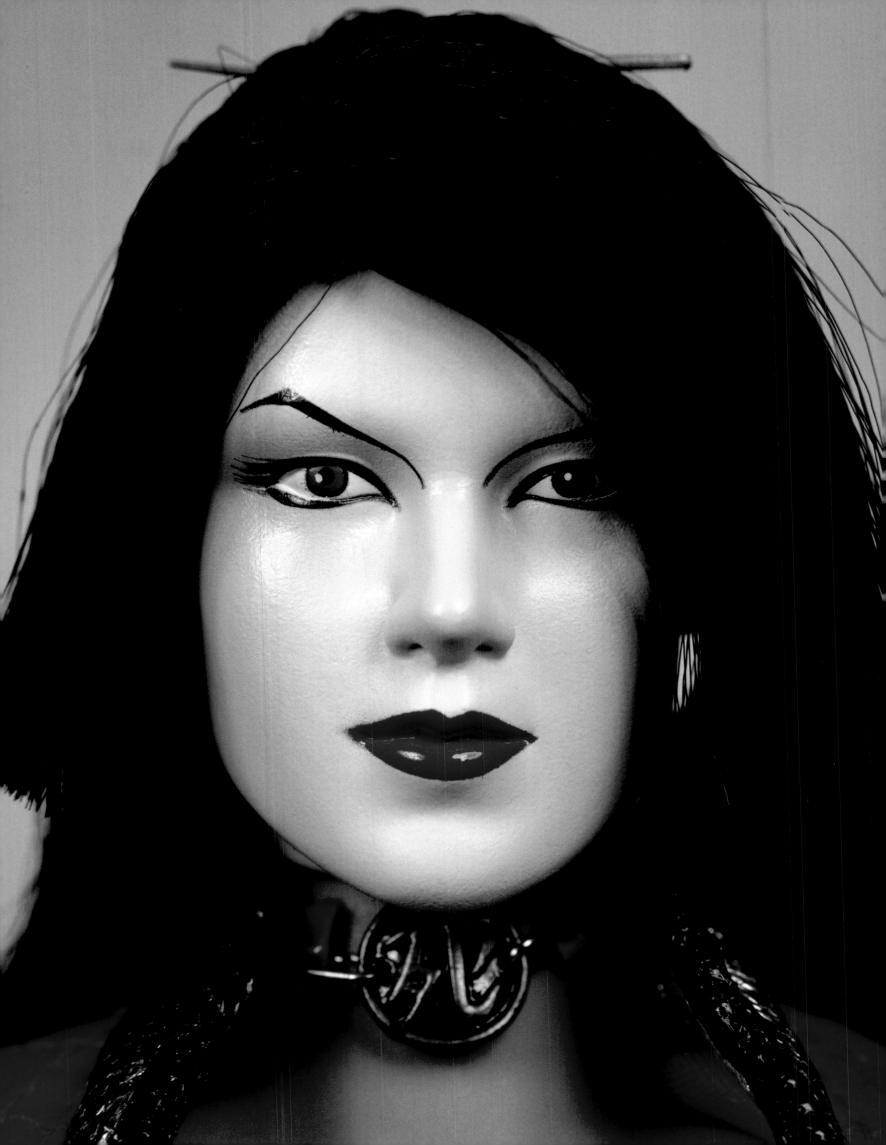

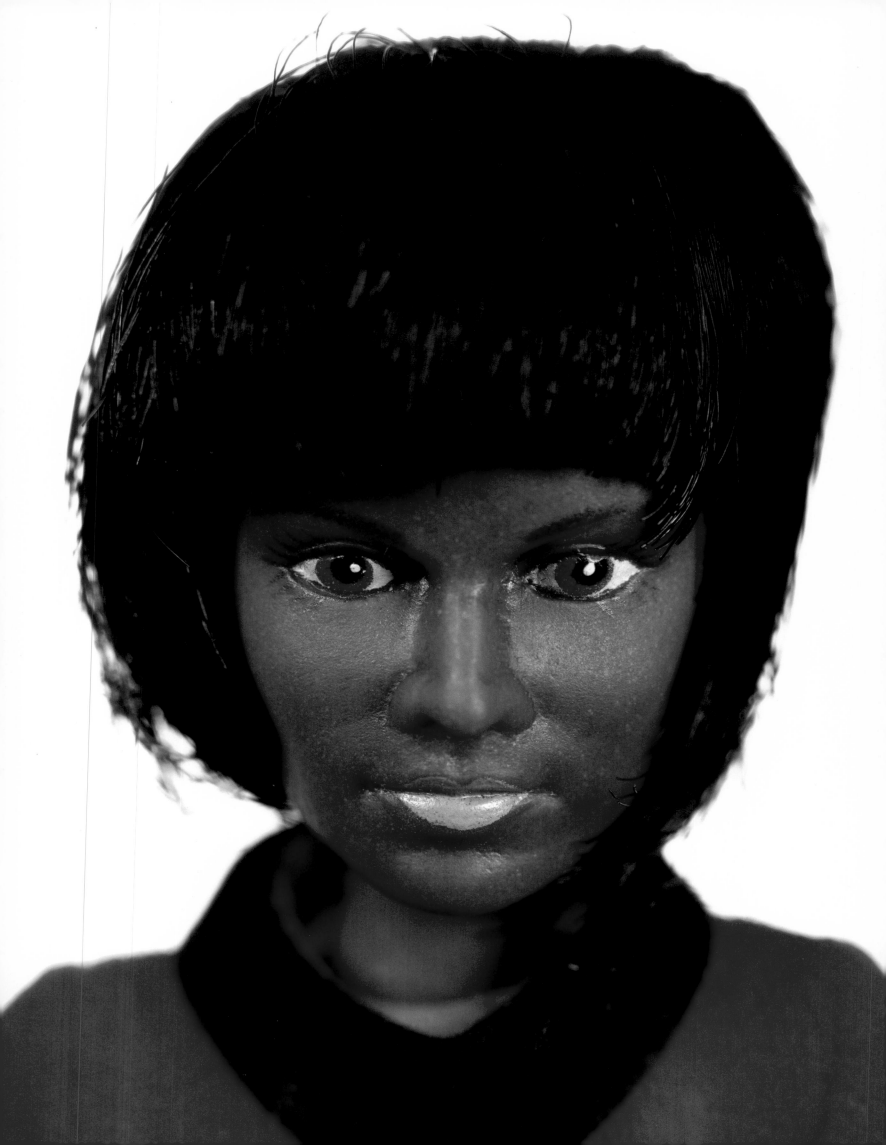

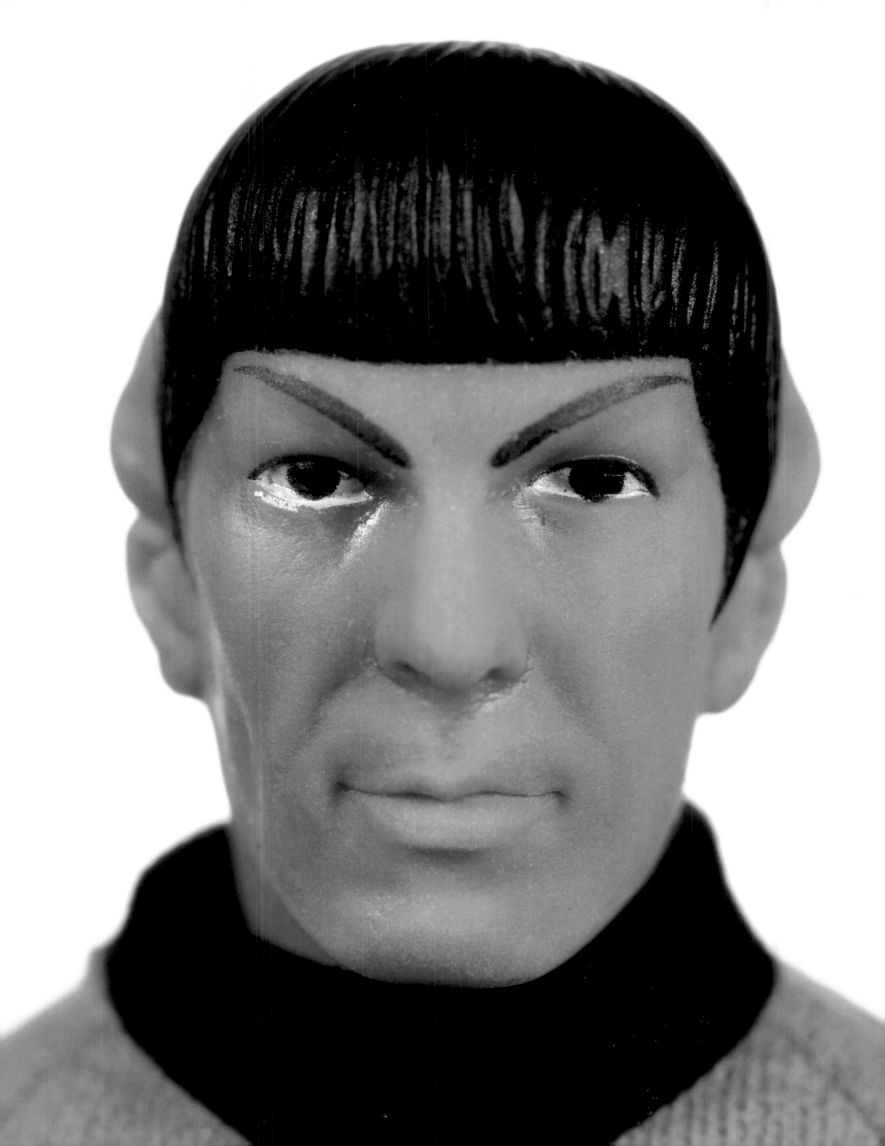

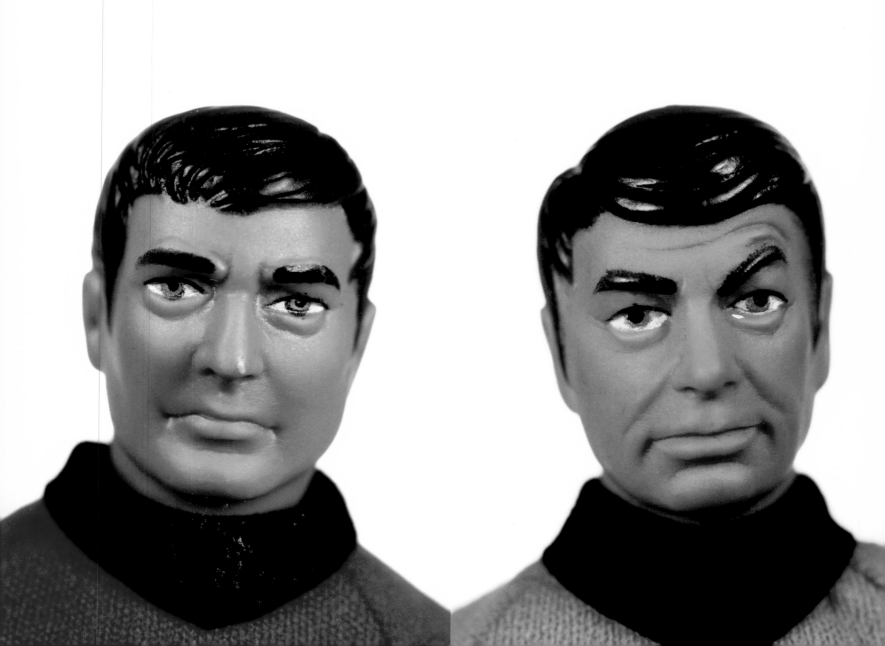

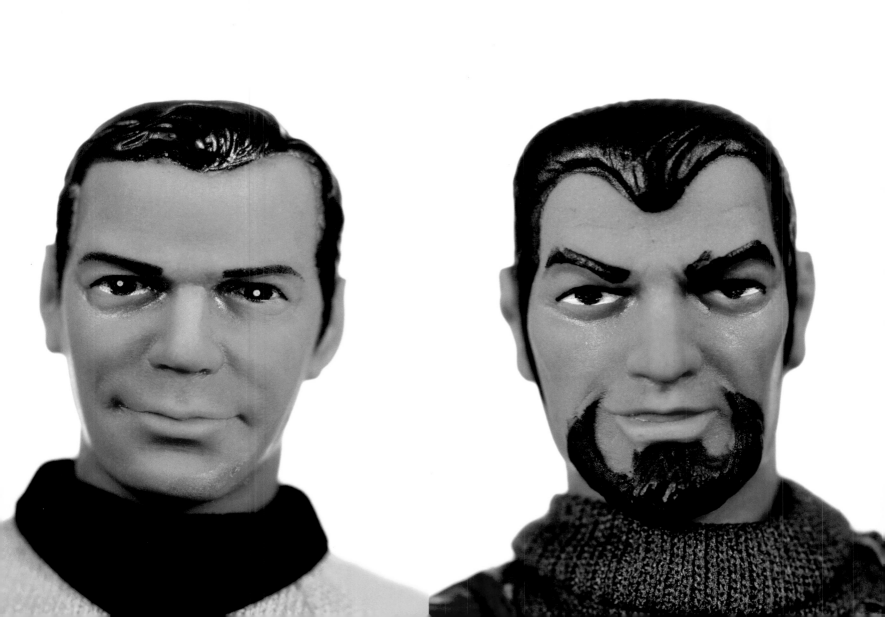

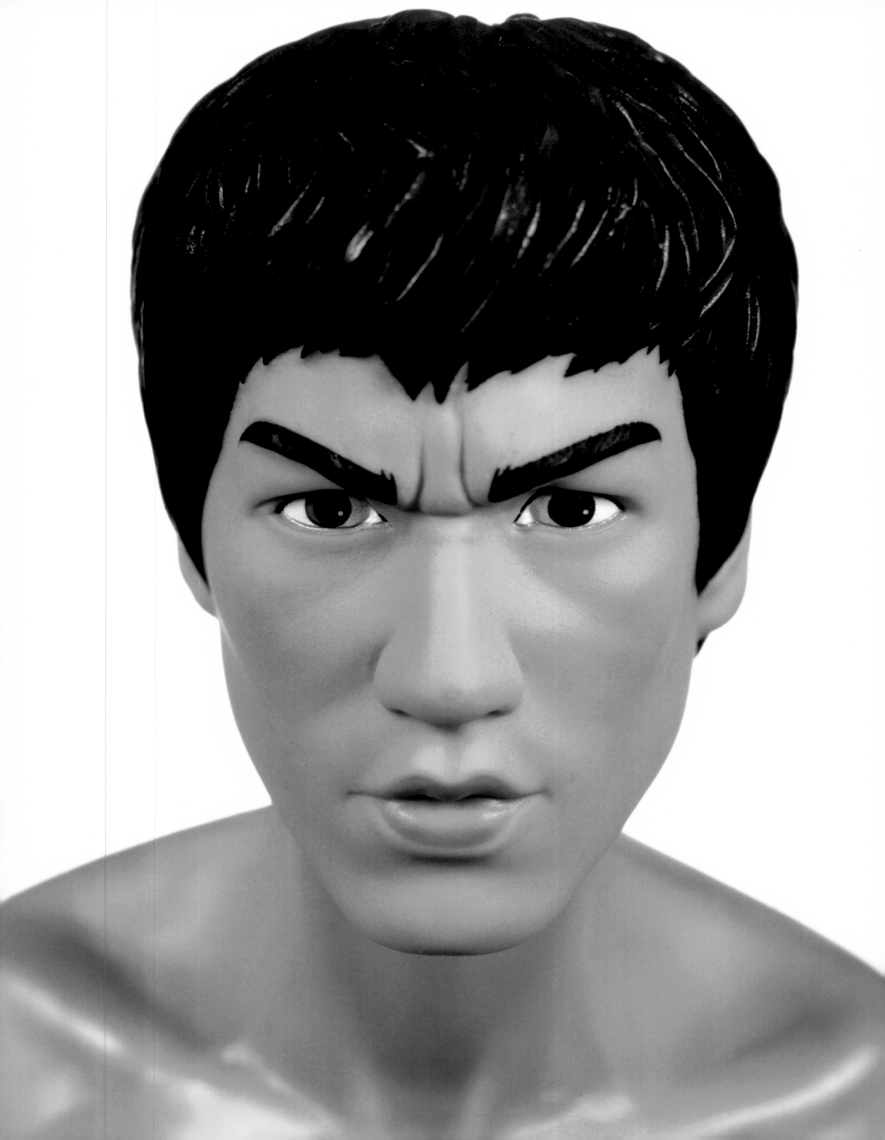

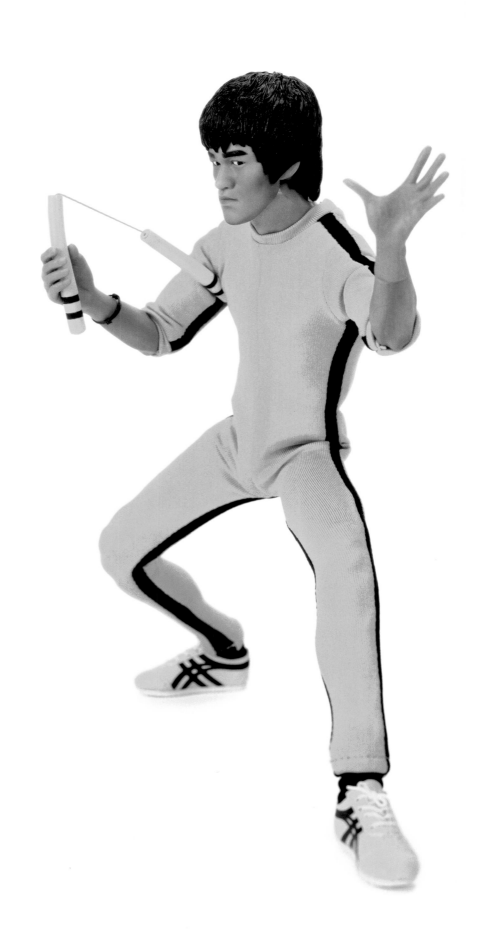

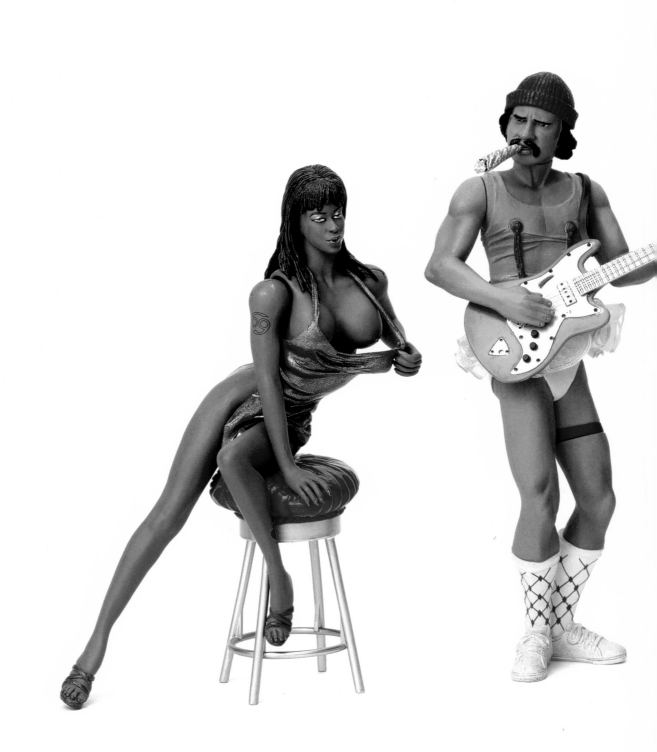

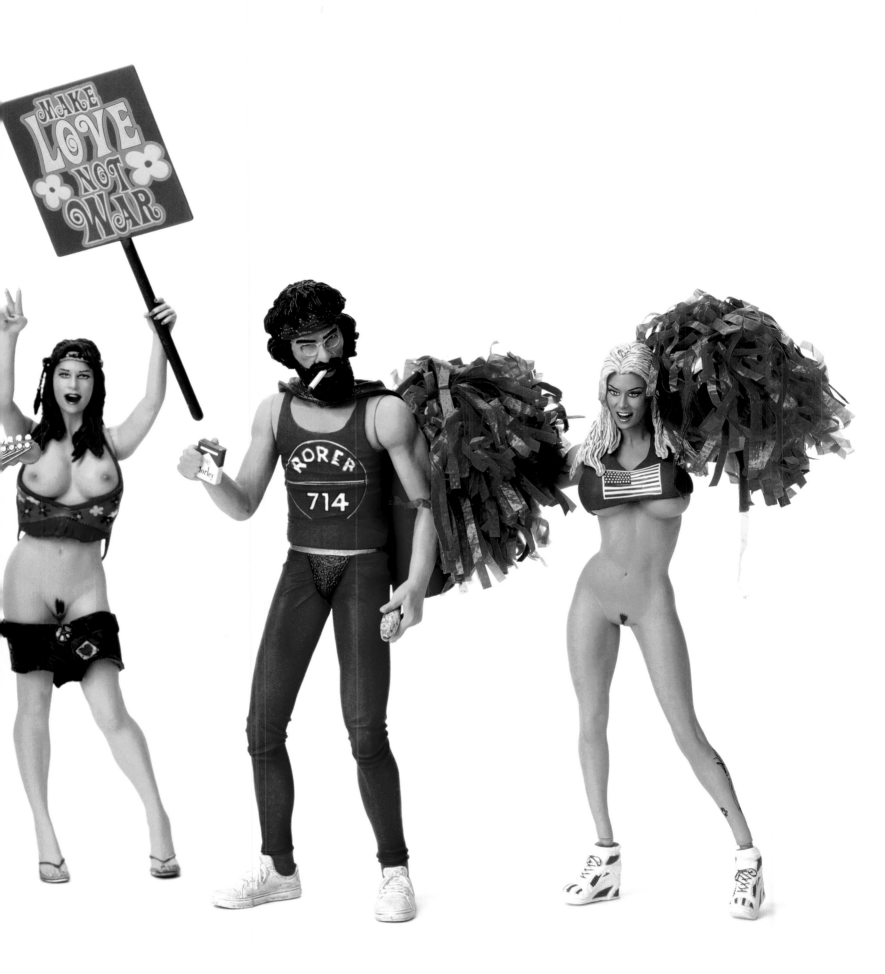

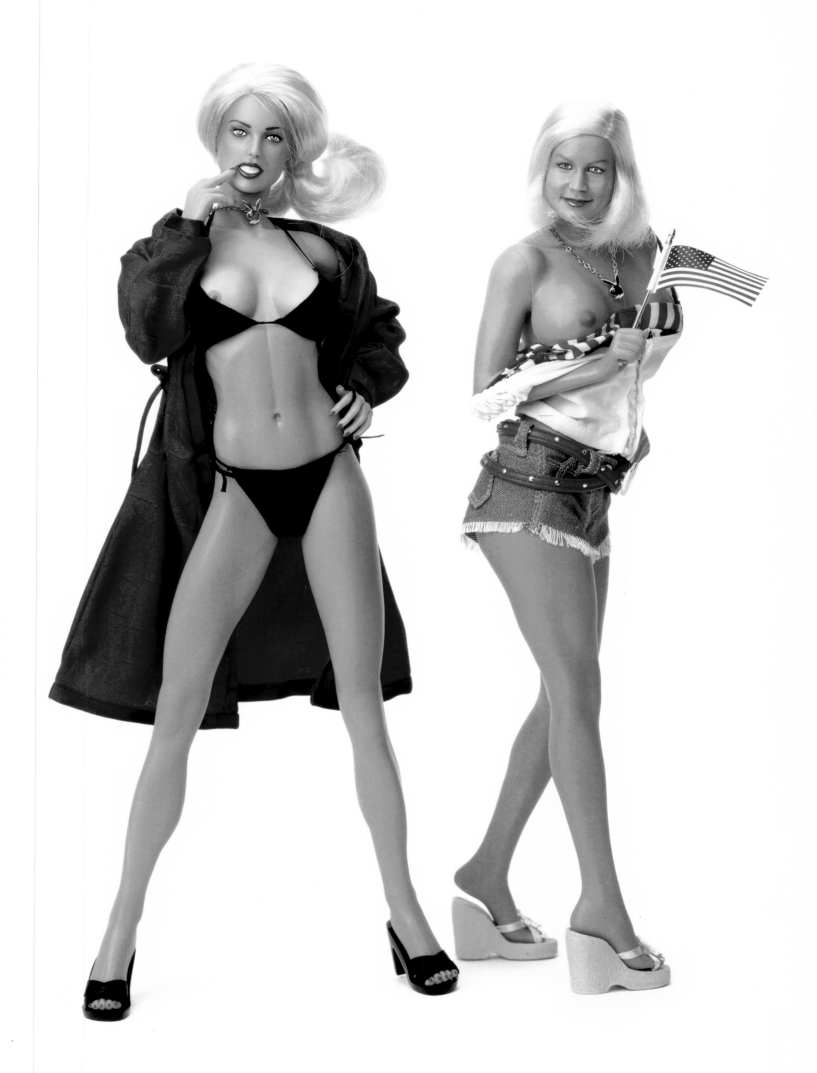

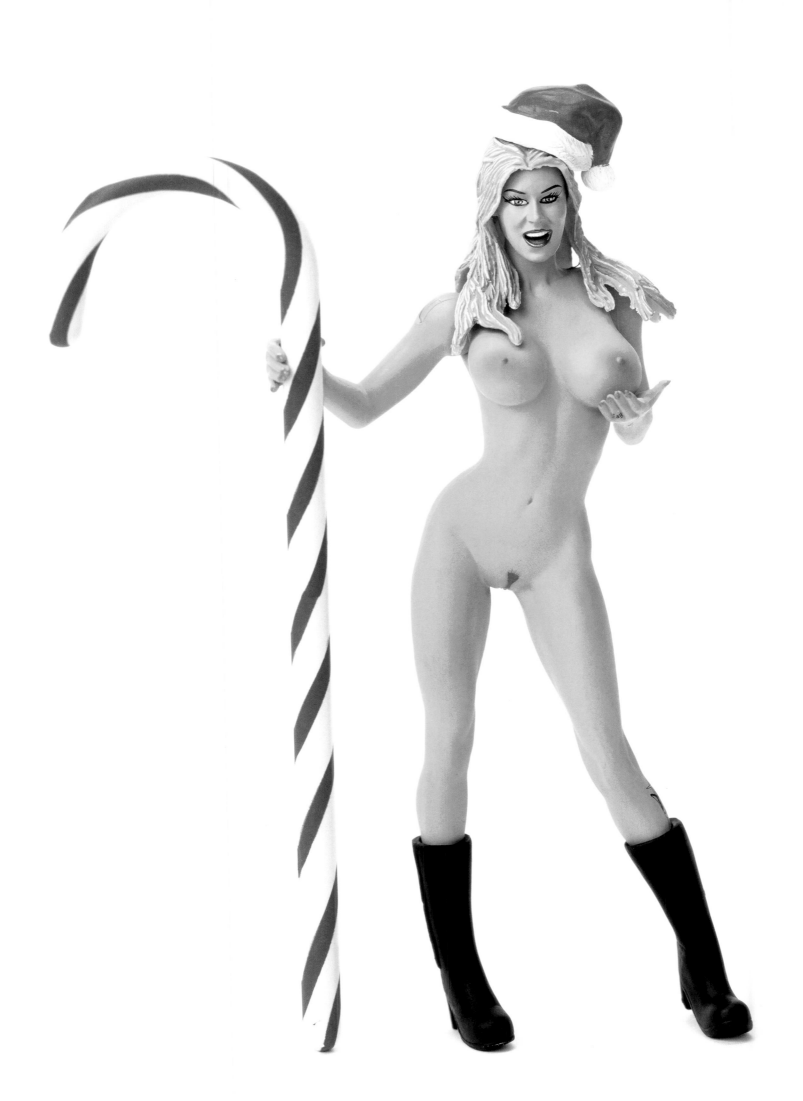

I LOVE YOU · ICH LIEBE DICH · JE T'AIME · TI AMO · JA TE VOLIM · JEG ELSKER DIG · TE DUA · T'ESTIMO · EU TE AMO · TE QUE
RO · EK IS LIEF VIR JOU · ANA AHEBIK · AMI TOMAKE WALOBASHI · OBICHAM TE · WO AI NI · MI AMAS VIN · MAE RAKASTAN
· ANEE OHEV OTAKH · IK HOU VAN JE · SAYA CINTA PADAMU · KIMI O AI SHITERU · KULO TRESNO · QAMUSHA' · MI AIME J
ES TEVI MILU · JIEN INHOBBOK · KANBHIK · MAN TORA DUST DARAM · MAHAL KITA · KOCHAM CIE · EU TE AMO · CANDA MUN
· TE IUBESC · YA TYEBYA LYUBLYU · LUBIM TA · KHAO RAAK THOE · MILUJI TE · KE A GO RATA · SZERETLEK · YA TEBE KOKH.
· SENI SEVIYORUM · MENA TANDA WENA · I LOVE YOU · ICH LIEBE DICH · JE T'AIME · TI AMO · JA TE VOLIM · JEG ELSKER D
TE DUA · T'ESTIMO · EU TE AMO · TE QUIERO · EK IS LIEF VIR JOU · ANA AHEBIK · AMI TOMAKE WALOBASHI · OBICHAM TE ·
AI NI · MI AMAS VIN · MAE RAKASTAN SUA · ANEE OHEV OTAKH · IK HOU VAN JE · SAYA CINTA PADAMU · KIMI O AI SHITE
KULO TRESNO · QAMUSHA' · MI AIME JOU · ES TEVI MILU · JIEN INHOBBOK · KANBHIK · MAN TORA DUST DARAM · MAHAL KI
KOCHAM CIE · EU TE AMO · CANDA MUNANI · TE IUBESC · YA TYEBYA LYUBLYU · LUBIM TA · KHAO RAAK THOE · MILUJI TE · K
GO RATA · SZERETLEK · YA TEBE KOKHAYU · SENI SEVIYORUM · MENA TANDA WENA · I LOVE YOU · ICH LIEBE DICH · JE T'A
· TI AMO · JA TE VOLIM · JEG ELSKER DIG · TE DUA · T'ESTIMO · EU TE AMO · TE QUIERO · EK IS LIEF VIR JOU · ANA AHEE
AMI TOMAKE WALOBASHI · OBICHAM TE · WO AI NI · MI AMAS VIN · MAE RAKASTAN SUA · ANEE OHEV OTAKH · IK HOU VAN
· SAYA CINTA PADAMU · KIMI O AI SHITERU · KULO TRESNO · QAMUSHA' · MI AIME JOU · ES TEVI MILU · JIEN INHOBBOK · K
BHIK · MAN TORA DUST DARAM · MAHAL KITA · KOCHAM CIE · EU TE AMO · CANDA MUNANI · TE IUBESC · YA TYEBYA LYUBL
LUBIM TA · KHAO RAAK THOE · MILUJI TE · KE A GO RATA · SZERETLEK · YA TEBE KOKHAYU · SENI SEVIYORUM · MENA TAN
WENA · I LOVE YOU · ICH LIEBE DICH · JE T'AIME · TI AMO · JA TE VOLIM · JEG ELSKER DIG · TE DUA · T'ESTIMO · EU TE A
· TE QUIERO · EK IS LIEF VIR JOU · ANA AHEBIK · AMI TOMAKE WALOBASHI · OBICHAM TE · WO AI NI · MI AMAS VIN · MAE
KASTAN SUA · ANEE OHEV OTAKH · IK HOU VAN JE · SAYA CINTA PADAMU · KIMI O AI SHITERU · KULO TRESNO · QAMUSH
MI AIME JOU · ES TEVI MILU · JIEN INHOBBOK · KANBHIK · MAN TORA DUST DARAM · MAHAL KITA · KOCHAM CIE · EU TE A
· CANDA MUNANI · TE IUBESC · YA TYEBYA LYUBLYU · LUBIM TA · KHAO RAAK THOE · MILUJI TE · KE A GO RATA · SZERETL
YA TEBE KOKHAYU · SENI SEVIYORUM · MENA TANDA WENA · I LOVE YOU · ICH LIEBE DICH · JE T'AIME · TI AMO · JA TE VOL
JEG ELSKER DIG · TE DUA · T'ESTIMO · EU TE AMO · TE QUIERO · EK IS LIEF VIR JOU · ANA AHEBIK · AMI TOMAKE WALOBAS
OBICHAM TE · WO AI NI · MI AMAS VIN · MAE RAKASTAN SUA · ANEE OHEV OTAKH · IK HOU VAN JE · SAYA CINTA PADAMU ·
O AI SHITERU · KULO TRESNO · QAMUSHA' · MI AIME JOU · ES TEVI MILU · JIEN INHOBBOK · KANBHIK · MAN TORA DUST DA
· MAHAL KITA · EU TE AMO · CANDA MUNANI · TE IUBESC · YA TYEBYA LYUBLYU · LUBIM TA · KHAO RAAK THOE · MILUJI TE
A GO RATA · SZERETLEK · YA TEBE KOKHAYU · SENI SEVIYORUM · ♥ ICH LIEBE DICH · MENA TANDA WENA · I LOVE
· ICH LIEBE DICH · TI AMO · JA TE VOLIM · JEG ELSKER DIG · TE DUA · ♥ T'ESTIMO · EU TE AMO · TE QUIERO · EK IS I
VIR JOU · AMI TOMAKE WALOBASHI · OBICHAM TE · WO AI NI · ICH LIEBE DICH · MI AMAS VIN · MAE RAKASTAN S
ANEE OHEV OTAKH · IK HOU VAN JE · SAYA CINTA PADAMU · KIMI O AI SHITERU · KULO TRESNO · QAMUSHA' · MI AIME J
ES TEVI MILU · JIEN INHOBBOK · KANBHIK · MAN TORA DUST DARAM · MAHAL KITA · KOCHAM CIE · EU TE AMO · CANDA MUN
· TE IUBESC · YA TYEBYA LYUBLYU · LUBIM TA · KHAO RAAK THOE · MILUJI TE · KE A GO RATA · SZERETLEK · YA TEBE KOKH.
· SENI SEVIYORUM · MENA TANDA WENA · I LOVE YOU · ICH LIEBE DICH · JE T'AIME · TI AMO · JA TE VOLIM · JEG ELSKER D
TE DUA · T'ESTIMO · EU TE AMO · TE QUIERO · EK IS LIEF VIR JOU · ANA AHEBIK · AMI TOMAKE WALOBASHI · OBICHAM TE ·
AI NI · MI AMAS VIN · MAE RAKASTAN SUA · ANEE OHEV OTAKH · IK HOU VAN JE · SAYA CINTA PADAMU · KIMI O AI SHITE
KULO TRESNO · QAMUSHA' · MI AIME JOU · ES TEVI MILU · JIEN INHOBBOK · KANBHIK · MAN TORA DUST DARAM · MAHAL KI
KOCHAM CIE · EU TE AMO · CANDA MUNANI · TE IUBESC · YA TYEBYA LYUBLYU · LUBIM TA · KHAO RAAK THOE · MILUJI TE · K
GO RATA · SZERETLEK · YA TEBE KOKHAYU · SENI SEVIYORUM · MENA TANDA WENA · I LOVE YOU · ICH LIEBE DICH · JE T'A
· TI AMO · JA TE VOLIM · JEG ELSKER DIG · TE DUA · T'ESTIMO · EU TE AMO · TE QUIERO · EK IS LIEF VIR JOU · ANA AHEE
AMI TOMAKE WALOBASHI · OBICHAM TE · WO AI NI · MI AMAS VIN · MAE RAKASTAN SUA · ANEE OHEV OTAKH · IK HOU VAN
· SAYA CINTA PADAMU · KIMI O AI SHITERU · KULO TRESNO · QAMUSHA' · MI AIME JOU · ES TEVI MILU · JIEN INHOBBOK · K
BHIK · MAN TORA DUST DARAM · MAHAL KITA · KOCHAM CIE · EU TE AMO · CANDA MUNANI · TE IUBESC · YA TYEBYA LYUBL
LUBIM TA · KHAO RAAK THOE · MILUJI TE · KE A GO RATA · SZERETLEK · YA TEBE KOKHAYU · SENI SEVIYORUM · MENA TAN
WENA · I LOVE YOU · ICH LIEBE DICH · JE T'AIME · TI AMO · JA TE VOLIM · JEG ELSKER DIG · TE DUA · T'ESTIMO · EU TE A
· TE QUIERO · EK IS LIEF VIR JOU · ANA AHEBIK · AMI TOMAKE WALOBASHI · OBICHAM TE · WO AI NI · MI AMAS VIN · MAE
KASTAN SUA · ANEE OHEV OTAKH · IK HOU VAN JE · SAYA CINTA PADAMU · KIMI O AI SHITERU · KULO TRESNO · QAMUSH
MI AIME JOU · ES TEVI MILU · JIEN INHOBBOK · KANBHIK · MAN TORA DUST DARAM · MAHAL KITA · KOCHAM CIE · EU TE A
· CANDA MUNANI · TE IUBESC · YA TYEBYA LYUBLYU · LUBIM TA · KHAO RAAK THOE · MILUJI TE · KE A GO RATA · SZERETL
YA TEBE KOKHAYU · SENI SEVIYORUM · MENA TANDA WENA · I LOVE YOU · ICH LIEBE DICH · JE T'AIME · TI AMO · JA TE VOL
JEG ELSKER DIG · TE DUA · T'ESTIMO · EU TE AMO · TE QUIERO · EK IS LIEF VIR JOU · ANA AHEBIK · AMI TOMAKE WALOBA
· OBICHAM TE · WO AI NI · MI AMAS VIN · MAE RAKASTAN SUA · ANEE OHEV OTAKH · IK HOU VAN JE · SAYA CINTA PADAM
KIMI O AI SHITERU · KULO TRESNO · QAMUSHA' · MI AIME JOU · ES TEVI MILU · JIEN INHOBBOK · KANBHIK · MAN TORA DI
DARAM · MAHAL KITA · KOCHAM CIE · EU TE AMO · CANDA MUNANI · TE IUBESC · YA TYEBYA LYUBLYU · LUBIM TA · KHAO R.
THOE · MILUJI TE · KE A GO RATA · SZERETLEK · YA TEBE KOKHAYU · SENI SEVIYORUM · MENA TANDA WENA · I LOVE YC
ICH LIEBE DICH · JE T'AIME · TI AMO · JA TE VOLIM · JEG ELSKER DIG · TE DUA · T'ESTIMO · EU TE AMO · TE QUIERO · E
LIEF VIR JOU · ANA AHEBIK · AMI TOMAKE WALOBASHI · OBICHAM TE · WO AI NI · MI AMAS VIN · MAE RAKASTAN SUA · A
OHEV OTAKH · IK HOU VAN JE · SAYA CINTA PADAMU · KIMI O AI SHITERU · KULO TRESNO · QAMUSHA' · MI AIME JOU · ES T
MILU · JIEN INHOBBOK · KANBHIK · MAN TORA DUST DARAM · MAHAL KITA · KOCHAM CIE · EU TE AMO · CANDA MUNANI ·
IUBESC · YA TYEBYA LYUBLYU · LUBIM TA · KHAO RAAK THOE · MILUJI TE · KE A GO RATA · SZERETLEK · YA TEBE KOKHAY
SENI SEVIYORUM · MENA TANDA WENA · I LOVE YOU · ICH LIEBE DICH · JE T'AIME · TI AMO · JA TE VOLIM · JEG ELSKER D
TE DUA · T'ESTIMO · EU TE AMO · TE QUIERO · EK IS LIEF VIR JOU · ANA AHEBIK · AMI TOMAKE WALOBASHI · OBICHAM TE ·
AI NI · MI AMAS VIN · MAE RAKASTAN SUA · ANEE OHEV OTAKH · IK HOU VAN JE · SAYA CINTA PADAMU · KIMI O AI SHITE
· KULO TRESNO · QAMUSHA' · MI AIME JOU · ES TEVI MILU · JIEN INHOBBOK · KANBHIK · MAN TORA DUST DARAM · MAH
KITA · KOCHAM CIE · EU TE AMO · CANDA MUNANI · TE IUBESC · YA TYEBYA LYUBLYU · LUBIM TA · KHAO RAAK THOE · MIL
TE · KE A GO RATA · SZERETLEK · YA TEBE KOKHAYU · SENI SEVIYORUM · MENA TANDA WENA · I LOVE YOU · ICH LIEBE D
· JE T'AIME · TI AMO · JA TE VOLIM · JEG ELSKER DIG · TE DUA · T'ESTIMO · EU TE AMO · TE QUIERO · EK IS LIEF VIR JO

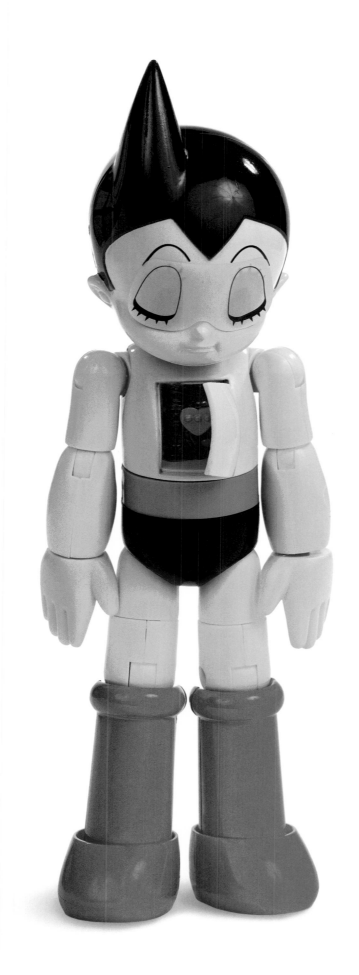

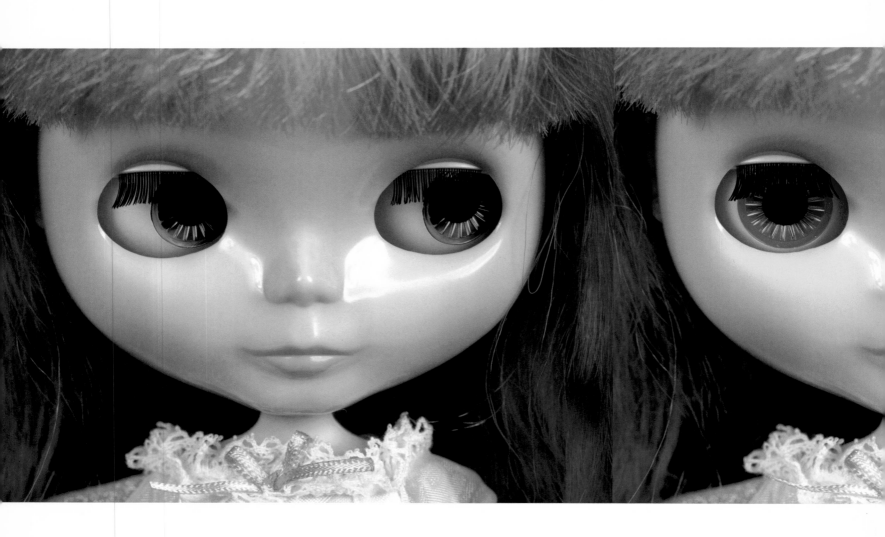

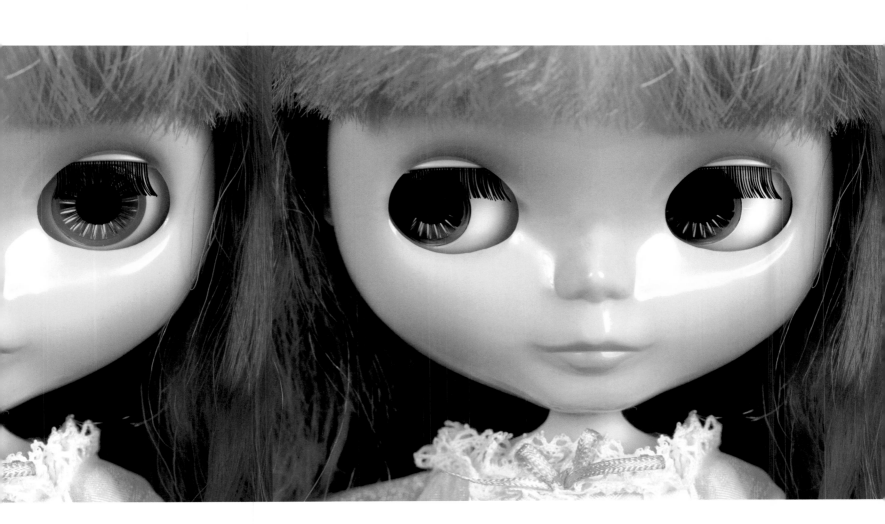

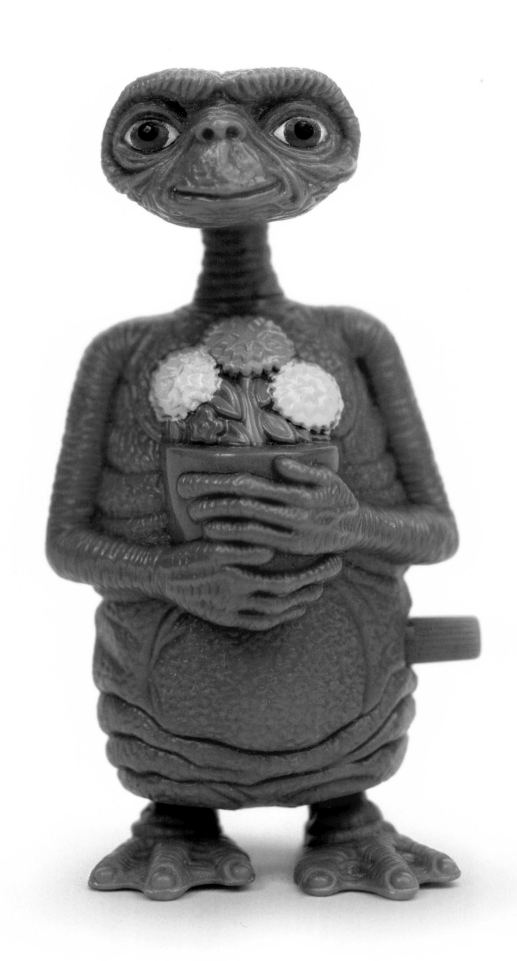

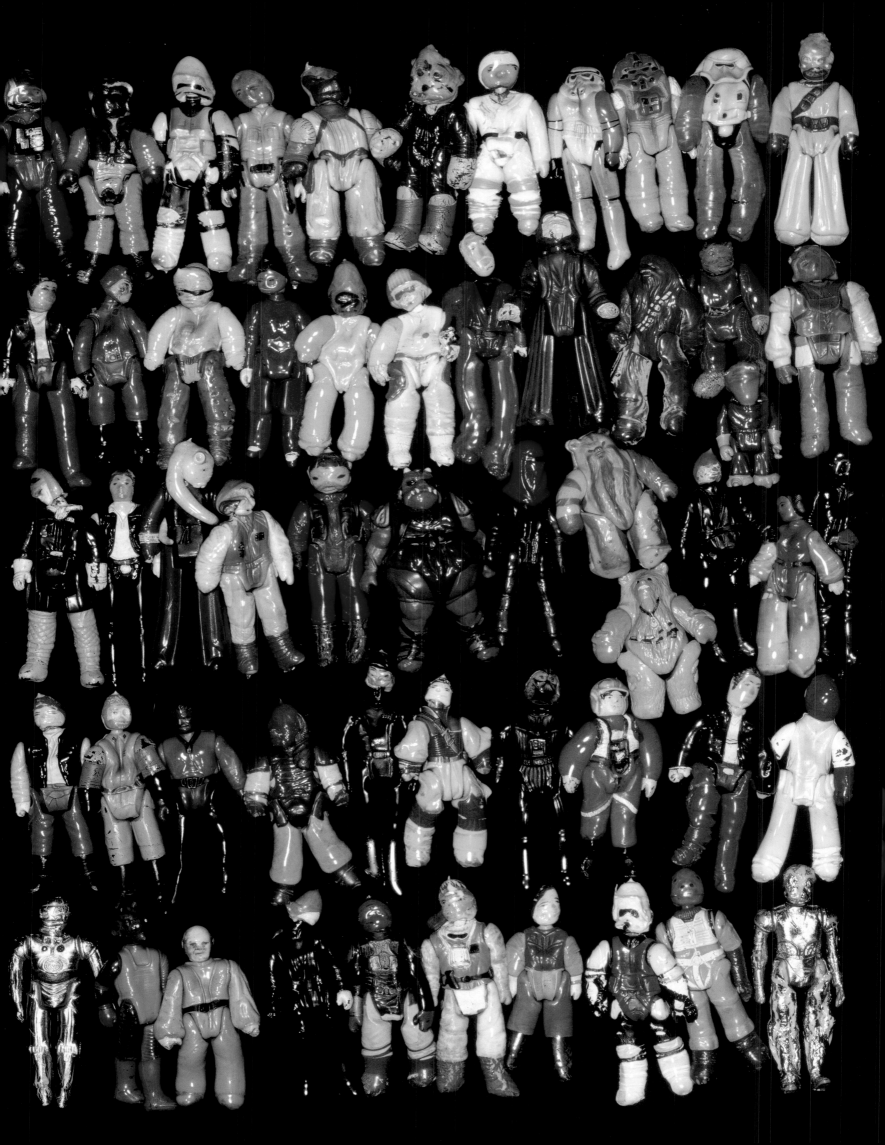

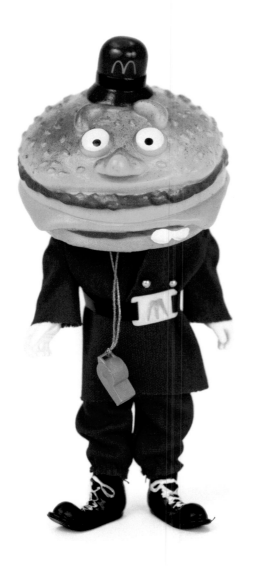
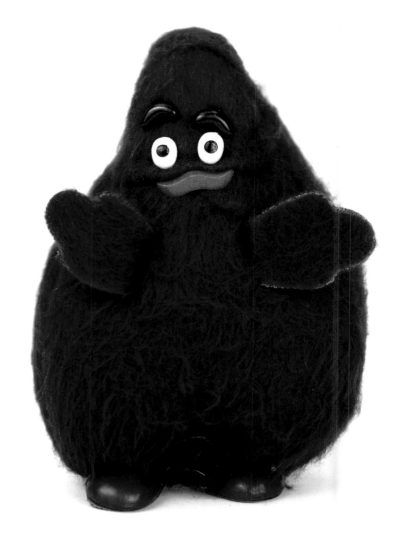

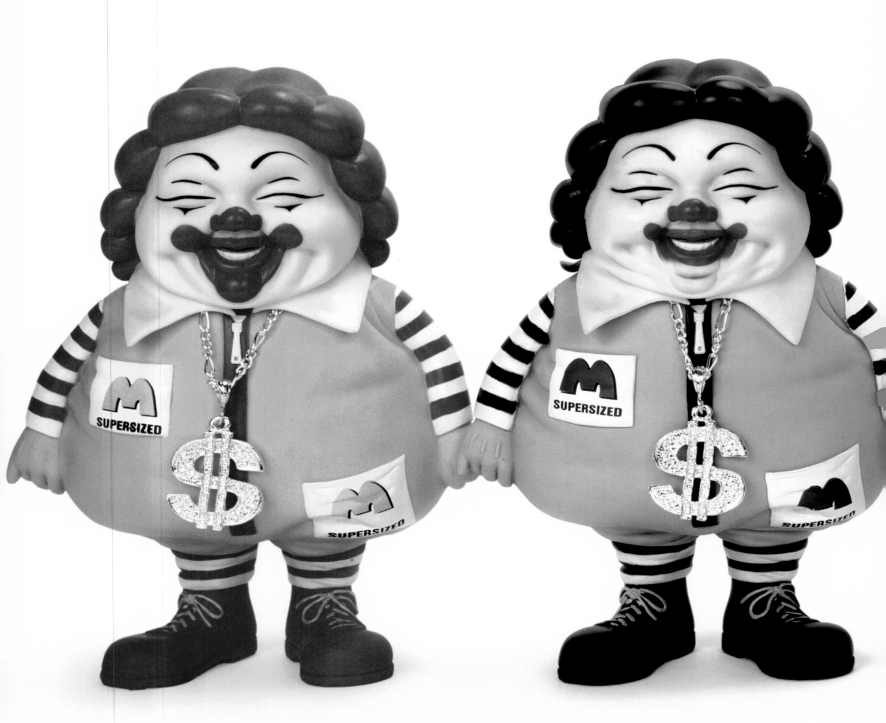

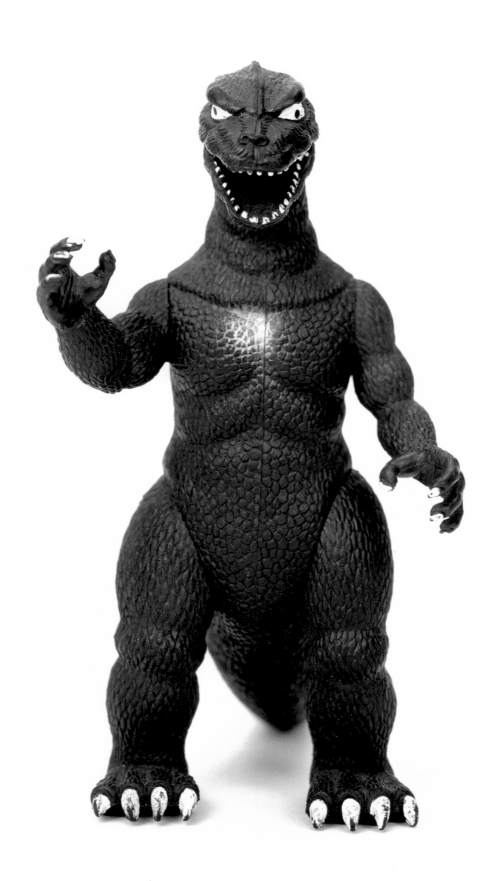

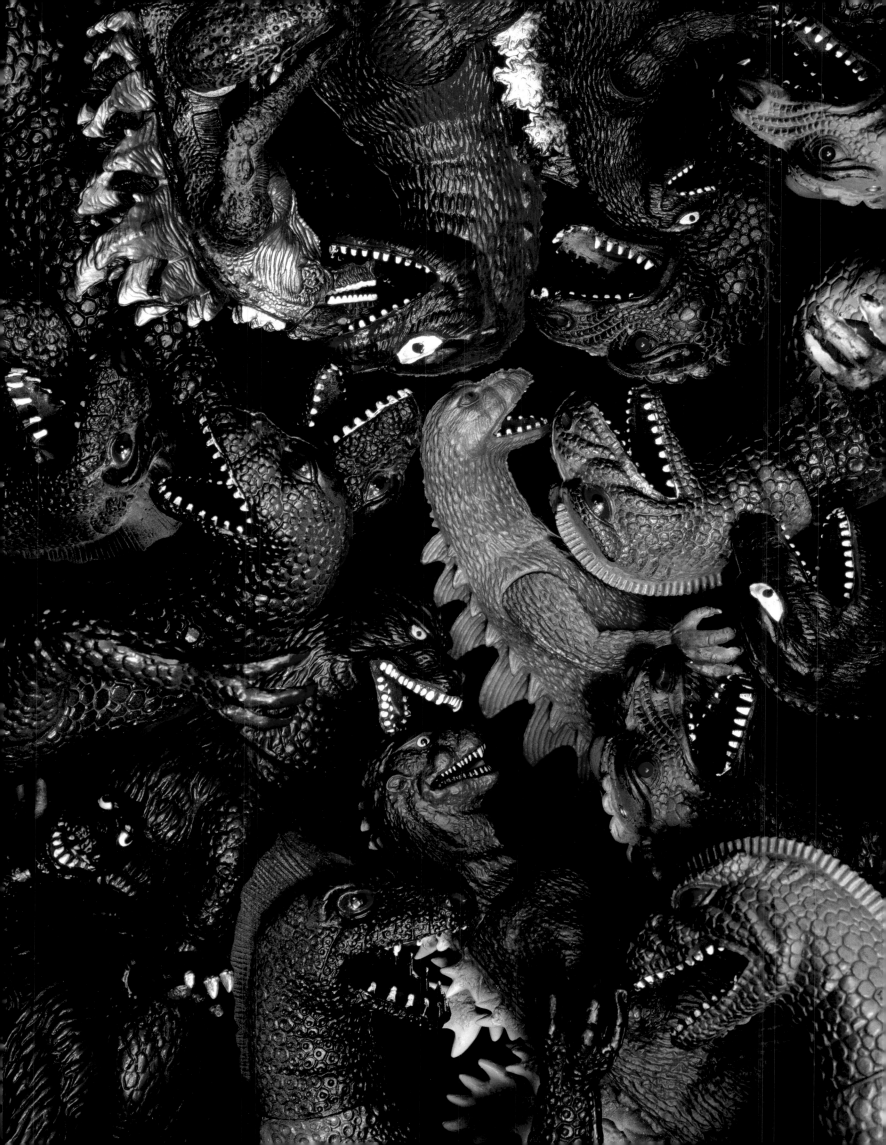

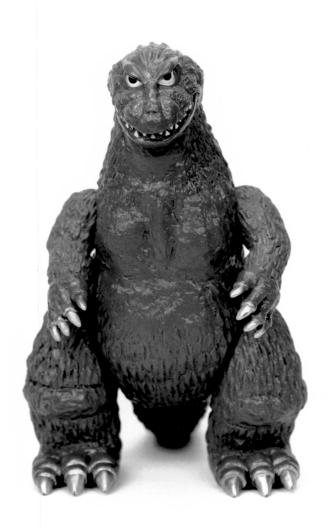

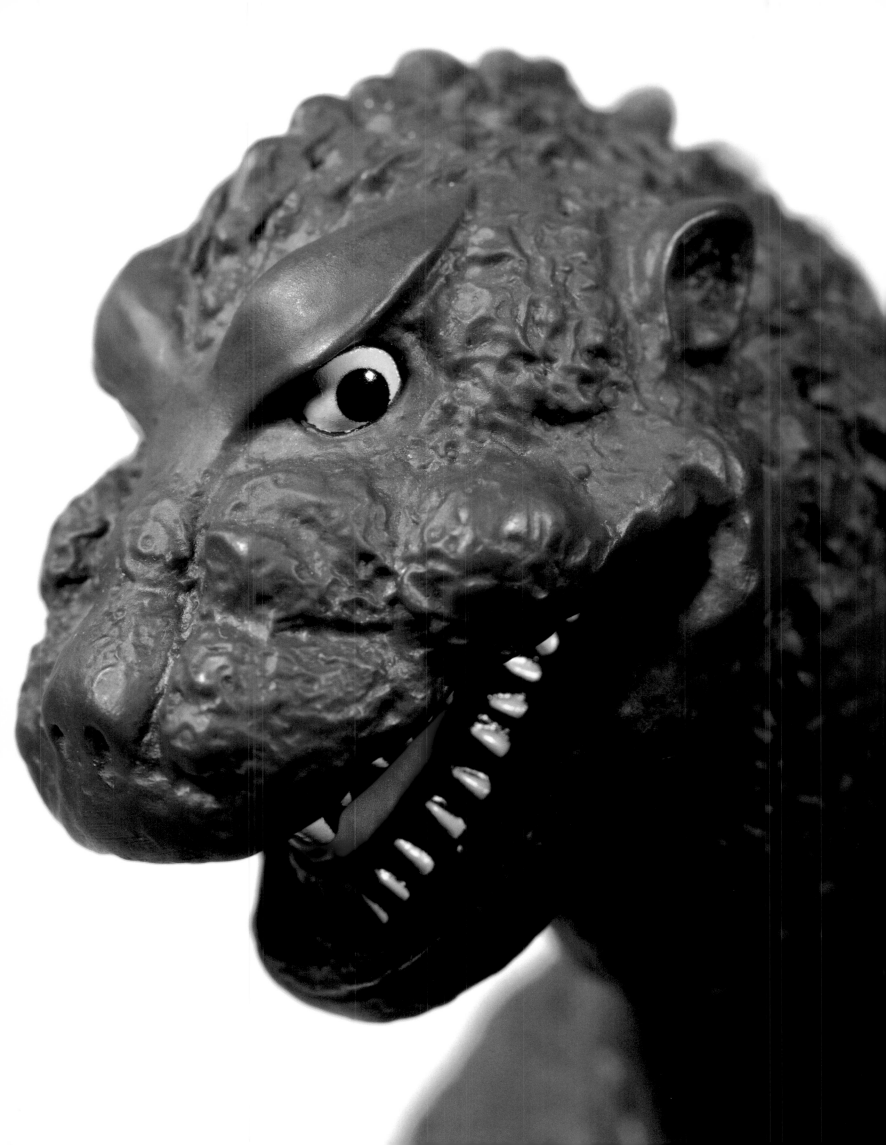

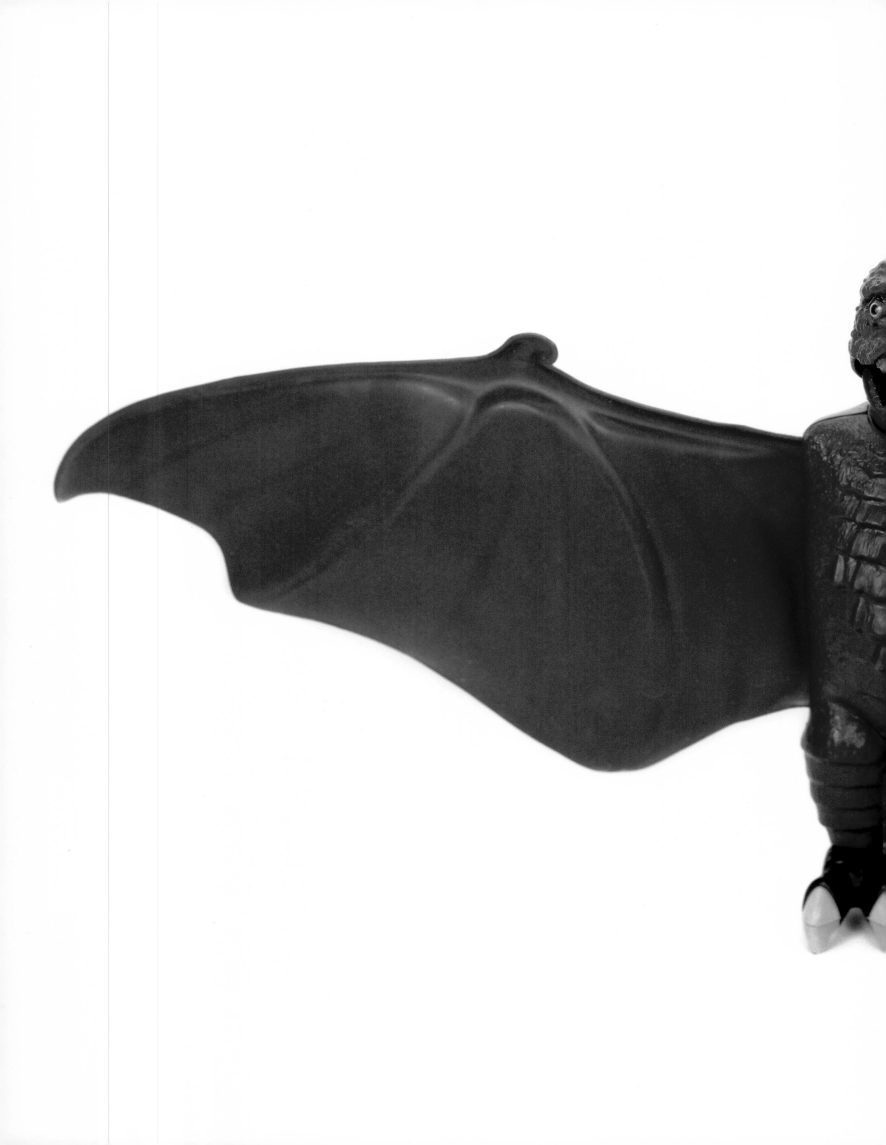

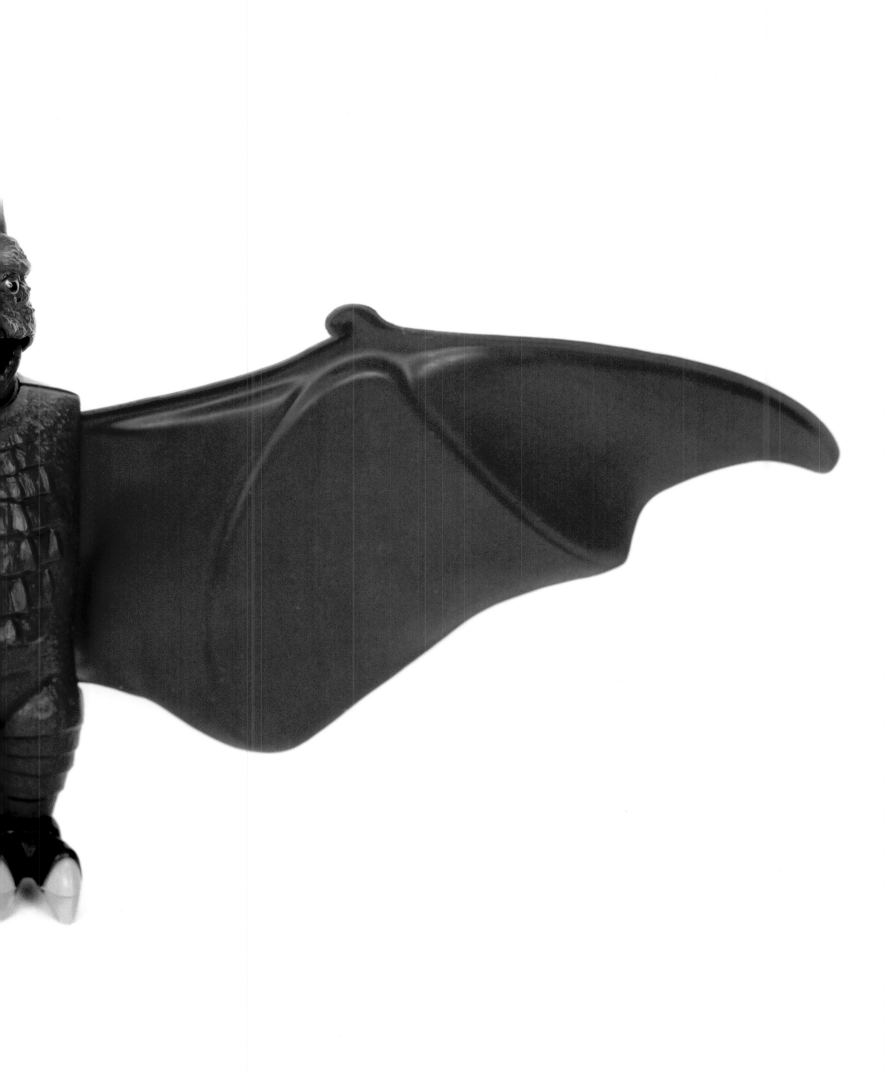

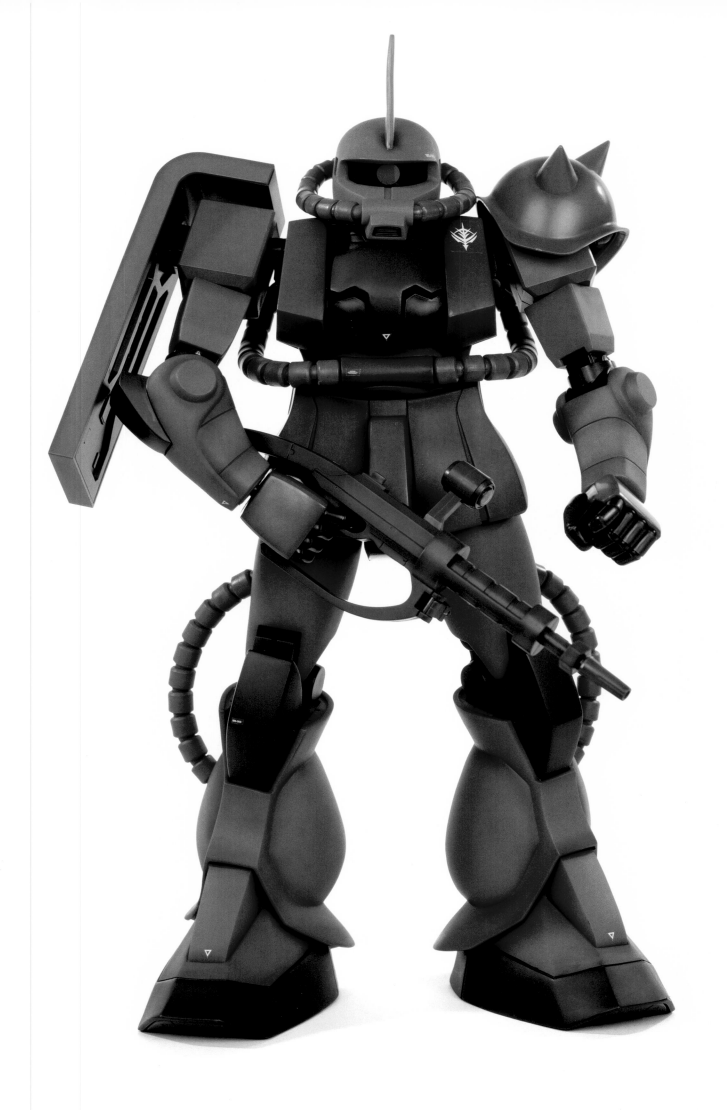

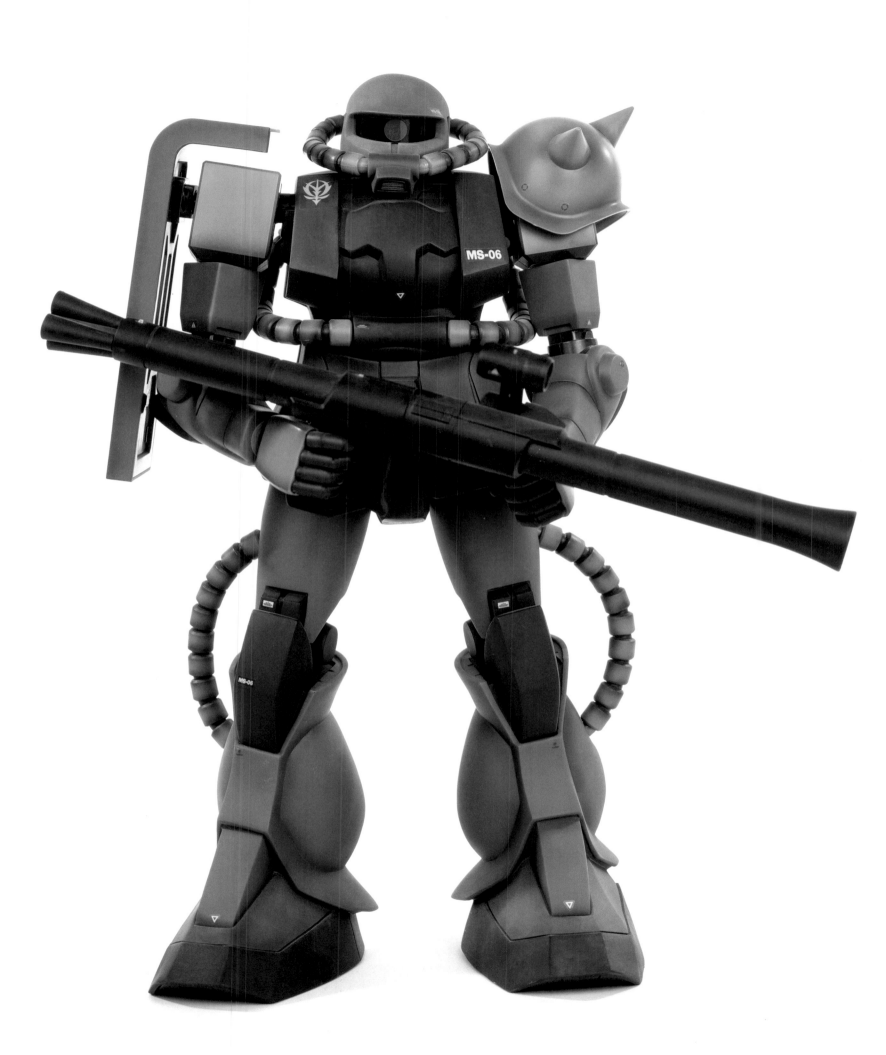

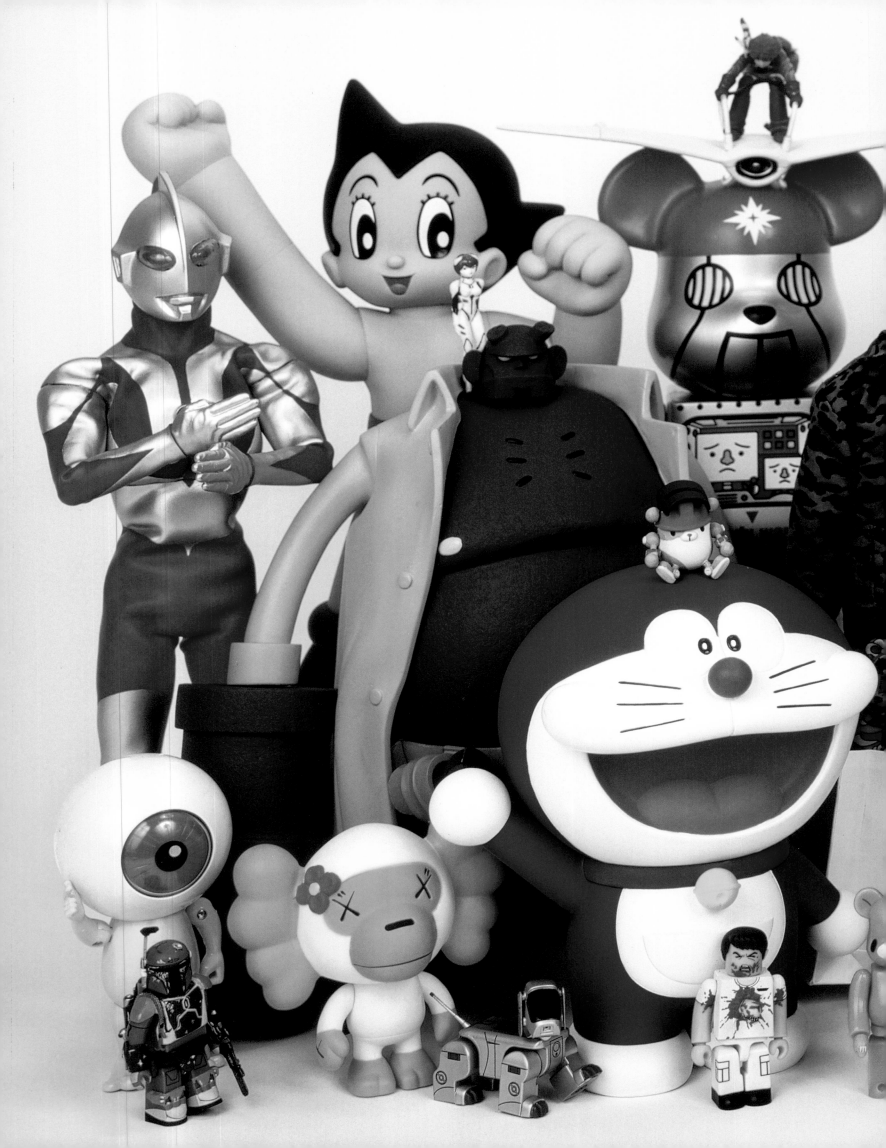

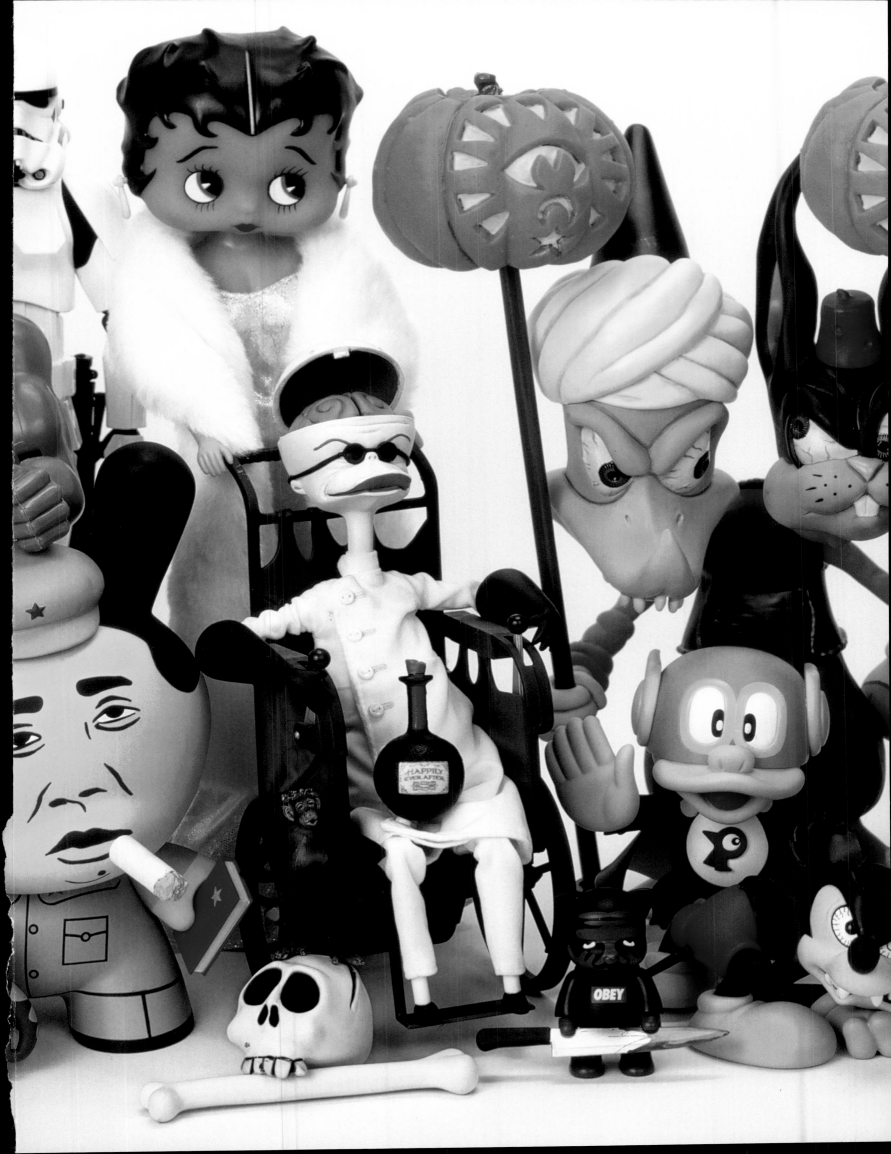

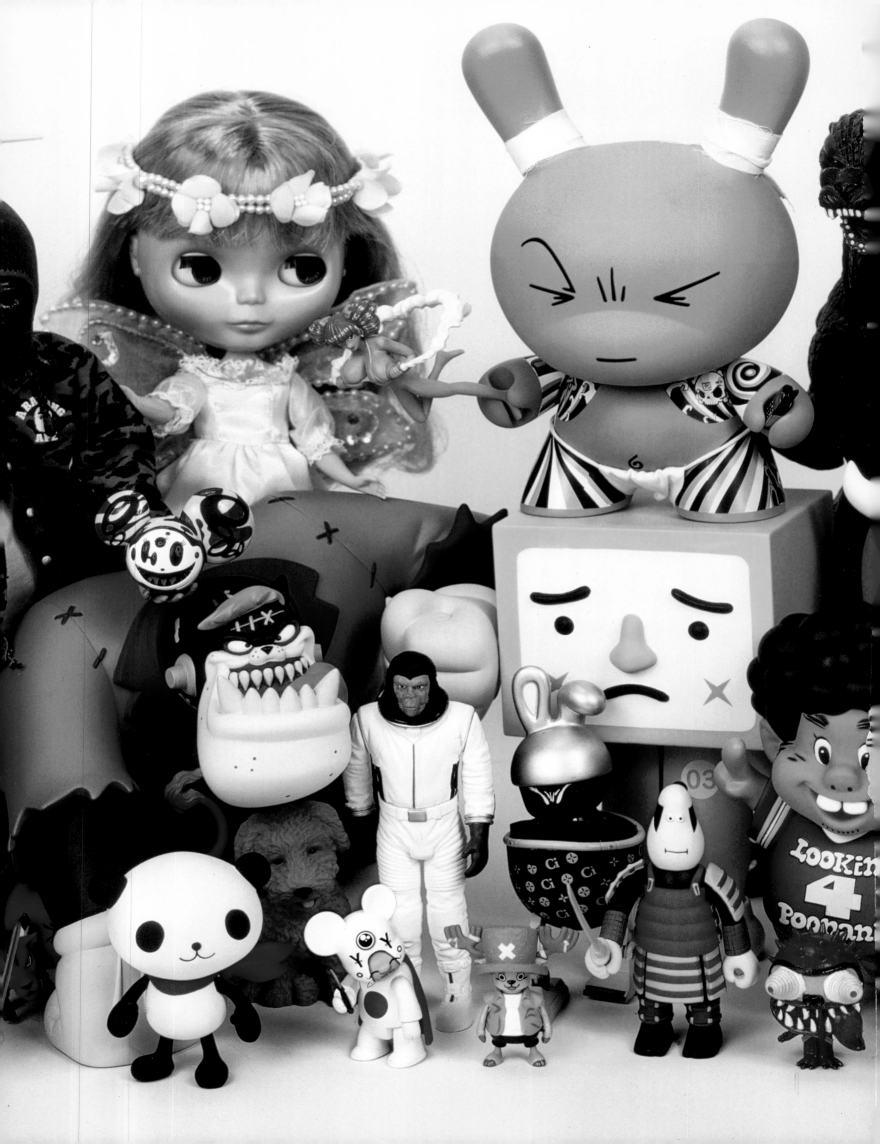

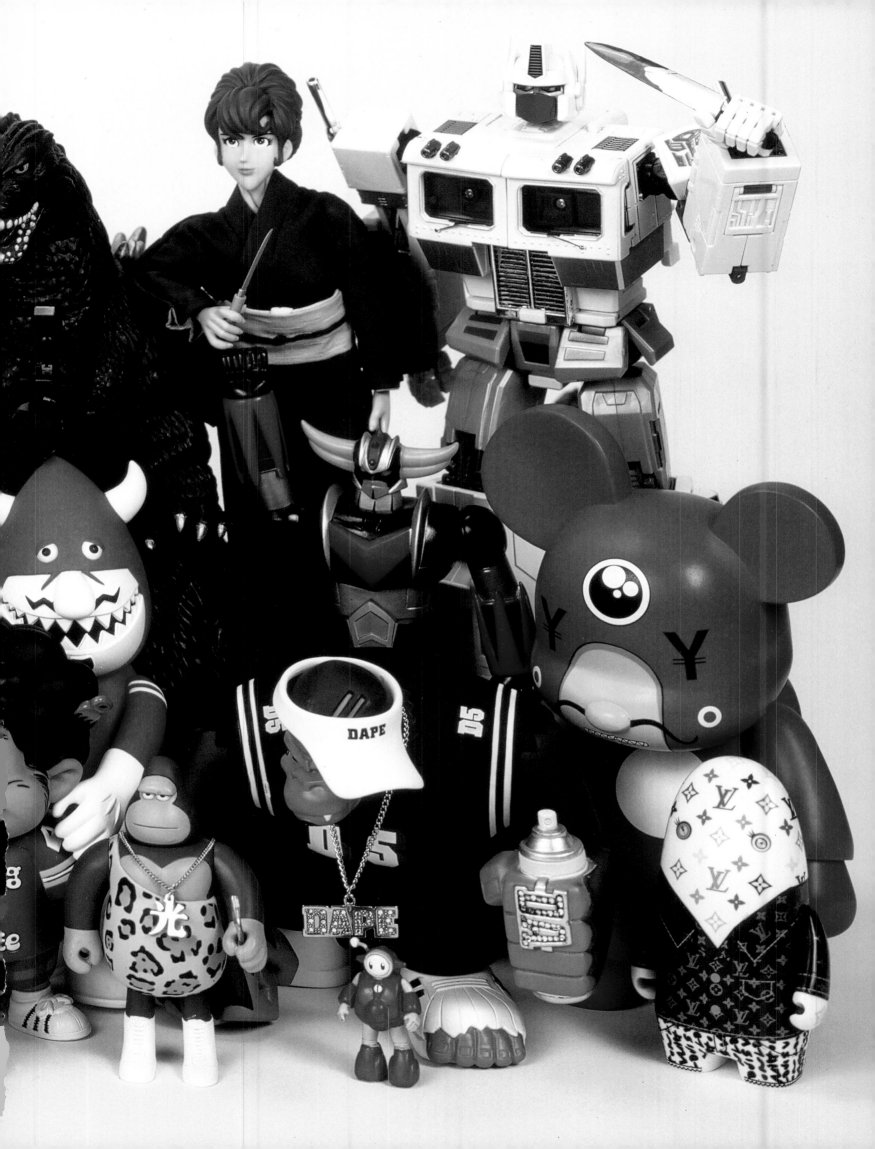

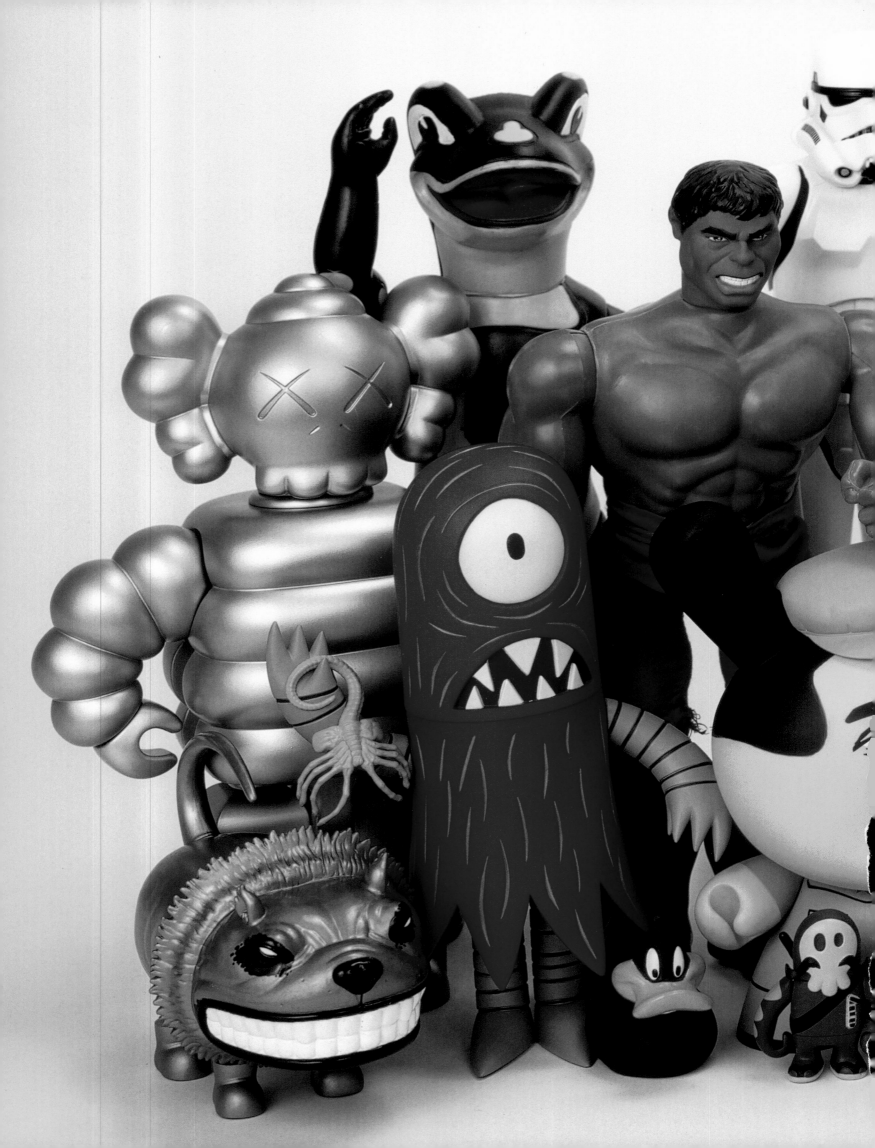

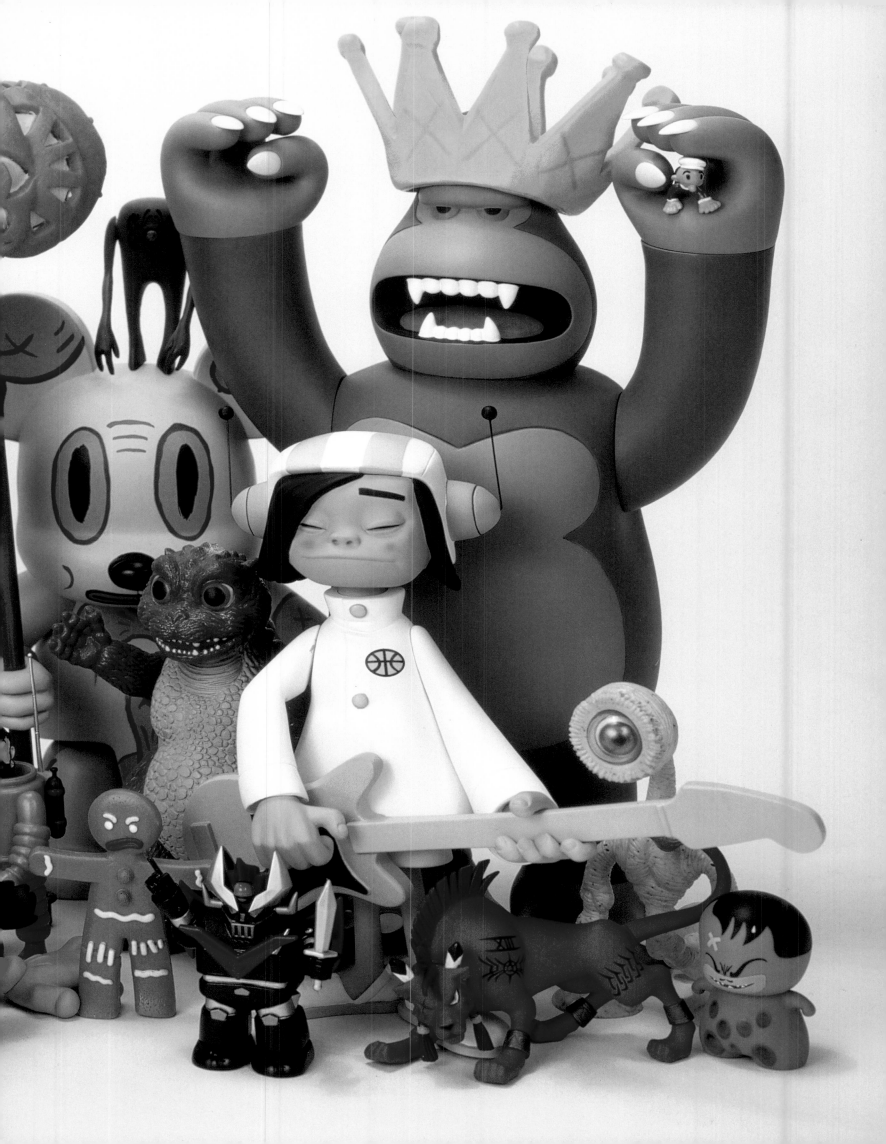

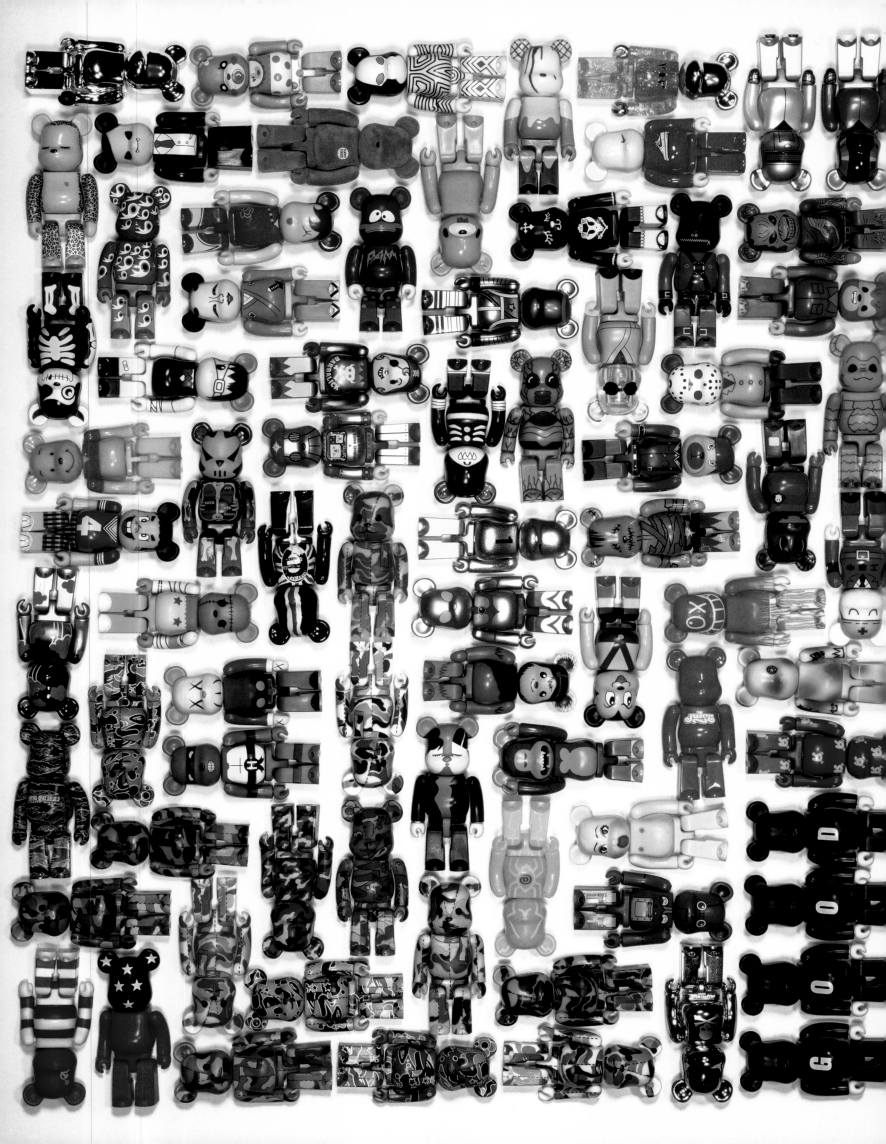

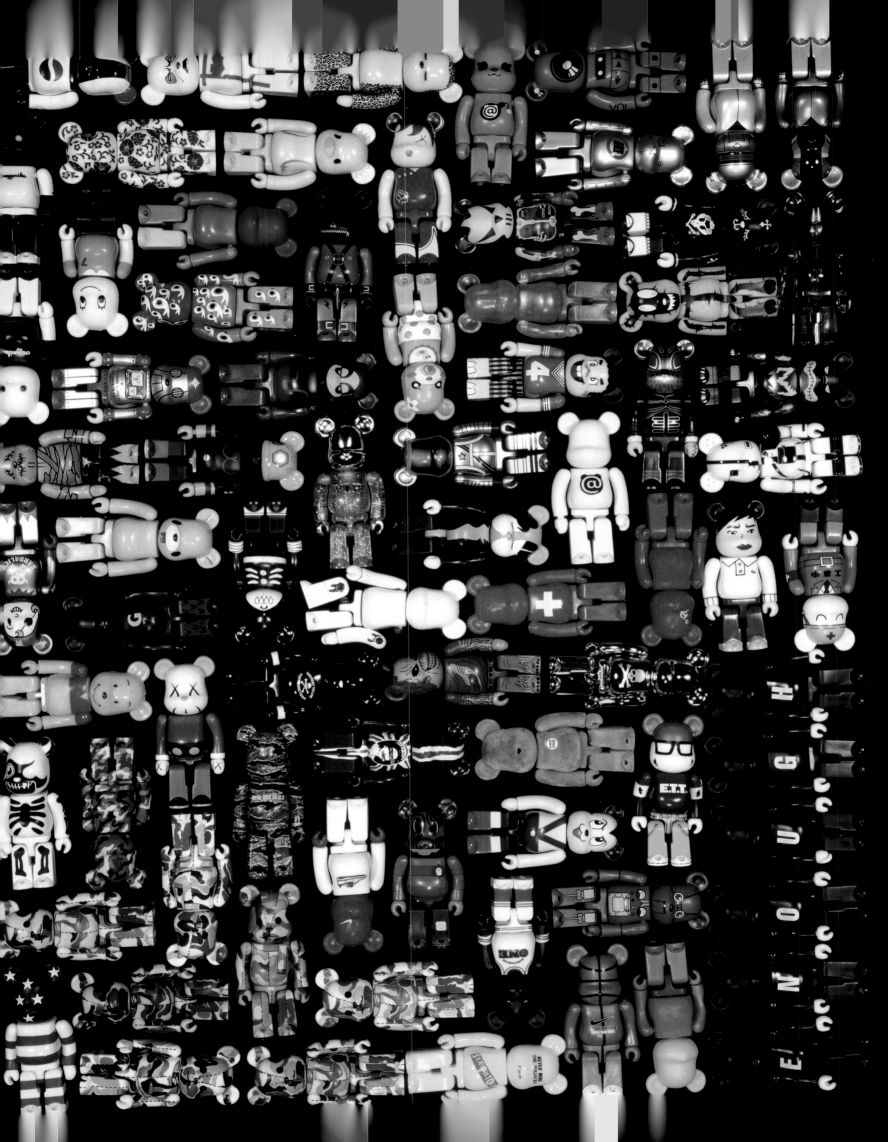

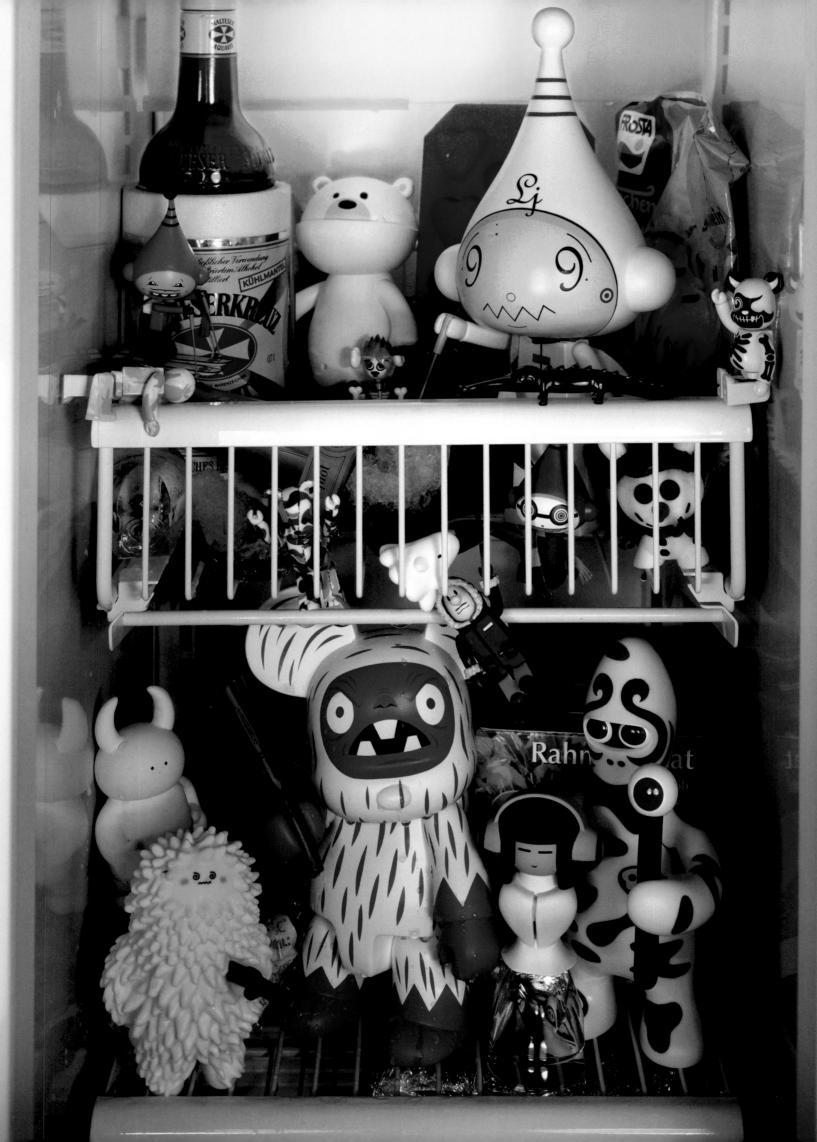

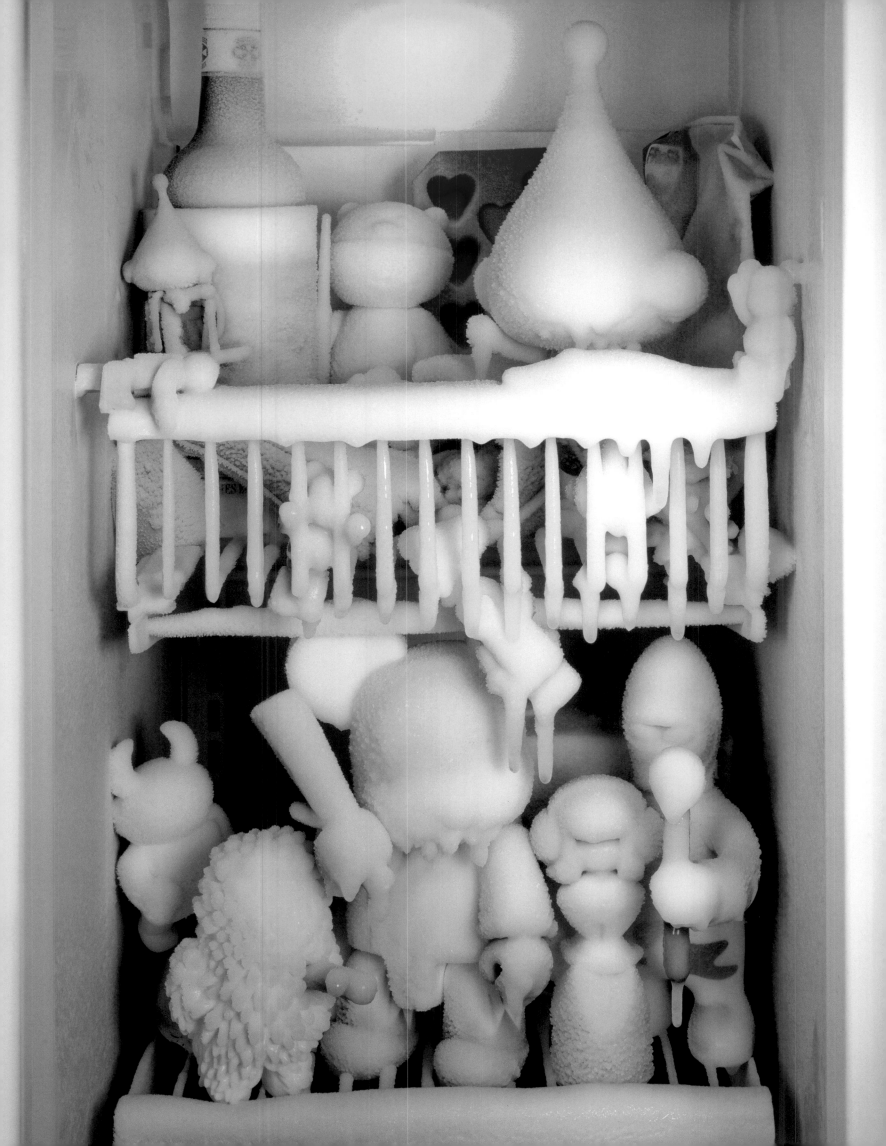

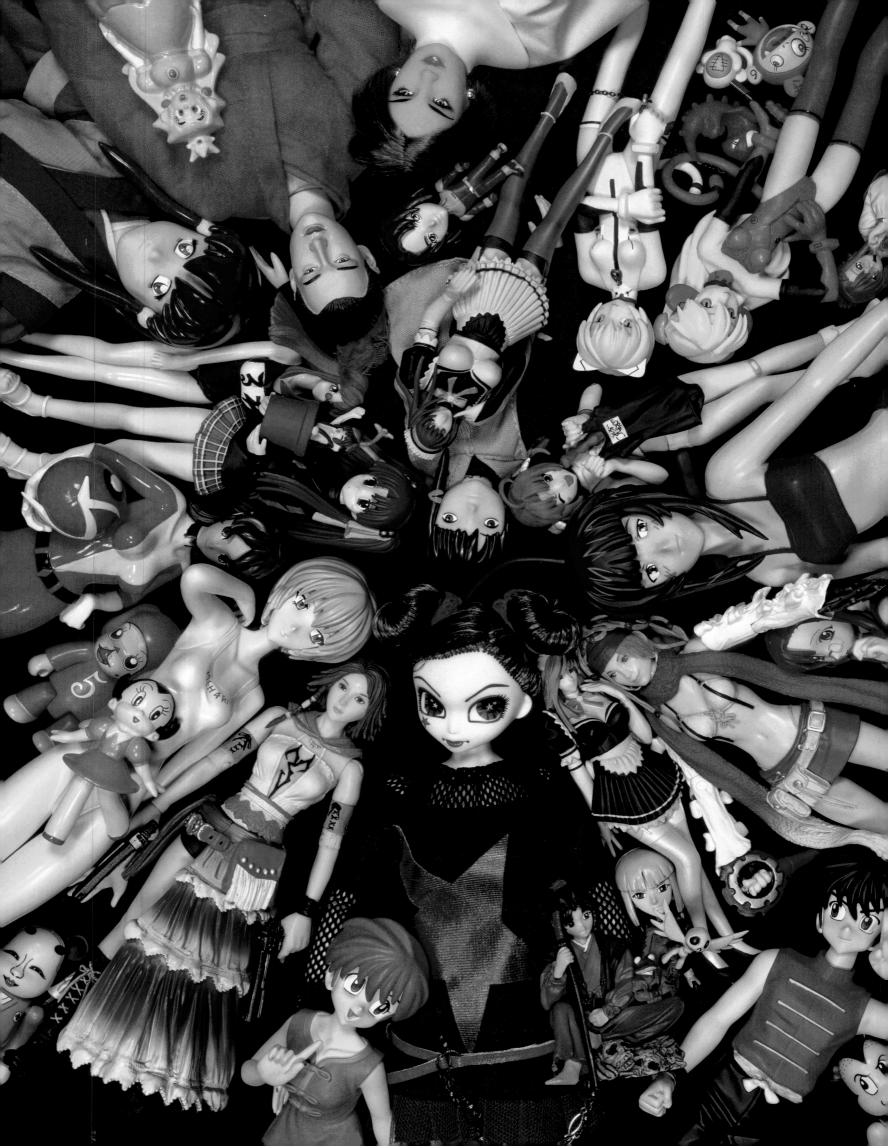

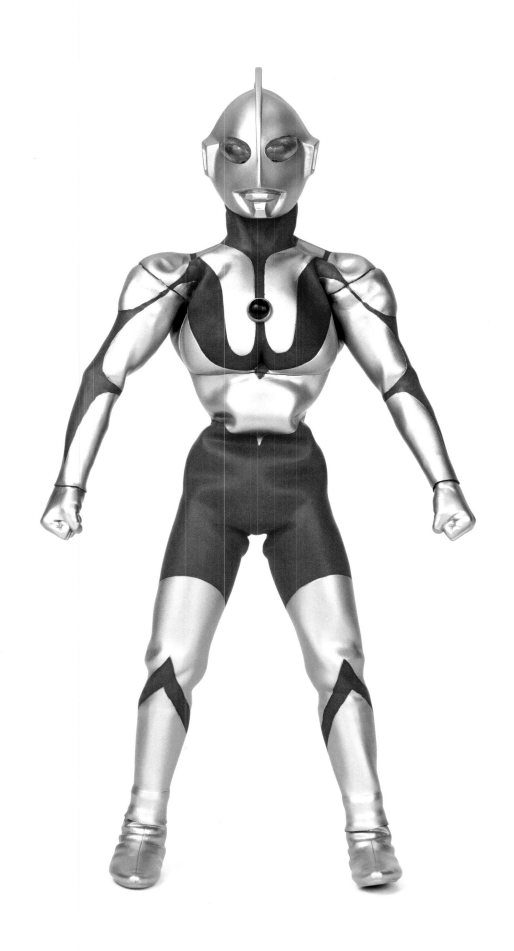

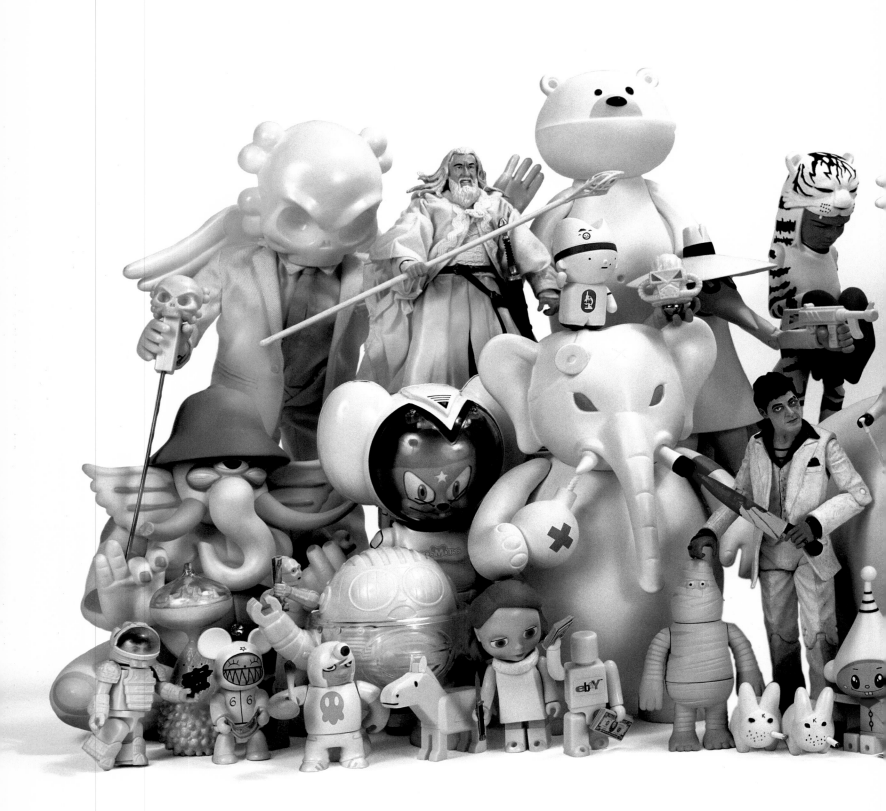

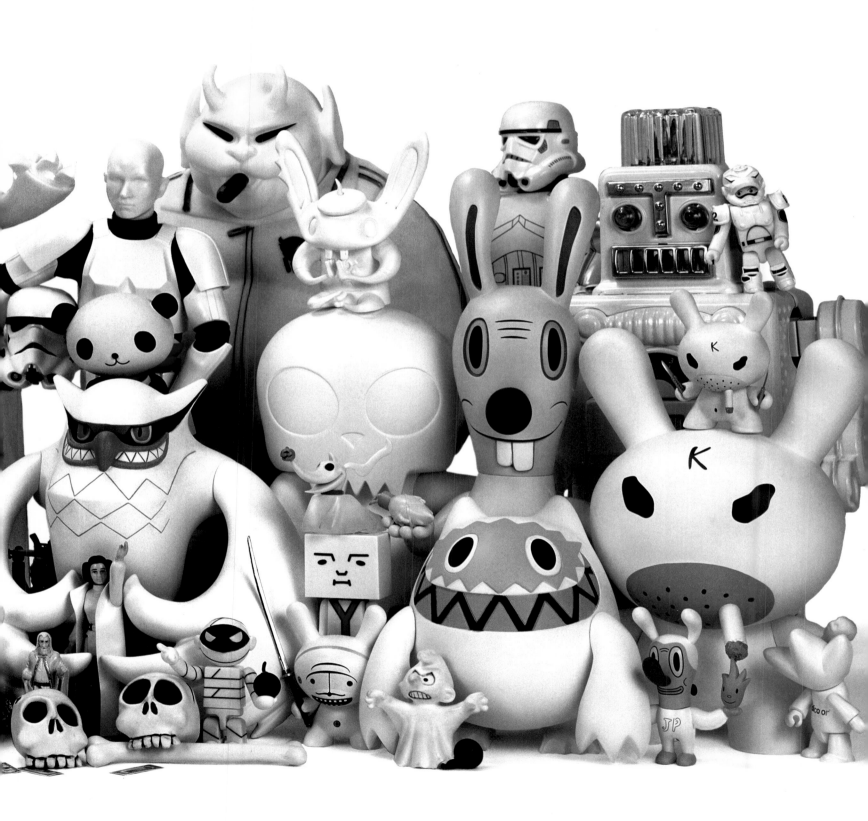

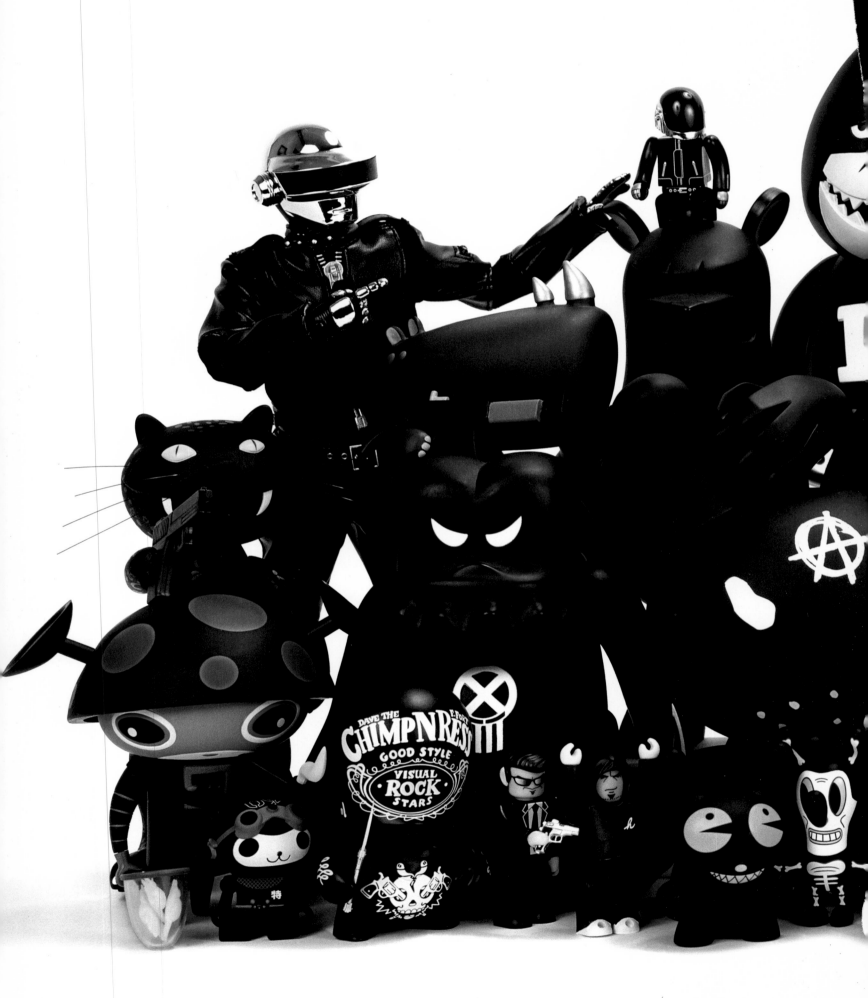

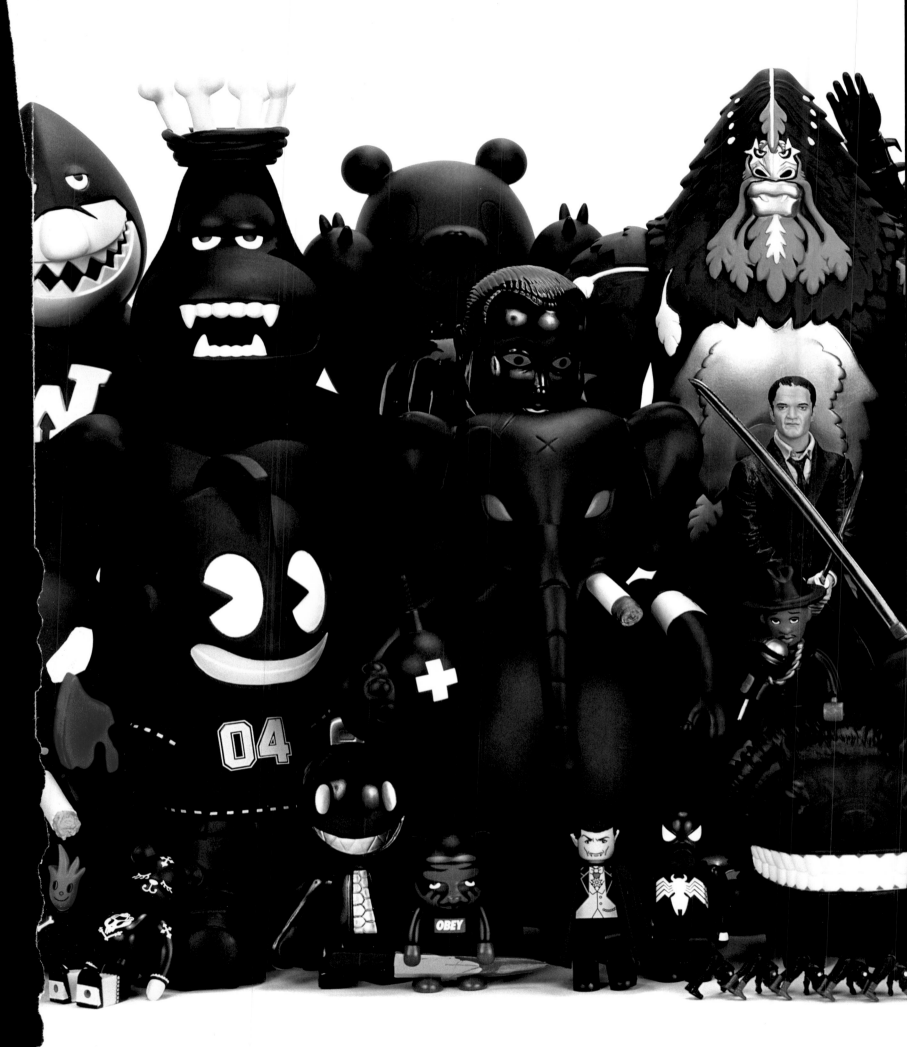

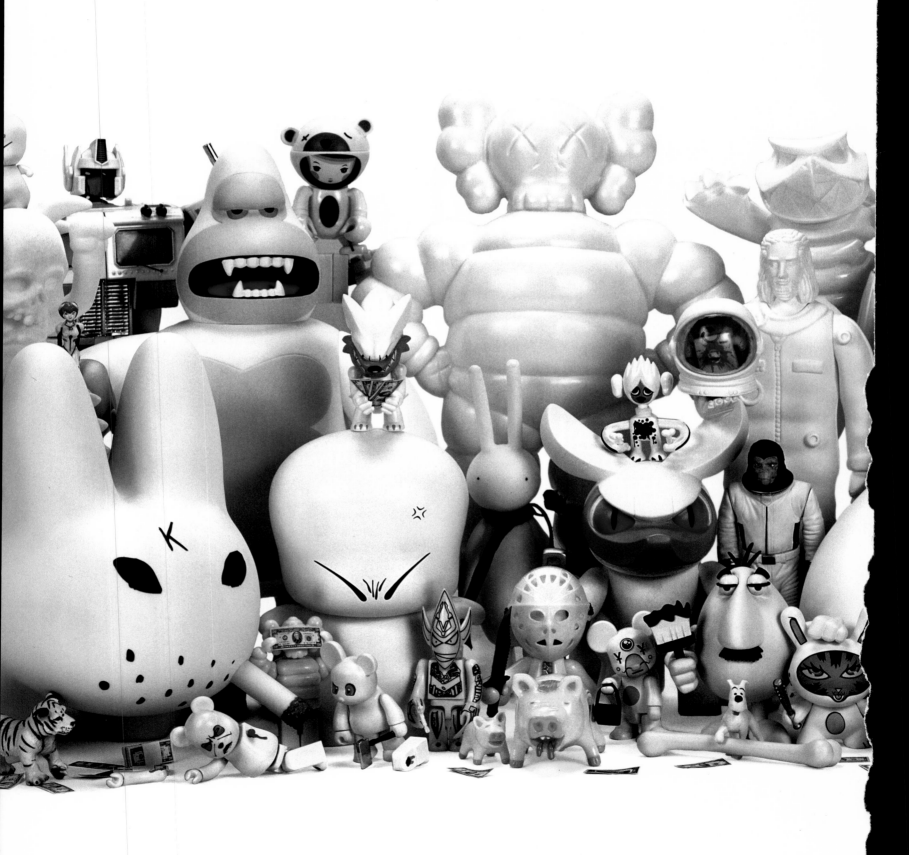

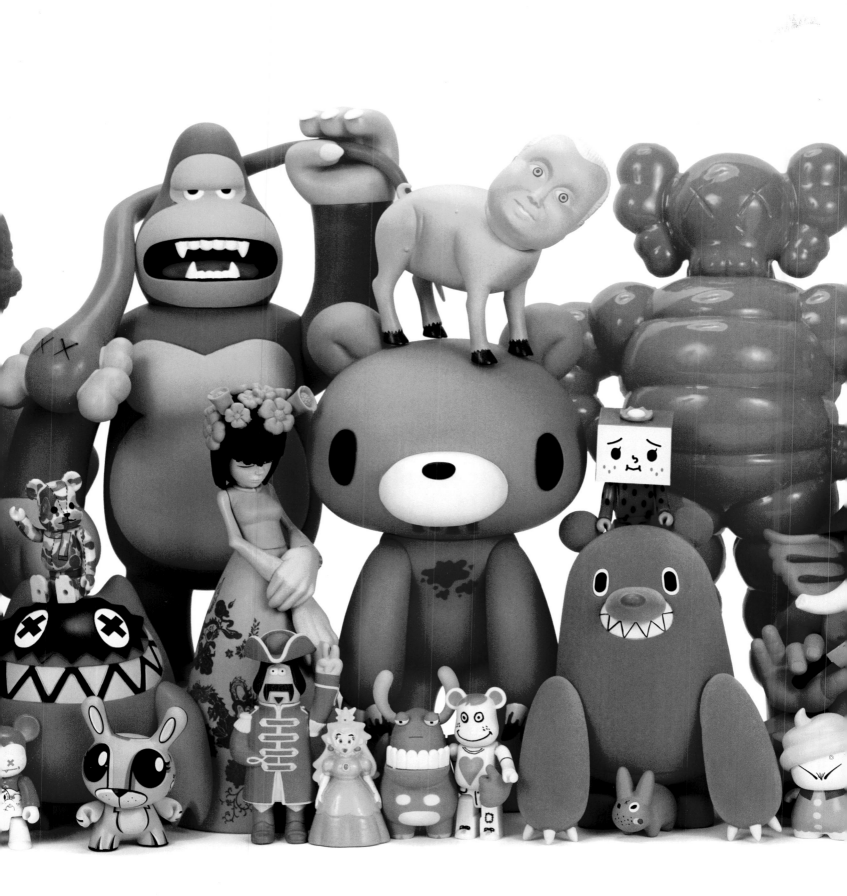

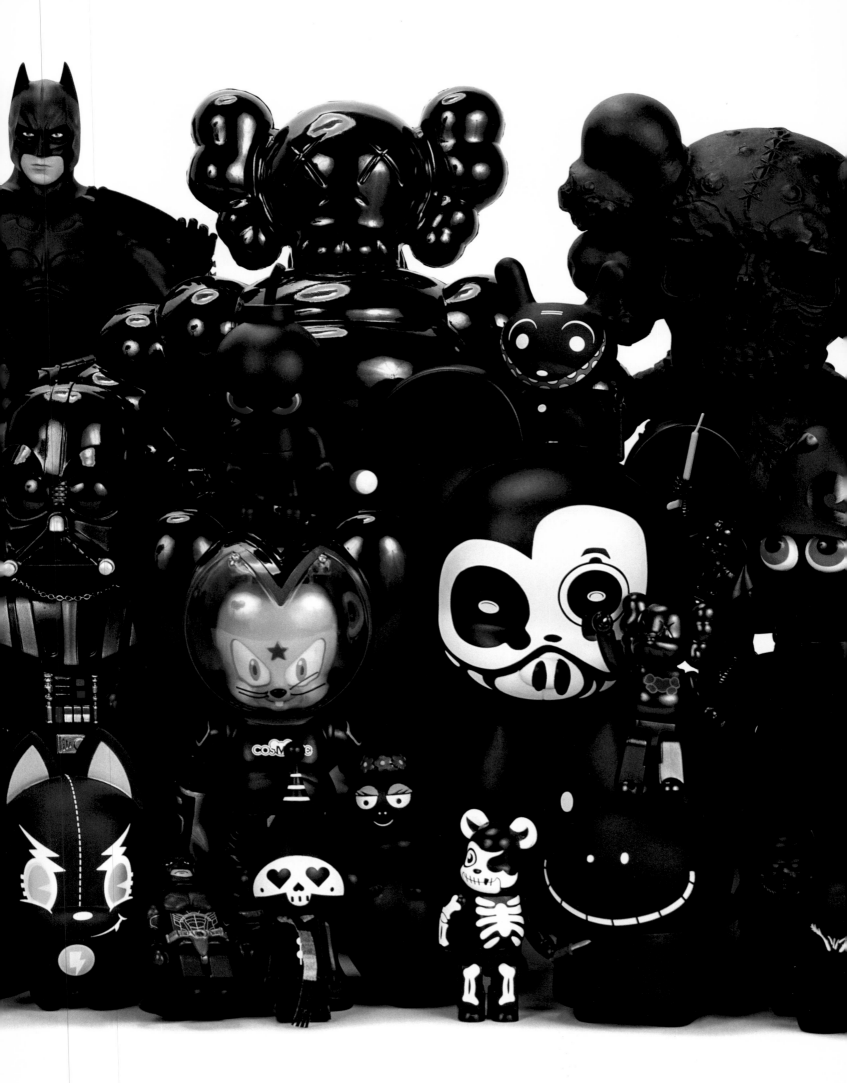

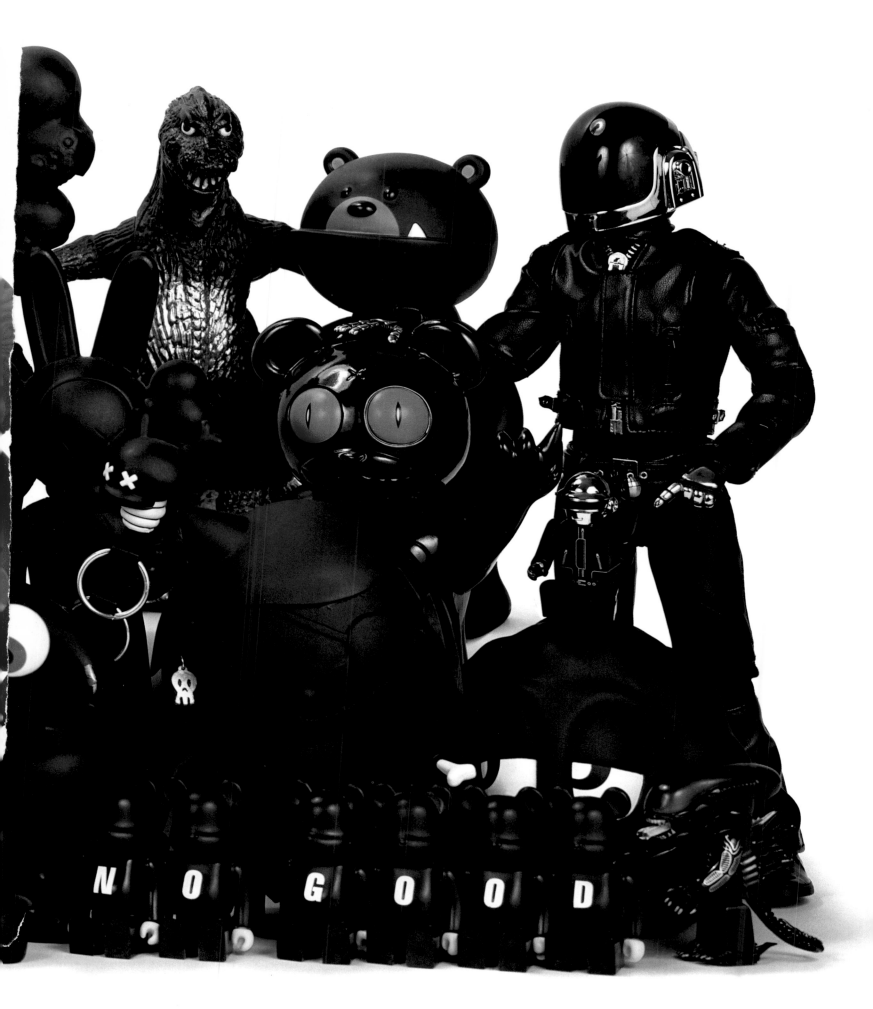

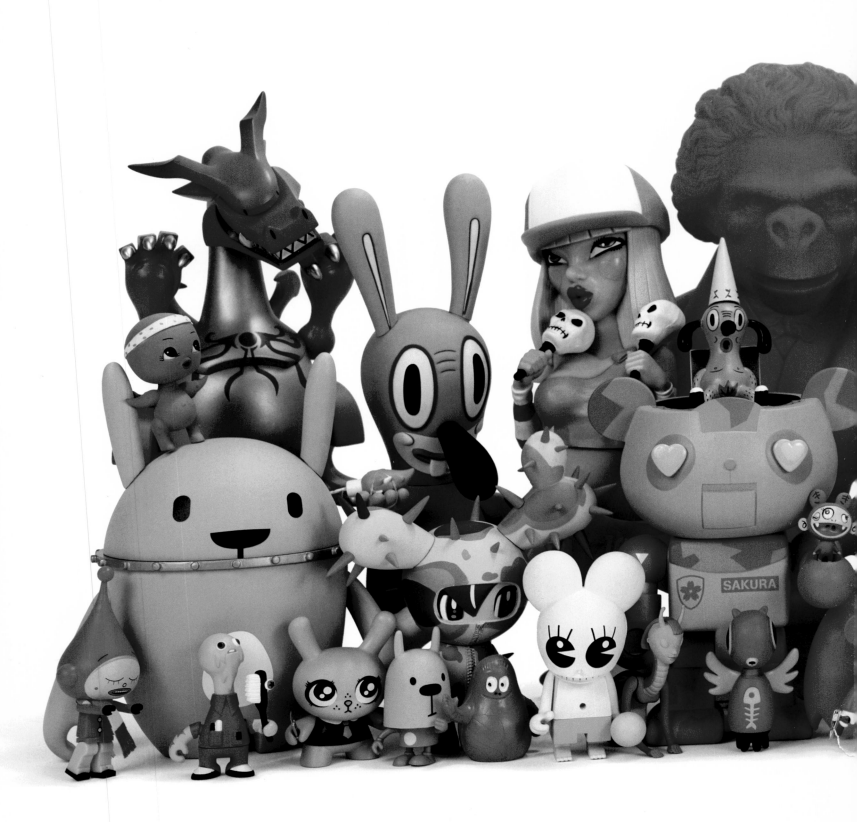

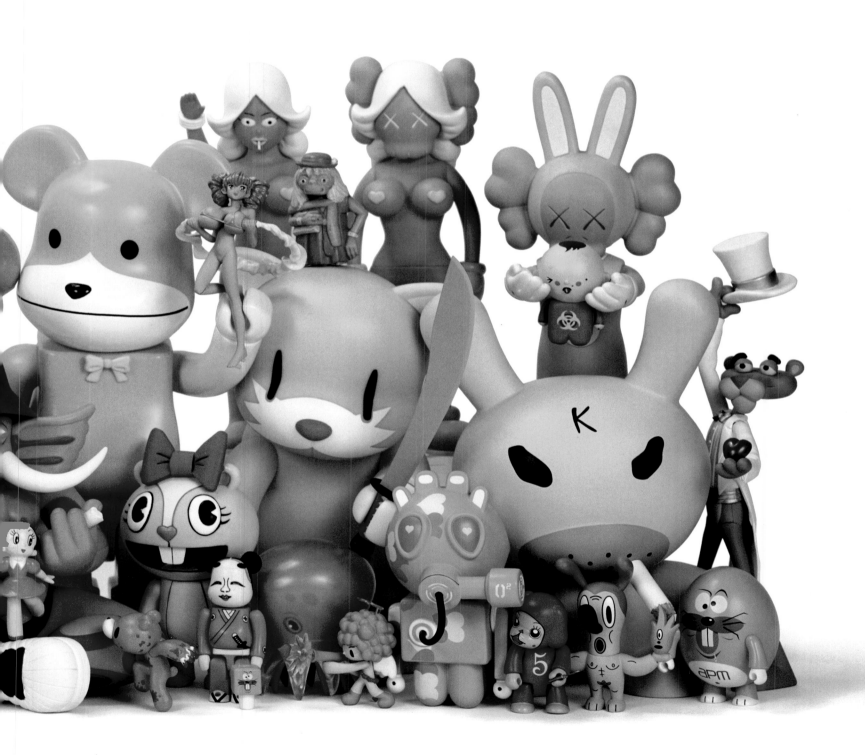

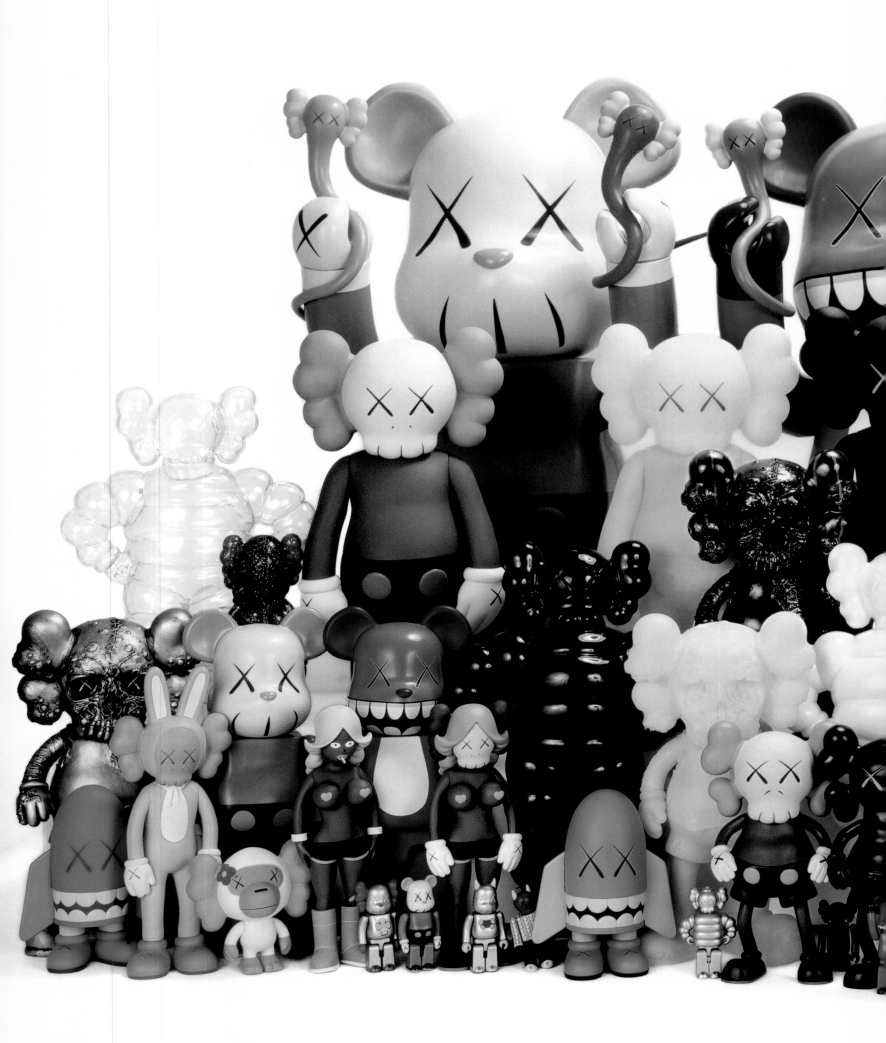

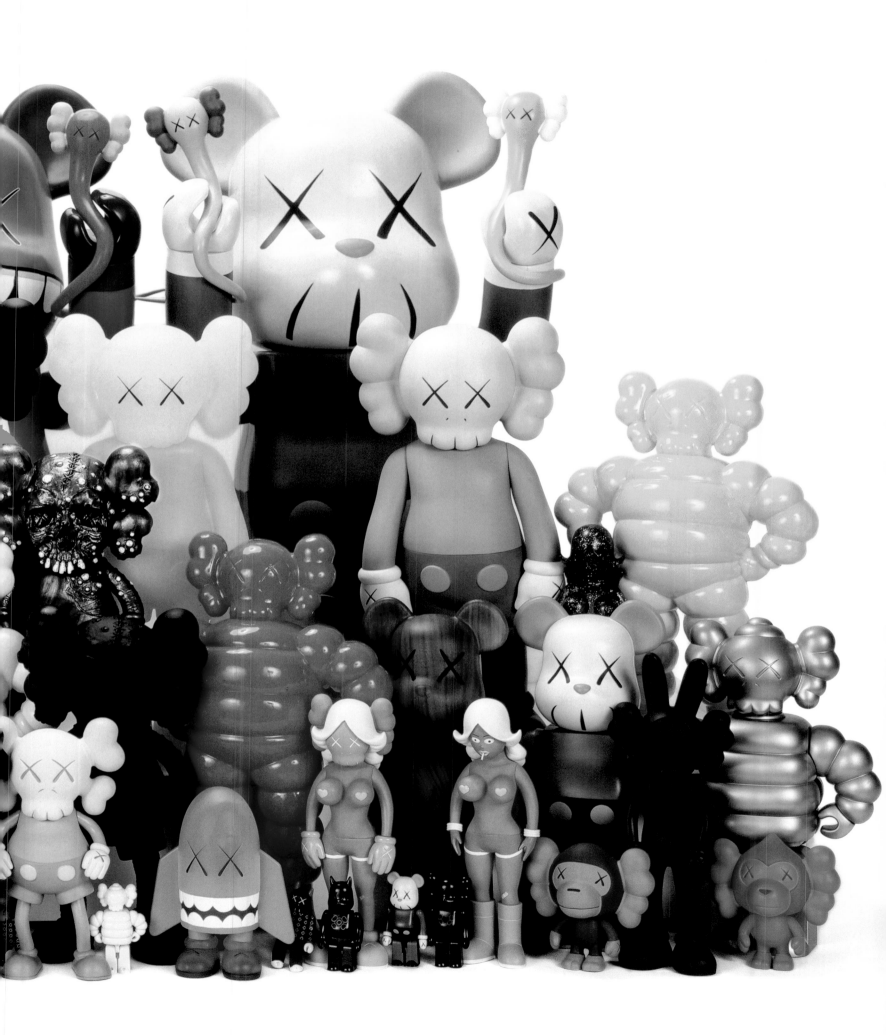

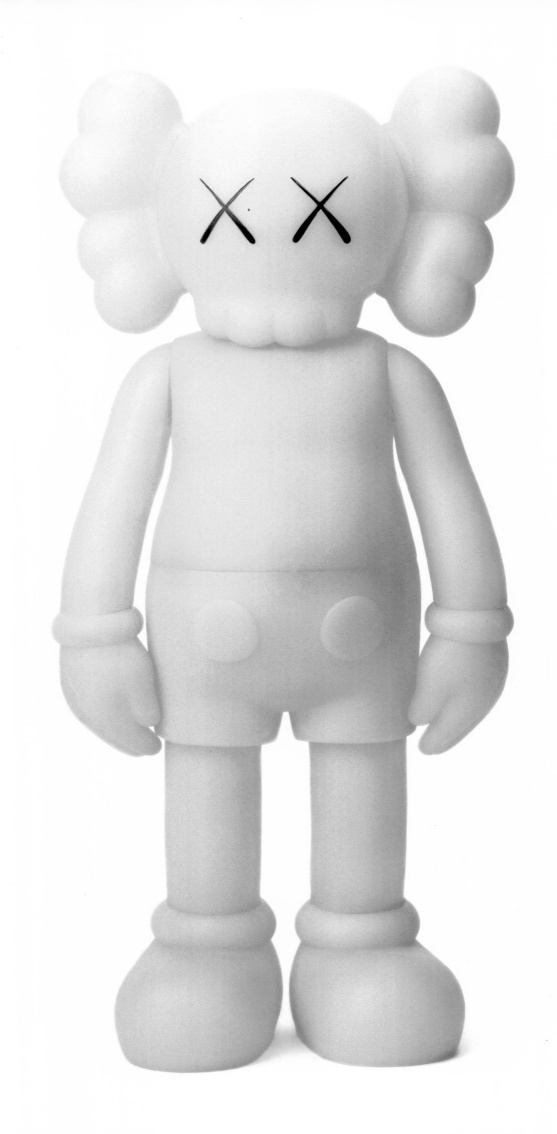

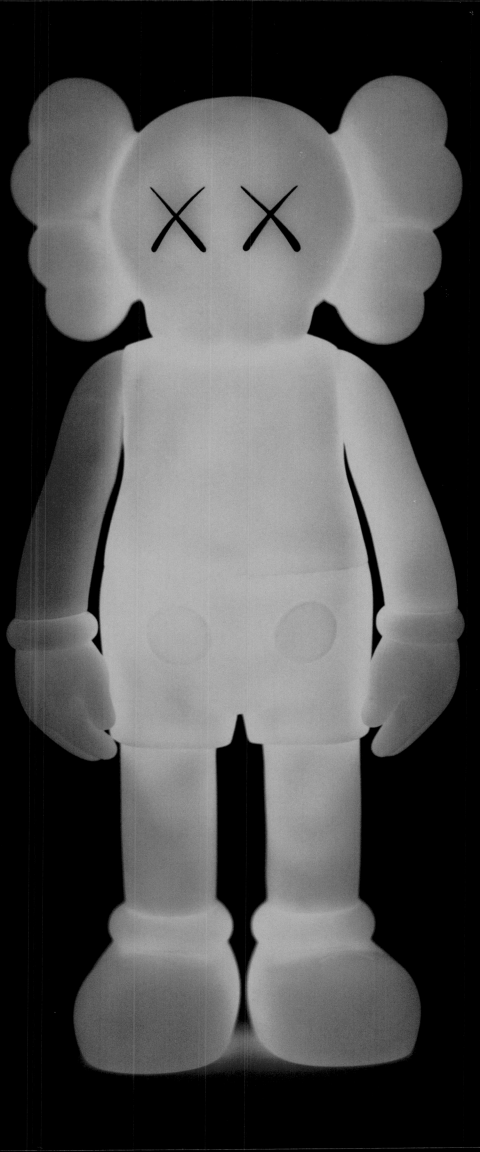

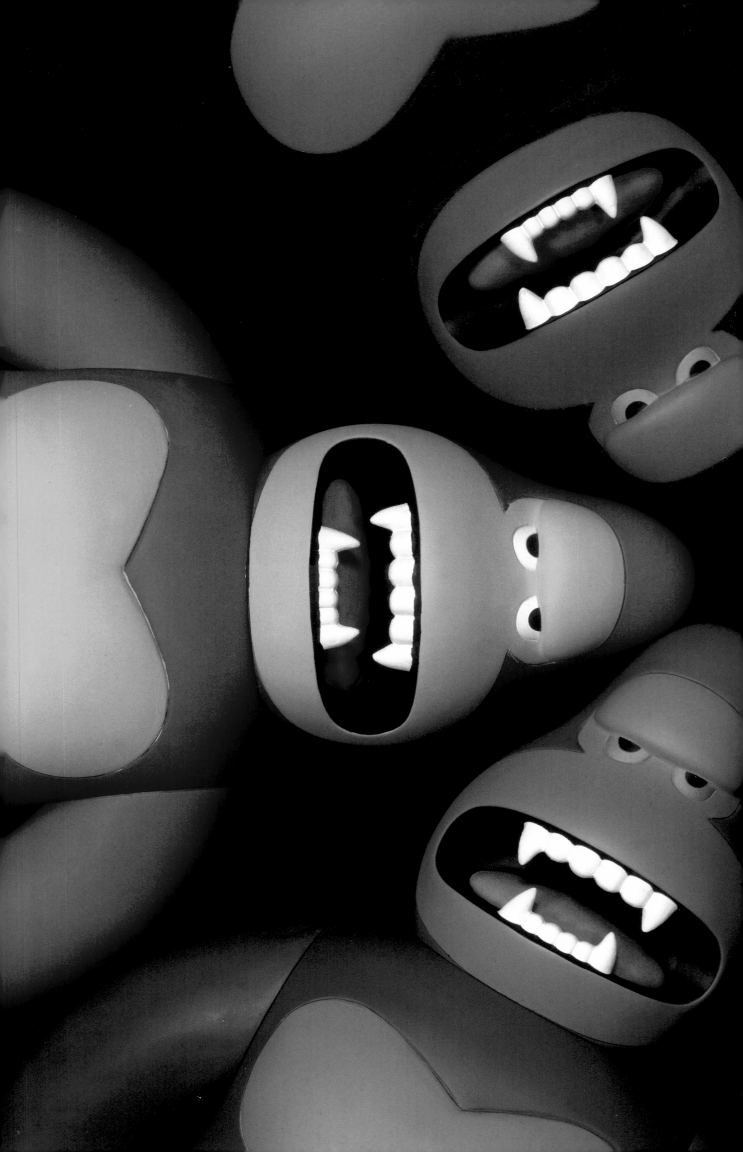

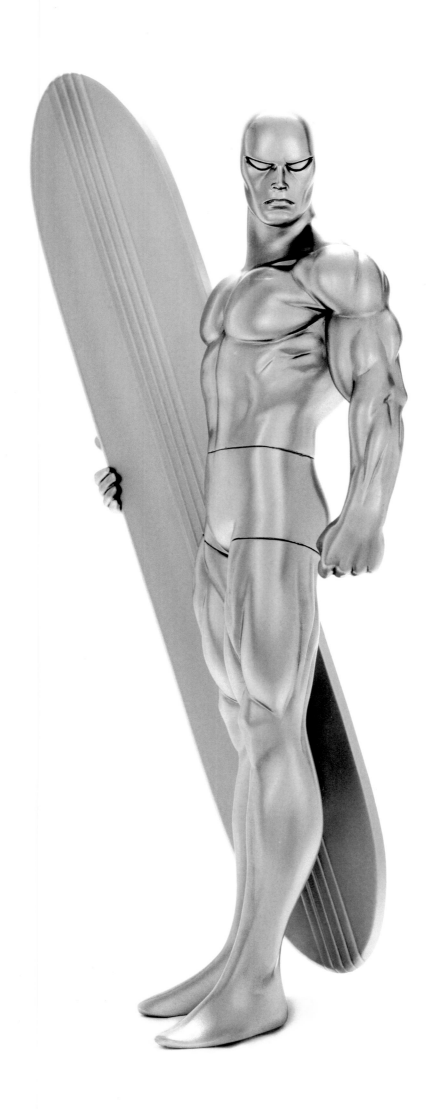

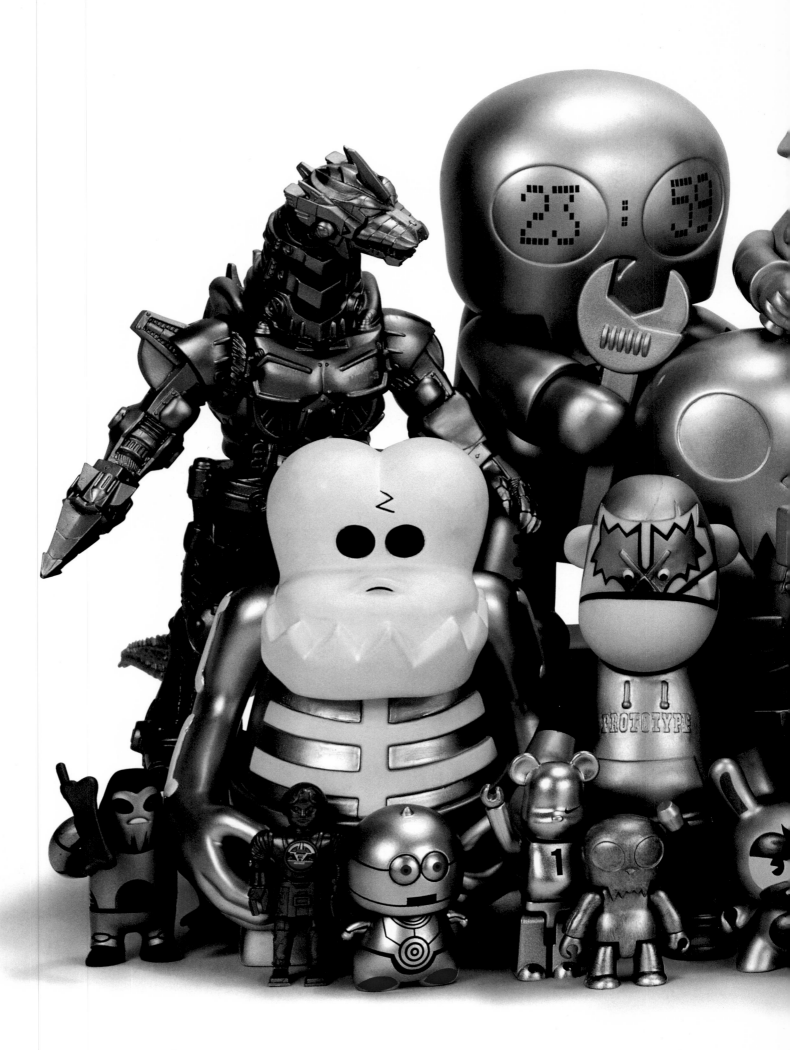

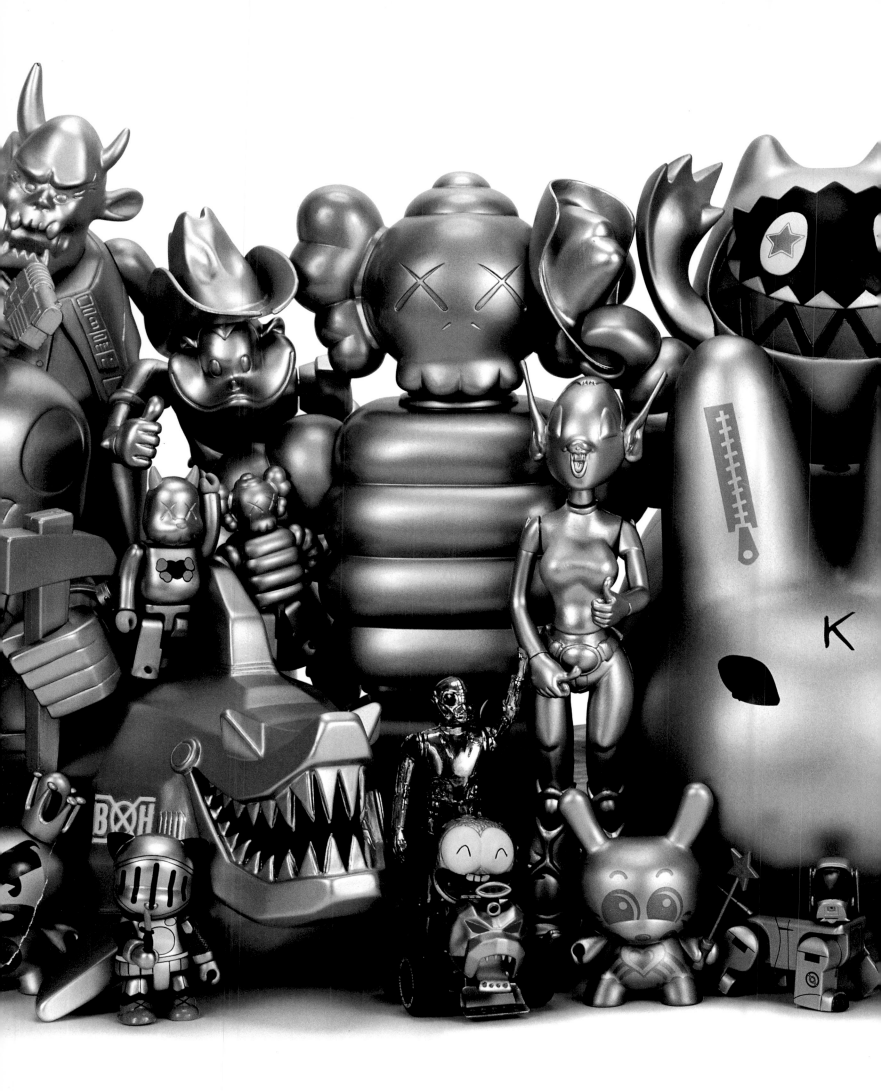

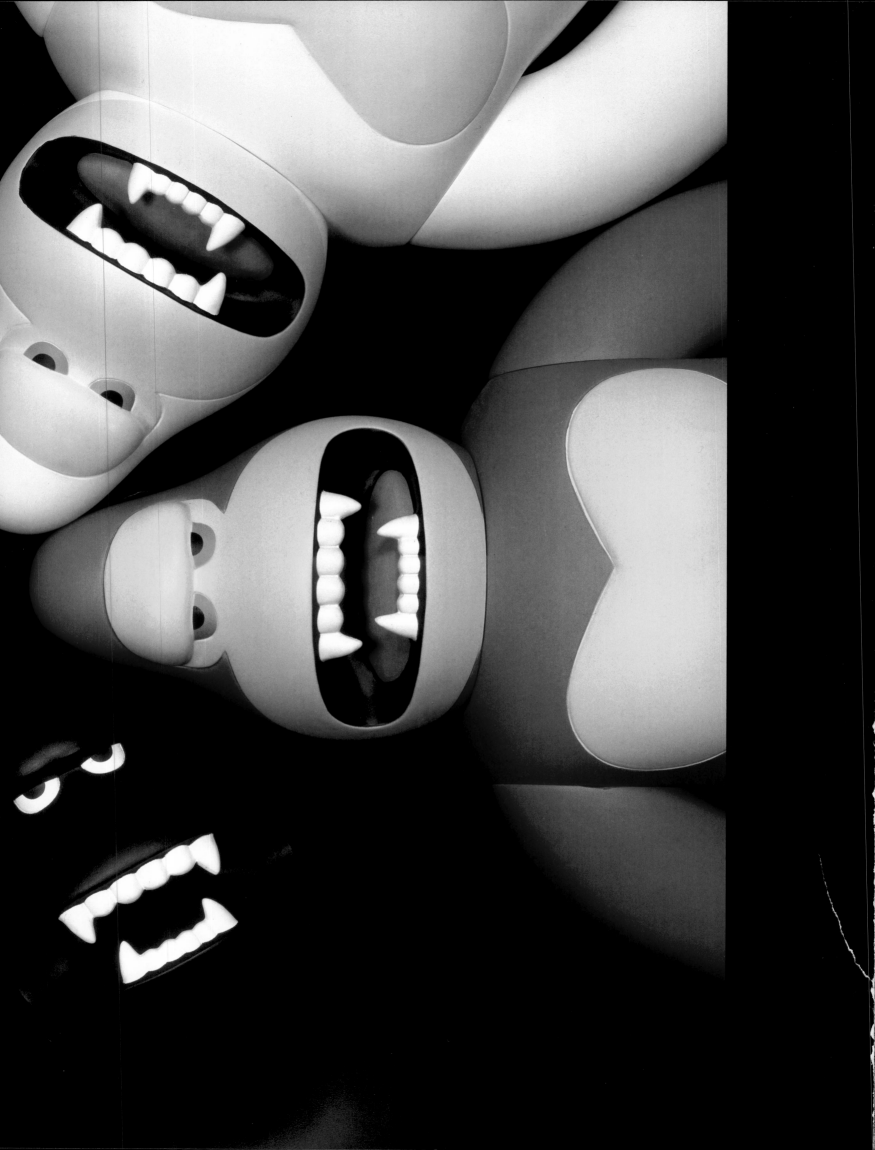

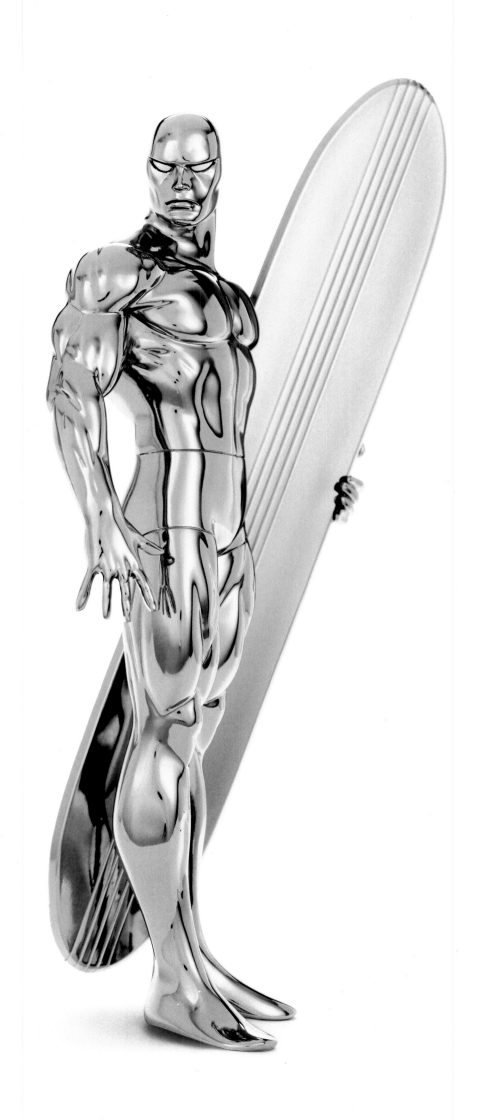

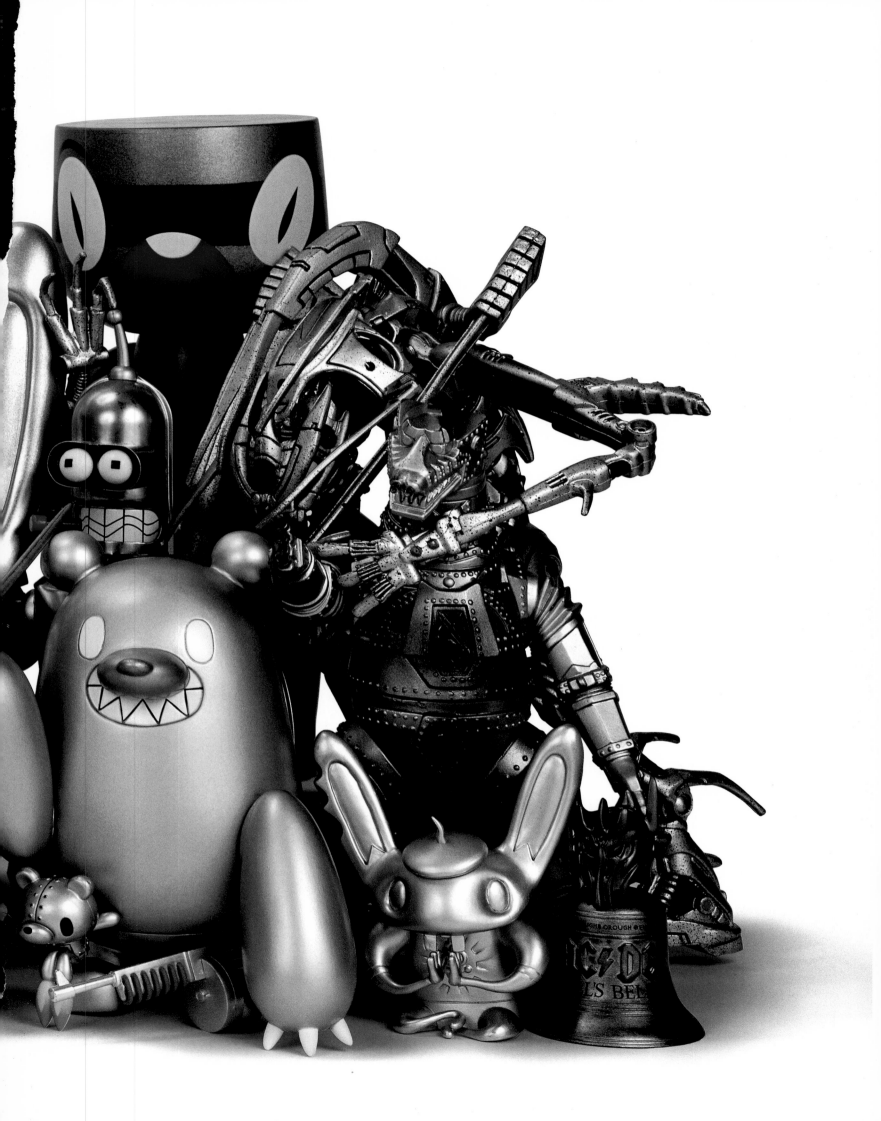

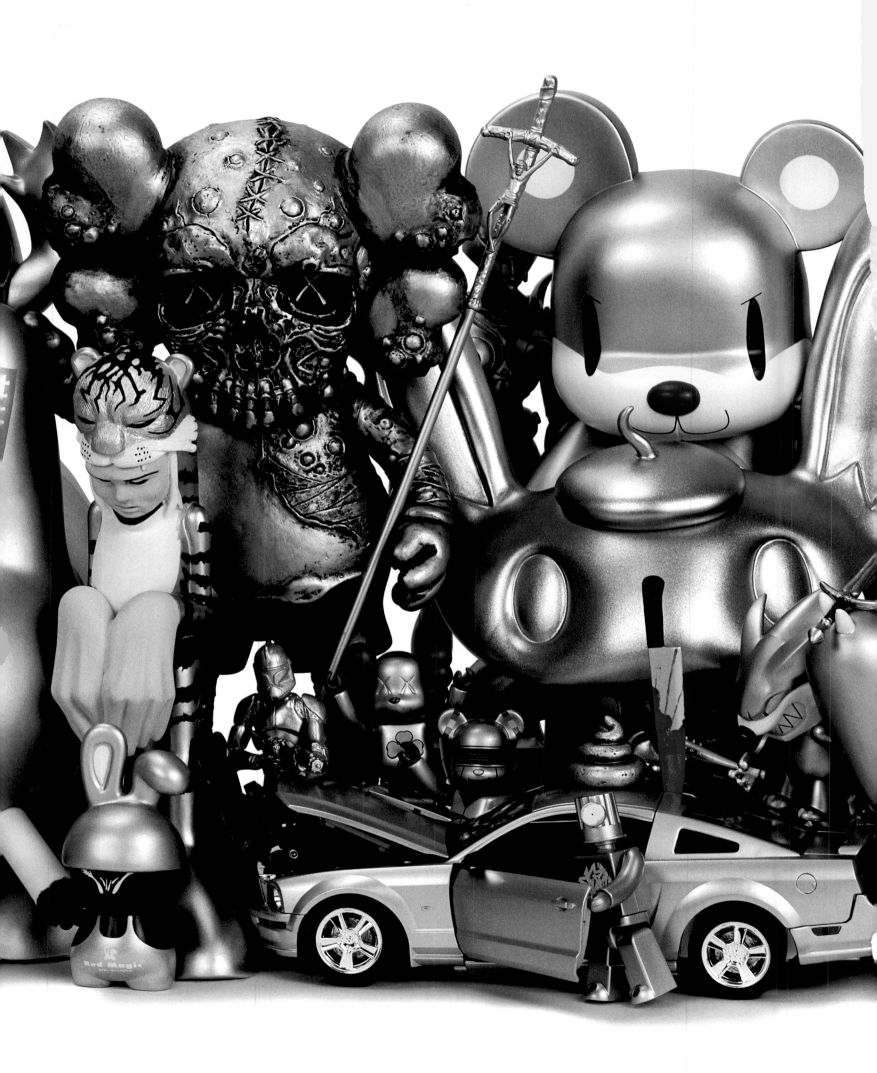

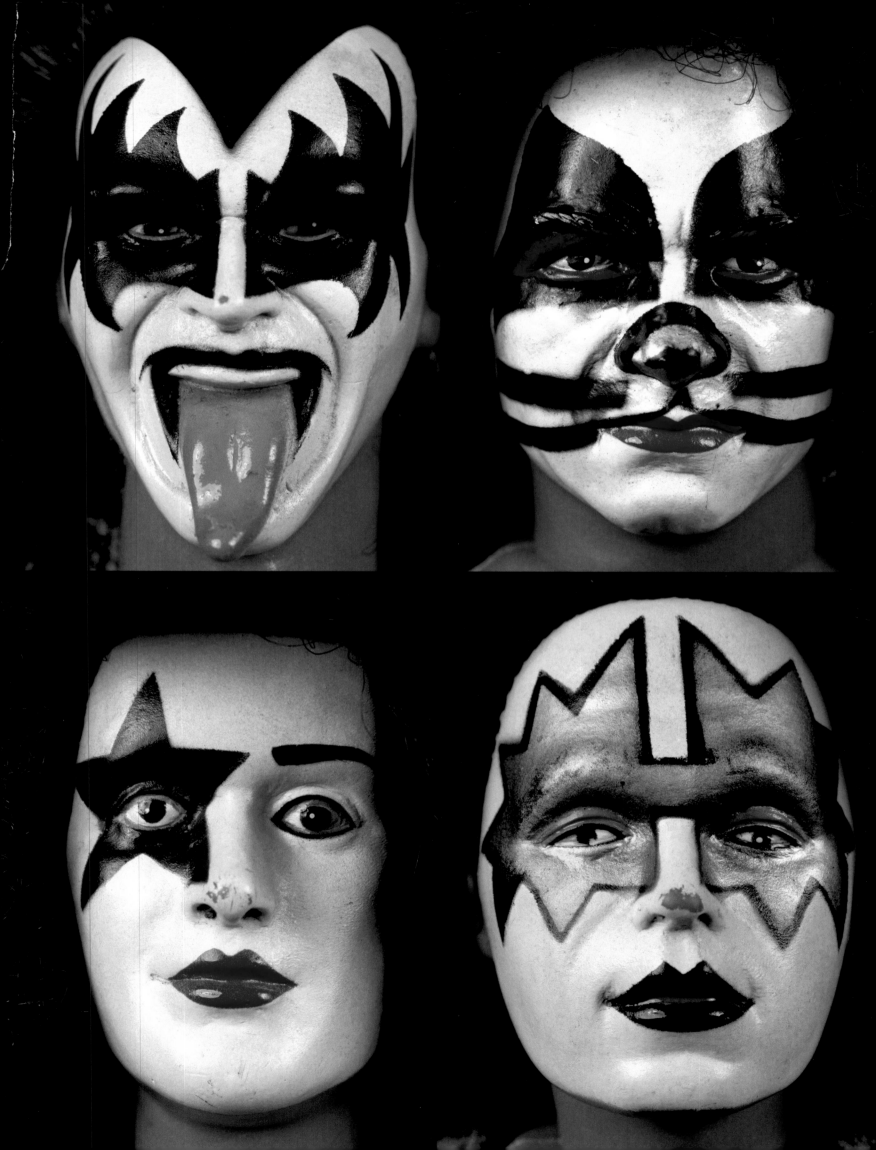

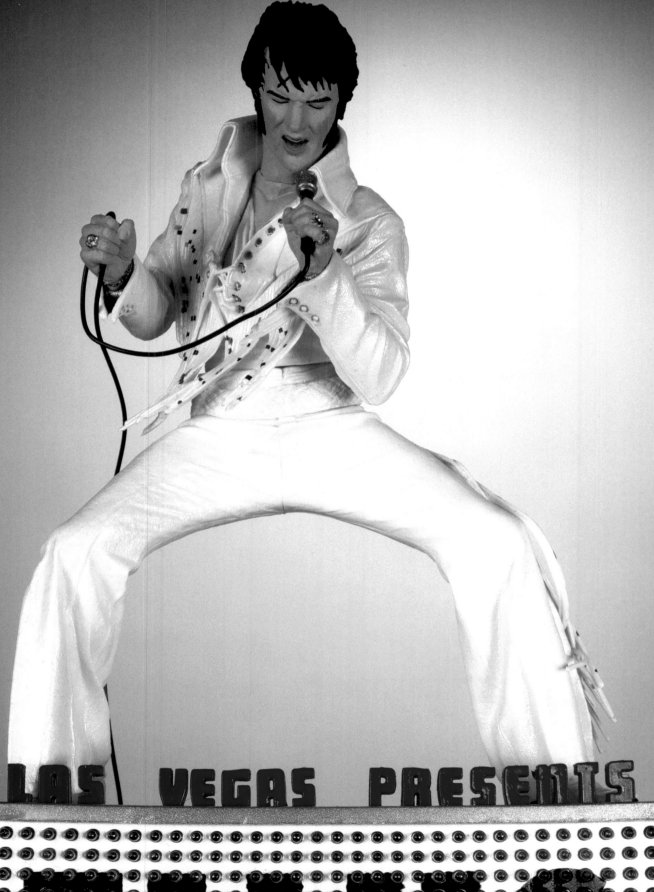

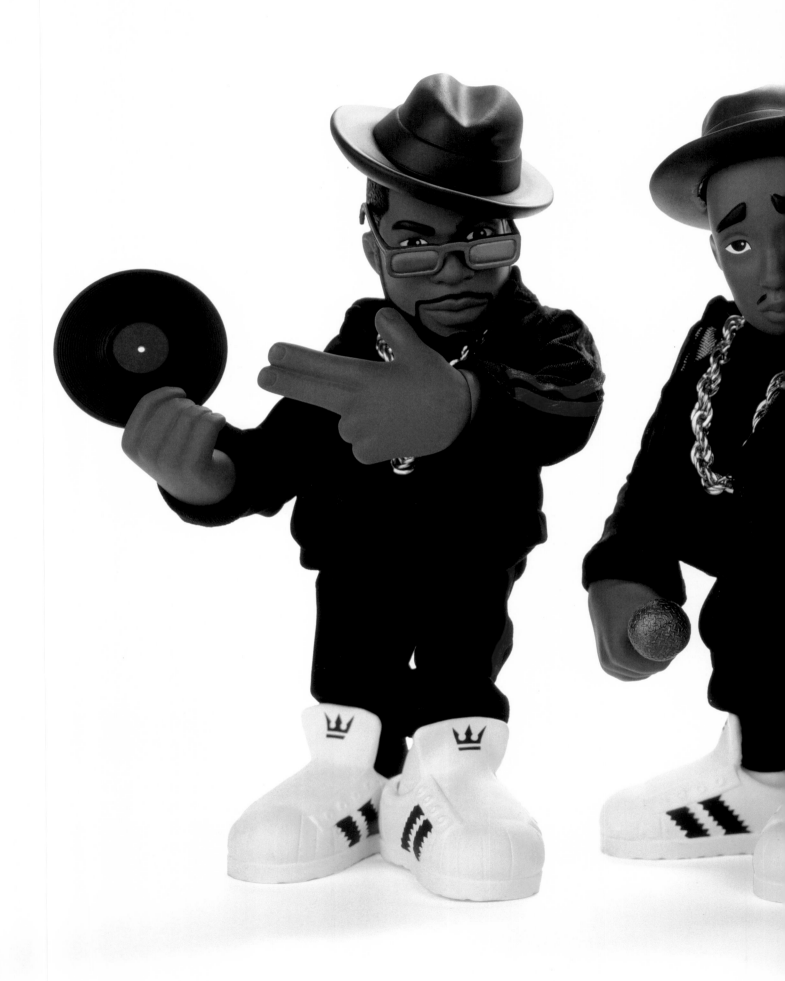

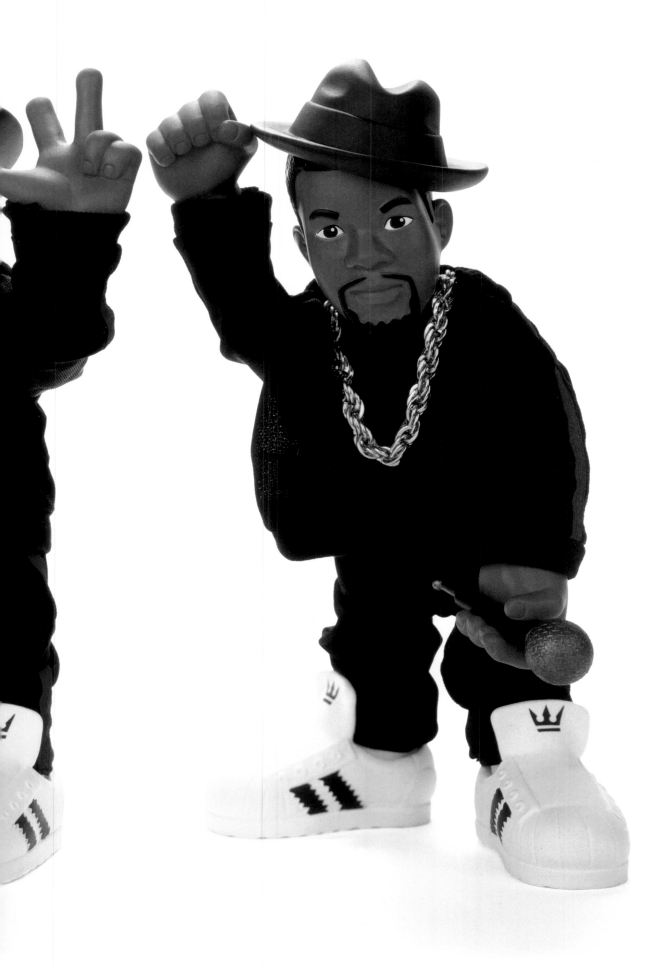

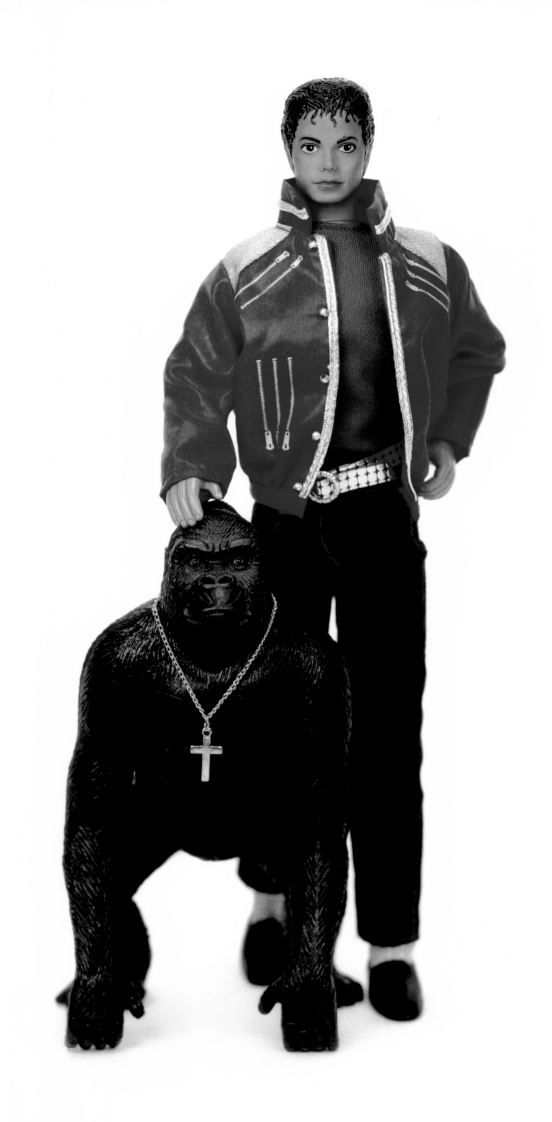

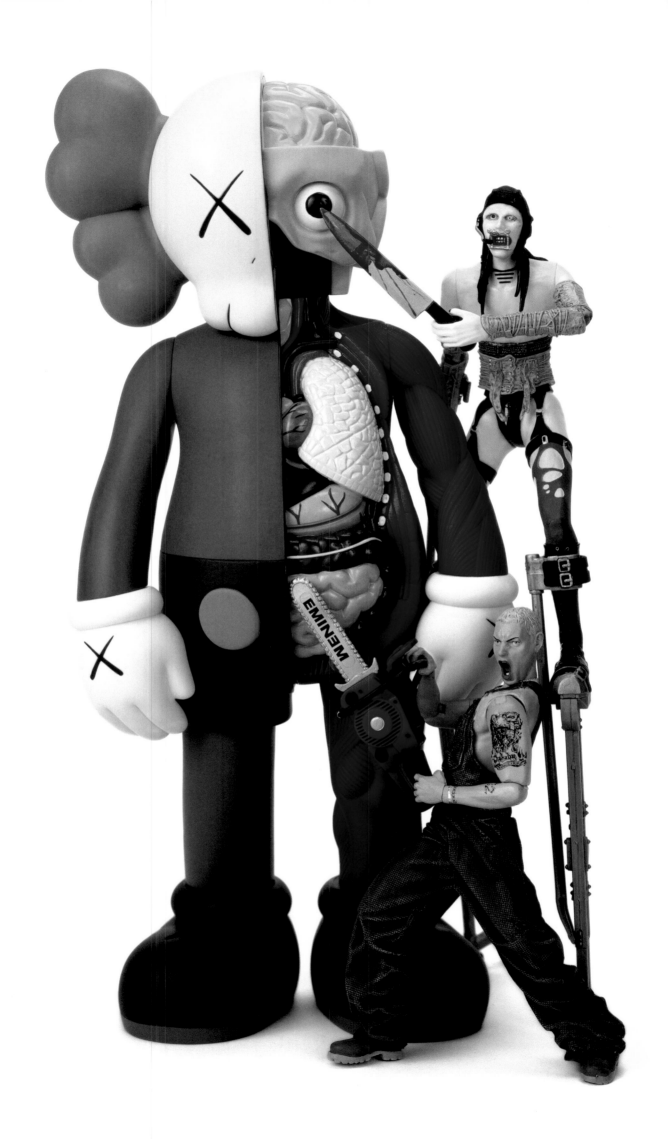

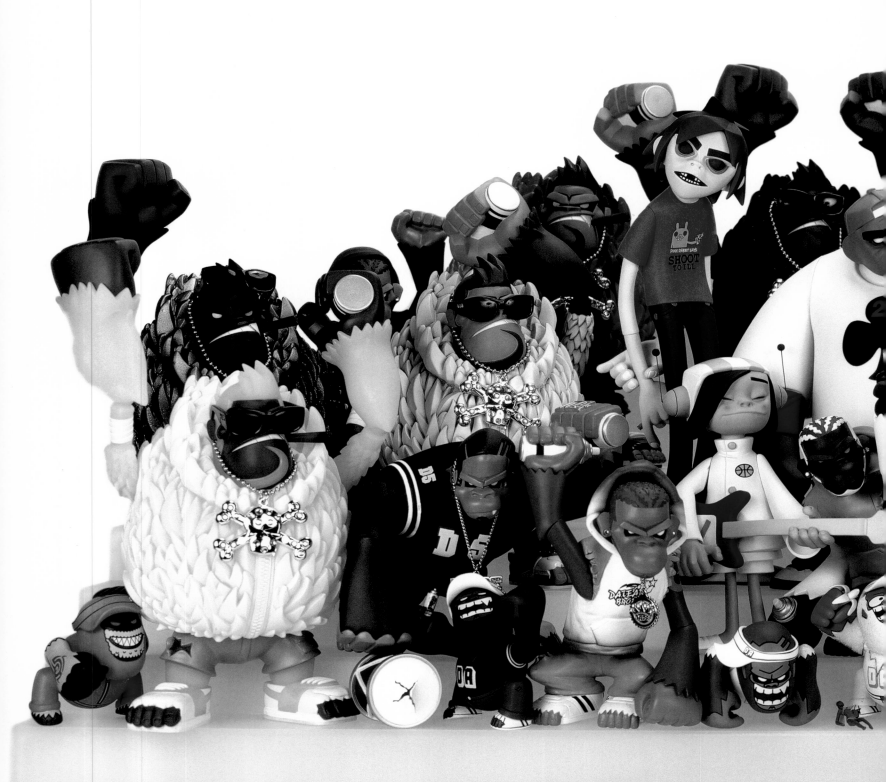

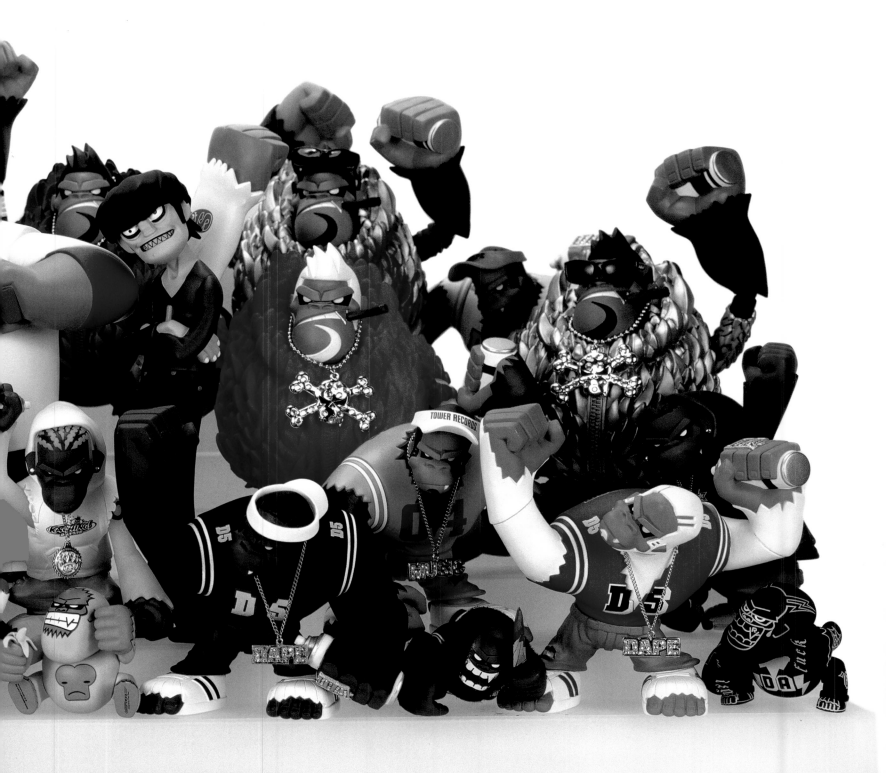

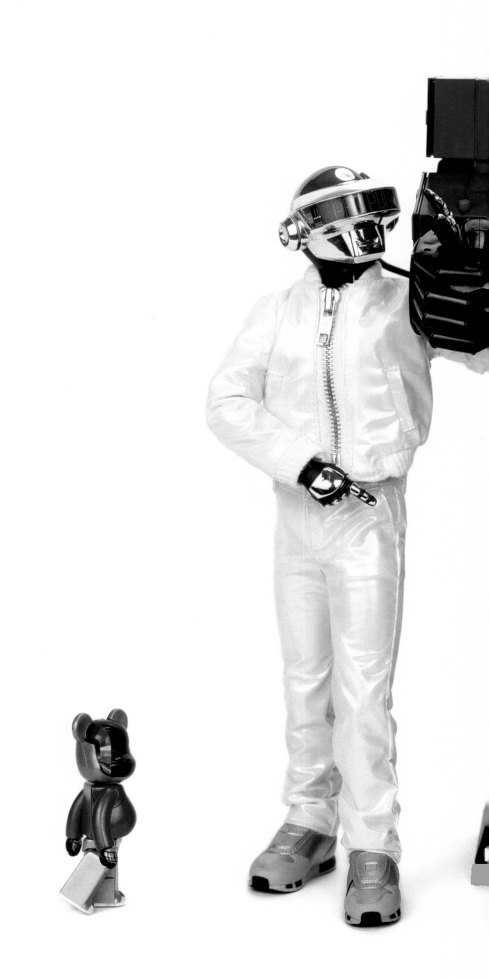

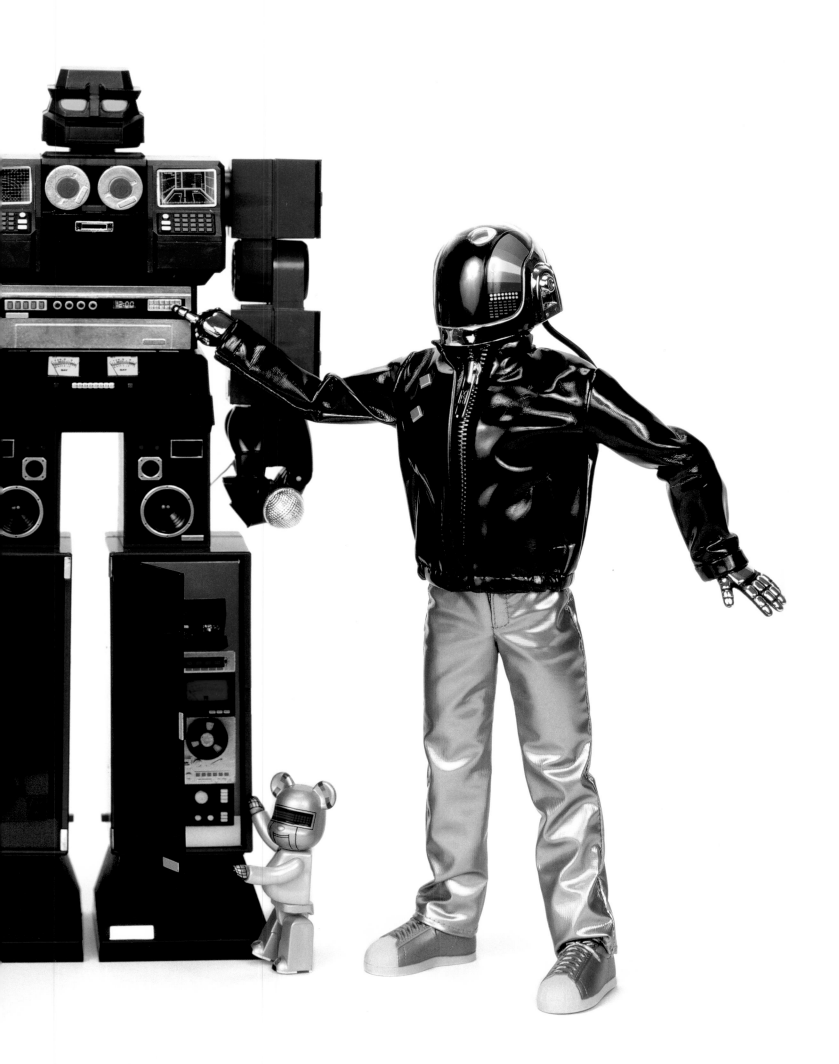

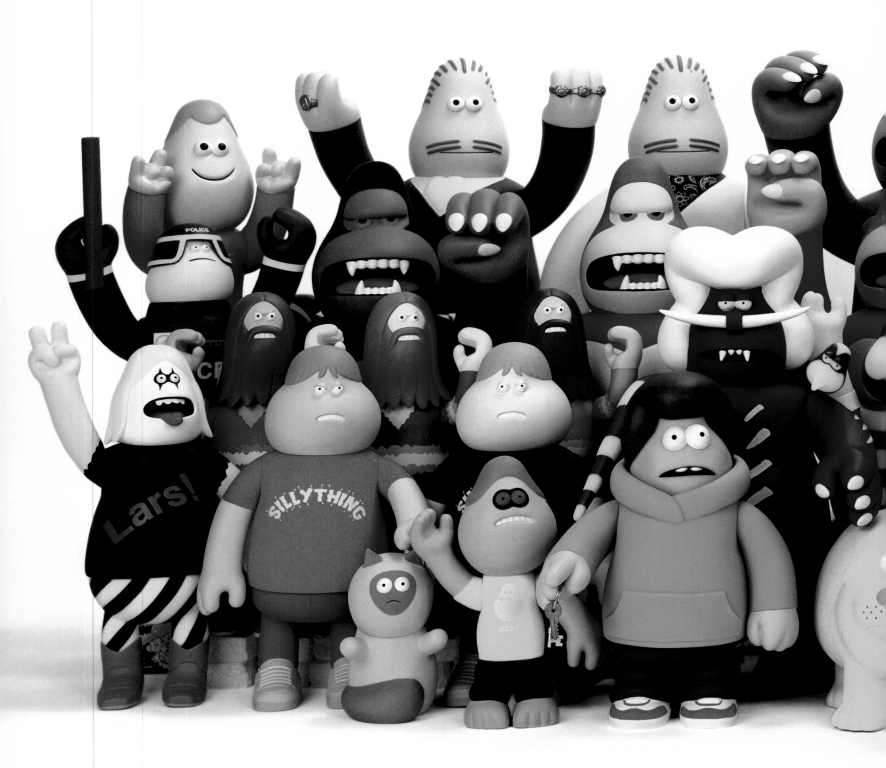

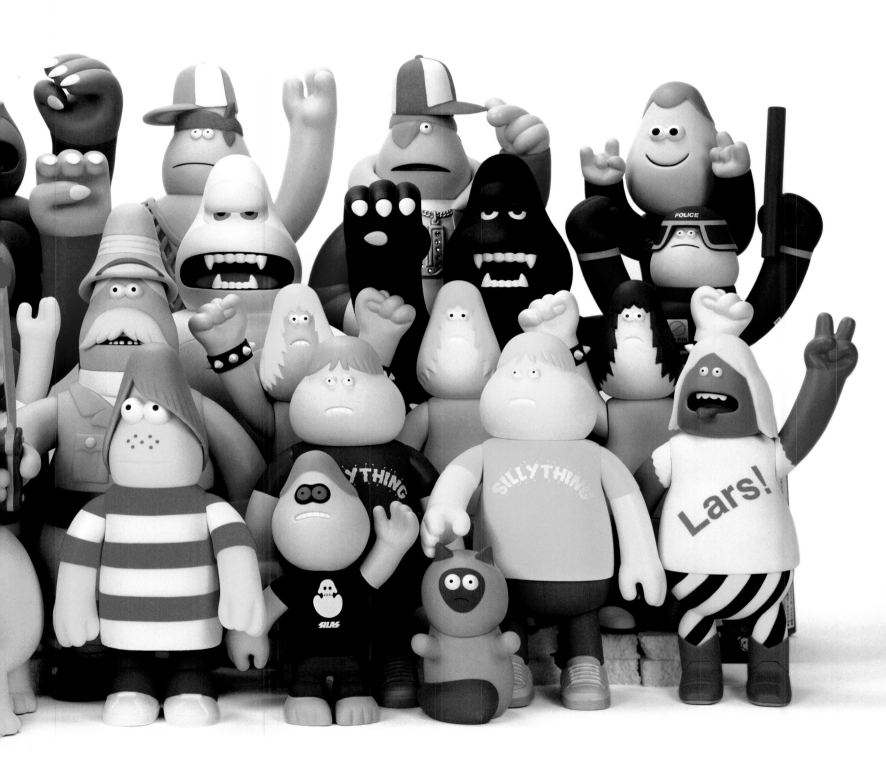

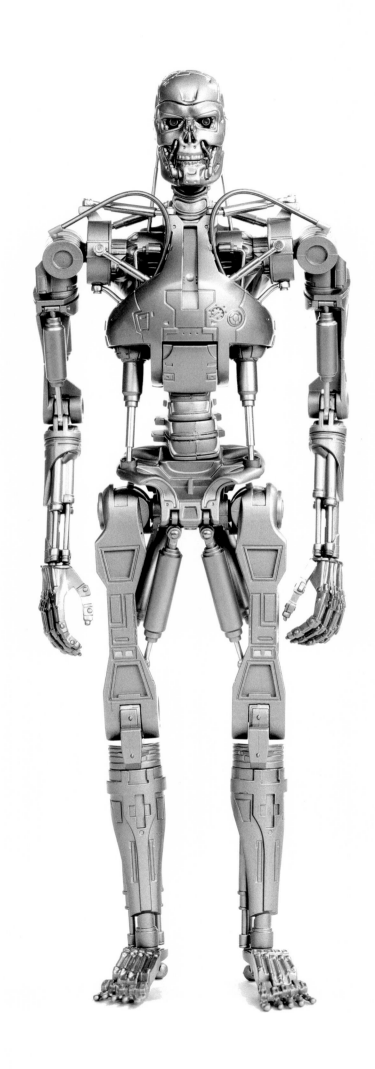

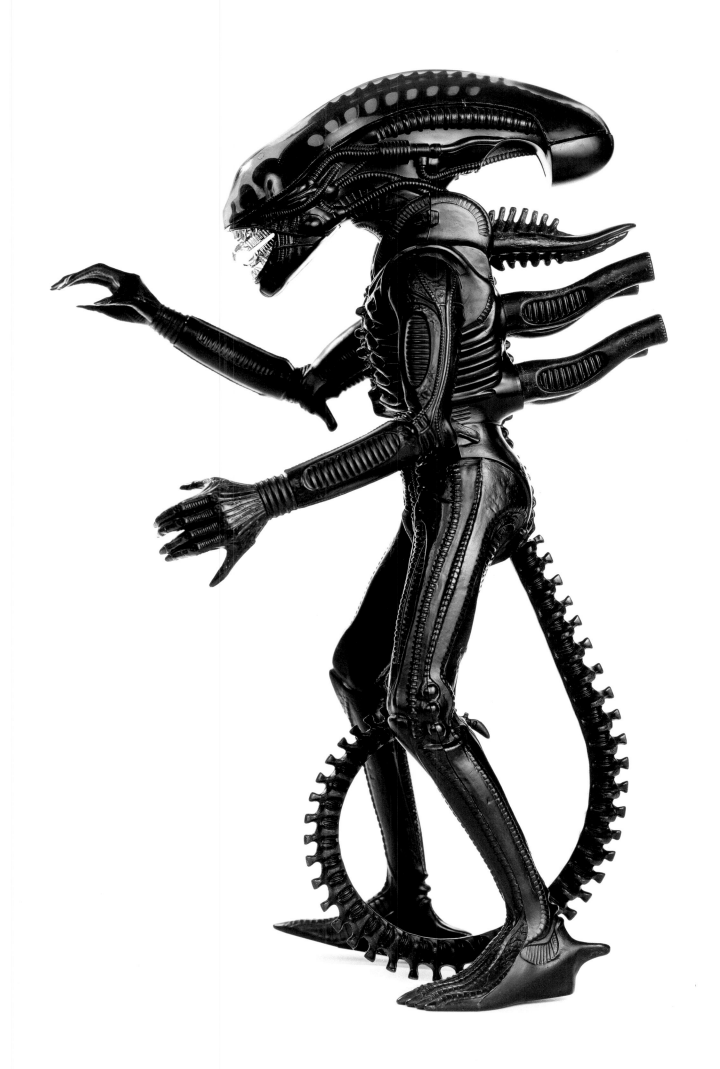

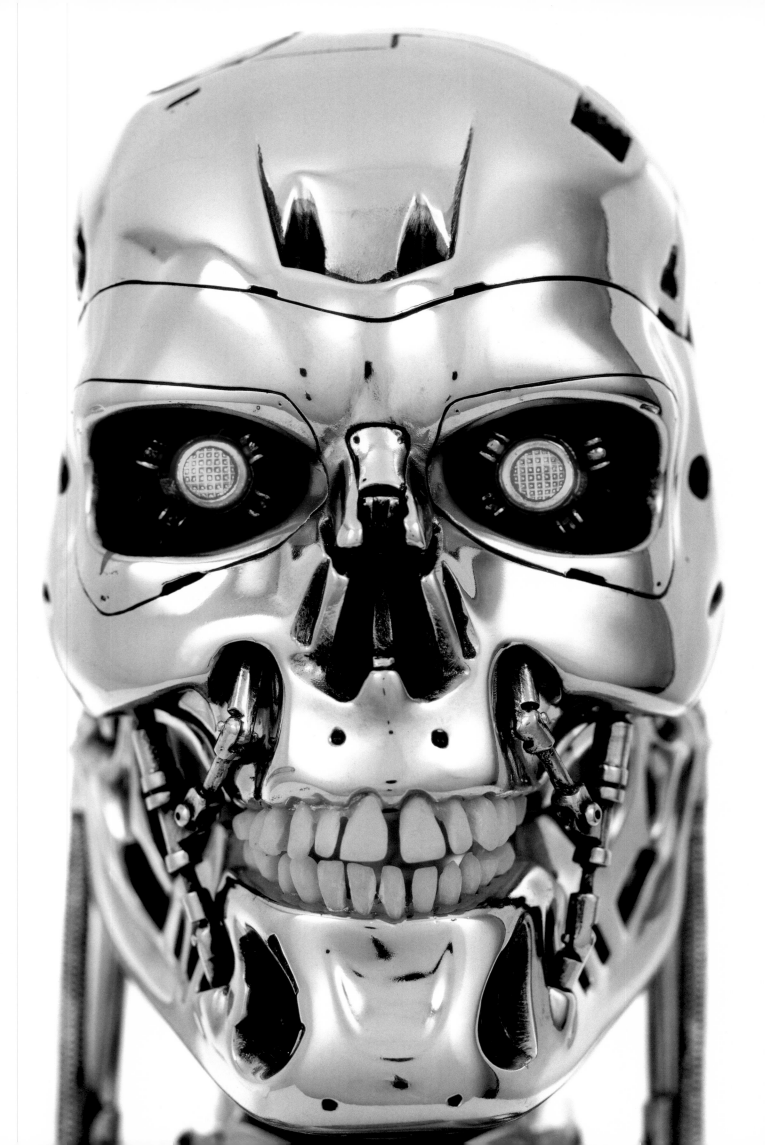

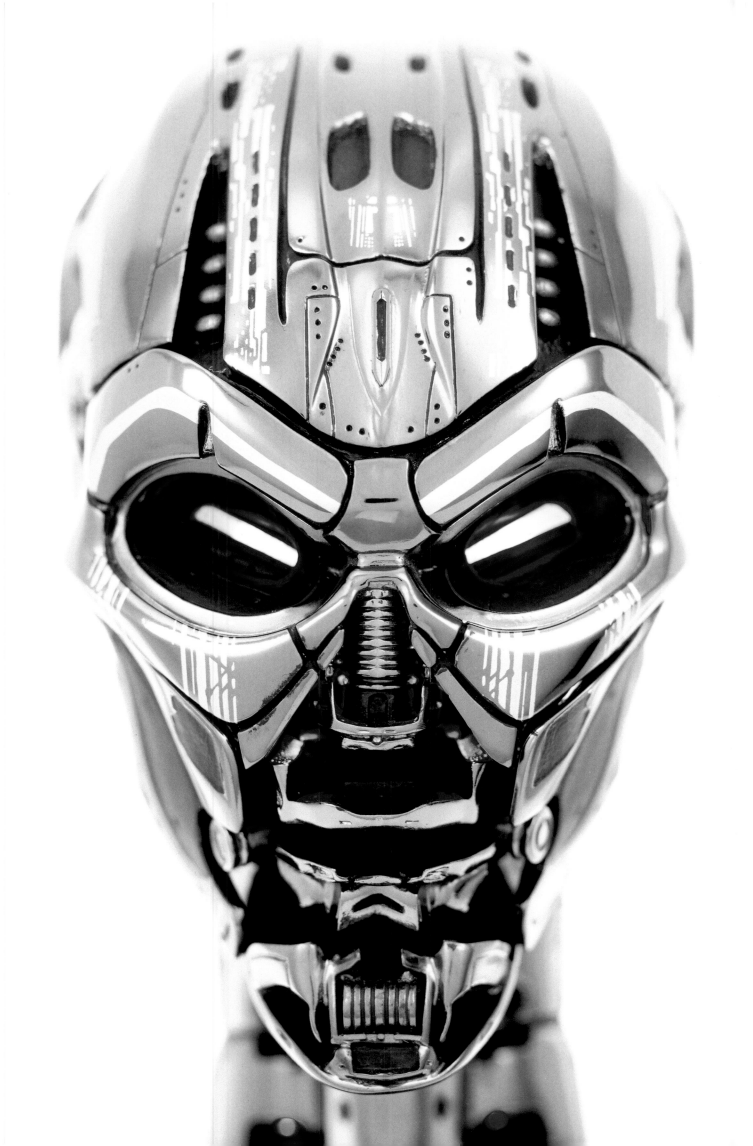

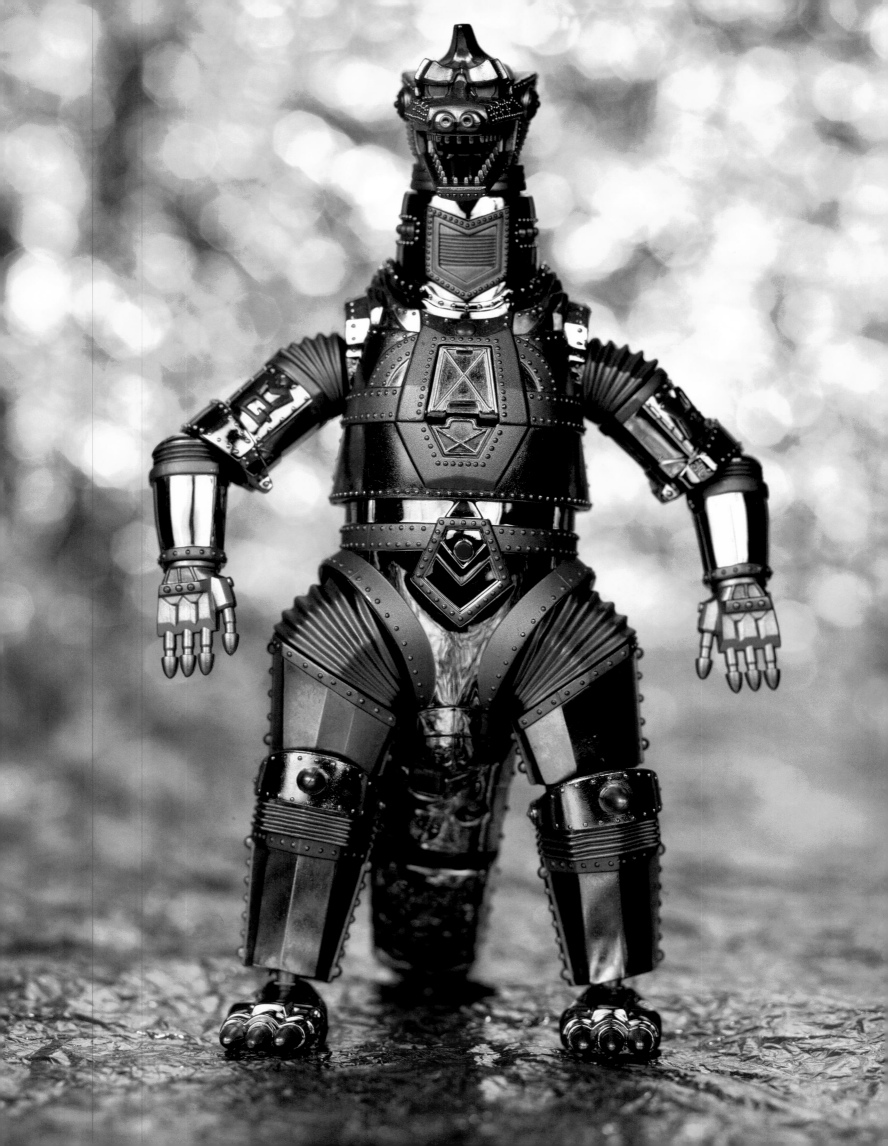

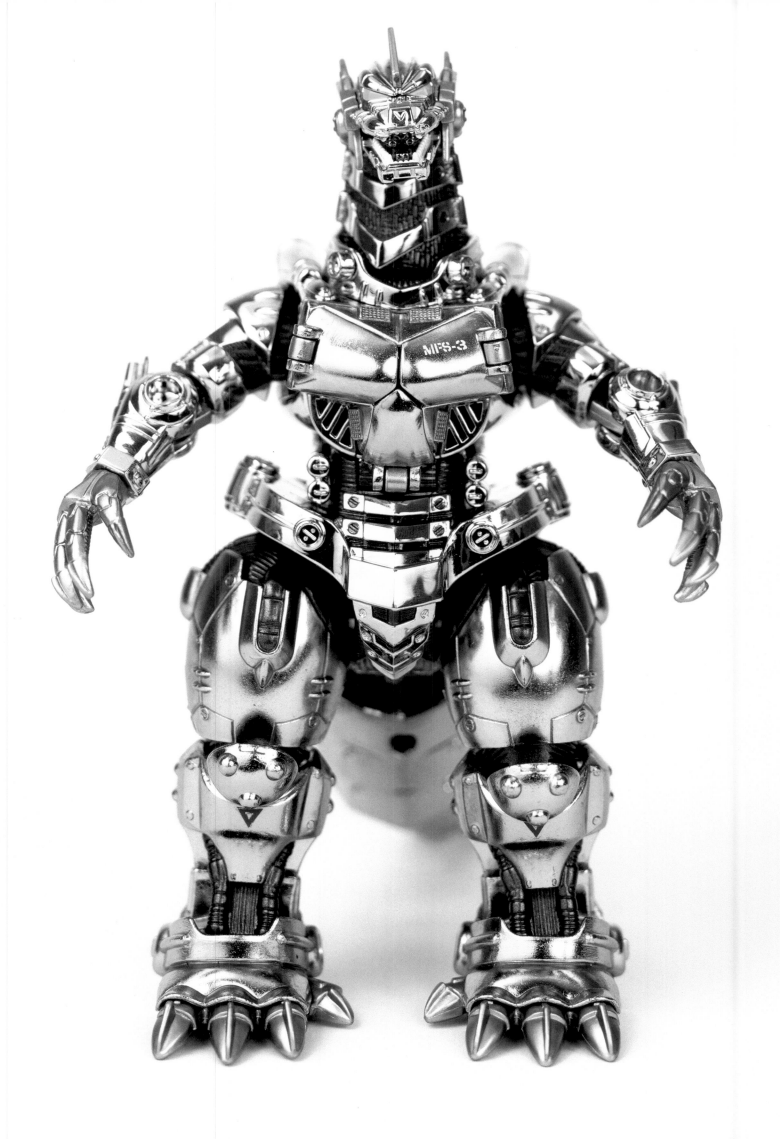

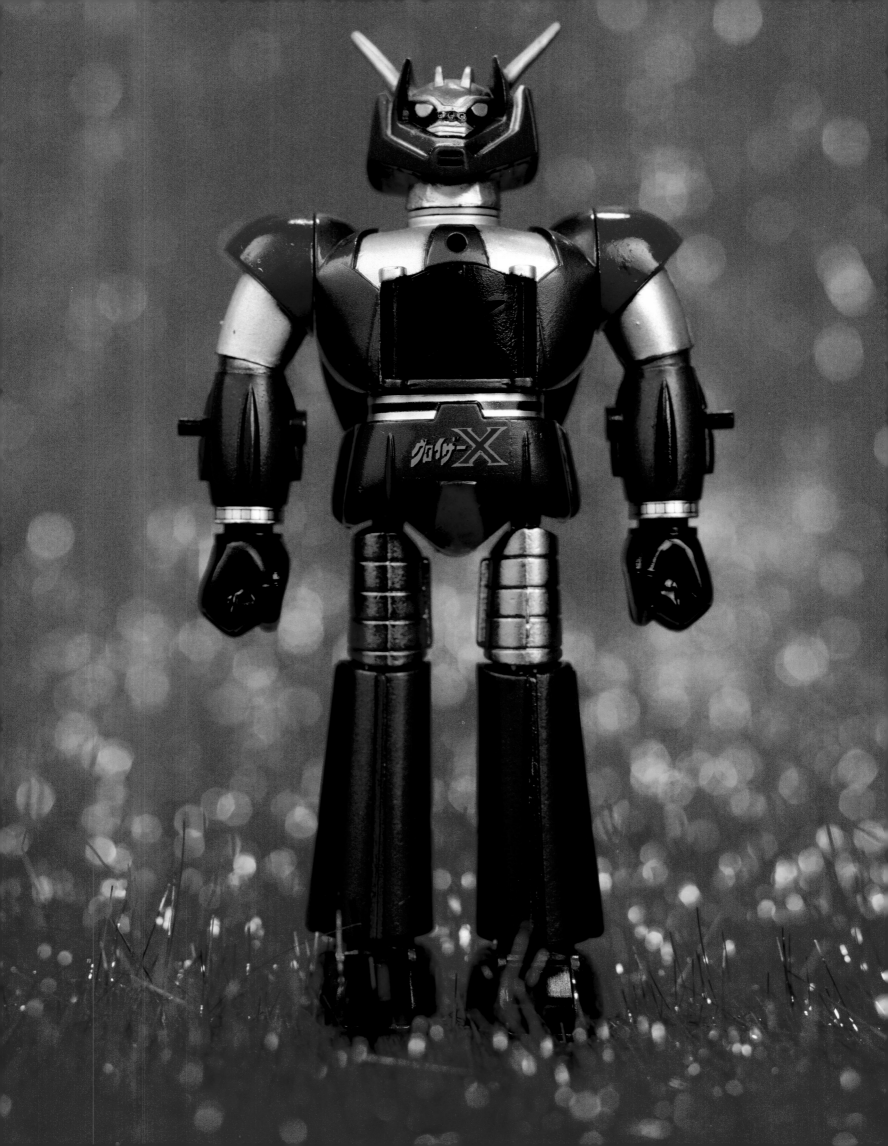

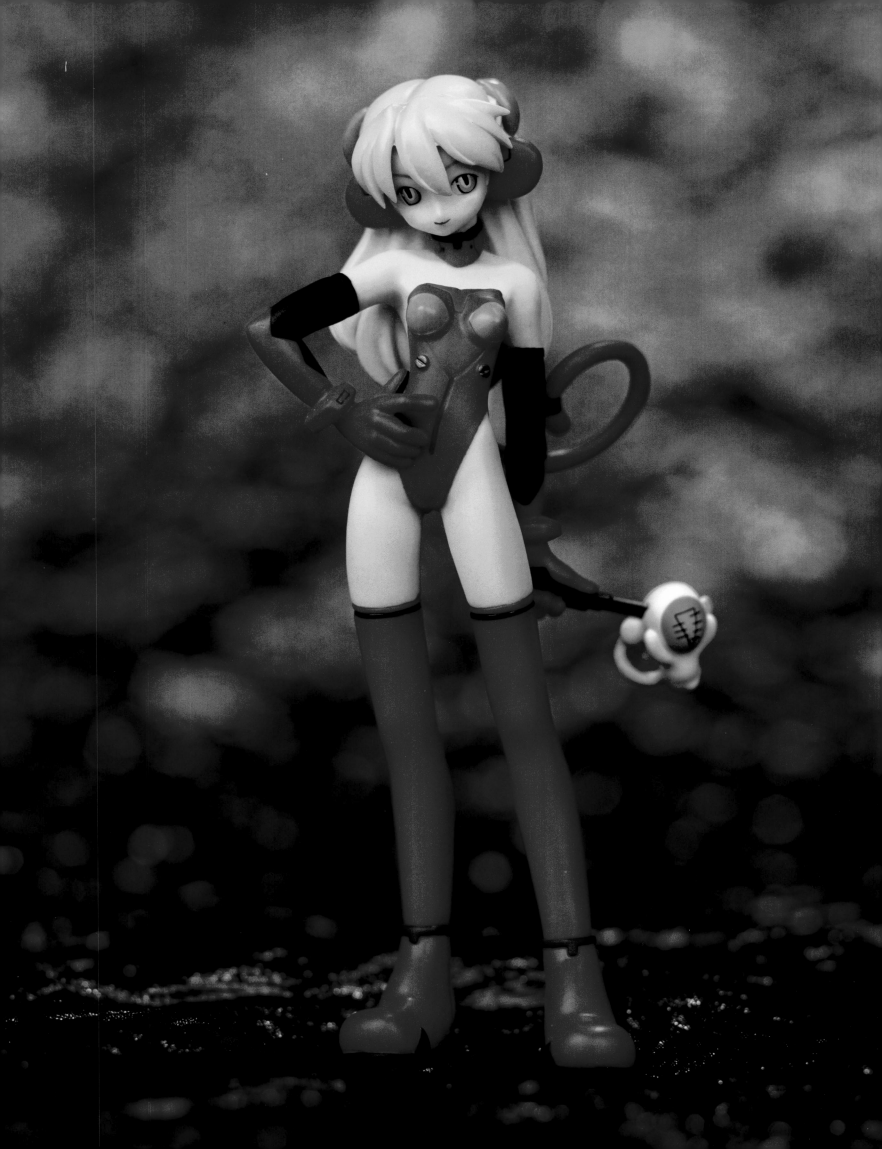

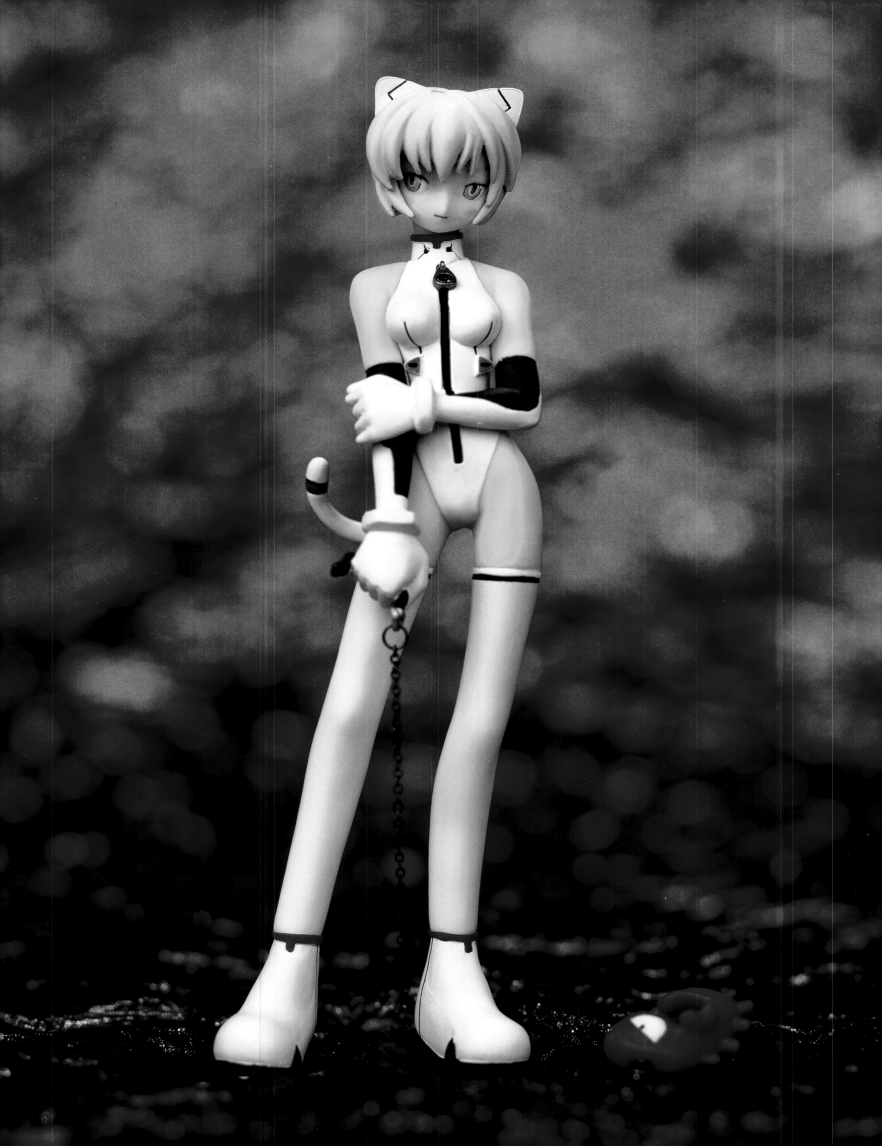

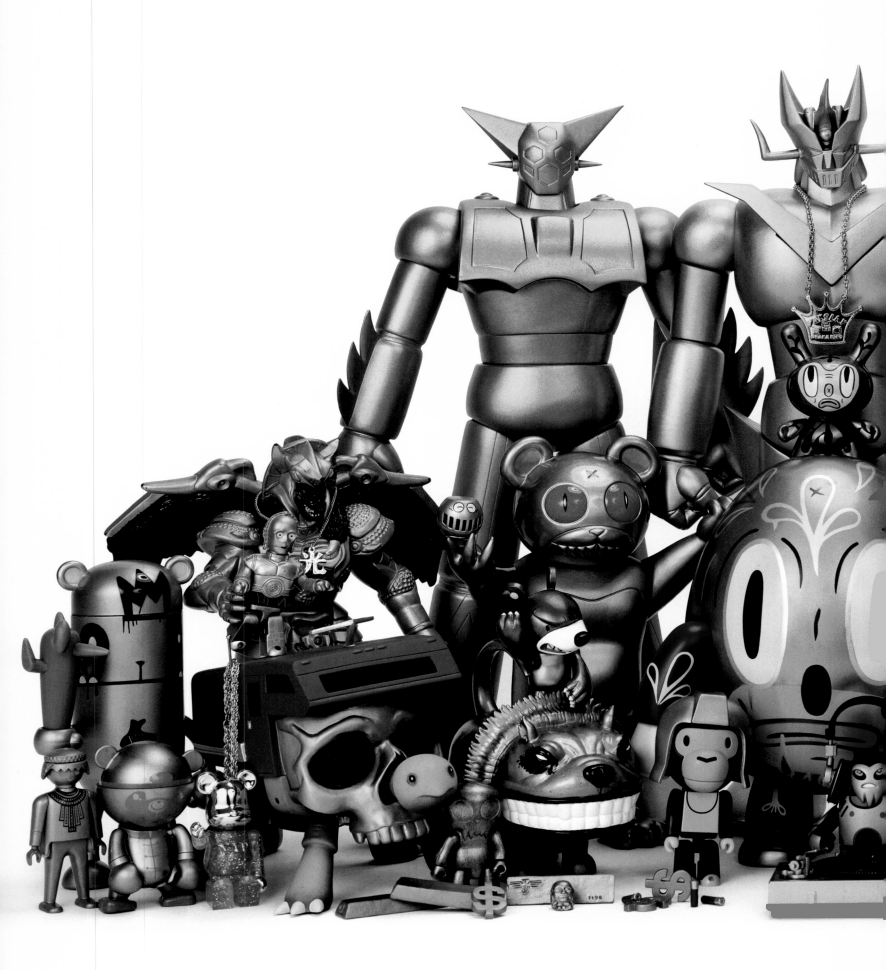

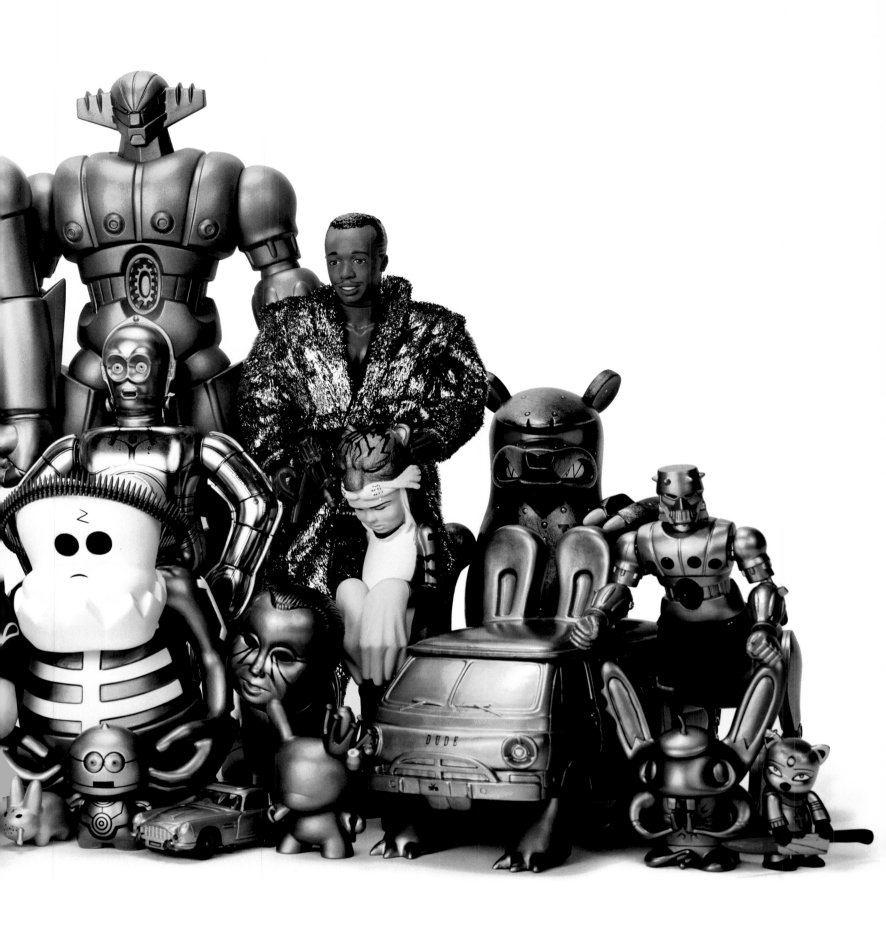

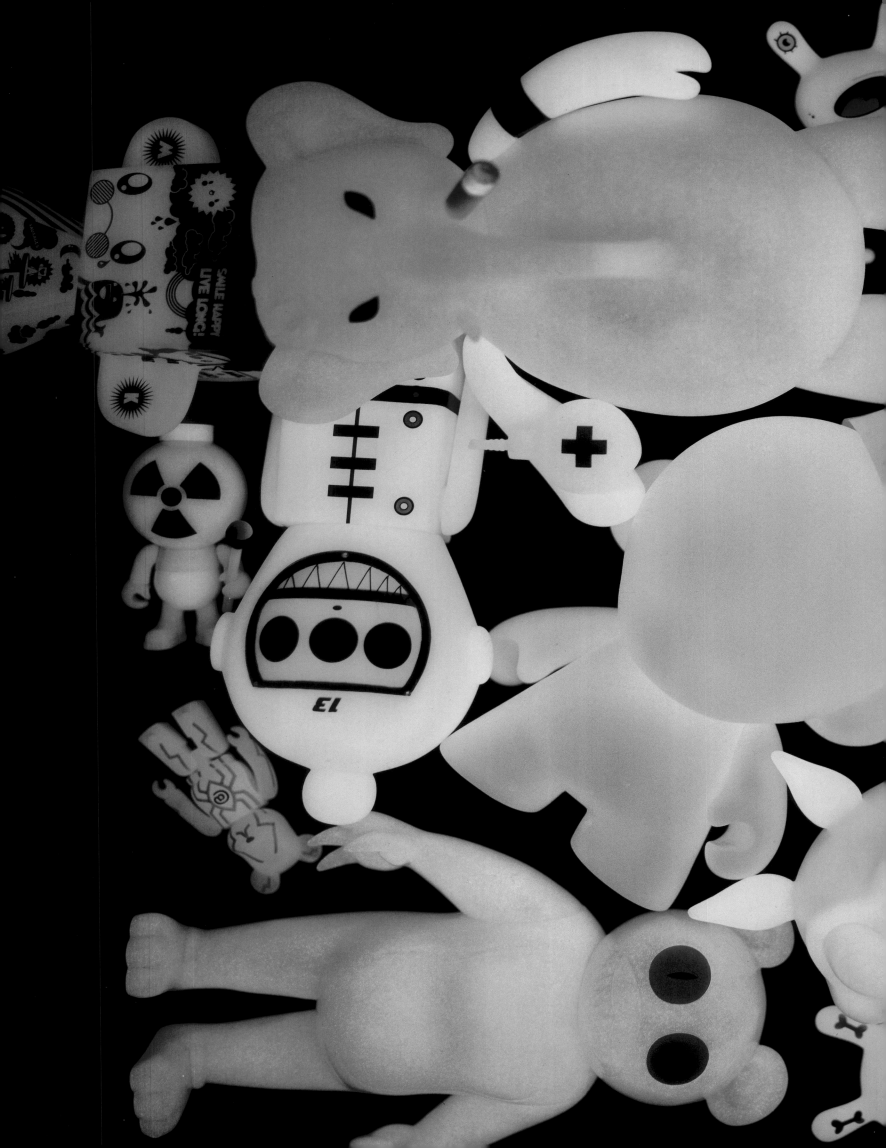

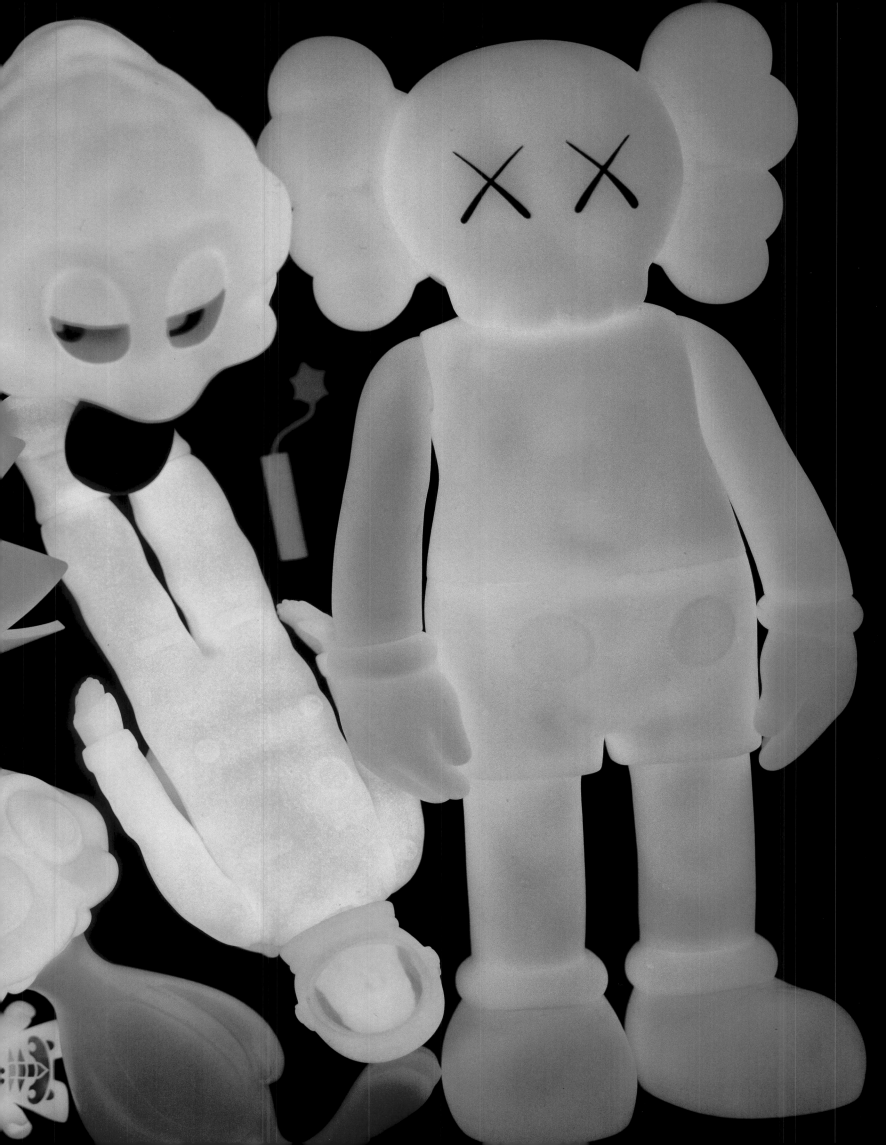

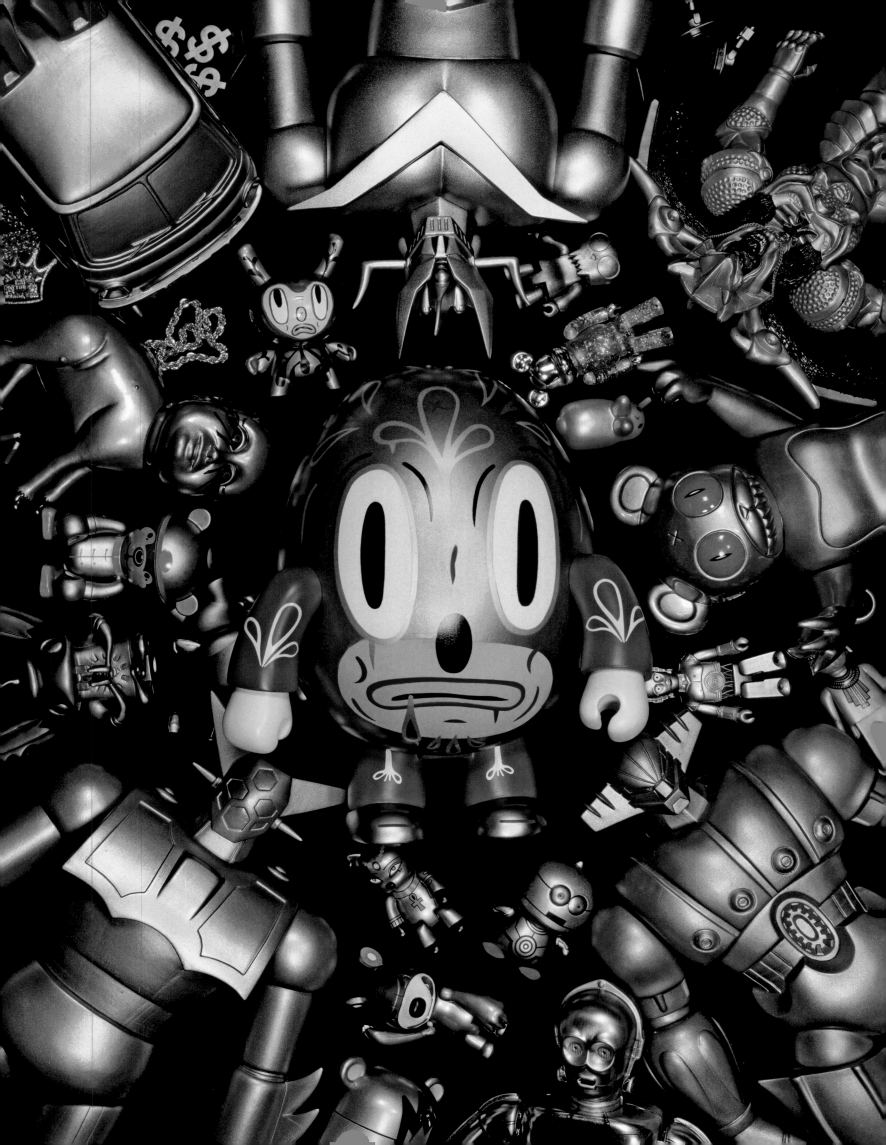

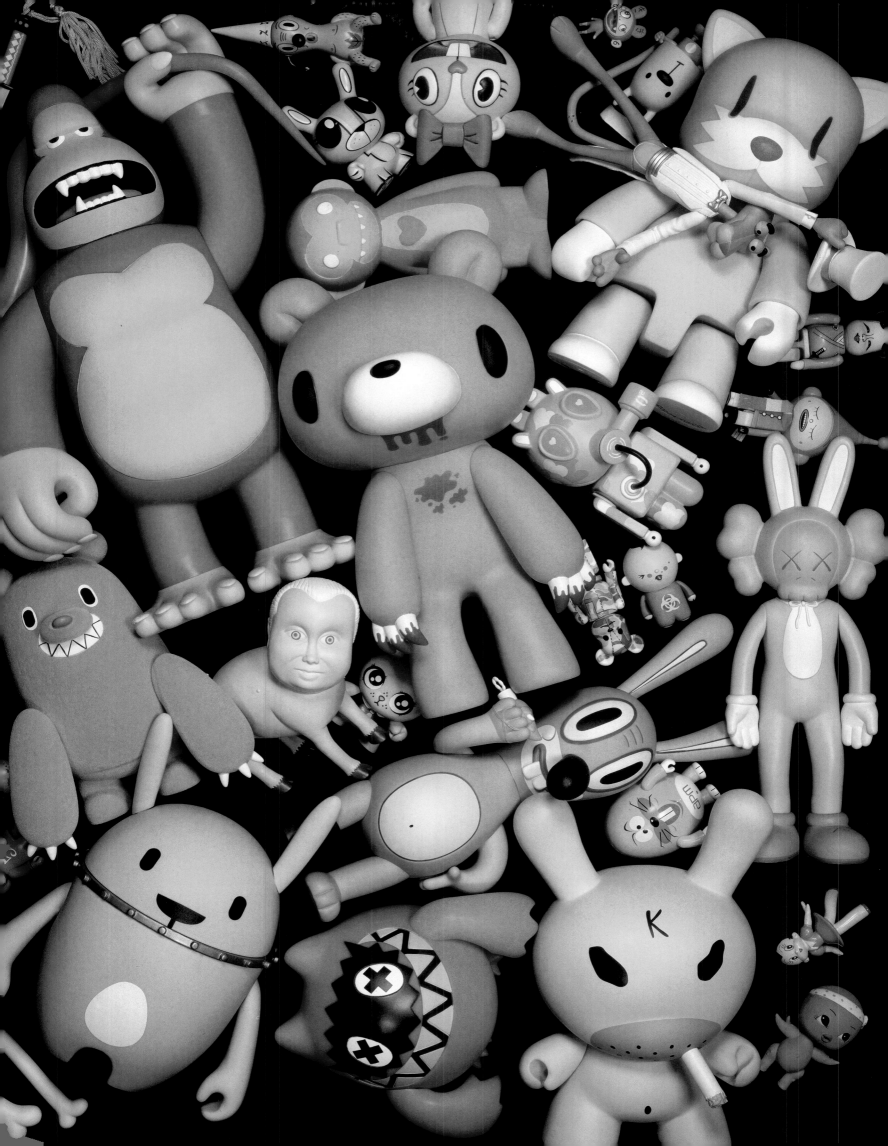

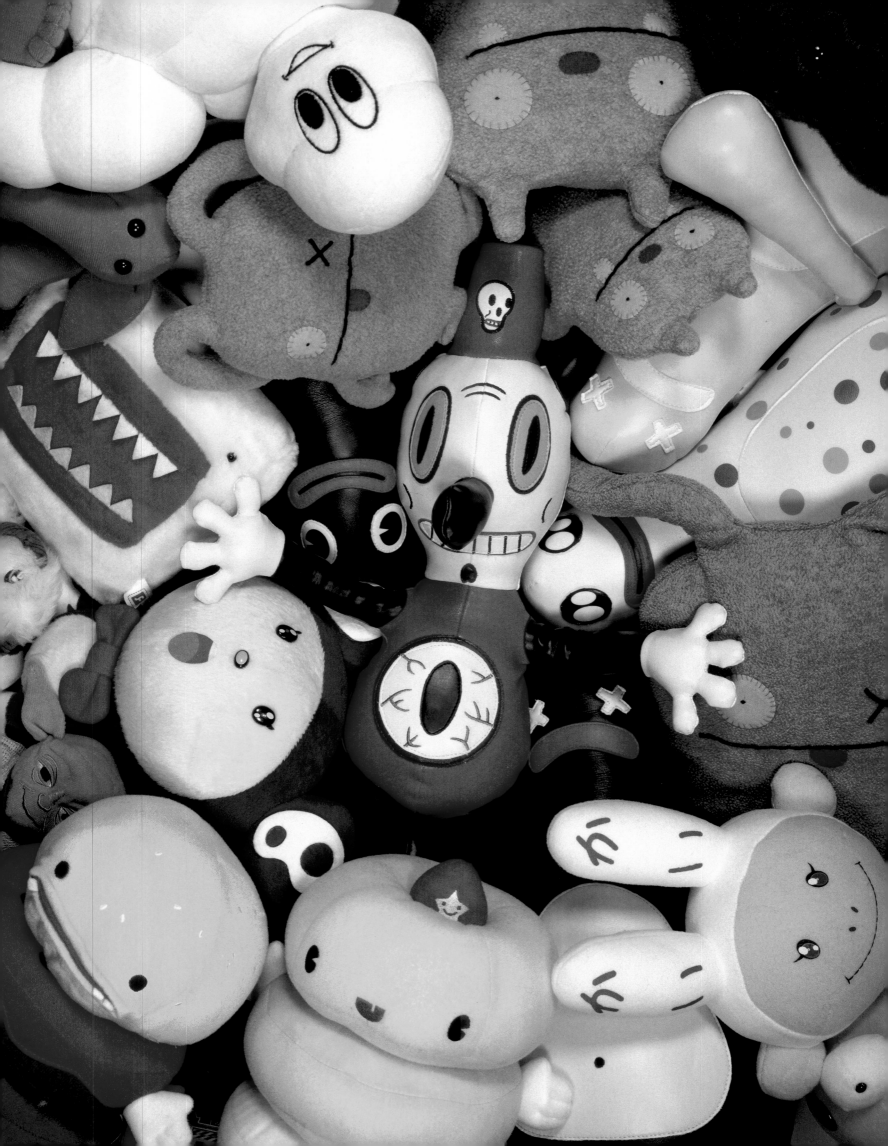

DANIEL & GEO & SELIM THANK:

GERTRUD & DIETER FUCHS · MARIO MARTINEZ · IRENE & MARCEL WIELAND · PAUL BUDNIZ ·

TORSTEN AUTH · WHITNEY & KIRBY KERR · SUSANNE PFLEGER · GUNDA PATZKE · THOMAS DOERING ·

NINA STURM · VERLAG FUER MODERNE KUNST NUERNBERG · JANA MARKO & ALEXANDER GERARD ·

JULIE CANGRAND · MUSEUM VILLA STUCK · OLIVER KORITTKE · MICHAEL THOSS · TIM BISKUP · JIM KOCH ·

WALTER SCHLAEPFER · PETE FOWLER · ROB MANLEY · BASIL THUERING · BARBARA DEN BROK ·

ECKEHARD FUCHS · JOHANNA & BERND PETER · JAMES MARSHALL · JAMES JARVIS · HANS-EBERHARD HESS ·

MARTIN GLOMM · BRIAN DONNELLY · HUCK GEE · KAY SCHLOSSMACHER · MARTINA RUEGER · MARC & YVONNE

GOELLNITZ · ANDREAS KNOCHE & JULIA DELVENDAHL · STEPHEN BULGER · HEINZ WALTER · MARTIN

ROGGE · NINA BINGEMER · FRIEDERIKE SCHMIDT-VOGT · NADIA CHAFFAI · SPIRIDON NAKOS · ACHIM LAHREM

MARION KNAUF · TADO · MARTIN WOIDER ·

MANFRED SAECK · TINO WOLFF

ANNE DOMDEY · ANTJE HUEBSCH EUGEN BLUME · RICHARD THE ·

ILVIA WOLF · · JOERG STARKE · ENNO HAEDE · JO-ANNE BIRNIE-DANZKER · MEHMET AYDIN

OV KELEMER · MICHAEL BUHRS · GEORGINE KNOELL · FAMILIE VAROL · IBRAHIM EMILY BROUGH

MICHAEL GUENCALDI · MATTHIAS REUSS & ANNETTE NELLESSEN · KATHRIN ROUAH ·

ATRICK MA · BIERLING · GINGKO PRESS · MO COHEN · ANIKA HEUSERMANN · DAVID RAYMOND

CHOY LOPES · TINA HUSEMANN · DANIEL & JOEL OSCHATZ · OSCHATZ VISU- ROBERT SILVA

OB MCBROOM ELLE MEDIEN · ANNETTE SCHERER · MIGUEL ANGEL SANCHEZ · MICHAEL · GLEN

LIBERMAN · KIM · ANNA OKONEK · UWE GEIER · ERWIN KNOELL · MARLIES FIEBIG SCOTT KNECHT

· CHIE FUJI · · FRANZ-JOSEF DROEGE · STEPHI WLOKA · JOHANNES DOMDEY FELIX BIERLING

GEORGE LUCAS · THORSTEN WITTLICH · CAPRICE HORN · MARITA RUITER · · DAVID WYNNE

WILLIAMS · GARY ROLF GOELLNITZ & ROXANN MADERA · PETER WEIER- BASEMAN · JOE

LEDBETTER · RON- MAIR · MELANIE GERZ · MAXIMILIAN GERZ · HUY NIE KIRST PIROVINO

· ALINE HOCHSCHEID · DIEU · BERKOL SCHLUETER · OLIVER RAEKE TAKASHI MURAKAMI ·

GUILIETTE JIMAA · · SAM BORKSON & ARTURO RON ENGLISH ·

CHRISTOPH SOEHNEL · SANDOVAL · SCOTT MUSGROVE ·

UWE HASENFUSS · TILT · CESS JOERG HENNING · LARS

NIEHBUR · FAMILIE MUHR · DANIEL GERTH · ILLMATIC DESIGNZ ·

SKET ONE · THOMAS JANSON · DAVID HORVATH · DOMA · DOZE GREEN ·

FRANK KOZIK · JAMES JARVIS · JAMIE HEWLETT · JEFF SOTO · JEREMY FISH · JERMAINE ROGERS ·

JIM WOODRING · NATHAN CABRERRA · NATHAN JURVEVICIUS · SPAN OF SUNSET · TOUMA · TIM

TSUI · SAM FLORES · TOKIDOKI · FAFI · KATHRIN BRETSCHNEIDER · FUTURA · MORI CHACK ·

MIKA TANAKA-SCHMACKS · BERND SPIECKER · JENNIFER ZWICK · MIKIKO SATO

OUR THANKS GO ABOVE ALL TO SELIM VAROL WITH WHOM WE DEPARTED ON THIS FANTASTIC VOYAGE INTO

>>TOYLAND<< AND WHICH EVOLVED INTO A MARVELOUS FRIENDSHIP. *DANIEL & GEO*

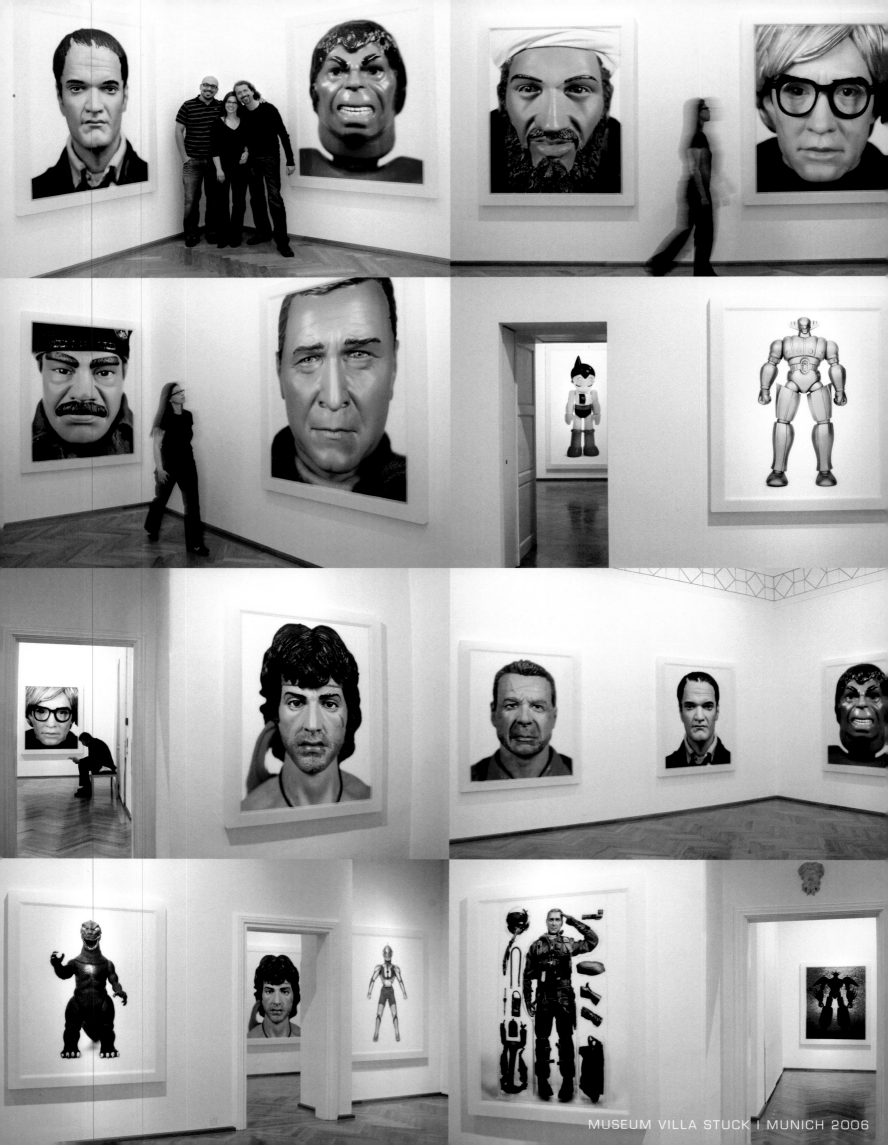

BIOGRAPHIES

DANIEL FUCHS, born in 1966
GEO FUCHS, born in 1969

SELECTED SOLO EXHIBITIONS

2008
Städtische Galerie Wolfsburg, "Toys" I ADN Galeria, Barcelona, "works of a decade"

2007
Palau de la Virreina, Barcelona, "STASI – Secret Rooms" I Galerie Le Lieu, Lorient, "STASI – Secret Rooms" I
Caprice Horn Galerie, Berlin, "Toys" I Gedenkstätte Deutsche Teilung, Marienborn, "STASI – Secret Rooms" I
Artempus, Düsseldorf, "Toygiants"

2006
Museum Villa Stuck, München, "Toys" I Museum Villa Stuck, München, "STASI – Secret Rooms" I Zeitgeschichtliches Forum Leipzig,
"STASI – Secret Rooms" I Städtische Galerie Neunkirchen, "STASI – Secret Rooms"

2005
Fotoforum West, Innsbruck, "Famous Eyes"

2004
Forum de l'Image, Toulouse, "Conserving" I Kunstverein Lippe, Detmold, "Famous Eyes" I Stiftung Starke, Berlin, "Famous Eyes" I
Photoforum PasquArt, Biel/Bienne, "Conserving"

2003
Flatland Gallery, Utrecht, "Famous Eyes – Conserving" I Galerie Clairefontaine, Luxemburg, "Luxemburger Porträts"

2002
Kunsthaus / Barlach Halle K, Hamburg, "Famous Eyes" I Photology, Milano, "For your eyes only" I Galerie
Clairefontaine, Luxemburg, "Famous Eyes" I Camera Work, Berlin, book presentation "Famous Eyes"

2001
Congress Centrum Saar, Saarbrücken, "Conserving" I Medizinhistorisches Museum, Zürich, "Conserving" I
Camera Work / Berliner Medizinhistorisches Museum, Berlin, "Conserving" I Staatsbank Berlin, slide-projection
"Conserving – Rammstein"

2000
Galerie Le Réverbère, Lyon, "Conserving" I Stephen Bulger Gallery, Toronto, "Conserving" I Rencontres
internationales de la photographie, Arles, "Conserving" I Naturhistorisches Museum, Basel, "Conserving" I
Fotografie Forum International, Frankfurt am Main, "Conserving" I Galerie Nei Liicht, Dudelange, "Conserving
Fish" I Kunsthaus / Barlach Halle K, Hamburg, "Conserving"

1999
Kunsthaus / Barlach Halle K, Hamburg, "Espada"

1998
Kunsthaus / Barlach Halle K, Hamburg, "Conserving Fish" I Galerie Nei Liicht, Dudelange, "Espada" I
galerie & edition m, Leipzig, "Im falschen Körper"

1997

Schirn Kunsthalle, Frankfurt am Main, "Espada" I Neue Gesellschaft für bildende Kunst, Berlin, "Im falschen Körper" I
Grundbuchhalle, Hamburg, "Menschen in der Psychiatrie"

1996

Halle K3 Kampnagel, Hamburg, "Im falschen Körper"

1995

Gasteig, München, "Im falschen Körper" I Römer, Frankfurt a. M., "Im falschen Körper" I Schauspiel, Frankfurt a. M., "Die Unbehausten"

SELECTED GROUP-EXHIBITIONS AND ART FAIRS

2008

Arco Madrid, ADN Galeria, Barcelona

2007

Biennale of Contemporary Art, Thessaloniki I Ursula-Blickle-Stiftung, Kraichtal, "small is beautiful" I Preview, Berlin, ADN Galeria,
Barcelona I Slick art fair, Paris, ADN Galeria, Barcelona I Photo Miami, ADN Galeria, Barcelona I Photo Miami, Galerie Caprice Horn,
Berlin I DFOTO, San Sebastian, Flatland Gallery, Utrecht I Cornice, Venice, Galerie Caprice Horn, Berlin I YEAR_07 Art Projects, London,
Galerie Caprice Horn, Berlin I Fotogalerie Wien, "Orte mit Geschichte" I Arte Santander, ADN Galeria, Barcelona I
OMC gallery, Huntington Beach, "Art, Made in Germany" I Art Cologne, Caprice Horn Galerie, Berlin I Art L.A., Caprice Horn Galerie,
Berlin I Kiaf Korea, Caprice Horn Galerie, Berlin I Art Brussels, ADN Galeria, Barcelona I swab Barcelona, ADN Galeria, Barcelona

2006

Palazzo Cavour, Turin, "Other Families" I Viennabiennale, Wien I Potsdam Museum, "Auslöser Potsdam" I
Locarno Film Festival, Movements, Play Forward section I Caprice Horn Galerie, Berlin, Monat der Fotografie, "Refraction" I
Photomeetings Luxemburg, "Mass Media Manipulation" I Galerie Clairefontaine, Luxemburg I Photo Miami, Caprice Horn Galerie, Berlin I
Photo New York, Caprice Horn Galerie, Berlin I Paris Photo, Galerie Clairefontaine, Luxemburg I Art L.A., OMC Gallery, Huntington Beach

2005

Museum für Fotografie, Braunschweig, "Polaroid als Geste" I Photo L.A., OMC Gallery, Huntington Beach

2004

art.fair Cologne, OMC Galerie für Gegenwartskunst, Huntington Beach I Photo L.A., Galerie Clairefontaine, Luxemburg

2003

Kunsthal Rotterdam, "Four centuries of smoking in art" I International Biennial of photography, Turin I Fotomuseum Den Haag,
"Mortalis" I Minerva Academy, Groningen, "De Voorproef" I Stephen Bulger Gallery, Toronto, "Suture" I Photology, Milano, "Occhio
per occhio" I Galerie Clairefontaine, Luxemburg, "autoportrait+nus" I Paris Photo, Flatland Gallery, Utrecht I Kunst Rai Amsterdam,
Flatland Gallery, Utrecht I Art Brussels, Galerie Clairefontaine, Luxemburg I Art Rotterdam, Flatland Gallery, Utrecht I Artefiera Bologna,
Photology Milano

2002

Muséum national d'histoire naturelle, Paris, "Histoire Naturelle" I Art Cologne, Galerie Clairefontaine, Luxemburg I
Paris Photo, Galerie Clairefontaine, Luxemburg

2001

Aipad New York, Stephen Bulger Gallery, Toronto I Muséum d'histoire naturelle, Lyon, "Carte blanche" I
Fiac Paris, Galerie Le Réverbère, Lyon I Photo Los Angeles, Stephen Bulger Gallery, Toronto

2000

Göteborg Museum of Art, "New Natural History" I Franckesche Stiftungen, Halle/Saale, "Kinder haben Rechte" I Elektrizitäts-Werk,
Tel Aviv, "Prometheus" I Paris Photo, Galerie Le Réverbère, Lyon I Art Cologne, Lipanjepuntin Artecontemporanea, Trieste I Art Brussels,
Lipanjepuntin Artecontemporanea, Trieste I Arco Madrid, Lipanjepuntin Artecontemporanea, Trieste I Arte Fiera Bologna, Lipanjepuntin
Artecontemporanea, Trieste

1999

National Museum for Photography, Bradford, "New Natural History" I Lipanjepuntin Artecontemporanea,
Trieste, "Still in motion" I Art Cologne, Lipanjepuntin Artecontemporanea, Trieste

1998

Internationale Photoszene, Köln, "Espada" I Alte Völklinger Hütte, Völklingen, "Prometheus" I
Airport Gallery, Frankfurt am Main, "Die Farbe Grün" I Art Frankfurt, galerie & edition m, Leipzig

1997

Rautenstrauch-Joest Museum, Köln, "Sie und Er – Frauenmacht und Männerherrschaft"

SLIDE-PROJECTIONS

"Looking at another world", with pictures of our projects from 1992–2002, for the CNA – Centre national de l'audiovisuel
Luxembourg I "Conserving – Rammstein" slide-projection of the first listening session of the Rammstein album "Mutter"

MONOGRAPHS

"Luxemburger Portraits", Edition Galerie Clairefontaine, Luxemburg, 2003 I "Famous Eyes", Edition Reuss, München, 2002 I
"Conserving", Edition Reuss, München, 2000 I "Im falschen Körper", Verlag Martina Rueger, Wiesbaden, 1995

CATALOGUES FOR GROUP EXHIBITIONS

"small is beautiful", Ursula-Blickle-Stiftung, Kraichtal, 2007 I "Other Families", Palazzo Cavour, Turin, 2006 I "Auslöser Potsdam", Museum,
Potsdam, 2006 I "Photomeetings Luxembourg", Galerie Clairefontaine, Luxemburg, 2006 I "Polaroid als Geste", Verlag Hatje Cantz,
Ostfildern, 2005 I "Rookgordijnen – Roken in de kunsten", Kunsthal Rotterdam, 2003 I "In Natura", Biennale Internazionale di Fotografia
Torino, 2003 I "Reality-Check", 2. Triennale der Photographie, Hamburg, 2002 I "La photographie traversée", Rencontres internationales
de la photographie, Arles, 2000 I "Histoire Naturelle", Muséum national d'histoire naturelle, Paris, 2002 I "Carte Blanche", Muséum
d'histoire naturelle, Lyon, 2001 I "Rammstein", 2001 I "Still in motion", Lipanjepuntin Artecontemporanea, Trieste, 1999 I "New Natural
History", National Museum for Photography, Bradford, 1999

DOCUMENTARY FILM

"Eyecatcher – ein Portrait über Daniel & Geo Fuchs", New Best Friend Film Production, Frankfurt 2001, 45 min.
The New Best Friend Film Production Frankfurt accompanied Daniel & Geo Fuchs from 1999 to 2001 on their work
on the "Conserving" and "Famous Eyes" projects.

ARTIST IN RESIDENCE

Stiftung Starke / Löwenpalais Grunewald Berlin 2004/2005

www.daniel-geo-fuchs.com I www.toygiants.com .

DANIEL

GEO

SELIM

SELIM

DANIEL

GEO

ANTJE

WHY TOYS AND WHY SO MANY OF THEM?

That's what most people ask, when they see the extent of my collection. One motivation was doubtless a fateful experience from childhood: At the age of twelve I entered my room only to find all the toys had vanished! My mom gave them all away. She probably thought it was time for me to outgrow this phase. Instead, my passion for collecting only intensified, and I proceeded to assemble over the next twenty years one of the largest toy-related collections in the world.

Who wouldn't recall their favorite toy from childhood, the one always at our side, that kept watch over us and stimulated our fanstasy? In the past few years the international toy market as well as my own perspective regarding TOYS have changed considerably. Heroes and villains pack a lot more muscle, and exhibit more violence, in a sense absorbing the present zeitgeist. Technical advances allow for ever more detail, whereby the line between fiction and reality is constantly blurred. An increasing number of artists create new characters or redesign and make over existing models, forging new works of art.

Nevertheless, the collaboration with Daniel and Geo Fuchs greatly impacted the development and direction of my collection. The times we spent together during the past three years, producing the images for TOYGIANTS were imbued by an aura of childlike intimacy where noone else was permitted. Irrespective of our artistic interchange, the fruit of which is visible through this book, and aside from some beautiful and lingering memories, during the life of this project a friendship was spawned.

A friendship resembling that among children, that play and become best friends and stay best friends. I hope that TOYGIANTS can take everyone on a journey through childhood, and stirs us to better understand our childhood and our children. How simply the problems of the world could be solved if everybody could think and act a bit more like kids. Playfully.

We move TOYS, and TOYS move us! The little and the grown-up children.

SELIM VAROL

WIESO SPIELZEUG UND WESHALB SO VIEL?

Das fragen sich die meisten, nachdem sie das Ausmaß meiner Sammlung gesehen haben. Ein Antrieb war sicherlich ein einschneidendes Kindheitserlebnis: Mit zwölf kam ich in mein Kinderzimmer, und das Spielzeug war weg! Meine Mutter hatte es verschenkt, wahrscheinlich dachte sie, ich sei zu alt dafür. Zusammen mit meiner ausgeprägten Sammelleidenschaft entstand so in mehr als zwanzig Jahren eine der größten Sammlungen rund ums Thema TOYS.

Wer erinnert sich nicht an sein Lieblingsspielzeug, das jeden von uns begleitet, beschützt und kreativ geprägt hat. Über die Jahre haben sich der weltweite Spielzeug-Markt und auch meine Sichtweise zu den TOYS maßgeblich verändert. Helden und Schurken werden immer muskulöser, brutaler und passen sich in gewisser Hinsicht dem Zeitgeist an. Der technologische Fortschritt ermöglicht ständig mehr Details, wodurch Fiktion und Realität zusehends verschwimmen. Immer mehr Künstler erschaffen neue Charaktere oder verarbeiten und bemalen bestehende Rohformen zu neuen Kunstwerken.

Nicht zuletzt hat die Zusammenarbeit mit Daniel & Geo Fuchs die Entwicklung und den Umgang mit meiner Sammlung stark beeinflusst. Unsere Treffen in den letzten drei Jahren, bei denen die Aufnahmen für TOYGIANTS entstanden sind, waren stets von einer kindlich intimen Stimmung geprägt, bei der kein anderer stören durfte. Abgesehen vom kreativen Austausch, dessen Resultate in diesem Buch zu sehen sind, und unvergesslich schönen Erinnerungen, entstand im Laufe dieses Projektes eine Freundschaft.

Eine Freundschaft wie bei Kindern, die beim Spielen beste Freunde werden und bleiben! Ich hoffe, dass TOYGIANTS jeden auf eine Reise in die Kindheit bringen und uns dazu animieren kann, unsere Kindheit und unsere Kinder besser zu verstehen. Wie einfach wären die Probleme dieser Welt zu lösen, wenn alle ein bisschen mehr wie Kinder denken und handeln würden? Spielerisch!

Wir bewegen TOYS, und TOYS bewegen uns! Kleine wie auch große Kinder!

SELIM VAROL

トイランドのダニエル&ゲオ・フックス

　僕のコレクションを見た後で、ほとんどの人が投げかける質問だ。収集を始めた直接の動機は、子供時代の、あの深刻な体験にあると思う。12歳のある日、自分の部屋に戻ると、僕のオモチャが全部消えていたのだ。もうオモチャで遊ぶ年ではないと思ったのだろう、母が誰かにあげてしまったのである。痛手から立ち直るため新たにオモチャを集め始めたのだが、僕が徹底した収集狂であることも手伝い、20年以上の歳月を経て「トイ」をテーマとした一大コレクションが誕生したのだった。

　子供の頃お気に入りだったオモチャを、みんな必ず覚えているだろう。いつも一緒にいて、僕たちを守ってくれ、創造性を伸ばしてくれたオモチャたち。時とともに世界の玩具市場は様変わりし、僕のオモチャに対する見方もずいぶん変わった。ヒーローや悪者たちはどんどんムキムキに、暴力的に、そしてある意味で時代の風潮にマッチするようになった。技術の進歩によってディテールのつくりも精巧になり、フィクションとリアリティの境界線が加速的に希薄になっていった。アーティストたちは次々と新キャラクターを創造・加工するだけでなく、既存のキャラクターには新たに彩色するなどして作品を生み出し続けている。

　ダニエル&ゲオ・フックスとの共同作業によって、僕自身、コレクションとの結びつきが強まり、付き合い方も密になった。過去3年間にわたり2人は何度も僕を訪ね、コレクションの撮影をして、その中からこのTOYGIANTSも生まれていった。3人で過ごした時間には、いつも子供同士のような親密な空気が漂っていて、僕たちは誰にも邪魔されたくなかった。3人によるクリエイティブなアイデアの交換は、この本にも表れていると思う。生涯忘れられないような、楽しい思い出もたくさんつくることができた。そして、このプロジェクトが進行する間に、僕たちの間には友情も生まれた。子供と子供が遊んでいる間に自然に親友になり、その友情がずっと続くような関係が生まれたのだ。TOYGIANTSに触れることで皆さんが子供時代に戻り、あの頃の自分をもっと理解し、そして今の子供たちをもっと理解できるようになってくれればと思う。少しでいいから子供のように考え、物事に対処できれば、世界の諸問題はもっと簡単に解決できるのではないだろうか?そう、遊びながらだ。

　僕たちがオモチャを動かして遊べば、モチャは僕たちに応えてくれる。それは小さい子供でも、大きい子供でも同じことだ。

セリム・ヴァロル

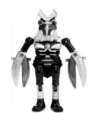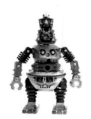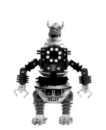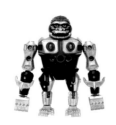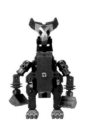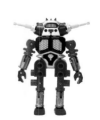

トイランドのダニエル＆ゲオ・フックス

ダニエルとゲオ・フックス。カップルでもある2人のアーティストの写真は、観る者を引きつける特殊な力を発散している。その効果は、展覧会場では額入りの大作に顕著だが、同時に2人のイニシアティブで出版した写真集の中でも、輝きを微塵も失っていない。大変な手間をかけて制作された写真集は、それ自身が芸術である。2人が意図した、いやむしろ2人の情熱から生まれたオブジェと表現すればぴったりくるだろうか。本を開いてみれば、その情熱はさらにはっきりと伝わってくる。ダニエルとゲオはカメラを使ったコレクターなのだ。2人はさまざまな事物を考察するが、ありきたりの意味においてみつめるのではなく、考察をアーカイブ的な作業として行っている。つまり、彼らの関心をひく特定の事物を分類した上で、フォトジェニックな風景としてカメラに収めるのだ。ほとんど科学的ともいえるアプローチと、精密で冴えた手仕事を通して、世界を細部に至るまでできる限り完全に保存しようとする2人の願望がさらに増長されている。2人の写真的ヴィジョンは、完璧な照明を施して至近距離から撮影した動物や人体の標本（"Conserving"）など、従来のテーマからのみ生まれたのではない。新たなテーマを追求する中から、独立したコレクション領域として発展してきたものもある。たとえば著名人を演出してその表情を撮影した（"Famous Eyes"）シリーズ、今では博物館的に扱われている旧東独秘密警察の刑務所と取り調べ室（"STASI – secret rooms"）のシリーズなどがその例だ。

"Conserving"で、ダニエルとゲオ・フックスは、保存された動物や人間のクローズアップのシリーズを発表した。人体標本の写真は、慣例的にタブーの領域に達している。現代社会がいくら好奇心いっぱいで何でも見たいと思っていても、すべてが公開されるわけではない。解剖室や病理標本の撮影は、昔も今も制限付きでしか許されていない。禁じられたものを見たいという願望、換言すれば、禁じられたものを科学的な視点から切り離し、アーティストのまなざしを通して公表したいという欲望。それは、死やセクシュアリティーなど社会的タブーとされている領域における「民主化」と言える行為だが、2人が撮影した人体標本はその民主化を高次のレベルで達成している。これはポルノ写真のようにその場限りの表現ではなく、モティーフを審美の対象とするため厳密に周到に考え抜かれたひとつのフォームだ。中には100年以上も経っている人体標本の中に命を呼び戻し、その細部にまで目を向け、常に意識に死をとどめておけば、観者は人間存在の深遠なる全体像を把握することができるだろう。恐ろしいものたちは、それを見たいという人間の欲望とあいまって、ここで写真芸術に止揚され、美しく変容し、生命のもつ神秘的次元にまで広がっていく。

STASIのシリーズでは、権力行使と完全監視、そして処罰の現場となった秘密の建物がモティーフになっている。独裁政権下、全体主義の名において政治犯に対し暴力と処罰が加えられた殺風景な部屋の数々を、ダニエルとゲオは旧東ドイツの終焉から15年経って初めて撮影した。カメラは、今となっては加害者も犠牲者も「住んでいない」部屋をみつめる。それでいて、当時のまま保管された細部に、鈍化した思想と意味を失い暴力性だけを増した秩序が、ぎょっとするほど如実に残存している。取り調べ室の非人間的な「ミニマリズム」は底知れぬ冷たさを伝えるが、2人の写真はこれをノーコメントで記録することに成功している。STASIシリーズは、救いのない風景の中に形式的な原則を追求する類の美的な写真ではない。ひとつの死んだ世界をクリアに、ひんやりとフィルムに焼き付けたかのようなのだ。

ポートレートを集めて独特の味を出している"Famous Eyes"のシリーズでは、ダニエルとゲオはまず人物の目だけを特製ポラロイドカメラで撮影した。目というのは、その人の顔を決定的に特徴づける存在だ。視線はこちらに投げかけられている。目は魂の奥底までを映し、その人の履歴を語る。つまり有名人たちの「語る」目がポラロイドに記録されているのである。その後、2人はモデルたちと話し合い、目をポートレートのどの部分にはめ込むのがよいかを決めていった。モデルと一緒に作品を構成する、この一風変わった共同作業によって、ダニエルとゲオは被写体とカメラの間に独特の心理的・社会的関係をつくり上げた。2人は「写真の中の写真」、つまりもうひとつ別の次元を通して、ポーズをつけた人物の本性を明かす。ここで発せられているのは、見つめられることに慣れている有名人たちが、自分の目とどう向き合っているのかという問いだ。2人はアーティストとして、見る行為を生業にまで高めている。

デュッセルドルフ在住のコレクター、セリム・ヴァロルを通じて、ダニエルとゲオはプラスチック・フィギュアを始めとするトイの世界を発見した。これらのトイは主にアジアで生産されてい

るものの、欧米の現代生活をファンタジーの領域まで含めて反映している。

ドイツ語では玩具を"Spielzeug"と言うが、玩具は常に人工のセカンド・ワールドとして存在していた。興味深いことに、語源的にZeugには「物質」とか「器具」といった意味だけでなく、何かを創り出すもの、生み出すものという意味もある。前にくっついている"Spiel"の語源は明らかでないが、Zeugという言葉の毒を消して無邪気な響きにまとめる役割を果たしている。同時に、この言葉には子どもたちにしっかり心の準備をさせるという意図も含まれる。ゲーム（"Spiel"）で、子どもたちは大人になっていくことに伴う種々のルールを覚え込まされる。すなわち玩具（"Spielzeug"）は、教育上から見て効率的な、自然な形での現実世界のコピーなのだ。人形の家、鉄道モデル、戦争ごっこの道具、ミニカーなどを、大人は子供のために小さいサイズで作る。現実性がないとはいえ、こうした玩具は、ミニチュアモデルを通して子どもたちに現実社会に対する心の準備をさせることを目的としている。そして子どもたちが人生の最初の時期をおもちゃと過ごし、大人の世界に入っていくときには、その役目を終えるべき存在だ。遊びでは社会階層が再現されるだけでなく、性別による役割分担もはっきりしている。男の子は戦争ごっこの玩具や、鉄道模型や飛行機、クレーンや車などのテクニカルな玩具、または積み木などを与えられるのが常だ。つまり、男の子たちは男性向けとされている職業を、子供特有の混沌としたファンタジーの世界でそのまま演じる。これに対し女の子たちは、ミニサイズのリビングと台所のついたままごと用の部屋の中で人形をせっせと働かせ、未来の母親役を演出する。

しかし、私たちがここで取り上げ、ダニエルとゲオが最新プロジェクトとして写真コレクションのシリーズに加えた「トイ」は、これとはまったく違う性格をもつ。プラスチックの玩具そのものは、合成物質が発明された時点で既に存在していた。プラスチックは高価で扱いにくい他の素材に取って代わり、当初から耐久性にも優れていた。この本の中に収められたトイのキャラクターは、基本的に映画産業のマーケティング戦略から生まれたものだ。全世界で商業的成功を収めた映画のキャラクターがプラスチックでリアルに造形され、映像という実体のない時間芸術からフェティッシュな存在として「生まれた」のである。映画の上映中は空を飛べたスーパーマンも、上映後に館内が明るくなると消えてしまう。でも家に帰れば「リアルな」フィギュアとして

手にとることができ、いつでも悪者を退治してくれる。日常のルールから逃れることができたらという、多くの人々の平凡な夢が、ハリウッドの超人によって輝かしく実現されたのだ。

映画産業から生まれたプラスチック・フィギュアは、慣例的な意味においての玩具ではなく、映画のストーリーを内包し、その役割を最初から担っている造形物である。スーパーマンやバットマンやランボーのフィギュアで遊ぶ場合、それは前述のような社会的役割を習得することにはならない。このヒーローたちの男らしさは過剰で、日常ではありえない特別な役割を通して表現されているからだ。超人的な力をもつことは、下層階級、つまり権力に縁のない大衆のサブカルチュラルな願望である。スーパーマンは権力を奪われた者たちのヒーローで、悪者たちを制し、必要とあれば自然の法則を超越して社会の秩序を取り戻そうとする存在だ。スーパーヒーローのイデオロギーは一匹狼のそれで、欧米で疎まれているような、階級闘争を目的とした左翼共同体のそれではない。スーパーマンはどこかから救済者としてやってくる。このように目的論的に形成されたヒーロー像は、西洋、東洋に関わらずすべての社会集団に浸透している。彼らは、キリストやモハメッドや仏陀など宗教界のスーパースターたちの世俗的変種で、超自然の力によって奇跡をもたらす存在なのだ。特権をもった超人たちの集まりは、ダニエルとゲオによる大判ポートレートに収められ、際めて印象的に演出されている。フィギュアの全身が、子供たちが遊んでつけた傷も含めて、肉眼で見るよりはるかにくっきりと隅々まで写し取られている。それでいながら、写真は奇妙にも、フィギュアを玩具の国から引き離す役割も果たしている。フィギュアの顔はプリミティブなつくりを持つが、2人の巧みな撮影によってそこにリアルな肖像が生まれているのだ。こうして境界線を越えていくこと、真実と現実の間で玉虫色に表情を変えることは、しかしトイ産業自身も意図的に目論んできた。フィギュアの中にはバットマンやスーパーマン以外に、チェ・ゲバラやビン・ラディンなど歴史上の善人や悪人も登場している。とりわけヒトラーやサダム・フセインなど20世紀の悪者たちが圧倒的に多い。プラスチックで成型した非現実な世界、にぎやかなトイの世界に加わってはいるものの、悪人たちにはヒーローとは違うルールが適用される。彼らはあらゆるタイプの敵、特にティム・バートンの映画でおなじみの、知性と学識の信徒であるバットマンのような輩と対決することも計算に入れておかなければならない。実在の悪者たちを使っ

て、ダニエルとゲオは現実にはあり得ないグループを編成し際立った手法で見る者のファンタジーをかき立てている。

たとえばアドルフ・ヒトラーといえば我々にとって最もポピュラーな悪党のひとりだが、ここではヒトラーが遂に、ワニとゲリラが合体した姿の武装戦士によってとどめを刺されている。また、ゴジラの口腔の中で苦痛にもだえるヒトラーの姿は、彼自身のキャラクターの狂気性を表現するメタファーとしてうまく機能している。悪夢を再現した王国でヒトラーは頼りない亡霊と化し、ゴジラによって象徴された自然の王国で他の悪党に征服されるのだ。歴史上の悪者たちの、服装や額のしわにまで至る精確な具体化、そしてヒトラーのコスチュームやマスクなどは、トイランドに封じ込められた否定的崇拝を象徴する呪物だ。彼の後に続いた悪党たちと同様、ヒトラーも最もアナーキックなゲームの規則に従わなければならない。そして彼の権力は、プラスチック・フィギュアにおいて最終的に破壊されるのである。欧米のリーダーかつ政治家であるジョージ・ブッシュのような人物、民主主義を「悪者の国」に導入したいとする人物のフィギュアも、きちんとした包装パックに収まった形で撮影された全身ポートレートにおいては意味のない人形、あるいはディテールの精確さだけに興味をもつコレクターのためのオブジェに成り下がっている。手袋をした手を何本も持つブッシュのフィギュア—航空母艦に乗り、勝利者のサインとして親指を立てているものも含めて—は、ブッシュの政治的パワーを、短期間しか続かない時事寸劇のレベルにまで浅薄化している。こうした遊びの世界を大判フォーマットで撮影したカラー作品は、遊びの世界と現実世界が同じ重要性を持つことを伝えている。

ダニエルとゲオは、いかにも本当にトイランドに足を踏み入れたかのように撮影しているが、見方によればこれは事実である。コレクターのセリム・ヴァロル、そして彼が保有する１万点近くのフィギュアと実際に出会ったことで、２人はメルヘン的ユートピアの摩訶不思議なパワーのとりこになったからだ。普通は、このフィギュア王国はインターネットを通じて愛好者を募っている。主にアジアのメーカーが、製品をなるべく速くコレクターに売りさばくために、ネットという迅速な情報経路を使っているためだ。フィギュアの種類は、時代を超えたバービー人形から、スターウォーズのヒーローたち、さらには日本のマンガやテレビ番組、ホラー映画、または何か人工的なイメージに着想を得たものまで、さらに増え続けている。現実と夢の世界が交錯するポップス界のスターたちも、硬いプラスチックや、柔らかいプラスチックのフィギュアとして誕生する。このほかに、誰も見たことがないようなフィギュア、たとえばデザイナーの純粋な発明やファンタジーの産物のようなものもあり、これらも実在の人物のコピーと同じようにファンの心を魅了する。

こうして考えていくと、これらのフィギュアはもはやほとんど玩具とは呼べなくなってくる。大人たちは、子供がまだ手元もおぼつかない頃から早々とフィギュアを買い与える。レアアイテムの値上がりを記載したカタログなども、とっくの昔から出回っている。フィギュアはひとつのサブカルチュラルなアートの形態にまで昇格したのだ。制作者の名前も知られるようになり、フィギュアのコレクターは芸術作品のコレクターと何ら区別がつかない。ただ、フィギュアのコレクターは独自のグループを形成しており、シュタイフのテディベアやケーテ・クルーゼ人形の愛好者たちとは一線を画している。フィギュアがむしろアートインスタレーションの展示会場やファッション店のウィンドーに登場し始めたのは偶然ではない。それは既に若者たちの消費社会の一部なのだ。

若者たちはフィギュアを自分のダブルとしてとらえ、独特で密接な関係を結んでいる。若者たちの服装やアウトフィットは、娯楽産業の人気スターたちの、架空の役割のイメージを模倣したものだ。フィギュアではそのイメージが三次元のミニチュアとして、自己を発見するためのデコラティブな呪物として具体的に喚起される。女性のフィギュアは、バービー人形を別にすれば、ごく物質的で強烈にエロティックな戦士たちである。彼女たちは筋肉隆々の男性フィギュアに対抗できる存在だ。実世界で過剰なデザインのファッションに身を包んだきらびやかなモデルたちを、トイ界の最も洗練されたフィギュアの女たちと区別することはほとんど不可能である。モデルたちはずっと以前から、年齢や死など人生につきもののすべての欠点を克服したかのようなトイランドに生きているのだ。ダニエルとゲオ・フックスが写真を通して、この特別な世界、私たちの現実世界に首尾よく入り込んできている、もうひとつの世界からレポートする。

オイゲン・ブルーメ / EUGEN BLUME

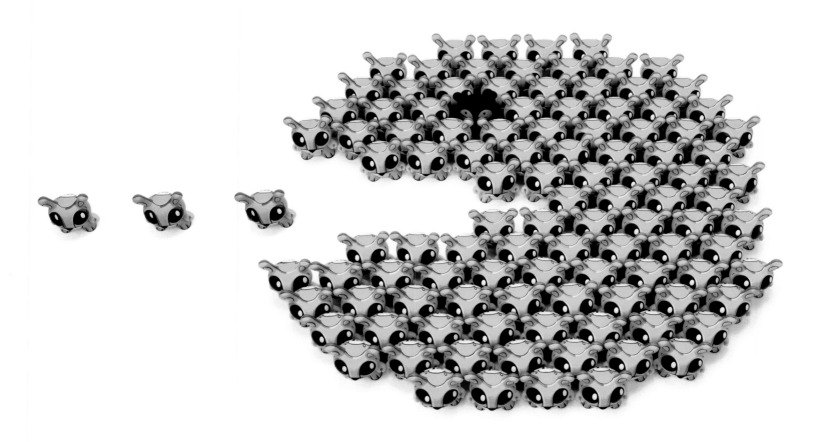

トイ・ジャイアンツ

DANIEL & GEO FUCHS

SILVER EDITION

GINGKO PRESS

ACKNOWLEDGEMENTS

Editor:
Selim Varol I www.toygiants.com
Graphic design:
Antje Hübsch I www.antjehuebsch.de
Editing and proofreading:
Martina Buder,
Anika Heusermann,
Gesine Märkel
Translation:
Mika Tanaka-Schmacks (Japanese),
Jeremy Gaines (English, texts)
Donna Wiemann (English, texts / interview)
Proof-Reading of English texts:
Susanne Lorenz,
David Lopes,
Anna Brown
Photo credits:
Daniel & Geo Fuchs I www.daniel-geo-fuchs.com

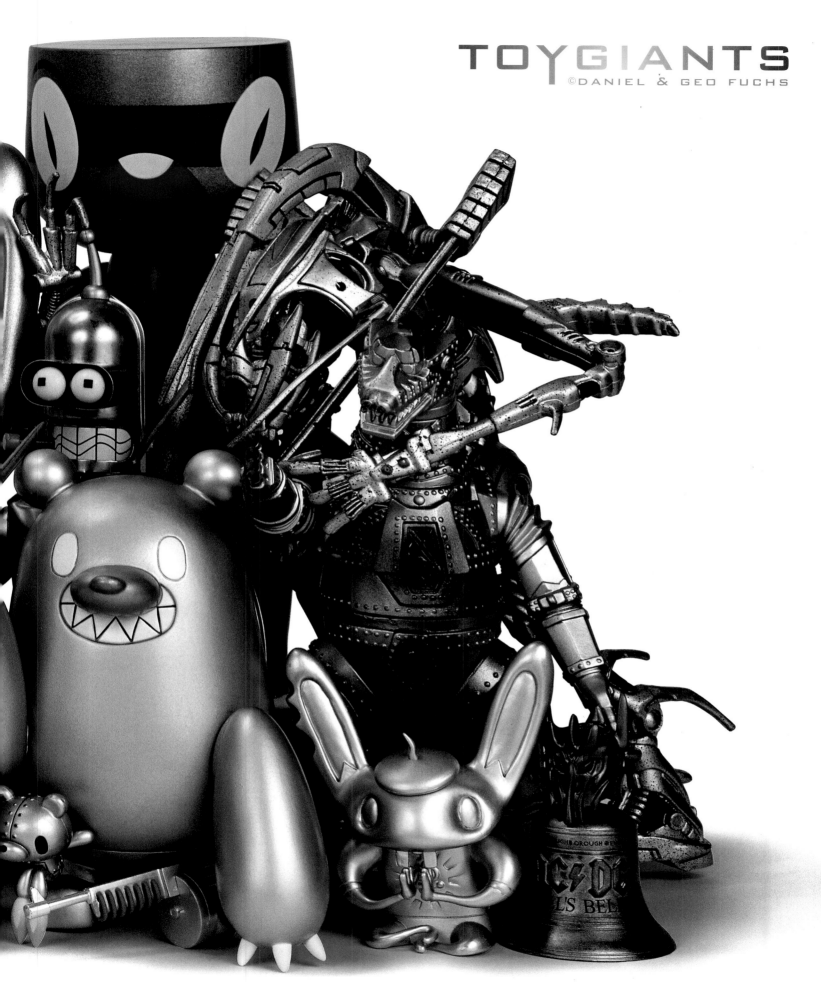

TOYGIANTS
©DANIEL & GEO FUCHS

GINGKO PRESS

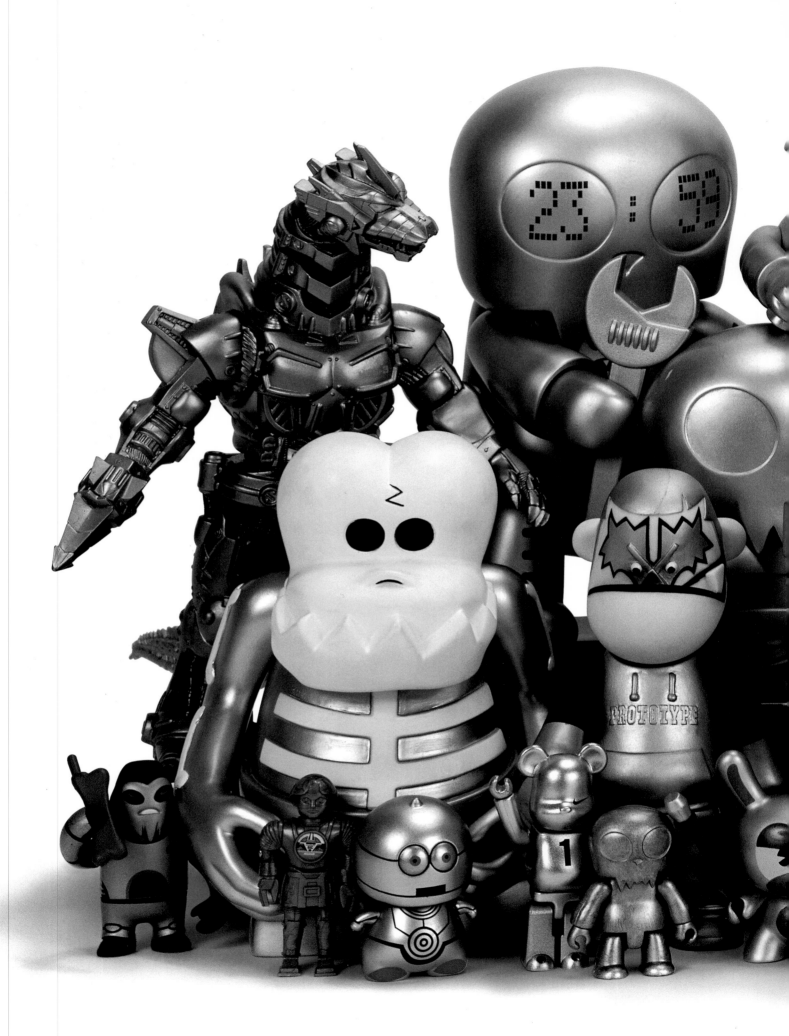